Time-Images

Time-Images:
Alternative Temporalities
in Twentieth-Century Theory, Literature, and Art

By

Tyrus Miller

Time-Images: Alternative Temporalities in Twentieth-Century Theory, Literature, and Art,
by Tyrus Miller

This book first published 2009

Cambridge Scholars Publishing

12 Back Chapman Street, Newcastle upon Tyne, NE6 2XX, UK

British Library Cataloguing in Publication Data
A catalogue record for this book is available from the British Library

ISBN (10): 1-4438-1258-7, ISBN (13): 978-1-4438-1258-0

TABLE OF CONTENTS

Section III: Moving Images of Time

ACKNOWLEDGEMENTS

Several of these pieces had their genesis in invitations to speak at conferences or to submit to special issues and volumes organized around various topics. I would like to thank Professor Ales Erjavec of the Institute of Philosophy in the Center of Scientific Research of the Slovenian Academy of Sciences (Ljubljana) for our on-going collaborations, as well as for his specific solicitation of my piece on "retroavantgardes" for a journal issue on the "revival of aesthetics." He also gave me the encouragement to assemble these essays as a volume organized around the theme of time and its multiple forms of expression in culture and thought. In connection to the essay on "Rethinking the Aesthetics of the Image," I am grateful to Chengji Liu of the Beijing Normal University for the opportunity to present a version of this to students and faculty in philosophy and sociology, and to Mao Xin who served as an extremely nimble and reliable interpreter for this encounter. For the essay on the Mass Observation dream project, I would like to acknowledge the kind assistance of Dorothy Sheridan of the Mass Observation Archive at the University of Sussex and the support of Professor Peter Nicholls during my periodic visits to Sussex; I also wish to thank Professors Laura Marcus, Nick Hubble, and Margaretta Jolly for their organization of a conference on Mass Observation at the University of Sussex and their subsequent publication of a special issue of *New Formations* on the topic. My sincere thanks go to Professors Paul Edwards and Alan Munton for their invitation to a conference on Wyndham Lewis at the Courtauld Institute, where my paper on Wyndham Lewis and cultural revolution was first presented; Professor Munton also helped me refine the essay in the process of preparing it for publication in the *Wyndham Lewis Annual*. For the Pasolini and Gramsci essay, I would like to acknowledge my co-organizer of a conference on Gramsci at the University of California at Santa Cruz, Professor Deanna Shemek, and the financial support of Cowell and Stevenson Colleges for the event. The essay on children as figures of historical witness had its origins in a course I taught at the University of California at Santa Cruz and subsequently was developed with the encouragement of Professor Thomas Vogler for the volume he was editing on *Witness and Memory*. The essay on Bruno Schulz and the Brothers Quay was originally presented in a conference

organized by Professors Mark Shiel and Tony Fitzmaurice at University College Dublin; they also gave considerable effort to suggesting revisions and refinements for the essay during the preparation of the *Screening the City* collection in which it originally appeared. I would like to thank Professors David James and Daniel Tiffany for their invitation to present my essay on Eisenstein and Olson at a conference on cinema and poetry at the School of Film and Television at the University of Southern California.

I would like to thank the artist Amey Matthews for the use of her wonderful paintings of world leaders as children for my cover images. Peter Harris deserves special thanks for the generous lending of his photographic skills in preparing the images for the cover, and Linda Pope put her skilled designer's eye to work on the layout of the cover images and text. I also wish to thank Erik Bachman for several rounds of meticulous editorial assistance.

My parents get grateful acknowledgement here for their steady support throughout the years and across the various moments of personal and professional change marked by these essays. Above all, my wife and best colleague Deanna Shemek deserves acknowledgement beyond my capacities here, for her patience in putting up with books, paper, and travel, and for her inexhaustible support, inspiration, and unwavering love.

CHAPTER ONE

INTRODUCTION: REFIGURING TIME

The term "time-image," introduced by Gilles Deleuze in his Bergson-derived cinema theory,[1] has to date not received much consideration as a concept in historiographic theory. Yet as I wish to suggest with the essays in this book, the concept of time-image holds untapped potential for the historical interpretation of cultural and aesthetic works—and well beyond the primarily cinematic field in which Deleuze himself applied it. As a broad interpretative notion, I argue, it sets in resonance the theoretical frameworks of heterodox cultural thinkers such as Walter Benjamin, Theodor Adorno, Michel Foucault, Antonio Gramsci, and Gilles Deleuze, insofar as it comprehends a diverse, open-ended set of possibilities to configure historical materials in novel ways and to communicate historical knowledge figurally. Many of the artifacts and works that may be interpreted as time-images would not ordinarily be thought to have anything to do with history more narrowly conceived, yet in light of this interpretative concept they reveal their latent historicity. One might, however, turn this argument back upon conventional historiography and see it not as the primary, normative frame within which historicity may be disclosed symbolically, but rather as a secondary, limited case of a much vaster set of historical figures, "time-images." In a sense, what we think of in the narrower sense as "historical" may be no more than a form of imagining history in which the historical time-image has become invisible. To put it otherwise, the disciplinary concepts, authorized sources, and paradigmatic narratives of historical writing may simply be conventionally modalized, naturalized cases of a much more general repertoire of time-images by which we may experience states of historicity, both actual and possible. It is their privilege within a disciplinary framework of training and writing and not their inherent monopoly on historicity that defines historical texts and documents as properly "historical" materials, as opposed to fiction, myth, custom, rumor, entertainment, or other putatively "extra-historical" genres of discourse and culture.

As already noted, Deleuze formulates his notion of time-image through reflection on the art of the cinema, in which the unfolding image on the

screen depicts both movement in space and duration in time. These phenomenological dimensions of experience are not simply abstract, external metrics of the cinema image, however; they are also singularly qualified by the particular movements and metamorphoses within the frame and by the specific kinds of linkage between the segments of a sequence. Deleuze distinguishes between two modes of cinema image, according to the relationship between motion and time in the image. In the first case, "the movement-image," movement of bodies in space is the predominant feature, and the experience of time derives from that primary experience of spatial movement. We might imagine a fairly clichéd montage sequence in which a car passes various recognizable sights of the city of Los Angeles, and at last is seen in a long shot with highway stretching out in front of it and the desert in the distance. Even with elliptical jumps from place to place, nothing violates our sense of normal spatial continuity and movement: the highway, the automobile, and the driver form a single coordinated representation of passage through space in a proportionate, homogeneous span of time. We would understand this as a spatial journey out of the city and into the open country, and our sense of the temporality of the sequence would derive from our construction of the spatial itinerary from the montage. Yet it can also be possible that the filmmaker wishes to make the primary focus an experience of time, and s/he will shape the movements and the space in ways that violate our intuitive sense of sensory-motor continuity, so as figurally to capture an image of time. Corollary to my first example, Michelangelo Antonioni's *Zabriskie Point* represents our drive out of Los Angeles into the desert as the passage from the time of modernity, a hectic time of traffic and real estate speculation and political violence, into a qualitatively heterogeneous temporal order composed of chthonic nature, slow geological metamorphosis, and mythic consciousness. Consistently faithful to this primacy of time as the raw material of his image, Antonioni concludes his film with the famous slow-motion explosion of a model housing development in the desert, in a radical "un-housing" of modern space that Antonioni shows us twice, first in the imagined anticipation of the disaffected young woman, then again in the actuality of the present, which is nonetheless dilated to several minutes of screen duration. Space, movement, and causality are figurally warped to the shape of a direct representation of time, a "time-image" that retains an intimate relation with the invisible thoughts and affections of mental events—in this case, the alienation of the young woman from her older capitalist boss and her conversion, in an indiscernable instant, to the revolutionary nihilism of her

young dead lover, with whom she had experienced the inhuman geological time-space of the California desert.

How might we apply to questions of historiography this distinction between "movement-image," in which time derives indirectly from the spatial and causal relations in and between images, and "time-images," which aim to represent a mode of time directly and bend movement and relation to conform to the temporal figure? Without making reference to Deleuze, Peter Osborne, in his *Politics of Time*, in fact suggests an analogous framework. "If Aristotle," Osborne asks, "sought to understand time through change, since it is first encountered in entities that change, might we not reverse the procedure, and seek to comprehend change through time?"[2] He goes on to conclude:

> [T]here is a deeper conceptual logic to be found at work in such categories of cultural self-consciousness than is suggested by the way in which they are usually deployed, as markers for chronologically distinct and empirically identifiable periods, movements, forms or styles: a logic of historical totalization which raises questions about the nature of historical time itself. (Osborne viii)

We need to distinguish two sorts of period notions, however, in keeping with this primacy of historical change or of states of time. In the first case, analogous to the "movement image," we derive the qualities of time—i.e. crisis-ridden, stagnating, peaceful, chaotic, etc.—from the events and movements of change. The time of history is derived from the rhythms of what happens "in" time. In the figure formed of them in historical writing, the facts and documents are made to reveal a pattern of evolution and movement through the successive days and months and years. In the second case, however, analogous to Deleuze's "time image," particular qualities and types of time express themselves in singular occurrences and mixtures, through particular images, artifacts, spaces, and movements. The historian may not be searching for direct links of narrative and causality between the different elements, which might even derive from diverse chronological or cultural contexts. Rather s/he seeks in them a virtual conceptuality that will be methodologically disclosed through techniques of montage, multimedia assemblage, play between documentary and personal memory, interpenetration of fictional and factual frameworks, or other experimental modes of figural thought typically associated more with the arts than the discipline of history. It is especially these latter forms of conceptually rich "time-images" that this set of essays explores.

The essays are divided into three main sections. The first section, entitled "Time-Images as Theory and Historiography," considers alternative

temporalities underlying historicizing theories and specific practices of history. The examples treated here include the notion of "retro-avantgardism," which was used by Central and Eastern European avant-gardes of late and post-socialism to legitimate their appropriation of an avant-garde past that was, in a sense, being experienced for the first time, since its original manifestation and memory had been suppressed under socialism. Two chapters consider the work of the Frankfurt School thinkers Walter Benjamin and Theodor Adorno on the interrelations of images and history, and in a further chapter, I discuss an unusual British archival documentation project, Mass Observation's dream project, in which dreams were collected from ordinary citizens just prior to World War II through the first wave of aerial bombing.

In the second section, entitled "Time-Images in Modernist and Postmodernist Literature," I consider a range of modernist and postmodernist literary instances in which alternative notions of historical time are engaged. In the first essay, I focus on the idea of "cultural revolution," the acceleration of material history through cultural and ideological forces; I discuss the ambivalent relationship of the painter, novelist, and cultural critic Wyndham Lewis to this idea that emerged out of the Bolshevik victory in backward Russia in 1917. I go on in the next essay to consider how modernism and documentary were seen by artists as convergent, complementary representational modes for capturing the complex historical reality of the 1930s. Another essay considers Theodor Adorno's reading of Samuel Beckett's *Endgame*, and how Beckett offers him a concrete time-image of historicity after the end of large-scale dialectical History, which for Adorno, as for Beckett, coincided with the mass-death events of World War II. A similar engagement with a certain post-historicity is discussed in the essay that follows, on the poet and filmmaker Pier Paolo Pasolini, who utilized the work of Antonio Gramsci and the practice of philology to consider why the teleologies of Marxism and the assumptions of philology might no longer provide reliable knowledge of the historical present.

The third section, "Moving Images of Time," returns to the more properly Deleuzian homeland of the time-image, cinema. In the first essay of this section, I discuss the use of child experience and subjectivity as modes by which filmmakers have rendered tangible the intimate phenomenology of traumatic historical events, ranging from partisan warfare to political repression to nuclear annihilation. The following essay discusses the Quay Brothers' wordless animated adaptation of Bruno Schulz's masterpiece of literature, "Street of Crocodiles"; I suggest that the film displays a process of historical stratification in its translation from

word to animation, which replicates a similar process internal to Schulz's text. However, this "translation" is not meant so much to preserve experience as to ostentatiously reveal its decay, the sometimes gradual, sometimes catastrophic rhythms of loss that characterize a certain image of historical time. In a final essay, I confront two modernist artists, Sergei Eisenstein and Charles Olson, working in Mexico on projects that caused them to engage with questions of hieroglyphic or pictographic representation, etymology, speech / writing relationships, and archeological time. Eisenstein and Olson never met, though in my essay they are placed in a tripartite dialogue of poet, filmmaker, and Mayan glyphs. It is my hope that not only have I thus disclosed something about the time-images that these two artists sought to discover in Mexico in the middle of the twentieth century, but that in placing them in a speaking relationship, I have paid homage to their historiographic lesson as well.

Notes

[1] Gilles Deleuze, *Cinema 1: The Movement-Image*, trans. Hugh Tomlinson and Barbara Habberjam (Minneapolis, Minnesota: University of Minnesota Press 1986); *Cinema 2: The Time-Image*, trans. Hugh Tomlinson and Robert Galeta (Minneapolis, University of Minnesota Press, 1989).
[2] Peter Osborne, *The Politics of Time: Modernity and Avant-Garde* (London: Verso Press, 1995) viii.

SECTION I:

TIME-IMAGES AS THEORY AND HISTORIOGRAPHY

CHAPTER TWO

RETROAVANTGARDE:
CONFIGURATIONS OF TWENTIETH-CENTURY TIME[1]

The paradoxical term "retroavantgarde" was first developed by artists working in the late socialist and post-socialist contexts of Eastern Europe, Central Europe, and the territories of the ex-Yugoslavia.[2] In general, its semantic field has been defined by a range of post-modern and mostly post-socialist art practices that draw formal, philosophical, and social inspiration from the politicized, powerfully utopian avant-gardes of the early decades of the twentieth century, especially in the USSR and East-Central Europe. For example, the following manifesto by the Slovene art group IRWIN figured the post-communist legacy of the Cold War's east-west geo-political divide in terms of alternative temporal zones, in which the arts of the twentieth century exhibit significantly different rhythms and narratives of development. In the former "East," this temporality authorized—or even compelled—an artistic return to the avant-gardes of the past, which had never been allowed to play out their historical potential fully. The contemporary artist could help release those untapped utopian energies of the past, while utilizing them creatively in a historically and ideologically problematic present:

As artists from the EAST, we claim that it is impossible to annul several decades of experience of the EAST and to neutralize its vital potential.

The development of EASTERN MODERNISM from the past into the present will run through the FUTURE. The FUTURE is the time interval denoting the difference.

Being aware that the history of art is not a history of different forms of appearance, but a history of signifiers, we demand that this DIFFERENCE be given a name.

THE NAME OF EASTERN ART IS EASTERN MODERNISM.

THE NAME OF ITS METHOD IS RETROAVANTGARDISM.[3]

The tone of this appropriative look back by contemporary artists throughout the former "East Bloc" was not always as affirmative as it was for IRWIN, however. It ranged from extremes of nihilistic critical parody to rhetorical reference to avant-garde rigor against the banal hypocrisy of cultural policy in state socialism to authentically celebratory tribute, with many highly complex hybrid positions in between. At the negative extreme, reviewing in 1980 a number of the emigré review *Á-Ya*, the Russian artists Komar and Melamid, associated with Russian underground versions of pop art and conceptualism, wrote a bitter assessment of Kazimir Malevich and more generally denounced the whole avant-garde and socialist cultural legacy of the Soviet Union:

> [N]ot only was Malevich an illiterate philosopher and the inventor of the artistic movement Suprematism. . . but he was also an active Commissar, one of the first of the Soviet bureaucrats who concerned themselves with the separation of good from bad in the realm of the arts. His bureaucratic heirs, having exchanged Malevich's bad form for their own good uniforms, left his content untouched, and currently reign supreme in Russia. Recognizing this, Russian artists discovered that Lenin's avant-garde and Stalin's academicism are essentially only two different sides of the same socialist utopia. With the failure of this utopia its art too was discredited. [4]

In contrast, the statement by the Neue Slowenische Kunst artists Eda Cufer and IRWIN accompanying their Moscow "Embassy" action—which included unfurling a huge Malevich-inspired black square on the Kremlin's Red Square—established a much more measured, even redemptive relation to the radical avant-garde of the socialist past:

> Retro-avant-garde is the basic artistic procedure of Neue Slowenische Kunst, based on the premise that traumas from the past affecting the present and the future can be healed only by returning to the initial conflicts. Modern art has not yet overcome the conflict brought about by the rapid and efficient assimilation of historical avant-garde movements in the systems of totalitarian states. The common perception of the avant-garde as a fundamental phenomenon of twentieth-century art is loaded with fears and prejudices. On the other hand this period is naively glorified and mythicized, while on the other hand its abuses, compromises, and failures are counted with bureaucratic pedantry to remind us that this magnificent delusion should not be repeated.[5]

Shuttling between the domain of artists' manifestos and contemporary art criticism, the term "retroavantgarde" received further elaboration by curators and theorist-practitioners such Peter Weibel, Boris Groys, Marina Grzinic, and Inke Arns, who over the last decade have attached it to a number of exhibitions, catalogues, video productions, and theoretical texts.

In all these operative uses of the term, evidently, the conceptual and ideological content has been extremely variable, linked to a wide range of artistic, theoretical, and programmatic intentions. But they have in common a specified version of the "revival of the aesthetic" of the classical avant-garde within the contemporary cultural-political horizon: an artistically mediated qualification of the postmodern present, drawing its energy retrospectively from a largely fictive relation to the past, a return that creatively revises the actual historical lack of continuity or the ugly actuality that eventuated from the avant-garde's utopian dreams. Retroavantgarde artists responded to a futurism past from the perspective of that now-actualized "future" which had once been addressed as the utopian horizon of earlier avant-garde artworks. This revival of the aesthetic under the paradoxical banner of the retroavantgarde can be understood, thus, as a self-conscious and reflexive way to phenomenalize and reshape the *time* of the twentieth century in contemporary works of art: a way of re-imagining and imaging this lost, or at least lapsed, time, rendering available for artistic manipulation and aesthetic experience its passing, its continuities and traumatic breaks, and its entwinement with the empirical contingencies of national and global histories.

It is not my intention, however, to discuss here specific interpretations of the "retroavantgarde" term and concept by artists or critics. This is partially because the extensive research of Inke Arns, published first in her 2004 dissertation at the Humboldt University, more recently in the book based on her thesis, documents these developments in detail and with considerable critical acumen.[6] Yet it is also because my intention in this paper is more properly philosophical, or metahistorical and metacritical, than historical and critical. Here I would echo Peter Osborne's claim, in *The Politics of Time*, that such basic terminology like modernism and postmodernism, avant-garde and—I will add—retroavantgarde, have generally not in themselves been taken as problems for philosophical reflection, although philosophers such as Jean-François Lyotard, Jürgen Habermas, Richard Rorty, and Gianni Vattimo (to name only a few luminaries) were actively involved in generating a critical and polemical discourse in which such notions were employed.[7] Accordingly, in what follows, I will not be greatly concerned with practical matters of how one might do things, artistic and critical, with this paradoxical, neologistic

word "retroavantgarde," and still less will I seek to enumerate and evaluate the various ways it has already been used. Rather I seek to illuminate the more fundamental problem of what this seemingly bizarre term would imply if we were to take it seriously as a historiographic concept. Furthermore, I wish to understand the philosophical conditions under which its conceptual content becomes thinkable and meaningful. Finally, I will also ask what these considerations might tell us about our conceptions of time, historical change, and the role of aesthetics in historical knowledge.

<div align="center">* * *</div>

Peter Osborne suggests that basic periodizing categories can be understood as diverse ways of "temporalizing history." In other words, they describe ways in which we interpret and figure being in time as meaningful historical activity and experience:

> "Modernity" and "postmodernity," "modernism," "postmodernism" and "avant-garde" are categories of historical consciousness which are constructed at the level of the apprehension of history as a whole. More specifically, they are categories of historical totalization in the medium of cultural experience. As such, each involves a distinct form of historical temporalization. . . through which the three dimensions of phenomenological or lived time (past, present, future) are linked together within the dynamic and eccentric unity of a single historical view. (Osborne ix)

Two aspects of Osborne's formulation are notable for my purpose. First is that these periodizing conceptions are not simply monodimensional metrics of chronology and the quantitative differences between successive moments—i.e. on this day in 1921 we are in the "modern," whereas seventy years later, we have entered the "postmodern" epoch. Rather, they also designate shifts in the *configuration* of past, present, and future that gives "history" its content and character at a given moment. In a sense, we might say that the difference between modernity and postmodernity lies less in the sheer chronological difference between 1921 and 1991, than in the different ways in which modernity and postmodernity configure the possible relations between 1921 and 1991. In this regard, 1921-1991 is not necessarily commutable with 1991-1921, since these chronological coordinates exist within a different topology of past, present, and future in the two cases. Periodizing terms are needed precisely to mark these topological shifts within an apparently homogeneous chronology. Such

terms, thus, not only measure chronology, but also advance interpretations about qualitative differences in the way historicity is being represented and experienced, against the background of chronological continuity. In an essay that touches upon some of the same temporal paradoxes as retroavantgardism, Fredric Jameson has suggested that in our readings of cultural artifacts we must not only account for them historically, but also consider how they express epochal qualities in their very stance towards historical representation:

> Historicity is, in fact, neither a representation of the past nor a representation of the future (although its various forms use such representations): it can first and foremost be defined as a perception of the present as history; that is, as a relationship to the present which somehow defamiliarizes it and allows us that distance from immediacy which is at length characterized as a historical perspective. It is appropriate, in other words, also to insist on the historicality of the operation itself, which is our way of conceiving of historicity in this particular society and mode of production; appropriate also to observe that what is at stake is essentially a process of reification whereby we draw back from our immersion in the here and now. . .and grasp it as a kind of thing.[8]

We might say accordingly: our periodizing concepts register under a single term both *historical* distinctions and differences in the mode of *historicity*, as the dynamic topology in which the dimensions of time are configured.

Second, Osborne connects this configurational aspect of time in period concepts with different modes of cultural experience, which are themselves figurally mediated by images, language, constructed spaces and artifacts, and bodily performances. We might go on to conclude—although Osborne does not develop this argument at length—that various sorts of figural acts and artifacts, such as art objects and performances, narratives and images, serve as the vehicles by which our temporalizing apprehension of historicity is experienced. Thus, historical experience and aesthetic experience of figural products of culture are intertwined, even mutually constitutive. Each provides the other with a hermeneutic framework by which the other can be interpreted and experienced as meaningful. When we read Joyce's *Ulysses*, for example, we do not merely encounter a cultural artifact that communicates something about its represented context, Dublin on the 16th of June 1904, or of the context of its production in the years of World War I and the early 1920s. We also apprehend, through our aesthetic experience of the work, the very texture and meaning of time in modernity: that particular way in which the past and future are qualified and related to the present. Thus, the canonical opinion that *Ulysses* is a paradigm of the "modernist novel," seemingly so

natural given its style and the time of its publication, is actually a highly complex correlation of an artistic figuration with a temporal configuration, which thus implies a further interpretative hypothesis about the mutual translatability of these two types of figure, the temporal into the cultural and vice versa. Moreover, we should note, it is within this periodizing framework of modernity—in which cultural figuration and temporal configuration are conceived as transposable analogues of one another—that the historical sense of "avant-garde" is also developed.

One of the most sophisticated extensions of this idea of the figural nature of historicizing concepts is the deconstructive rhetorical criticism of Paul De Man, especially in his early writings collected in *Blindness and Insight.* There, in essays such as "Literary History and Literary Modernity" and "Lyric and Modernity," De Man subjected to scrutiny literary criticism's typical ascription of period successivity to figural and stylistic aspects of poetic texts. Especially the terms "modern" and "modernity" with respect to literature bring this problem to the fore:

> The term "modernity" is not used in a simple chronological sense as an approximate synonym for "recent" or "contemporary" with a positive or negative value-emphasis added. It designates more generally the problematical possibility of all literature's existing in the present, of being considered, or read, from a point of view that claims to share with it its own sense of a temporal present. In theory, the question of modernity could therefore be asked of any literature at any time, contemporaneous or not. In practice, however, the question has to be put somewhat more pragmatically from a point of view that postulates a roughly contemporaneous perspective and that favors recent over older literature. This necessity is inherent in the ambivalent status of the term "modernity," which is itself partly pragmatic and descriptive, partly conceptual and normative. In the common usage of the word the pragmatic implications usually overshadow theoretical possibilities that remain unexplored. My emphasis tries to restore this balance to some degree: hence the stress on literary categories and dimensions that exist independently of historical contingencies.[9]

De Man's focus is on certain basic rhetorical mechanisms in literature, especially the tendency to allegorize structural features of literary language in terms of historical—or pseudo-historical—indices, which in turn generate what is, for him, the largely illusory substance of literary historical and critical discourse. Indeed, in his later work, De Man advances a radical Nietzschean skepticism about any substantive linkages between literary meaning and history, which he views as an

unrepresentable play of material actions and blind forces, only
retrospectively and willfully allegorized as meaningful.

I do not think this is a necessarily trajectory from De Man's point of
departure. But in any case, however, his work does point to a far more
rhetorically constructed—and hence, critically *de*-constructible—
interaction between modes of temporality and frameworks of historical
explanation than has generally been acknowledged by the disciplines of
literary history, art history, or cultural history in their use of periodizing
concepts. Moreover, when he suggests that critical ascriptions of
modernity employ a rhetoric of temporality that need not entail strict
historical contemporaneity, he opens the periodizing concept of modernity
to the sort of figural mobility and transposibility that also self-consciously
characterizes the concept of retroavantgardism. Unlike De Man, however,
I do not believe that the figural nature of historicizing terms renders any
use of them merely strategic, unstable, and ultimately spurious. Rather, I
would suggest that their function is hermeneutically projective and
culturally creative, insofar as they play an active role in constructing any
possible historical experience and in any account of historical experience
we inevitably rediscover their figural precipitate. Akin to the schemata
and frameworks that preshape our perceptual encounters with the world,
periodizing figures are images we actualize and concretize in our
metabolic encounters with the cultural world, with its temporal dimensions
of past, present, and future and its geo-cultural extension.

Indeed, I believe that already with the classical avant-gardes there was
a high level of self-consciousness about their artistic activity being, above
all, a labor of qualifying time in the form of a new historicity that would
be proper to their age. It is in this light that we can the reconsider the
comically hyperbolic paradox of anticipation and future realization of the
final passages of Filippo Tomaso Marinetti's 1909 "Founding and
Manifesto of Futurism." Marinetti imagines the last act of the aging
futurists as that of provoking their own totemic murder at the hands of the
younger generation, who by killing their ancestors, will unwittingly
become the most orthodox "disciples" of those "old men" they kill:

> The oldest of us is thirty: so we have at least a decade for finishing our
> work. When we are forty, other younger and stronger men will probably
> throw us in the wastebasket like useless manuscripts—we want it to
> happen! They will come against us, our successors, will come from far
> away, from every quarter, dancing to the winged cadence of their first
> songs, flexing the hooked claws of predators, sniffing doglike at the
> academy doors the strong odours of our decaying minds, which will
> already have been promised to the literary catacombs.

But we won't be there. . . At last they'll find us—one winter's night—in open country, beneath a sad roof drummed by a monotonous rain. They'll see us crouched beside our trembling aeroplanes in the act of warming our hands at the poor little blaze that our books of today will give out when they take fire from the flight of our images.

They'll storm around us, panting with scorn and anguish, and all of them, exasperated by our proud daring, will hurtle to kill us, driven by a hatred the more implacable the more their hearts will be drunk with love and admiration for us.

Injustice, strong and sane, will break out radiantly in their eyes.

Art, in fact, can be nothing but violence, cruelty, and injustice.[10]

The implications of this temporal self-consciousness are more far-reaching and enduring, ultimately, than the more dated characteristics of the classical avant-gardes, such as their critical negativity, their vaunted penchant for public scandal, or their demand for perpetual formal innovation. In fact, it is this lesson, first and foremost, that the retroavantgardists have learned from the historical avantgarde and which retroavantgardism has reflexively taken up as its characteristic note: treating time as a malleable resource for cultural creation, as an immaterial material that can be crafted into aesthetically communicable images.

* * *

"Modernism" and "avant-garde" are generic classes of *time-images*, which correlate particular cultural figures—an archive of spaces, acts, and artifacts—with specific ways of experiencing the qualitative articulation of time. In light of Deleuze's distinction of movement-image and time-image, which I discussed in my introduction, I would suggest a similar distinction might be applied to the periodizing concepts of *avant-garde*, in its classical sense of advanced "movements" and their succession, and *retroavantgarde*, which reflexively highlights the fundamentally *temporal* configuration and content of avantgardism. Typically, theories of the avant-garde, including Peter Bürger's influential institutional theory, have emphasized the avant-garde's provocative and critical negativity, its transgression of conventions and public norms of communication and behavior, and its rejection of the limits of art as a specialized realm of production, practice, and perception. In turn, these characteristics underwrite its peculiar temporal dynamics as a series of conflicting movements: the rapid succession of ever-more radical "isms," the demand for perpetual innovation in advance of the generalized adoption of the avant-garde's utopian projections, the swift rise and fall of avant-garde movements as public provocations, and their ambivalent fellow-travelling

and sometimes identification with broader revolutionary social movements of the right and left. Put more simply, however, the basic trope of classical avant-gardism is precisely "movement": the forward thrust of the small, militant, disciplined, organized group, which is temporarily provocative, incomprehensible, and utopian, because of the historical lag of the masses behind the historical condition to come, which the avant-garde adumbrates. Critical negativity in the domain of culture and aesthetics, thus, is figuratively projected onto the temporal axis of history as anticipation and prefiguration.

Retroavantgarde, in its paradoxical highlighting of the temporal dynamics of anticipation that it rhetorically inverts, brings this temporal element to the fore and derives its own nature as present tense occurrence from its more primary, direct figuration of temporal relation: its belated, retrospective, backwards-turned reference to the futural thrust of the avant-garde. The seeming loss of forward "movement," the apparent stasis in which past and present seem to pool together in retroavantgarde works, or the odd temporal void in which the revived utopian rhetoric of the past appears to be suspended, is in fact not a loss of time, but a more direct confrontation with it. The aberrant movement of backward-referring futurism leads us to ask why anticipation, and hence negativity as its aesthetic correlate, once seemed like the exclusive temporal resource the avant-garde had to transform culture and explore utopian alternatives to the existing social, sensory, and semiotic order.

If it is understood as the heir of avant-garde time-consciousness, accomplishing a break with the linear progressive thrust of the avant-garde and an elaboration of more complex temporal figures out of avant-garde artistic practice, retroavantgardism need not be seen as just one more in a long line of valedictory gestures towards a discredited avant-garde. It may help recover the avant-garde's authentically revolutionary position in culture, which was never, or never solely, based on its critical negativity, but rather more generally on *temporal heterogeneity to the present*, which results from its artistic treatment of time as a figurable material. If this is so, however, then there may still be much cultural work for a reconceived avant-garde to do, and despite regular, authoritative announcements of the "death of the avant-garde," we may yet bear witness to the revival of avant-garde aesthetics in many times and places. Insofar as there is not just one mode of temporal heterogeneity available to artists, but a plurality—critical, poetic, redemptive, and utopian—there may also be an indefinite multitude of ways in which the avant-garde's cultural work of shaping time can be artistically achieved.

Notes

[1] This essay originally appeared as "Retroavantgarde: Aesthetic Revival and the Con/Figurations of 20th-Century Time," *Filozofski Vestnik* 28/2 (Ljubljana, Slovenia) (2007): 253-265.

[2] The first use of the term dates back to 1983 with the exhibition of the political / conceptual rock group Laibach in the SKUC Gallery in Ljubljana, in which they presented art works, their first video, and a cassette tape recording of music. The exhibition's title was Ausstellung Laibach Kunst—Monumentalna Retroavantgarda. For documentation and further information, see *Neue Slowenische Kunst*, ed. New Collectivism, trans. Marjan Golobic (Los Angeles: Amok Books, 1991).

[3] Eda Cufer and IRWIN, "The Ear behind the Painting" (1991), in *Impossible Histories: Historical Avant-gardes, Neo-avant-gardes, and Post-avant-gardes in Yugoslavia, 1918-1991*, ed. Misko Suvakovic and Dubravka Djuric (Cambridge, Massachusetts: The MIT Press, 2003) 581.

[4] Vitaly Komar and Alexander Melamid, "The Barren Flowers of Evil" (1980), in *Primary Documents: A Sourcebook for Eastern and Central European Art since the 1950s* (New York: The Museum of Modern Art, 2002) 270.

[5] Cufer and IRWIN, "NSK State in Time" (1992/93), in *Primary Documents* 301.

[6] Inke Arns, *Objects in the Mirror May Be Closer Than They Appear! Die Avantgarde im Rückspiegel, Zum Paradigmenwechsel der künstlerischen Avantgarderezeption in (Ex-)Jugoslawien und Russland von der 1980s Jahren bis in die Gegenwart*, Dissertation: Humboldt University, Berlin 2004; Inke Arns, *Avangarda v Vzvratnem Ogledalu* [Avantgarde in the Rearview Mirror] (Ljubljana: Maska, 2006).

[7] Peter Osborne, *The Politics of Time: Modernity and Avant-Garde* (London: Verso, 1995) vii.

[8] Fredric Jameson, "Nostalgia for the Present," in *Postmodernism, or, The Cultural Logic of Late Capitalism* (Durham, North Carolina: Duke University Press, 1991) 284.

[9] Paul De Man, "Lyric and Modernity," in *Blindness and Insight: Essays in the Rhetoric of Contemporary Criticism*, 2nd Edition (Minneapolis, Minnesota: University of Minnesota Press, 1983) 166-167.

[10] Filippo Tommaso Marinetti, "The Founding and Manifesto of Futurism" (1909), in *Manifesto: A Century of Isms*, ed. Mary Ann Caws (Lincoln, Nebraska: University of Nebraska Press, 2001) 189.

CHAPTER THREE

FROM CITY-DREAMS
TO THE DREAMING COLLECTIVE:
WALTER BENJAMIN'S POLITICAL
DREAM INTERPRETATION[1]

Interpretation of / and Dreams

By the latter half of the 1920s, Walter Benjamin had begun to employ in his literary and cultural investigations a novel conceptual frame: "political dream-interpretation."[2] This term meant for Benjamin the work of an interpreter who attended to the particular "image-puns" (*Bilderwitz*) or superimposed pictures emerging not from the dream or the sensuous world—the former the domain of the psychoanalyst, the latter of the artist—but from social reality (*GS* III, 227). This interpreter of social reality should, it was true, study well the methods of these two adepts of word and image, the psychoanalyst and artist. For ultimately, the hermeneutic labors of the political dream interpreter should subsume, if not wholly supplant, those of his therapeutic and artistic *semblables*.

What began for Benjamin as a series of local probes into the sleep-walking and daydreaming of his own social milieu—child's play in the bourgeois household, toys and picture books, tourist travel, interior decoration and kitsch art, the writings of Kafka and Proust—eventually grew by the 1930s into a full-scale historiographic and political problematic in which the concept of "dream" played a central role.[3] In the study of nineteenth-century Paris that occupied Benjamin from 1927 until his suicide in 1940, his Arcades Project or *Passagenwerk*, the dreaming collective, dream-houses and the dream-city, and the historical dialectic of periods of mass dreaming and revolutionary awakening, were pivotal motifs, at times modified and reconfigured but never definitively relinquished.

Reflected perhaps in the very notion of dream and certainly in Benjamin's bold extension of it is its pregnancy of meaning and its correlative blurriness of reference. Benjamin himself speaks of the "untrue

duskiness" of dreams, and it is legitimate to ask whether there is not something of this shadowy luminosity lending the concept a false aura of depth. At the same time, however, the importance of dream as the passageway to new psychic and semiotic terrain, explored above all by Freud at the turn of this century, is undeniable. As Paul Ricoeur writes, regarding the dream as Freud's "royal road" to the unconscious:

> ... the word "dream" is not a word that closes, but is a word that opens. It does not close in upon a marginal phenomenon of our psychological life, upon the fantasies of our nights, the oneiric. It opens out onto all psychical productions, those of insanity and those of culture, insofar as they are the analogues of dreams, whatever may be the degree and principle of that relationship.[4]

The concept of dream has, one might venture to add, a propensity towards the semiotic logic that it seeks to describe: the condensation of multiple themes and motifs, the rebus-like overlaying and overdetermination of thoughts, an uncertain oscillation between literal and figural senses, a suggestion of occulted meanings visible through the manifest sign. Certainly in Benjamin's corpus several central themes converge upon and emanate from the concept of the dream. His rich but scattered employment of dream suggests the existence, somewhere beneath the surface of his writings, of a hidden node from which the individual uses take their *Ursprung*. And the present-day interpreter's search for this "origin" or "originary idea" of the dream-concept in Benjamin's work requires, like the narration of the dream itself, a narrative elaboration of the concept which may (re-)produce, for the first time, the story of its discontinuous emergence.

One of Benjamin's works from his student years, "Program of the Coming Philosophy," sets the later emergence of the dream-concept in a broad philosophical and historical context. In this programmatic essay, Benjamin criticizes Kant's conception of experience and in turn the enlightenment which Kant sought to foster (by implication, too, the neo-Kantian hegemony of Benjamin's own academic milieu). He argues that Kant's "experience," based on the perceptual empiricism of the physical sciences, was not universal but "unique and temporally limited"; it was thus an historically contingent rather than necessary element of transcendental philosophy. Benjamin means here that this conception of experience is typically "modern," which in turn stands under the general world-view of the Enlightenment. Such experience, he argues, has at best an historical privilege and one that should be challenged for what it is: a mythology of the modern.

> We know of primitive peoples of the so-called pre-animistic stage who
> identify themselves with sacred animals and plants and name themselves
> after them; we know of insane people who likewise identify themselves in
> part with objects of their perception . . . we know of sick people who do
> not relate the sensations of their bodies to themselves, but rather to other
> creatures, and of clairvoyants who at least claim to be able to feel the
> sensations of others as their own. The commonly shared notion of
> sensuous (and intellectual) knowledge . . . is very much a mythology like
> those mentioned . . . and indeed, only a modern and religiously particularly
> infertile one. [5]

In contradistinction to this impoverished mythology, Benjamin points to a
"unity of experience" greater than the mere sum of separate experiences, a
metaphysical continuity between apparently distinct spheres, a totality of
which religion constitutes the "object and content" (*PCP*, 49, 51). This
unity and continuity, however, can be sought by philosophy only through
its reorientation towards *language*. "A concept of knowledge gained from
reflection on the linguistic nature of knowledge," Benjamin writes, "will
create a corresponding concept of experience which will also encompass
realms that Kant failed to truly systematize" (*PCP*, 49).

Three things converge in Benjamin's essay. First, he criticizes the
historical Enlightenment or "modernity" in general, its mythology of
experience and the restricted knowledge based on that experience. Second,
he argues for a systematic reorientation of philosophy towards language,
towards problems of interpretation—its recasting as *hermeneutics*. Finally,
he calls for a rethinking of "experience" in light of hermeneutics, for the
recognition that human existence is inseparable from an engagement with
meaning and that the dimensions within which experience takes place are
those within which meaning emerges.

Formulated in this way, Benjamin's somewhat arcane and metaphysical
language sounds more familiar. Benjamin, like many other German
thinkers immediately preceding him, and those of the quarter century after
his death, was arguing for a version of the "hermeneutic turn" in
philosophy and the social sciences. Like Wilhelm Dilthey, Martin
Heidegger and Hans-Georg Gadamer—all likewise shaped by the neo-
Kantian and phenomenological movements in the German universities of
the late nineteenth and early twentieth centuries—Benjamin would make
his own idiosyncratic turn towards language, textuality, and interpretation,
which would leave neither his field of objects for study nor his methods by
which to study them unchanged.

This emergence of hermeneutical philosophy out of neo-Kantianism
and phenomenology is a complex history, the exposition of which lies
beyond this paper. But of relevance to Benjamin's later adoption and—I

will argue—hermeneutic adaptation of the dream-concept is a twofold process common to modern hermeneutics: the extension of the field of hermeneutics and the operativization of interpretative procedure.[6] As is evident in his early criticisms of Kant as well as in his later critical and historiographic practice, Benjamin sought to extend the field of valid, significant "objects" beyond the "mythological" restrictions imposed by modern metaphysics and scholarly precepts. Indeed, the very consideration of theological entities and forces on the one hand, and the detritus and kitsch products of culture on the other, represents an initial "demythification" of knowledge and experience, a challenge to the restrictive mythology of the modern. It is as if these pariahed objects could bespeak in their very existence a critique of modernity and testify to a utopian, unmanifest "otherness" nested within—or beyond—modern space and time. Correlatively, the question of how one was to approach these curious objects took on a crucial importance for Benjamin. As Heidegger said of the "circle" of interpretation, the important thing is entering it in the right way. Benjamin's writing is replete with images of the proper approach to his objects of study, ranging from the "mosaic" of his *Trauerspiel* book, to the "thought-pictures" of his short prose of the late 1920s, to the ragpicker's piles of the *Passagenwerk*, to the "*plumpes Denken*" (crude thinking) of his Brechtian phases, to the "brushing of history against the grain" in his final meditations on the philosophy of history.

In his development of a political dream interpretation, Benjamin might be thought to synthesize Marx's critique of ideology with Freud's problematic of the unconscious. Benjamin's dream theory would stand in the line of attempts by thinkers like Wilhelm Reich, Erich Fromm, Theodor W. Adorno, Herbert Marcuse, Norman O. Brown, and Gilles Deleuze/Félix Guattari to couple theoretically the respective economics of material production and desire—the legacy of so-called Freudo-Marxism. Yet such an assimilation of Benjamin's political dream-interpretation to this theoretical tendency would, in my view, misrepresent his intentions and the conceptual functioning of "dream" in his writings.[7] Benjamin's dream-concept is first and foremost an hermeneutic tool which cuts across both the Freudian and Marxist problematics eccentrically.

In *Freud and Philosophy*, Ricoeur identifies two basic postures of modern hermeneutics. Hermeneutics, he argues, serves either to restore meaning, to recollect and fulfill a "message" partly given in symbolic language; or to unmask ideologies, to destroy false appearances, to root out myths and illusions.[8] The former approach is generally linked to phenomenology, especially to the phenomenology of religion. The latter is

represented by what Ricoeur calls "the school of suspicion," most notably, by the founding figures of Marx, Freud and Nietzsche. The Freudo-Marxist synthesis, clearly, retains the latter posture of hermeneutic suspicion, amalgamating the frameworks of Marx and Freud in order to construct a more powerful arsenal of critical weapons against ideology and illusion. In his political dream interpretation, Benjamin likewise emphasizes the tactics of suspicion and unmasking against error, myth, and ideology. The dream has to be fully dismembered and discharged of its fascinating spell, to become "mortified" through analysis and interpretation.

Benjamin, however, links this unmasking to the telos of recollection and redemption of meaning—the restoration of an absolute meaning independent of either the cognizing subject or the constituted object, yet emerging only beyond the limits of an analytical destruction of false appearances. This absolute meaning properly pertains to theology, to the things of this world seen in the light of salvation. Benjamin conjoins these two conflicting hermeneutic stances in a unique way, brushing the hermeneutics of suspicion against the grain and replacing it in the service of a hermeneutics of restoration. Marcus Bullock aptly describes Benjamin's thinking as a projection of two paths: "It is most striking that he sets the axis between theology and secularization across rather than alongside that running from mythos to emancipation."[9] Benjamin accordingly places dream, as a critical concept and the pivot of his dual hermeneutic, at the crossroads where these paths meet.

The critical-destructive moment of Benjamin's dual hermeneutic, nevertheless, has significant points of contact with Freud's theory of dreams and Marx's theory of commodity fetishism. In *The Sublime Object of Ideology*, Slavoj Žižek suggests a comparison between Freud's and Marx's theory of commodity fetishism. Marx, Benjamin, and Žižek all address a common problem in their analyses of consciousness in advanced capitalist society. How is it, they ask, that the atomistic actions of individuals can have not just systemic effects, but precisely those systemic effects which allow the perpetuation of the system as a whole? Restated in more epistemological terms, their question becomes: How does one understand a system that realizes systemic ends precisely insofar as its actors do not see themselves as pursuing systemic, but individual goals? What is the nature of this collective "unknowing" or "unconsciousness" in the system?

Marx's answer lies in the form of the commodity. This form itself, Marx argues, has inscribed in it the peculiar deformation of consciousness he calls "fetishism," in which relations between producers of products (the

division of labor in society) appear only in the form of a relation between things (the relative values of exchangeable goods). Freud, in Žižek's view, followed an analogous interpretative procedure in attempting to crack the enigma of the dream. The important element of the dream for Freud is not the thought in the dream, and certainly not what one thinks *about* the dream. It is rather the thinking that the dream itself *is*: the dream-work. To get at its operations, one must defer questions of the dream's content, even its hidden or deformed content, in order to ask: why is the content deformed *in this way*? What does the configuration of elements reveal about the unconscious structure that articulates the dream?

Benjamin, I would argue, employs an analogous interpretative procedure in applying his political dream-theory. The dream provides a model of a systematic and active process of unknowing, in which, paradoxically, a necessary labor—the dream-work—gets done. Benjamin's use of the dream as an analogue of ideology stresses the necessary figural deformations and repressions that occur in the consciousness of the atomized collective. Benjamin thus reconceives ideology not so much as a particular set of ideas, but rather as a figural process which both distorts and expresses: the dream-work by which the collective brings its historical experience to remembrance, though in mutilated form. It is in tracing out this dream-work, he suggests, that one receives hints of a determining set-up, binding yet silent in its machination, withdrawing from view behind the luminous phenomena of history.

Dream and Remembrance

Rehearsing in better times his later habits of stealth and travel, Benjamin spent the spring of 1926 in Paris. There, as he wrote the poet Hugo von Hofmannsthal, his projected short collection of "aphorisms, jokes, and dreams" found its definitive form: the book of *Denkbilder* (thought-pictures) appeared two years later as *One-Way Street*. About this time, too, Benjamin first discovered the writings of the Surrealists: André Breton's *Manifesto of Surrealism* and *Nadja* and Louis Aragon's *Le paysan de Paris*. In these books he encountered a new conception of writing focused on the intersection, in concrete images and objects, of individual desire and urban social dynamics. In these early writings of the Surrealists, Benjamin detected a project kindred to his own attempts to capture in vivid, oneiric images the discontinuous juncture between the singular writer's fate and the historical memory of a whole generation or social class.

The dream, of course, is only one of a family of genres within which remembrance may occur. Narrative in its various forms, autobiographical reflection, the collection of objects, play, even the body's experience of habitual movement through spaces, all constitute potential modes of memory. Benjamin took up many of these recollective genres in successive writings during the 1920s and 1930s. In *One-Way Street*, however, alongside the deliberate paralogic of jokes and the rebus-like concision of aphorisms, literal dream-narration constituted a central generic as well as thematic node.

Under the caption "No. 113," for example, Benjamin recounts three actual dreams. An unattributed couplet of verse, probably composed by Benjamin himself, prefaces them: "The hours that hold the figure and the form / Have run their course within the house of dream" (*OWS*, 46). The title of his dream-log, "No. 113," designates not a paragraph or section number, but apparently a house number—the site, perhaps, of a recurrent cluster of dreams. As the metonymy of both the dreamed space and of a real urban locale, the number is the occult document of a meeting between the psyche and the city, a cipher relating the dream's inner architecture to that which encloses the sleeper. Benjamin deepens this conjuncture of dreaming and dwelling by subtitling each of the three dreams with the name of a room in the "house of dream": "Cellar," "Vestibule," and "Dining-Hall." Each locale is invested with a particular charge of memory, expressed in the dream-text; his dreamer retraverses the palace of memory in the surreal penumbra of sleep. Throughout this section, and indeed throughout *One-Way Street*, Benjamin seeks in this way to open up anamnestic avenues between dreams and the built spaces of the city.

Here, in full, is the first of the three dreams, "Cellar." As its name suggests, it emerges from the deepest strata of memory:

Cellar. — We have long forgotten the ritual by which the house of our life was erected. But when it is under assault and enemy bombs are already taking their toll, what enervated, perverse antiquities do they not lay bare in the foundations. What things were interred and sacrificed amid magic incantations, what horrible cabinet of curiosities lies there below, where the deepest shafts are reserved for what is most commonplace. In a night of despair I dreamed I was with my first friend from my school days, whom I had not seen for decades and had scarcely ever remembered in that time, tempestuously renewing our friendship and brotherhood. But when I awoke it became clear that what despair had brought to light like a detonation was the corpse of that boy, who had been immured as a warning: that whoever one day lives here may in no respect resemble him.[10]

"Cellar" tells of a re-encounter with a childhood friend and the shock of recognition upon waking that the dream had cracked open a sealed vase of *temps perdu*—in Benjamin's imagery, a crypt in which a corpse of lived experience laid preserved. Here the dream appears as at once a mode of memory, the chance to recover things forgotten in the progress of life, and an index of mortality, a measure of the distance of the adult sleeper from the dreamer who revives the happiness of childhood.

The dream's subterranean setting is essential, for Benjamin would continually characterize memory as archeological. Interred in material and psychic depths, it must be methodically unearthed by the investigator. In a note from 1932 entitled "Excavation and Remembering," Benjamin makes explicit his sense of the metaphysical unity of the different forms of remembrance and the archeological tasks this unity implies. Remembrance, Benjamin argues, is not so much an instrument for the exploration of the past as the *medium* in which the past survives:

> It is the medium of what has been experienced as the soil is the medium in which the ancient cities lay buried. He who endeavors to approach his own buried past must conduct himself like a man who excavates. Above all he must not shrink from coming back again and again to the same fact—to scatter it like one scatters earth, to ransack it like one ransacks the soil. For "facts" are no more than strata, which only to the most careful exploration deliver up that which makes the excavation worthwhile. (*GS IV* 400)

In the *Passagenwerk*, as in *One-Way Street*'s "Cellar," Benjamin connects subterranean spaces with dreaming and anamnesis, likening dreaming to a mythic descent into the underworld.[11] In turn, the subterranean systems of city sewers and cellars appear as the architectural corollaries of archaic residues in human consciousness.[12] In literary works like Victor Hugo's *Les Misérables*, with its vivid evocation of the sewers honeycombing the limestone foundations of Paris, Benjamin discerns a hidden archaism that would obsess and haunt modern urban culture. Out of the oblivion into which modernity had cast the pre-capitalist and even natural foundations of the city, a repressed mythic force irrupts, rendering uncanny the image of progress projected by the modern surface. In the city, Benjamin concludes, "The modern has antiquity as a nightmare, which came over it in sleep" (*PW* [J82a, 4]).

Awakening Suspicion

To this point, I have emphasized the element of recollection in Benjamin's dream-concept, the dream as the instrument and medium of

memory. Yet "Cellar," with its discovery of the ligatures binding memory and death, and Benjamin's depiction of modernity's recollection of antiquity as "nightmare," both suggest an ambivalence at the heart of memory. Memory can be fatally seductive, the siren song of life long gone, and thus requires careful safeguards against falling under its sway. With respect to the dream as a mode of memory, this means attention to the technique of awakening—the critical interpretative moment in the process of dreaming. Awakening represents the destructive force of hermeneutic suspicion in Benjamin's dream interpretation: the dissipation of false appearances to open the ground for a genuinely redemptive, *absolute* recollection—not a restricted history contingent on social power, a "conservative" selection legitimating the rule of the class victors.

"Cellar" already exhibits the semiological process that would later become the hermeneutic pivot for Benjamin in the *Passagenwerk*: the dialectical reversal of the meaning of dream elements upon waking. Waking disperses the phantasmagoria of the dream and replaces it with the advance of consciousness and self-mastery that follows upon the mortifying interpretation of dream elements. In "Cellar" the dreamer dreams and revisits a lost childhood friend; he wakes and recognizes this dream-image as a *memento mori*, an emblem of mutability and lost time.

Waking, as the privileged moment of interpretation, must be methodically prepared. It must be entered upon with care and precision, if one would negotiate the turn towards daylight and not fall prey to the dream's chthonic powers even during waking hours. The dream for Benjamin, as for Michel Foucault in his early essay on dreams, is a dimension of human existence under the sway of destiny or fate.[13] Thus, in the *Trauerspiel* study, the *summa* of his early research and thought, Benjamin remarks on the "almost obligatory" presence of prophetic dreams in the Baroque drama. These dreams, he claims, were for the German dramatist what the oracles were for the Greek. Moreover, they revived the most archaic stratum of oracular discourse: "here it is worth pointing out that these dreams belonged to the natural domain of fate and so could only be related to certain of the Greek oracles, most particularly the telluric ones."[14]

At this point, however, Benjamin rejects one of the coherent outgrowths of this starting-point: an existentialist, "tragic" conception of dream. Foucault, for example, following the lead of the existential psychiatrist Ludwig Binswanger, interprets the dream's "fatal" element in a Heideggerian vein, as revealing the ungrounded freedom of human being in its deliverance over to death.[15] In contrast, Benjamin stresses the necessity of wriggling free of death's grasp, of discharging fate's power—

of waking from the dream in the right way. Moreover, Benjamin chose this interpretative direction in full awareness of its philosophical implications, explicitly counterposing an anti-tragic, surrealist-inspired approach to a Heideggerian tragic one.[16] Thus in one of the earliest notes for the *Passagenwerk*, begun in the immediate wake of *One-Way Street*, Benjamin writes: "Life-or-death interest in recognizing at a particular point of development a parting of ways in thought: this means a new look at the historical world at points where a decision must be made about its reactionary or revolutionary evaluation. In this sense, one and the same thing is at work in the surrealists and in Heidegger" (*PW* [O°,4]).

Throughout his career as a thinker, Benjamin gave a number of strategies by which waking, a general figure for the critical dissolution of fate, could be accomplished: through cunning (the solution of Odysseus), through laughter (for Benjamin, liberating laughter before destiny was the foundation of the comic genre), and through Messianic or revolutionary violence (an answer which can be found throughout Benjamin's work). But *One-Way Street*, with its focus on the practices of everyday life of the urban individual, gives another answer—a ritual discipline of purification, which extends allegorically into the very practice of interpretation, into the life of the critic and literary historian in all its aspects.

Immediately preceding the dreams in "No. 113" (from which I quoted "Cellar") and positioned as a kind of iconic performance of the argument it advances is a passage entitled "Breakfast Room":

> A popular tradition warns against recounting dreams on an empty stomach. In this state, though awake, one remains under the sway of the dream. For washing brings only the surface of the body and the visible motor functions into the light, while in the deeper strata, even during the morning ablution, the gray penumbra of dream persists and, indeed, in the solitude of the first waking hour, consolidates itself. . . . [The dreamer] thus avoids a rupture between the nocturnal and the daytime worlds—a precaution justified only by the combustion of dream in a concentrated morning's work, if not in prayer, but otherwise a source of confusion between vital rhythms. The narration of dreams brings calamity, because a person still half in league with the dream world betrays it in his words and must incur its revenge. . . . He has outgrown the protection of dreaming naiveté, and in laying clumsy hands on his dream visions he surrenders himself. For only from the far bank, from broad daylight, may the dream be recalled with impunity. This further side of the dream is only attainable through a cleansing analogous to washing yet totally different. By way of the stomach. The fasting man tells his dream as if he were talking in his sleep. (*OWS*, 45-6)

Here the dream appears not as the trivial and confused double of sober waking life, but as the more powerful of the two states: the grip of natural history, of myth, of death upon human history, whether in its biographical or its collective form. The dream must be grasped, for to leave it free is to guarantee its recurrence; yet it takes the utmost delicacy, a touch gained only in the discipline of daily work or of prayer, to *ride* this dragon once caught.

From "Breakfast Room"—telescoping an extended reading of its enigmatic formulae—four basic ideas can be distilled, which together stand as a veritable canon of dream interpretation for Benjamin:

- The recollection of the dream is a radical discharging of its power, the critical "combustion" of its psychically charged elements in the interpretative work of waking: their transmutation into deadened fragments of the past (like the childhood memories of "Cellar") which may then be montaged with other such scraps into the fabric of biography or collective history.
- This destructive purgation of the dream upon waking may involve the total reversal of its significance for the dreamer (as the resurrection of the childhood friend signifies upon waking the corpse of that boy). A semiotic process occurs between dreaming and waking analogous to Hegel's "cunning of reason," the advance of rationality through apparently irrational manifestations.
- Waking is not a simple or spontaneous process. True waking requires analytic intelligence and "cunning" in the Ulyssean sense: an ability to crack open the mythic closure of the dream by miming its thought patterns, while at the same time not capitulating to its spell.
- Waking is akin to spiritual disciplines originating in religious rites and purifications. The dialectic of dreaming and waking is the secularized surrogate of religious means for cultivating attention and interpretational acumen. Dream, as a symbolic phenomenon calling for interpretation, refers to a continuum of meaning the essential content of which is theological. Together, dreaming and waking constitute a secularized analogue of the total experience previously centered in religious illumination and the explication of sacred texts: dreaming provides the transcendent, ecstatic element, while waking involves rigor and the authority of doctrine.

Dreams and collective memory

Dreams in which the buried levels of the past are redeemed, the formulations of "Cellar" suggest, occur most readily under circumstances of the greatest adversity: under assault, as enemy bombs are falling, or the

psychic corollary, a night of despair. These moments are decisive in the structure of lived experience, as moments of decision, moments of change. They occur both through objective historical conditions and through more private factors (the war or the German inflation, of course, confounded such public-private distinctions). Benjamin's accent, however, falls on the dialectical character of such moments, the collective nature of apparently "interior," "private" experiences.

In an article written contemporaneously with *One-Way Street* entitled "*Traumkitsch*" (dream kitsch), Benjamin makes this collective, indeed historical, character of dreams explicit. "Dreams participate in history," he asserts. "Dream statistics would advance beyond the charming landscape of anecdotes into the barrenness of a battlefield" (*GS* II, 620). As one of the means by which collective experience is mediated and actualized in the lives of individuals, Benjamin thus suggests, dreams themselves might constitute an underestimated historical agency.

Benjamin notes in his essay on Surrealism, "In the world's structure dream loosens individuality like a bad tooth" (*OWS*, 227).[17] A contemporary investigator of dreams out of the most extreme of circumstances, the Nazi concentration camps, tends to confirm Benjamin's observation. In his article "Terror and Dream," Reinhart Koselleck describes a particular type of "salvational" dream, in which the empirical self, both past and present, is dissociated within the timelessness of the dream. Such dreams could appear paradoxically as a "sign of a chance for survival."[18] Koselleck concludes that this dissociation, which under normal circumstances would indicate schizophrenic withdrawal, "assumes in the inverted constraints of concentration camp confinement a surprising and adaptive significance" (224). Benjamin, writing in the troubled 1920s, a moment of crisis yet prior to the extremes which Koselleck documents, nonetheless also viewed redemptive dreams as a "normal" response to situations of crisis. The loosening of the self they indicate might not function solely in a defensive, *adaptive* way; it might also represent the subjective precondition of collective struggle for social change. Like the Enlightenment mythology of individual perception, however, such a collectivized consciousness was historically contingent and thus equally "mythological." To put it concretely, such collectivization might as easily imply fascism and Stalinism as genuine collective liberation. Its cultural indices had to be subjected to the mortifying gaze of critical analysis, before their "absolute" meaning could be discerned.

Benjamin concludes *One-Way Street* with an eloquent passage ("To the Planetarium") invoking the reinitiation of humanity to cosmic experience through the technology of mechanized war:

Human multitudes, gases, electrical forces were hurled into the open
country, high-frequency currents coursed through the landscape, new
constellations rose in the sky, aerial space and ocean depths thundered with
propellers, and everywhere sacrificial shafts were dug in Mother Earth.
(*OWS*, 103-4)

This upheaval implied a massive reorganization of the relation between
humanity and nature. It also prefigured changes in social organization:

In the nights of annihilation of the last war the frame of mankind was
shaken by a feeling that resembled the bliss of the epileptic. And the
revolts that followed it were the first attempt of mankind to bring the new
body under its control. (*OWS*, 104)

At the same time, however, Benjamin sensed in this collective "paroxysm"
a terrifying loss of individuation, an impoverishment of experience like
schizoid dissociation, and a precursor to fascism. Thus, in his "Storyteller"
essay, he writes:

With the World War a process began to become apparent which has not
halted since then. Was it not noticeable at the end of the war that men
returned from the battlefield grown silent—not richer, but poorer in
communicable experience? A generation that had gone to school on a
horse-drawn streetcar now stood under the open sky in a countryside in
which nothing remained unchanged but the clouds, and beneath these
clouds, in a field of force of destructive torrents and explosions, was the
tiny, fragile human body.[19]

In numerous texts, Benjamin lent close attention to such
"depersonalizing" forces working on his own generation: most importantly,
the war, the inflation, the depression, and the political coalescence of the
masses. Similarly, in his cultural studies of the late 1920s and the 1930s,
he focused on such tendencies as the commodification of artistic
production and nineteenth-century urbanization, tendencies which
threatened to displace the bourgeois individual from his/her place of
privilege in cultural life. A crucial index of this general reconstitution of
psychic life, this loss of individuation and impoverishment of experience,
Benjamin believed, could be found in the mutations of the dream-world.

In the conditions of Europe after the First World War, Benjamin
argued, dreaming tended towards a rapprochement with a devalued mass
culture. As he notes in "*Traumkitsch*": "Dreams are now the shortcut into
the banal. . . . The side that things present to dreams is kitsch" (*GS* II,
621). In the *Passagenwerk*, documenting an analogous moment of rapid

cultural change during the nineteenth century, Benjamin would examine the convergence of kitsch and dream-consciousness as an historical index of high modernity, with its rapid succession of fashions, its proliferation of commodities, and its chaos of styles. Thus he notes:

> [Franz] Hessel speaks of the "dreamy time of bad taste." Yes, this time was completely outfitted with the dream, furnished with dreams. The change of styles, the Gothic, Persian, Renaissance, etc., that means: over the interior of the bourgeois dining-room slipped a banquet hall of Cesare Borgia; out of the bedroom of a housewife arose a Gothic chapel; the workroom of the man of the house played iridescently over to the chamber of a Persian sheik. Photomontage, which fixed such images for us, corresponds to this generation's most primitive form of illustration. Only slowly did the images, among which they lived, dissolve themselves and precipitate out as the figures of publicity on advertisements, price tags, and posters. (*PW* [I 1,6])

Benjamin traces the phantasmagoria of advertisement to the nineteenth-century kitsch interior, conceived as a matrix of dream elements. In turn, once the spatial images produced in the dream-houses of the bourgeoisie had precipitated into forms of discourse, they became available for critical reappropriation, for the political task of destructive/redemptive interpretation.

Thus Benjamin in no way viewed the convergence of dream-consciousness and kitsch as wholly lamentable. In fact, in the *Passagenwerk* he went so far as to express the desirability of a "closed season," a "nature preserve" for kitsch; Benjamin saw film as the "providential place" for such a preserve (*PW* [K3a, 1]). For if dreams had taken on the banal character of kitsch, so too had mass art taken on the role of dreams as the collective repository of unfulfilled wishes. In the cultural sphere, mass art, with its tendency towards kitsch, formed a privileged site for the articulation, elaboration, and transformation of utopian wishes. It was precisely these "degraded" symbolic forms which in the "age of technical reproducibility" most demanded the labor of the political dream interpreter.

For Benjamin, the task of reworking collective dreams fell first to those of the artistic avant-garde like the Surrealists, who commenced the task of deciphering the utopian wishes half-smothered by the "narcotic historicism" and "addiction to masks" of nineteenth-century culture. Thus Benjamin viewed Surrealism, with its aesthetic revaluation of decaying city-spaces like the arcades (Louis Aragon's *Paysan de Paris*) and outmoded luxury items sold in the fleamarkets (André Breton's *Nadja*), as a potential model for the interpretative work of waking. Under the pressure

of modernity, cultural labor had become a kind of dream-work. In turn, the canon of interpretation of the collective wishes expressed in commodity culture would, of necessity, build upon the theory of dream interpretation recently established by psychoanalysis and upon the textual practices of contemporary art.

Political Dream Interpretation and Historical Awakening

In the *Passagenwerk*, begun in the late 1920s, both the dialectic of dreaming and waking and changes in the structure of experience form central nodes of Benjamin's inquiry. As I showed previously, in his early criticisms of Kant, Benjamin viewed historical mutations in perception (like the changes that shaped Enlightenment individualism) as "mythologies" embedded in the structure of knowledge and the products of culture. He argued for an hermeneutical refocusing of critical philosophy in order to recapture the metaphysical unity lost in the modern separation of "spheres" and subjectivization of knowledge. Similarly, in his mature work, Benjamin continued to view the historical structures of perception (now conceived as increasingly collective in character) as mythologies that must be critically dismantled. This critical work, however, would occur within an expanded hermeneutical field of collection and recollection—the restitution of a concealed "original history" (*Urgeschichte*) of the modern.

In the early phases of the *Passagenwerk*, Benjamin generalized the paradigm of the dream through an analogy between generational succession or historical phases and the transition from dream to waking life. Thus, in his expose for the *Passagenwerk*, submitted to—and rejected by—the Institute for Social Research in 1935, Benjamin quoted from Michelet the maxim that "Every age dreams its successor." He developed the kernel of this idea in numerous and complex formulations in Notebook K (on the Dream-city and Dream-house, Future dreams, Anthropological Nihilism, and Jung), in Notebook L (on Dream-house, Museum, and Spa), Notebook N (on Epistemology and the Theory of Progress), and individual notes throughout the work. An important formulation inaugurates Notebook K, which is almost entirely devoted to the dream problematic:

> The experience of youth of a generation has much in common with dream experience. Its historical form is dream-form. Each epoch has this aspect which is affiliated to dreams, its child-aspect. . . . But whereas the education of earlier generations in the tradition, religious instruction, interpreted these dreams for them, today's education amounts simply to the

distraction of children. . . . What is advanced here in what follows is an attempt towards [developing] the technology of awakening. (*PW* [K 1,1])

This formula is exceedingly condensed and complex. But I will try in what follows to unravel its several threads and explicate them piece by piece.

Benjamin employs here an analogy, favored in the earlier phases of the *Passagenwerk* research, of the generational process to the dream-waking sequence. Crucial to this analogy is the peculiar, romantic view of childhood held by Benjamin. For him, childhood was that time in the individual's life when s/he is most open to "mimetic" experience. The "mimetic," in Benjamin's conceptual framework, signifies not only the child's ability to mimic others; but also its ability to discover unapparent resemblances *between* things, to empathize affectively with other people and with things, and to adapt and extend its whole sensory body to the object-world in sympathetic concord with it. The mimetic faculty remains as a residual element in adult life, where it plays a role closely tied to what Marcel Proust called "involuntary memory." The perception of resemblance—the similarity of a tea-dipped madeleine to one eaten many years before, to take the canonical example—facilitates the recollection not just of particular episodes and events, but potentially of a whole other mode of receptivity and empathy lost to the adult.

A more common and easily accessed mode of involuntary memory than the Proustian variety exists, however, in dream-life. Both playing in children and dreaming in adults exhibit the workings of the "mimetic faculty."[20] The idiosyncratic logic of children in playing shares the figural resources of dreaming, in which rebus-like resemblances of image and discourse, contingent phonetic similarities, attention to marginal details, and elisions of essential facts may provide the hinges of elaborate narrative constructions. As in play, moreover, subjectivity in the dream is less "Cartesian," less "mental," less situated than in normal waking life. Foucault has aptly noted that "The subject of the dream, the first person of the dream, is the dream itself, the whole dream. In the dream, everything says 'I,' even the things and animals, even the empty space, even objects distant and strange which populate the phantasmagoria" (Foucault, *Dream* 59). Similarly, as Benjamin saw it, the child doesn"t play *under* a table, *with* a toy car; the subject of the play is play itself, and the child becomes mimetically assimilated to the playing ensemble of child, toy, and cavernous space. Through this assimilation, the child grows sensitive to systems of resemblances between things: of the space below the table to a tunnel through a mountain; of the child's own eyes to the headlights of the car, by which the play will be guided through blind subterranean depths.

Benjamin elaborated this problematic of the mimetic faculty in two brief essays from 1933, "Doctrine of the Similar" and "On the Mimetic Faculty" (*GS* II, 204-10 and 210-13). In these texts he focuses on the historical roots of mimetic capacities in ritual and later in practices of writing. Here Benjamin hints at something he will later develop at great length in the *Passagenwerk* notes: in league with the post-First World War dispossession of the individual subject, the metropolis as a functional whole had subsumed the individual as the true locus of "spiritual" or "mental" life.[21] The restructuring of experience that took place in his generation, the first in Germany to confront the metropolis as a consummately modern space—the *Großstadt*, with its new intensities of advertisements, streets signs, crowds, and mass transportation—had impelled a migration of the submerged mimetic capacities of individuals, exemplified by childhood, to the urban masses. In the *Passagenwerk*, Benjamin goes so far as to suggest that one must conceptualize the consciousness of the collectives loosely articulated by the spaces of the city as forming—in a rigorous and not simply analogical sense—a mass dream.

Benjamin advanced a radical phenomenology of the urban collective based on a bold appropriation of Bergson's *Matter and Memory*, which more than any work of Freud must be seen as the philosophical armature of Benjamin's dream theory.[22] Bergson had argued that consciousness is present in the form of perception insofar as it is concentrated on the immediate possibility of bodily action; any retreat from the immediacy of the body and its sphere of action enmeshes consciousness in memory. Bergson asks us to imagine a cone, of which the tip represents consciousness as present in perception and corporeal action, and each successive plane of the broadening figure represents an enriching of the content of memory in consciousness. At the base is the dream, in which the sleeping body is entirely removed from the sphere of action, and memories may freely interpenetrate and combine in strange, loose configurations not conforming to the demands of utility. Neither extreme is representative of consciousness as such; the essential point for Bergson, and certainly for Benjamin, is the continuum of varying degrees of memory and perception in the concrete instances of consciousness.

Benjamin accepted this formal conception of consciousness, but argued that Bergson reified the individual consciousness and was unable to see the contextual origins of his theory in the rise of modern city experience, the subject of which was necessarily collective. Thus, in a note to his Baudelaire study, which derived from his *Passagenwerk* research, Benjamin wrote:

Bergson's idea of action would have to be modified, if he kept in mind the possibility of an organized collective subject. His definition of presence as the state of our body would in a moment lose its impermeability to the dream, where a less formed and determined body than that of the individual had been envisioned by him. Supposing that it is the body of mankind, then it would perhaps become clear, how much this body must be penetrated by the dream, in order to be capable of action as such. (*GS* I, 1181)

By collectivizing both body and consciousness, Benjamin was able to consider the entire city space as an ensemble that produces the concrete constellations of cultural images and action. Once the individual body has been translated to the collective, he notes,

Much of what was external for the individual is . . . for the collective internal: architectures, fashions, indeed even weather are in the interior of the collective what the sensations of organs, feelings of sickness or of health are in the interior of the individual. (*PW* [K1,5])

In light of this extended, but more vaguely delineated "body," Benjamin sought to redefine the relation between dream (expressing collective wishes and memories) and action (collectively realizing them in the present) in more differentiated terms than Bergson's strict opposition of passivity and activity. I would characterize Benjamin's recasting of the Bergsonian nexus of dream and action as hermeneutic: both poles are conceived as loci of *meaning*, between which the dialectical task of destructive/recollective interpretation ("awakening") mediates.

Benjamin's reversal of the inside-outside polarity in his image of the city has important implications for the relation between "mental" and "material" entities as well. The arcades, with their combination of transparency and enclosure, their fusion of house and street, became a privileged locus of this perspective shift from the apparently external spaces of the city to the interior of a loosely articulated, dreaming, collective body. As Benjamin would note, "Arcades are houses or passages which have no outsides—like dreams" (*PW* [Lla, 1]). In light of this topological reversal, Benjamin could treat the objects that drifted through this ambiguous city-space—commodities and fashions, prostitutes and dandies, bohemians and anarchists—as so many mystic writing-pads of cultural memory, as *immediate* instances of collective consciousness. Capitalist culture represented a kind of collective dream-work upon the material, human and non-human, of the city; a collective "mythology" requiring hermeneutical destruction and reconstruction.

Benjamin implies here a theory of language and of knowledge based on a distinction exemplified in the semiological working of dreams: the distinction between the "proposition," which refers to the intentional system of knowledge (*Erkenntnis*), and the radically different "presentation" (*Darstellung*, or what Benjamin called the "constellation"), which appears only through and within knowledge, yet remains distinct from it, as an image of a non-intentional truth. The dream-work, while utilizing the propositional resources of language, narration, and image, renders the dream-presentation parabolic to its re-presentation in the language of biography or history. The dream recounted is not identical to the dream. Yet by attending to the traces of the dream-work in the narrated text, this non-identity between proposition and presentation, the dream-analyst gains access to a structuring framework analogous to that which Wittgenstein claimed could not be said but only shown: a real-ideal structure that is the totality of "what is the case," the communicability or representability of the world as such.[23]

Benjamin recognized the immense implications this conception might have for a Marxist theory of culture. It suggests that the collective city-body model might provide an alternative to the traditional base-superstructure model of the determination of culture by economic forces. Utilizing his city-body image, Benjamin reconceived the relation between cultural artifacts and material forces not as one of mirroring but rather of "expression":

> The economic conditions, under which society exists, are expressed in the superstructure; exactly as with the sleeper an overfull stomach finds in the dream content not its reflection, but its expression, although it may causally "determine" it. The collective first expresses its living conditions. They find in the dream their expression and in awakening their interpretation. (*PW* [K2,5])

In Benjamin's view, the crux of materialist interpretation, both critical and restorative, would thus be the superstructure's non-resemblance to the economic base: the kaleidoscopic non-identity of collective dream-expressions with the social conditions which occasion them.

Benjamin's reformulation of Marx's theory also, however, exhibits a crucial ontological point of difference, holding significant implications not just for Benjamin's work, but for broader tendencies in Western Marxist and non-Marxist philosophy. Marx, as a number of texts show, appreciated the role of nature in social life; he thus argued in his "Critique of the Gotha Program" against the proposition that labor creates all wealth, by recalling that labor creates value on the basis of the given bounties of

nature. In *Capital*, likewise, his opposition of use-value and exchange-value exposes capitalism's abstraction away of the object's intrinsic qualities as historically contingent upon the existence of commodity production. Nonetheless, if "value" is correctly taken as a specified form of *meaningfulness*, Marx still tended to cast natural objects in the role of arbitrary vessels to be filled by value-producing labor. Even the concept of use-value, while rooted in the intrinsic qualities of things, views their meaningfulness as following from their appropriability for instrumental human activity—for their use, if not for their exchange.[24] Nature, in short, remains a pendant to human instrumental power.

Benjamin's recasting of the Marxist theory of material determination as a dialectic of figuration (requiring destructive interpretation) and prefiguration (calling for restorative interpretation) offers, perhaps, a corrective towards Marx's complicity with the domination of nature. His hermeneutical dialectic is undergirded by an ontology in which all being, both animate and inanimate, is seen as embedded in a common structure of meaning—occulted and repressed, perhaps, by the positivistic "mythology" of the modern. Human being has a special relation to the totality of being; dreamlike, it truncates and condenses the immense span of meaningful natural history, recalling it and bringing it to expression: "The present, which, as a model of Messianic time comprises the entire history of mankind in an enormous abridgement, coincides exactly with the stature which the history of mankind has in the universe."[25] Yet the revolutionary destruction of mythologies and the restitution of a totality of human experience should not, Benjamin implies, aim to extend human dominion in a millenary reign. The recollection of Paradise must instead be a saving dispossession and diminishment, the restoration of humanity to its modest role as speaker for a vaster sphere of meaningful being.

Notes

[1] Originally published as "From City-Dreams to the Dreaming Collective: Walter Benjamin's Political Dream Interpretation." *Philosophy and Social Criticism* 22/6 (1996): 87-111.

[2] I have adapted this term from Benjamin's 1930 review of Siegfried Kracauer's *Die Angestellten* ("White-Collar Employees"). See Walter Benjamin, *Gesammelte Schriften*, Vol. III, ed. Rolf Tiedemann and Hermann Schweppenhäuser (Frankfurt am Main: Suhrkamp Verlag, 1974) 227; hereafter cited as *GS*.

[3] Susan Buck-Morss has recently employed Benjamin's conception of dream to discuss early twentieth-century cultural "utopias" and to define the new condition of art, in her view, after the Cold War. See Buck-Morss, "The City as Dreamworld and Catastrophe," *October* 73 (1996): 3-26.

[4] Paul Ricoeur, *Freud and Philosophy: An Essay on Interpretation*, trans. Denis Savage (New Haven, CT: Yale University Press, 1970) 6.

[5] Walter Benjamin, "Program of the Coming Philosophy," *Philosophical Forum* 15/1-2 (1983-4): 44-5; hereafter cited as *PC*.

[6] I am indebted to Richard Terdiman for this formulation of the two-part process shaping modern hermeneutics.

[7] I argue this independently of the question of the degree of Freud's direct influence on Benjamin, which seems to be fairly limited. On Benjamin's list of over 1,700 books, charting with a fair degree of comprehensiveness his reading from around 1917 to his death in 1940, there are only four entries of Freud's works: around 1918, the study of jokes, the Schreber case and the *Five Lectures on Psychoanalysis* given at Clark University; and then one more work in 1939, *Beyond the Pleasure Principle*, which found its way—probably through Theodor Adorno's influence—into the final revision of the Baudelaire essay, "On Some Motifs in Baudelaire"; for the book list, see *GS* VII, 437-76. Similarly, in the published edition of Benjamin's letters, there are only three index entries for Freud: one in a letter from Adorno to Benjamin, another in a letter mentioning Adorno's use of Freud in his book on Richard Wagner, and a third in a letter thanking Greta Adorno for her gift of a yearbook of psychoanalysis containing Freud's essay "Telepathy and Psychoanalysis." Benjamin thought this essay was suggestive for his own analysis of the "mimetic faculty" (see my discussion below). One might also note in this context Benjamin's hostility to psychoanalytic interpretations of Kafka, a sentiment he makes clear in his 1934 essay, where he argues that such readings "miss the essential points."

[8] Ricoeur, *Freud and Philosophy*, 28-36.

[9] Marcus Bullock, review of Michael W. Jennings, *Dialectical Images: Walter Benjamin's Theory of Criticism*, in *Comparative Literature* 43/1 (1991): 74.

[10] Walter Benjamin, *One-Way Street and Other Writings*, trans. Edmund Jephcott and Kingsley Shorter (London: NLB, 1979), 46-7; hereafter cited as *OWS*.

[11] In his 1929 review of Franz Hessel's book of Berlin "walks" (*Spazieren in Berlin*), Benjamin writes that remembrance "leads downward, if not to the mothers, then nonetheless into a past that can be all the more spell-binding as it is not just the author's own, private one" (*GS* III, 194). In his reference to "the mothers," Benjamin probably alludes to Bachofen's *Mutterrecht*, which postulated a matriarchal, hetaeric society as the most archaic social form. In 1926, Benjamin reviewed Carl Albrecht Bernoulli's study *Johann Jacob Bachofen und das Natursymbol*; in 1928, he reviewed Bachofen's own *Griechische Reise* ("Trip to Greece"); and in 1934, he wrote an extensive essay in French on Bachofen.

[12] Walter Benjamin, *Das Passagenwerk*, ed. Rolf Tiedemann (Frankfurt am Main: Suhrkamp Verlag, 1982) C1a, 2. I cite here and hereafter in my text Benjamin's letter/number designations for notebook/note, e.g. *PW* [C1a, 2].

[13] Michel Foucault, "Dream, Imagination, and Existence," trans. Forrest Williams, in Michel Foucault and Ludwig Binswanger, *Dream and Existence*, ed. Keith Hoeller (Seattle, WA: *Review of Existential Psychology and Psychiatry*, 1986) 29-78.

[14] Walter Benjamin, *The Origin of German Tragic Drama*, trans. John Osborne (London: NLB, 1977) 134.

[15] "[D]eath can also appear in dreams with another face: no longer that of contradiction between freedom and the world, but that in which their original unity and their new alliance is woven. Death then carries the meaning of reconciliation, and the dream in which this death figures is then the most fundamental of all: it no longer speaks of life interrupted, but of the fulfillment of existence, showing forth the moment in which life reaches its fullness in a world about to close in" (Foucault,"Dream" 55).

[16] This anti-tragic element in Benjamin's thought was already strongly in place before his encounter with either surrealism or Bertolt Brecht. Indeed, it might be said to have prepared the ground for Benjamin's appreciation of their very different attempts to demystify fate. In his early essays "Goethe's Elective Affinities" and "Fate and Character," Benjamin affirms anti-mythic powers against myth, which in his view tragedy conserves. In the *Trauerspiel* study, Benjamin carefully distinguishes tragedy, which preserves a link with chthonic forces, from *Trauerspiel*, which is theological but anti-mythic.

Considerations of dream and tragic drama intersect in two reviews Benjamin wrote in 1926 and 1928, of the successive, and substantially different, versions of Hugo von Hofmannsthal's neo-*Trauerspiel* play *Der Turm* ("The Tower"), based on Calderón's *La vida es sueño*. In his review of the first version, Benjamin notes that the function of the dream motif in its relation to historical events is different in Calderón from in Hofmannsthal. He emphasizes that Hofmannsthal allows his character Sigismund to name the crimes of the father, and himself, and thus uncovers in Hofmannsthal's play an anti-mythic, theological moment. "Whereas in Calderón," Benjamin writes, "[the dream], like a concave mirror, throws open in an immeasurable ground interiority as a transcendent seventh heaven, here with Hofmannsthal it is a truer world, into which the waking world as a whole migrates" (*GS* III, 30). In his review of the second version, he slightly modifies his judgment of the first, but does so in order to praise the second's more decisive break with the fatality of dream. Thus he writes: "The dream had . . . in the first version of *The Tower* every accent of a chthonic origin. . . . So it could be said that in a certain sense the prince perished from powers that out of his own interior revolted against him. . . . [I]t is unmistakable how in the new version the pure features of a long-suffering figure, in the sense of Christian *Trauerspiel*, demanded manifestation ever more clearly; with that the original dream-motif retreated, and the aura around Sigismund became brighter" (*GS*, III, 98-9).

[17] This characteristic "loosening" activity of the dream was, in Benjamin's early work on Hölderlin, attributed to poetry. The poem, he argued, has a transcendental structure which Benjamin calls "*das Gedichtete*, an untranslatable term that might be awkwardly suggested by the English neologism "the empoemed." The "empoemed," Benjamin writes, "is a relaxation of the fixed functional unity that rules in the poem itself, and it can come into being in no other way than by ignoring certain determinations; in that in this way the intertwinement, the functionality of the remaining elements become visible" (*GS*, Vol. II 106). He goes

on to argue that the *Gedichtete* forms the threshold between the formally enclosed work and the life of the community and its history. Benjamin's later, surrealist-inspired attempt to open up an occult communication between the dream and history and to develop, as it were, a political dream interpretation, must be seen to be rooted in his previous poetics and not just as a passing enthusiasm for surrealism.

[18] Reinhart Koselleck, "Terror and Dream: Methodological Remarks on the Experience of Time during the Third Reich," in his *Futures Past: On the Semantics of Historical Time*, trans. Keith Tribe (Cambridge, MA: MIT Press, 1985) 224.

[19] Walter Benjamin, "The Storyteller," in *Illuminations*, ed. Hannah Arendt, trans. Harry Zohn (New York: Schocken Books, 1968) 84.

[20] In his late essay "On Some Motifs in Baudelaire"—the most consummate work to come out of the *Passagenwerk* research—Benjamin relates Baudelaire's "correspondences" to dream perception and quotes Paul Valéry: "To say, 'Here I see such and such an object' does not establish an equation between me and the object. . . . In dreams, however, there is an equation. The things I see, see me just as much as I see them." — Quoted in *Illuminations*, 188-9. Elsewhere in this essay, Benjamin relates the correspondences to the "reproducing [*abbildende*] aspect" of the object and "the object of experience in the state of resemblance [*Ähnlichsein*]." However we are to interpret these difficult formulations, it is clear that both dream and Baudelairean correspondence are models through which Benjamin attempts to conceive of a human faculty of appropriating *being as likeness*, for encountering the object through being-like.

[21] I allude here to Georg Simmel's landmark essay from 1903, "Metropolis and Mental Life," in *On Social Individuality and Social Forms*, ed. Donald N. Levine (Chicago, IL: University of Chicago Press, 1971) 324-39. Benjamin makes explicit reference to Simmel's essay in his 1939 version of the Baudelaire essay, although I would question the degree of Simmel's direct influence on Benjamin. More probable is that Benjamin arrived at formulations that resonate with those of Simmel through two factors: first, their common sensitivity to highly concrete cultural phenomena, which often form the point of departure for their investigations; and secondly, the decisive impact on Benjamin of Georg Lukács's *History and Class Consciousness*, a book evidently influenced by Simmel. Nonetheless, the following passage from "Metropolis and Mental Life" seems an indispensable foundation for Benjamin's more extended attempts to conceive a collective subject embodied in and *as* the metropolis: "A man does not end with the boundaries of his body or the vicinity that he immediately fills with his activity, but only with the sum of effects that extend from him in time and space: so too a city consists first in the totality of its effects that extend beyond its immediacy" (335; translation modified).

[22] Henri Bergson, *Matter and Memory*, trans. Nancy Margaret Paul and W. Scott Palmer (New York: Zone Books, 1991) 85.

[23] Slavoj Žižek, following Lacan, calls this structure the "fantasy-framework," underscoring its relation to images, imagination, and the imaginary. He writes:

"When we awaken into reality after a dream, we usually say to ourselves 'it was just a dream,' thereby blinding ourselves to the fact that in our everyday, wakening reality we are nothing but a consciousness of this dream. It was only in the dream that we approached the fantasy-framework which determines our activity, our mode of acting in reality itself."—*The Sublime Object of Ideology* (London: Verso, 1989) 47.

[24] For a critique of use-value and quality in Marx, see Jean Baudrillard, *The Mirror of Production*, trans. Mark Poster (St Louis, MO: Telos Press, 1975) 22-33.

[25] Walter Benjamin, "Theses on the Philosophy of History," in *Illuminations*, 263.

CHAPTER FOUR

RETHINKING THE AESTHETICS OF THE IMAGE: THE FRANKFURT SCHOOL

Walter Benjamin and the Image

The term "image"—*Bild* —has a rich set of usages in Benjamin's work, and the careful establishment of the contexts and senses which it possesses for him would be a valuable philological labor. Here I wish only to point out that Benjamin uses it to mean something like a critical portrait in his essay on the novelist Marcel Proust, "Towards an Image of Proust"; it designates the genre of his collection *One-Way Street*, for which Benjamin insisted on the designation of "images of thought" (*Denkbilder*) rather than aphorisms; and it figures in his investigations of material culture, art, architecture, photography, and cinema throughout the 1930s, where for obvious reasons the image is a central concern. As I discussed in the previous chapter, it also shaped his notion of political dream-interpretation, which seeks to decipher the appearance of social reality as a set of "image-puns" (*Bilderwitz*); Benjamin first introduced this idea in texts of the later 20s like *One Way Street* and the essay "Dream Kitsch" and in his 1930 review of Siegfried Kracauer's study, *White Collar Workers*. The political "dream-analysis" that Benjamin derived from reflections on his own childhood experiences, his eccentric collecting, and his literary passions took on, later in his work, rigorous methodological lineaments. Although the dream problematic was only one of several conceptual frameworks Benjamin tried out in his *Passagenwerk* research, for a number of years it formed the key theoretical armature of this historical study.

Benjamin's interest in the model of dreams provides a useful point of departure for thinking about the issue of images. For dreams are, first of all, composed of images, drawn from both recent and distant experiences, and rearranged into new constellations. These concatenations of images, moreover, are not so much pictorial or even narrative in essence, but, as Sigmund Freud was careful to note, ideational and discursive. Thus, in an

example discussed in *The Interpretation of Dreams*, Freud recounts a girl's dream about her brother, who had promised her a feast of caviar; in this dream, the brother's legs were covered with black spots like caviar. Freud comments: "The element of *contagion* (in the moral sense) and a recollection of a *rash* in her childhood, which had covered her legs all over with *red* spots, instead of black ones, had been combined with the *grains of caviar* into a new concept—namely the concept of '*what she had got from her brother.*'"[1] The images, thus, have to do with their referents only insofar as these referents themselves become signs; their combination implies a conceptual or discursive meaning which literally does not *appear*, that is, which requires an active engagement of the interpreter to render it—and I use the word advisibly—*legible.* (Dream images are not, strictly speaking, something to see, but rather to read.)

The passage from the *Passagenwerk,* quoted in my previous chapter, about nineteenth-century kitsch interiors offers an example of how Benjamin sought to apply this conceptual framework to a concrete investigation of material culture. After referring to Hessel's characterization of the nineteenth century as the "dreamy epoch of bad taste," Benjamin goes on to suggest how this promiscuous leveling and mixing of historical styles, this bourgeois degradation of the aristocratic past, gradually begins to translate itself into a discourse, at first virtually, then literally, in the form of new commercialized media. Photomontage, he continues,

> which fixed such images for us, corresponds to this generation's most primitive form of illustration. Only slowly did the images, among which they lived, dissolve themselves and precipitate out as the figures of publicity on advertisements, price tags, and posters.[2]

Benjamin suggests a process in which three-dimensional images embodied in bourgeois interiors precipitate out into technically reproducible, mobile, manipulable forms, which in turn offer possibilities for an *explication*—a rendering discursively explicit—of their historical meanings. We have here a crucial conjunction of two dynamics, the first of which traces the continuity and preservation of the "images" as they are transferred from lived space to media space, and the second of which is the passage from the kitschy superimpositions in domestic interiors to the montage-like juxtapositions in publicity. Publicity becomes, as it were, the destiny of the nineteenth-century interior, while at the same time it provides discursive forms in which the visible images of domestic space may become legible in public space, revealing their political meanings.

What is crucial about this process in the social and political sense is the one-way street Benjamin traces from perceptible things in empirical spaces to inscriptions situated in the mobile spaces of representational media: books, posters, newspapers, and so forth. Benjamin anticipates here the work of the philosopher of science Bruno Latour, who, in a different domain, has similarly emphasized the crucial importance of this move, which renders things and empirical events manipulable and mobile by transmuting them into images. In fact, Latour offers a rationale for this process which is highly relevant to our considerations of the image. Inscriptions, Latour writes, are:

- Mobile, whereas often the objects they represent are not.
- They are immutable or at least resistant to change when they are moved, something which anyone who has dealt with a moving company will know is not true of a domestic interior.
- Inscriptions render three-dimensional spaces flat, which reduces opacity and hidden aspects, allowing visual domination of the object.
- The scale of inscriptions can be modified at will (a point Benjamin also stresses when he characterizes photography and other forms of technical reproduction as essentially a technology of miniaturization).
- They can be reproduced and distributed at minimal cost; they can be reshuffled and recombined (Benjamin's point in relating interiors and photomontage)
- They allow superimposition of several scales or types of images.
- They can be made part of a written text; and they can be manipulated using geometry, so that work done on the inscription in two dimensions can be used to find things out about the real objects represented.[3]

For all these reasons, the move from empirical spaces to images allows gains in mobility, speed of circulation, and power over objects. Hence, innovations in the techniques for producing images and the media of their dissemination may have crucial consequences for the social contexts in which such images enter: scientific contexts for Latour, the various domains of everyday and cultural life of the modern city for Benjamin.

Given Latour's interest in the instrumentality of images in the power/knowledge nexus of the sciences, his discussion deals almost exclusively with the passage from empirical space to the mobile spaces of inscriptions. Benjamin, however, as an historian, retains an interest in the reverse movement as well: the preservation of phenomenological data, traces of sensory experiences derived from real spaces, in the sedimented, reproducible forms of image-texts. To put it in terms of the *Passagenwerk* quote, the historian may seek to read within the images of publicity, in which the historical process terminated, the lost pattern of objects among

which people lived. This second possibility reveals not a nostalgic demand for an empathetic imagining of "how it really was," but a holding in tension of two antithetical, but complementary situations of the image in relation to the historical process.

A passage from Benjamin's "Small History of Photography" helps clarify this relation that I am describing as that of "complementarity in antithesis": the complementary relation between the idea of the image as that which can render empirical things and events mobile, reproducible, and manipulable; and the seemingly opposed idea of the image as a unique configuration of reality at a particular moment in time (e.g. the images among which the nineteenth-century European bourgeois lived). Benjamin suggests that these two aspects of the image coincide, in the particular domain of photography, with dominant trends of two successive phases in the history of photography.

In early photography, Benjamin argues, technical limitations of the medium compelled long exposure times with little motion; the subjects had to compose themselves and hold the moment in its duration as the photographer exposed the plate. Moreover, the social context in which the photograph appeared was different:

> The first people to be reproduced entered the space of photography's gaze still respectable, or better put, uncaptioned. Newspapers were still luxury items that one more often looked at in coffeehouses than bought; the photographic process had not yet become their tool, and only the fewest people saw their name in print at this time. The human countenance had a silence around it, in which the gaze rested.[4]

Benjamin goes on to suggest that the photographs by David Octavius Hill in the Edinburgh cemetery render this space "like an interior, a separate closed-off space where the gravestones propped against gable walls rise up from the grass, hollowed out like chimney-pieces, with inscriptions inside instead of flames" (373). Yet despite what Benjamin describes as the lack of contact between early photos and "actuality," they nonetheless tended to register momentary, contingent configurations, highly particular in time and space, which long after their making were able to testify to the "thusness of the long-past moment" ("Sosein jener längstvergangenen Minute").

Later photography took up this aspect of actuality and began to incorporate it integrally in both its technical apparatus and its social institutions. As the interior-like space in the "pictures" of early photography passes into the forms and media of publicity, a different logic begins to predominate: that of the *copy* and the *snapshot*, in German, the

Momentaufnahme—literally, the registration of the instant. In the snapshot time is segmented into a series of views, while space is penetrated by the technical apparatus, transforming it into reproducible, saleable images. As Benjamin notes in his 1936 "Paris Letter" on "Painting and Photography," photography "made ever more numerous selections from the field of optical perception saleable. It has conquered for circulation as commodities objects that previously had almost never entered into this process."[5] This reproduction process begins to drive a wedge into the unitary image, differentiating image as picture or pattern from the image as copy. As Benjamin writes: "Every day the need to possess the object in close-up in the form of . . . a copy (*Abbild*), becomes more imperative. And the copy (*Abbild*), which illustrated newspapers and weeklies hold in readiness, differentiates itself unmistakably from the picture (*Bild*). Uniqueness and duration are as intimately conjoined in the one as transiency and repeatability in the other."[6] The picture compacts meanings into the visible image, lending it a sort of metaphorical, even dream-like overdetermination; the copy, in contrast, simplifies and renders univocal the image, which nonetheless allows it to enter into complex juxtaposition with other discrete fragments. What it loses in metaphorical density, it gains in its ability to enter into new complexes and contexts of meaning. Benjamin suggests that this tendency of photography towards the latter "copy" mode, its projection of its previous poetic thickness onto the extensive plane of information, represents the overcoming of uniqueness through reproduction, the winning of a sense of sameness even out of the unique. Yet paradoxically, at the same time, that quality which Benjamin refers to as the "authenticity of the photograph" (*Authentizität*)—its "thusness" in the moment of the "instant," the photographic snap of the snapshot —takes on an extraordinary new intensity and political importance, even as the number of reproducible images and their dissemination in popular media increases exponentially.

In fact, Benjamin argues, the combination of a vastly increased image density along with an ever-more forceful shock of the moment has begun to overpower the ability of photography's producers and consumers to make the move from visible images of empirical appearance to the legible inscriptions which carry meanings in the social text of history. He quotes the playwright Bertolt Brecht to the effect that a snapshot of a factory reveals very little of its social meaning. And like Brecht, Benjamin points to the critical role of language with respect to visible images, whether in theater or in photography and film. To bring visible images into the signifying space of discourse was for both a crucial political task for artists in a society which, even then, was being overrun by mass media images.

"The camera is getting smaller and smaller," Benjamin writes, "ever readier to capture fleeting and secret moments whose images paralyze the associative mechanisms in the beholder. This is where the caption comes in, whereby photography turns all life's relationships into literature."[7]

I want to suggest, then, that Benjamin saw as part of a single complex development these three tendencies: the increasing reproduction and mobility of images, the increasing differentiation of the picture and copy functions of the image, and the increasing necessity to give the flood of images a discursive form. A brief look at Benjamin's programmatic reflections on the writing of history in the *Passagenwerk* can offer some insight into the implications he drew for his own historical and political investigations. Here Benjamin draws two major distinctions, which circumscribe the role of the image. First, he distinguishes images from phenomenological essences and idealistic humanistic categories like "habitus" and "style." It is their "historical index" which distinguishes them, and this index is defined precisely in terms of their "legibility" at particular moments of historical writing. Benjamin distinguishes between the "present," as a chronological category, and the "now," as a truly historical one, the point at which the past presents itself to be read: "[W]hile the relation of the present to the past is a purely temporal, continuous one, that of the past to the now is dialectical: not of a temporal, but of an imagistic nature. Only dialectical images are genuinely historical, i.e., not archaic images. The image that is read, I mean the image at the now in which it can be seen and recognized, bears to the highest degree the stamp of the critical, dangerous impulse that lies at the source of all reading."[8] Secondly, Benjamin distinguishes imagistic history from narrative history: "History decays into images, not into stories."[9]

Images are thus marked, for Benjamin, by a peculiar in-between status as historiographic units: insofar as they are intimately historical, they are not timeless essences; yet insofar as their relation to historical time is not a narrative one, they resemble phenomenological data more than chronological facts in narrative history. Moreover, like dream-images, their effective force in memory comes from their ability to take a discursive form rather than their visible status. In fact, one might conceptualize images best as the means by which this translation from sensual data to legible text is effected. The becoming-legible of images would be, then, the coming to presence of history as such, as a comprehensible text to be read and interpreted.

I will conclude this discussion with a quote, perhaps not accidentally, from Benjamin's writings on photography which reveals how he conceived this process of history as the momentary becoming-legible of

images. In a discussion of Gisèle Freund's important study *Photography in France in the 19ᵗʰ Century*, Benjamin raised an objection to Freund's understanding of the relation of cultural artifacts, in this case photography and its techniques, and social context. In her study, Freund suggested that the greatest nineteenth-century photographers were able, precisely out of their superior sense of form, to reflect most closely the tendency of their social contexts. Benjamin responded:

> What seems questionable about this sentence is not the attempt to define the artistic consequence of a work in relation to the social structure of the age of its genesis; it is rather the assumption that this structure appears once and for all under the same aspect. In truth its aspect may change with the different epochs that direct their glance back on it. Defining the significance of an artwork with reference to the social structure of the time of its genesis thus goes much further; it means considering the artwork's ability to offer the most distant and estranged epoch a passage into the age in which it originally appeared.[10]

Benjamin projects onto the temporal axis of history a similar relation of picture and copy as pertained to the production of photographic images. The objectively subsisting "social structure" of past epochs—the constellation of forces in a particular place and time—is not immediately legible. It is only in the retrospective construction of these virtual "images" or "pictures" through the historian's labor, the conversion of the "images they lived among" to the reproducible images of documents, photographs, and illustrated texts, that the original images come to be legible for a moment.

Theodor Adorno: Imagining Music

Whereas the image is a constant topic of reflection in the work of Walter Benjamin, in Theodor Adorno's voluminous writing, it does not, at first glance, appear to be a central concern. In fact, among the forty-some volumes of his collected writings, and among the incredible diversity of topics upon which Adorno chose to comment, the visual arts and image culture more generally occupy remarkably little space. In fact, their presence is first and foremost indicated negatively: for example, in the *Aesthetic Theory*, Adorno develops the theme of modern art's abolition of mimesis in relation to the *Bilderverbot*, the ban on graven images of the Old Testament God of the Hebrews. One might conclude, with justification, that Adorno, as a trained composer and analyst of music, is

concerned above all with music, and beyond that with the word in literature, but basically not with the image.

Yet as is typical with Adorno, the issue is not so simple. With Benjamin, the image takes on a number of different aspects, including a quasi-scriptural dimension that puts images in resonance with language and allows them to be read. Benjamin's image does not simply pertain to visual culture, because communication through images entwines invisible, conceptual, or rhythmic elements with the visible features and iconic meanings of the image. For its part, music likewise exists within an ensemble of the senses, some of which involve visible, embodied movement as well as the virtual, structural movement of the melodies, harmonies, and counterpoints. This visibility is above all evident when music is integrated into performance contexts of dance, theater, opera, or cinema. Several of Adorno's major writings on music, in fact, deal with precisely this problematic interface between music and performance arts, where music confronts language, gesture, movement, and image, interacting with them to make complex artistic forms—a multimedial image, so to speak, as well as an image of the harmonious or dissonant interaction of the media contributing to the overall artwork. These writings include his early book, *In Search of Wagner*, written between 1937 and 1938, where the question of Richard Wagner's opera and musical drama is central; *Composing for the Films*, on which Adorno collaborated in the late 1930s with the communist composer and Bertolt Brecht's friend, Hanns Eisler; and *Philosophy of Modern Music*, written in the United States during the early 1940s and published in Germany in 1948, which praises Arnold Schoenberg's atonal composition and castigates Igor Stravinsky's dance- and theater-oriented work such as *The Rite of Spring, Petrouchka,* and *L'Histoire d'un Soldat.* Finally, Adorno's dismissals of jazz in several essays and in *Dialectic of Enlightenment* rest at least in part on what he supposes to be its stereotyped and stereotyping function as dance music, reducing both bodily and musical movement to a common, mechnical denominator. Each of these, in different ways, revolves around the problem of music's internal form and its relation to various sorts of bodily and visual objectifications, which involve also translations across the semiotic and sensorial boundaries of material media. I would suggest, then, that if we want to discover Adorno's contribution to discussions of images and visual culture, we have to look for it in an unlikely place: in his writings on music.

Adorno's book on Richard Wagner is written in the late 1930s in the clear awareness of Wagner's contribution to the style of monumentalized kitsch and mythicizing aesthetic politics that was characteristic of Nazism.

Adorno's study is thus a musically very knowledgeable analysis, but at the same time is biting in its social criticism of Wagner as a symptom of a crisis of musical expression symptomatic of the larger social tendencies leading to fascism. His dual focus, aesthetic and socio-political, is clear, for example, in his analysis of Wagner's musical gestures as analogous to oratory:

> Faults of compositional technique in his music always stem from the fact that the musical logic, which is everywhere assumed by the material of his age, is softened up and replaced by a sort of gesticulation, rather in the way that agitators substitute linguistic gestures for the discursive exposition of their thoughts. It is no doubt true that all music has its roots in gesture of this kind and harbours it within itself. In the West, however, it has been sublimated and interiorized into expression Wagner's position lies athwart this tradition. The uncontrollably intensified expressive impulse can barely be contained within the interior, within historical consciousness, and finds release as external gesture. It is this that gives the listener the embarrassing feeling that someone is constantly tugging at his sleeve.[11]

Rather than passing through the spiritualizing mediation of musical form, Adorno suggests, the Wagnerian gesture remains theatrical and histrionic, calculated to move the listener or spectator immediately, to bring about some sort of effect rhetorically. To put it otherwise, Adorno suggests rather than stimulating the internal musical imagination of each listener by the interconnected patterns of sound, Wagnerian music attempts to impose the image forcibly onto the audience, as if imprinting it or stamping it musically onto its collective body and nerves. These "typographical" moments, paradoxically, are those in which the greatest claim to subjective expression, to primordial emotion, are made by the composer:

> The element of gesture in Wagner is not, as he claims, the utterance of undivided man, but a reflex that imitates a reified, alienated reality. It is in this manner that the world of gestures is drawn into the artistic effect, into the relationship with the public. Wagnerian gestures were from the outset translations onto the stage of the imagined reactions of the public—the murmurings of the people, applause, the triumph of self-confirmation, or waves of enthusiasm.[12]

Adorno's thought is complexly dialectical, making the musical gesture both a cue to the public about how to react to the music and a kind of echo of that response itself. Wagner, Adorno suggests, by-passes the audience's critical reflection and knowledge to go directly for some sort of emotional response, but in doing so, he impoverishes the expressive language of

music to an instrument for producing that particular effect. Music is externalized, spatialized, theatricalized in Wagner's operas, so the invisible dimension of musical perception is increasingly eclipsed by the visible, hierarchical form to which the singers, orchestra, and audience are all subordinated. We can say that Adorno suggests that Wagner's music tends towards a kind of static theatrical architecture that is the microcosmic image of a social order in which each actor is assigned a fixed place. For Adorno, the spectacle architecture of Bayreuth extends seamlessly into the stadium rally space of the 1935 Nuremburg Nazi Party Congress (where, in fact, a performance of Wagner was part of the events of the Congress, and where daily throughout the Congress's seven days, political speeches were staged in the Nuremberg Opera House).

In a later chapter, devoted to musical drama, Adorno relates Wagner's operas to another collective art-medium, cinema. Insofar as music is tied externally to the action on the stage, it loses the autonomy of its own formation, while the poetry and dramatic elements of the opera are also fractured and diminished. This, Adorno argues,

> explains the intermittent, dragging effect so suggestive of the film. The words, uttered with one eye fixed on the music. . . are constantly overdoing things Whereas for its part, the music, because of its extra, interpretative function, finds itself drained of all the energies that make it a language remote from meaning, pure sound, and so contrast it with human sign-language And, finally, the stage is compelled to go along with what is happening in the orchestra. The infantile actions of the singers—the opera often seems like a museum of long-forgotten gestures—are caused by their adaptation to the flow of the music. They resemble the music, but falsely; they become caricatures, because each set of gestures effectively mimics those of the conductor. The closer and the more indiscreetly the different arts are brought into proximity, and the more the musical drama approaches their fundamental indifference to each other, the more they prove mutually disruptive.[13]

Adorno's analysis derives from the idea that the division of labor has penetrated the human sensorium as well, separating vision from movement and touch and hearing, specializing single senses at the expense of others, as professional activity in both labor and the arts heightens one or another sense while allowing others to atrophy. The sensory totality of experience breaks up into fragments, intensifying some, while diminishing the whole. In building up his myth of the total work of art, brought into being by the total artistic genius himself, Wagner sought to unify the various arts that contribute to musical drama, but without actually overcoming the alienated forms that separated them in the first place. The multimediality of

Wagner's musical drama does not imply a synthesis of the contribution of the various media, but only their aggregate, their piling together and setting side-by-side. This aggregate of media generates a quantitative buildup of abstract intensity, but according to Adorno, the intoxicating or dazzling effects of this intensity can only be a short-lived diversion of a listener's awareness of the banality and senselessness of the whole. Wagner's music bludgeons the senses into a semblance of sublimity, rather than building their sensitivity to the qualitative dimensions of the various senses involved and the complexities of their interactions. Moreover, Adorno argues, in this respect Wagner's operas, for all their high-culture and poetic pretension, presage the degraded products of the culture industry, which yoke together elements with great technical skill in order to produce intense, but empty emotional and sensory effects:

> Nietzsche, in his youthful enthusiasm, failed to recognize the artwork of the future in which we witness the birth of film out of the spirit of music. For this nexus, there is an early piece of authentic evidence from Wagner's immediate circle. On 23 March 1890, that is to say, long before the invention of the cinema, Chamberlain wrote to Cosima about Liszt's *Dante* symphony, which can stand here for a whole tendency: "Perform this symphony in a darkened room with a sunken orchestra and show pictures moving past in background—and you will see how all the Levis and all the cold neighbours of today, whose unfeeling natures give such pain to a poor heart, will all fall into ecstasy." Few documents could demonstrate more tellingly how inaccurate it is to assert that mass culture was imposed on art from outside. The truth is, it was thanks to its own emancipation that art was transformed into its opposite.[14]

Adorno proceeds in a similar vein against Stravinsky in his essay "Stravinsky, or Restoration," in *The Philosophy of Modern Music*. Adorno generally sees in Stravinsky a surrender of music's hard-won autonomy of constructive principle, particularly music's special internal organization of time, to the external compulsion to represent images of dancing or acting bodies, literary elements, and painted forms. Thus, he argues that Stravinsky employs the trick of portraying "time as in a circus tableau," and presenting "time complexes themselves as though they were spatial," which increasingly reduces his work to a "parasite of painting."[15]

Referring to Stravinsky's collaborations with the Ballet Russe, above all in the *Rite of Spring*, Adorno points to the externalization of rhythmic construction in the visible movements of the body of the dancers, which in turn he interprets as reflex registrations of traumatic social forces:

Rhythm is underscored, but split off from the musical content. This results not in more, but rather in less rhythm than in compositions in which there is no fetish made of rhythm; in other words there are only fluctuations of something always constant and totally static—a stepping aside—in which the irregularity of recurrence replaces the new. This is evident in the final dance of the chosen victim—in the "sacrificial dance," where the most complicated rhythmic patterns restrain the conductor to puppet-like motions.[16]

Adorno criticizes Stravinsky's apparently archaic, mythic image of sacrifice in the depths of Siberian Asia and in the deep recesses of time as anything but primordial. Instead, it depicts a shock reaction to forces of modernity, in the process turning the musical composition into an image of the traumatized body:

Such rhythmic patterns alternate in the smallest possible units of beat for the sole purpose of impressing upon the ballerina and the listeners the immutable rigidity of convulsive blows and shocks for which they are not prepared through any anticipation of anxiety.[17]

The result is, under the mythic mask, spasmodic movement, which communicates its effect through direct, physical impact from dancer or singer to listener and viewer:

The subject behaves literally like a critically injured victim of an accident which he cannot absorb and which, therefore, he repeats in the hopeless tension of dreams. What appears as the complete absorption of shock—the submission of music to the rhythmic blows dealt it from an external source—is in truth the obvious sign that the attempt at absorption has failed.[18]

Once again, the larger reference-point of this analysis is the pseudo-ritual formations of the culture industry and of fascism. Adorno sees a resonance of Stravinsky's technically brilliant orchestration of archaic physical effects with the "mass ornament" of the dance revue and the fascist rally. The image of collective strength that is projected by both depends on a prior traumatization and depersonalization of the individual subjects. What is imaged in Stravinsky's musically animated stage figures, Adorno claims, is not an active community of individuals, but rather a dominated crowd of those who have been reduced to abstract building blocks of visible form and stylized movement.

Notably, Adorno does not even spare his musical master, Arnold Schoenberg, this criticism. In his essay "Sacred Fragment: Schoenberg's

Moses und Aron," Adorno suggests that the subject-matter of Schoenberg's unfinished musical drama leads to a fundamental, ontological contradiction within the work that creates problems for its realization and effectiveness as a work of art. The opera—dramatizing the Hebrew Old Testament story of Moses and Aaron—circles around the infinite, invisible, nameless God of the ancient Hebrews and his exclusion of polytheistic myth and idolatry. At the same time, however, Schoenberg's work treats this intrinsically anti-imagistic subject matter within a theatrical simulacrum, making a dazzlingly masterful imagistic work of art out of it, a "graven idol" that testifies to Schoenberg's genius for making artistic images instead of his submission to an unimaginable theological sublimity. Adorno does not, it is important to note, think that this is a failure of Schoenberg in his artistic skill or compositional efforts. Instead, it points to a more deep-seated and intractable problem, rooted in history: the objective impossibility of making sacred art in the secular age of modernity in any way that does not bring to the fore, with ever greater intensity, the paradoxical nature of this aspiration.

Schoenberg's general tendency, according to Adorno, was anti-imagistic: "The non-repeatability of atonal cells is essentially hostile to the architectonic and the monumental."[19] Yet in *Moses and Aron*, which strives to represent an historical content monumentally, the specific character of this atonal musical vocabulary is betrayed:

> The prohibition on graven images which Schoenberg heeded as few others have done, nevertheless extends further than he even imagined. To thematize great subjects directly today means projecting their image after the event. But this in turn inevitably means that, disguised as themselves, they fail to make contact with the work of art.[20]

The very task of aspiring to monumentality means subordinating autonomous music to the image, to "project" the theme into a moving image, if I may underscore the cinematic overtones of Adorno's language.

In Adorno's discussion of Wagner and implicitly in relation to Schoenberg as well, the film medium appears in a largely negative light, as the typical culture industry product. However, in his collaborative book with Hanns Eisler, *Composing for the Films,* Adorno takes a more sympathetic stance towards the possibilities of film, and hence too towards the interactions of music and film, which need not betray the potential richness of either media, however much present practice tends towards reductive and stereotypical products.

The Adorno-Eisler book on film composition is a rich collection of practical, theoretical, sociological, and aesthetic reflections on the

relations of cinema and music. If I can reduce this richness down to a core idea, however, it is that the technical rationalization that is characteristic of modern music—the analysis and control of music in its various parameters—makes it particularly well adapted to interact productively with cinematic images, which treats their various media components with similar analytic and technical rigor. Thus, Adorno and Eisler conclude,

> as music becomes more pliable through its own structural principles, it also becomes more pliable for purposes of application to other media. The release of new types of resources, which was denounced as anarchistic and chaotic, actually led to the establishment of principles of construction far more strict and comprehensive than those known to traditional music. These principles make it possible always to choose the exact means required by a particular subject at a particular moment and there is therefore no need to use formal means unsuitable for a specific purpose. Thus it has become possible to do full justice to the ever-changing problems and situations of the motion picture.[21]

In a note, they go on to suggest that Alban Berg's operatic compositions, *Wozzeck* and *Lulu*, exhibit the same technical exactitude and micrological construction as the best-made cinema:

> It is worthy of note that certain features of the work of Alban Berg, whose late-romantic, expressionistic instrumental and operatic music is far removed from the motion-picture. . . illustrate the prevalence in advanced music. . . of rational construction which come[s] close to the requirements of the motion picture. Berg thinks in terms of such exact mathematical proportions that the number of bars and thereby the duration of his compositions are determined in advance. It is as if he composed them with a stop watch in his hand. His operas, in which complex stage situations are often accompanied by complex musical forms, such as fugues, in order to make them articulate, strive toward a type of technical procedure that might be called a musical close-up.[22]

I believe that Adorno's and Eisler's observations here take on their full resonance when we recall the emergence about this time of a composer who literally composed with a stop watch in his hand, John Cage. The young Cage was a native of the Los Angeles in which Eisler and Adorno were exiled newcomers, and like the two older men, Cage's training was connected to Arnold Schoenberg, whom Cage persuaded to give him composition lessons. From the outset, the Cagean revolution in music had subterranean links with the most important technological art form of the age, the cinema. In the 1930s, Cage worked with the abstract animator Oskar Fischinger, taking inspiration from the filmmaker to explore the

resonant properties of objects and materials, releasing their "vibrations" in percussion music.[23] In his 1937 talk "The Future of Music: Credo"—thus even slightly preceding Adorno's and Eisler's treatise on film music—Cage wrote, "The composer (organizer of sound) will be faced not only with the entire field of sound, but also with the entire field of time. The 'frame' or fraction of a second, following established film technique, will probably be the basic unit in the measurement of time. No rhythm will be beyond the composer's reach."[24] Cage, it is likely, was not merely offering a vague prognostication based on the analogy of music and cinema, but concretely thinking about the technical possibilities of the film medium with respect to sound registration. At that time, prior to the advent of magnetic tape, only the sound track of the film strip promised the composer the kind of technical control over the metrical properties of sound that Cage here envisages. Cage looked to the cinema as a specific form of machinery to "liberate" and develop the spirit immanent to matter, to sound out and experience the resonances of the material world: the artistic project to which he would dedicate his subsequent life's work and thought.

Adorno and Eisler, however, would develop this proximity of music and cinema in a somewhat different direction, stressing two potentials of both cinema and music that should inform their mutual development: their capacity to communicate emotional intensities that by-pass representation and directly affect the body of the listener and viewer; and their capacity for analytic separation and control of different artistic parameters in a new, highly complex montage.

In a passage that merges perfectly Adorno's dialectical criticism of "civilized" culture and Eisler's Brechtian affirmation of popular culture, the avant-garde composers find inspiration in an unlikely source, in the untamed intensities of trashy genre films and novels:

> The horrors of sensational literary and cinematic trash lay bare part of the barbaric foundation of civilization. To the extent that the motion picture in its sensationalism is the heir of the popular horror story and dime novel and remains below the established standards of middle-class art, it is in a position to shatter those standards, precisely through the use of sensation, and to gain access to collective energies that are inaccessible to sophisticated literature and painting. It is this very perspective that cannot be reached with the means of traditional music. But modern music is suitable to it. The fear expressed in the dissonances of Schoenberg's most radical period far surpasses the measure of fear conceivable to the average middle-class individual; it is a historical fear, a sense of impending doom.[25]

They consider three musical examples, the first from Schoenberg, whom they juxtapose to *King Kong*:

> Something of this fear is alive in the great sensational films, for instance. . . in *King Kong* when the giant gorilla hurls a New York elevated train down the street. The traditional music written for such scenes has never been remotely adequate to them, whereas the shocks of modern music. . . could meet their requirements. Schoenberg's music for an imaginary film, *Begleitmusik zu einer Lichtspielszene,* op. 34, full of a sense of fear, of looming danger and catastrophe, is a landmark pointing the way for the full and accurate use of the new musical resources.[26]

They also consider Eisler's own music for Fritz Lang's anti-Nazi film, *Hangmen Also Die*, and Alban Berg's operatic masterpiece, *Lulu*:

> For example, *Hangmen Also Die,* after the preliminary music, begins by showing a large portrait of Hitler in a banquet hall of the Hradshin Castle. As the portrait appears, the music stops on a penetrating widespread chord containing ten different tones. Hardly any traditional chord has the expressive power of this extremely advanced sonority. The twelve-tone chord at the moment of Lulu's death in Berg's opera produces an effect very much like that of a motion picture. While the cinema technique aims essentially at creating extreme tension, traditional music, with the slight dissonances it allows, knows of no equivalent material. But suspense is the essence of modern harmony, which knows no chord without an inherent "tendency" toward further action[.][27]

Dissonant harmonies correspond to and potentially contribute to multimedia images of extreme intensity and impact, communicating with listeners and spectators on an affective channel running directly from screen to nerves and bodies.

If this degree of intensity represents a shared "theater of cruelty" in the cinema and modern music, it is complemented by new constructive means, opening unprecedented possibilities for complex multimedial artistry and rational control. Treating each element of the cinematic complex as distinct, Adorno and Eisler do not seek to merge them in a Wagnerian soup, but to exploit their differences in montage-like constellations:

> If the concept of montage, so emphatically advocated by Eisenstein, has any justification, it is to be found in the relation between the picture and the music. From the aesthetic point of view, this relation is not one of similarity, but, as a rule, one of question and answer, affirmation and negation, appearance and essence. This is dictated by the divergence of the media in question and the specific nature of each.[28]

Adorno and Eisler thus appropriate one of the precepts of modern formalist aesthetics, the idea of medium-specific qualities, and retool them to a vision of multimediality. Here the relation of media becomes fruitful insofar as their specificity is recognized and treated as a means of rationally controlling their particular contribution to an internally-complex, internally-differentiated but functionally-unified artistic whole: the sound film, the modern opera, the dance composition.

Notes

[1] Sigmund Freud, *The Interpretation of Dreams* [1900], trans. James Strachey (New York: Avon Books, 1965) 360.

[2] Walter Benjamin, *The Arcades Project*, trans. Howard Eiland and Kevin McLaughlin, ed. Rolf Tiedemann (Cambridge, Massachusetts: The Belknap Press of Harvard University Press, 1999) 213. Translation modified.

[3] Bruno Latour, "Visualization and Cognition: Drawing Things Together" 20-21. Article 21 at www.bruno.latour.fr, accessed 9 October 2008, 20-21. For a complementary view of visualization practices in modern science, see Peter Gallison, *Image and Logic: A Material Culture of Microphysics* (Chicago, Illinois: University of Chicago Press, 1997).

[4] Walter Benjamin, "Kleine Geschichte der Photographie" in *Gesammelte Schriften* II, eds. Rolf Tiedemann and Hermann Schweppenhäuser (Frankfurt am Main: Suhrkamp Verlag, 1977) 372: hereafter cited as *GS*.

[5] Benjamin, *GS* III 502.

[6] Benjamin, *GS* II 379.

[7] Benjamin, *GS II* 385.

[8] Benjamin, *Arcades Project* 463.

[9] Benjamin, *Arcades Project* 476.

[10] Benjamin, *GS* III 543.

[11] Theodor Adorno, *In Search of Wagner*, trans. Rodney Livingstone (London: New Left Books, 1981) 34-35.

[12] Adorno, *In Search of Wagner* 35.

[13] Adorno, *In Search of Wagner* 104.

[14] Adorno, *In Search of Wagner* 107-108.

[15] Theodor W. Adorno, *Philosophy of Modern Music*, trans. Anne G. Mitchell and Wesley V. Blomster New York: Continuum, 1985) 194, 195.

[16] Adorno, *Philosophy of Modern Music* 154-155.

[17] Adorno, *Philosophy of Modern Music* 155.

[18] Adorno, *Philosophy of Modern Music* 156-157.

[19] Theodor W. Adorno, "Sacred Fragment: Schoenberg's *Moses und Aron*" in *Quasi Una Fantasia: Essays on Modern Music*, trans. Rodney Livingstone (London: Verso, 1992) 240.

[20] Adorno, "Sacred Fragment" 243.

[21] Theodor Adorno and Hanns Eisler, *Composing for the Films* (London: The Athlone Press, 1994) 34.

[22] Adorno and Eisler, *Composing for the Films* 34.

[23] John Cage and Daniel Charles, *For the Birds* (Boston: Marion Boyars, 1981) 73-74; David Revill, *The Roaring Silence: John Cage, A Life* (New York: Arcade, 1992) 51-52.

[24] John Cage, "The Future of Music: Credo," in *Silence* (Middletown: Wesleyan University Press, 1961) 5.

[25] Adorno and Eisler, *Composing for the Films* 36.

[26] Adorno and Eisler, *Composing for the Films* 36-37.

[27] Adorno and Eisler, *Composing for the Films* 37.

[28] Adorno and Eisler, *Composing for the Films* 70.

CHAPTER FIVE

IN THE BLITZ OF DREAMS:
MASS-OBSERVATION AND THE HISTORICAL
USES OF DREAM REPORTS[1]

I

"*The Means of* Vision—matter (sense impressions) transformed and reborn
by Imagination: *turned into an image.*
The Means of Production—matter is transformed and reborn by *Labour.*"
—Humphrey Jennings, Introduction to *Pandaemonium* [2]

"In the imaginary dimension proper, existence *is* signification."
—Cornelius Castoriadis, "The Imaginary"[3]

An assumption held in common by the three founders of Mass-
Observation, Charles Madge, Humphrey Jennings, and Tom Harrisson,
was that the most prevalent social anxieties and wishes of the age express
themselves non-discursively in the idiom of "images." The image, as they
defined it, had a peculiar two-faced character, in which ideas were
sensualized and sensations given ideational content. The image is "more
vivid than an abstract idea," Madge and Harrisson wrote in the 1937
pamphlet *Mass-Observation*; yet "it is more intangible than a concrete
sensation."[4] Humphrey Jennings, as a painter and filmmaker, gave the
term a particularly psychological and aesthetic spin, as Charles Madge
noted retrospectively. In a text for a pamphlet produced by the Institute of
Contemporary Arts shortly after Jennings's death in 1950, Madge wrote
that Jennings gave the term "image," "a meaning personal to himself and
bound up with his early researches into poetry and painting. His use of
'image' is not far off from the way it is used in psychology, in literary
criticism and in surrealist theory, but it is not quite identical with any of
these. It has resemblances to the psychological concept of the *gestalt*."[5]
Implicit in a later consideration of the "image" by Madge, again in relation
to Jennings, is a more complex notion of a sort of intersemiotic translation,

from one medium such as text to a visible or imaginatively visualizable form. Thus, in his editorial preface to Jennings's collection of textual quotations about the rise of the machine in the modern age, quotations called "Images" by Jennings, Madge writes:

> In his notes for an introduction, Humphrey calls his extracts "images," a term which, in the way he uses it, can cover a wide range of meanings. He chose the extracts because, for him, they had an imaginative impact. . . . What gives this its force as an "image" is its place in Humphrey's "unrolling film". . . . Humphrey undoubtedly had an eye for such passages, a painter's eye, and a film-maker's, for whom the visual complement of the written word was never far away.[6]

Madge thus sees two main features compounded in Jennings's "image": it translates a sign-system that is not necessarily evocative pictorially into a visually striking image, and it allows a dispersed or hidden pattern to be discerned and rendered explicit as a visible whole, a *gestalt*. While in this second passage, Madge has the narrow context of Jennings's"text-images" in *Pandaemonium* in mind, it is easy enough to see this as a special case of a more general application of the image to a wide range of media, from arrangements of objects, to built spaces, to rituals and everyday practices, to explicitly symbolic artifacts. The image is an interpretative tool for making conscious and strikingly presentable a meaningful constellation of social meanings.

In the domains of everyday life, from grooming to popular superstition to home decoration and movie-going, in which the ideational and ideological contents remain largely a matter of implicit knowledge, the M-O directors believed "dominant images" would emerge that could be detected and possibly reshaped by the activist sociologist. In this regard, the Mass-Observation project was guided by assumptions that would become increasingly articulate in the sociology, ethnography, and cultural studies of the last three decades. Practices, it suggested, are not merely functional and instrumental. They are also meaningful, and the meanings they bear need not be either evident or derivable from the manifest "rational" intention of the practice. In at least some cases, one could legitimately speak of a "repressed" meaning and hence a distortion of social knowledge that keeps important aspects of the practice's effective nature hidden from those most directly involved in it. In other words, while avoiding the more metaphysical and archaic-mythic aspects of Jungian symbol theory one could conceive of a certain "collective unconscious" residing in the material textures of modern social life.

In this respect, Mass-Observation showed a remarkable prescience, anticipating in a genuine way what would become a paradigmatic conceptual framework of contemporary cultural theory. Especially as it has became possible to reconceive "psychic" agencies as embedded in linguistic, semiotic, informational, and ecological systems, this "deallegorization" of collective representations in contemporary theory has advanced rapidly. Without conjuring up mythic psychic entities like "racial memories" or the "national mind" or the like, it has nonetheless become possible to talk coherently about repositories of transindividual agencies for preserving and transforming meanings such as "culture," "collective memory," and "archives."

If the concept of the image, as formulated by the M-O directors, offered an epistemological entry into the social investigation of collectively meaningful objects, spaces, and practices, it is clear why the everyday (or everynight) process of dreaming would have attracted their interest. In a certain sense, dreams seem more than just entities to be interpreted as "images"; they already *are* images. They seemed to offer a readymade object and model for the work of the sociological collector and interpreter of images. Moreover, the foundational status of dream interpretation in the development of psychoanalytic theory meant that the M-O directors could count on a fairly authoritative body of theory about dreams that might be extended into the broader realm of social images they wished to investigate. While the dream project ultimately represented only one among many areas of Mass-Observation's interest—and could hardly be said to be their most important work—from a *theoretical* point of view, it was crucial.

II

"The sociologist. . . is ill-equipped for anything more than examining dreams as they appear on the surface. His job is not to dig deep into the unconscious lives of a few individuals, but rather to explore wider fields, at a more superficial level. His interest is not so much in individuals and depth, as in masses and extent."
—Mass-Observation, "A Report on Dreams," March 1949[7]

Despite its apparent promise, however, Mass-Observation's project of collecting dreams from its participant observers resulted in something less than a definitive new knowledge of the collective psychic life of the British populace. The project, as I have shown, began in the late 1930s as an outgrowth of the broad and brash programmatic ideas that situated the dream research among a number of areas of "mass-observation," data

collection, and interpretation in the pursuit of collectively-shared images. Although throughout the war, Tom Harrisson, the prime mover of the M-O dream project,[8] encouraged his correspondents with promises of valuable comparative results from the collection efforts, he seems to have realized fairly early that the submitted dreams were not really backing up the theories motivating the collection. By the last major document of the project, the "Report on Dreams" prepared in March 1949, the note of abortiveness is palpable. This project, at least nominally maintained for a full decade, did not in the end pan out.

For the scholar engaged in research using the Mass-Observation papers (or analogous collections of documents), the relative failure of the dream project poses some key methodological questions about the significance of dreams as social, cultural, and historical evidence. First there are issues related to the project itself. The documentation is rather scant at the directorial end. There are a few directives, a few hesitant attempts to evaluate the evidence, and little in the way of theoretical or interpretative reflection related to the project. One has to assemble scattered statements in the early M-O writings and ponder the practical shape of the documentary evidence itself to be able to come to a clearer sense of what Harrisson and company were up to with the dream project.

But an even more sticky set of problems relates to the material side of the project as it was realized. The number and intermittence of the dream directives only allow a few of the observers, those especially eager and therefore perhaps unrepresentative dream reporters, to emerge as particular personalities among the mass of scattered dreams sent in by other reporters. Yet the relatively small number of reporters and hence the relatively small sample of dreams does not amount to data for significant statistical analysis. A point of comparison will help bring in focus the betwixt-and-between character of the M-O dream evidence. In September 1940, the directive sent to the observers included questions about dreams among other questions about the air war and its role in bringing about changes in daily habits, mental attitude, reading, and radio listening. Tom Harrisson's report written on the basis of the responses, dated 14 November 1940, quantifies the results. He notes that 123 men and 77 women answered the questions. Of these, only 102 men and 58 women provided any reference to dreaming. The large majority (83% of men, 70% of women) reported no change in their dreams, and a look at the responses themselves will show that in most cases these respondents gave no more information than to note this fact. Only 16% of men and 30% of women reported dreams in which there were references to the war, one of the topics that Harrisson was particularly seeking to find reflected in dream-

life. Roughly estimating, this means that only about 20 women and 20
men reported war dreams.[9] By comparison, an American study of dreams
carried out in the late 1940s and early 1950s collected over 10,000 dreams
for statistical analysis. A single subgrouping, 18-28 year olds, provided a
sample of 1,819 dreams to the investigator.[10] This comparison is not meant
to ridicule the M-O efforts, but it does highlight the relative backwardness
of quantitative method and the very limited resources available to
Harrisson to conduct this kind of study of dreams.

 Aside from these methodological weaknesses in the way the project
was conducted, there are serious issues related to the intrinsic character of
the dream reports as historical evidence. Evidence of what, socially
significant patterns or idiosyncratically personal preoccupations?—a
skeptic might justifiably ask. Many of the dreams reported, clearly, have a
purely private significance, the background of which can no longer be
reconstructed, even were it of interest to do so. And even if the dreams
collected by Mass-Observation may be in some more "collective" way
significant—for example, as a window on an intimately experienced, but
widely shared emotional life—serious problems persist in assessing and
interpreting such documents. The partialness of the sample, the
unsystematic nature of the collection effort, the absence (in most cases) of
the dreamer's associations with the dream images, the possible influence
of the survey itself on what was dreamed or recorded, and the "irrational"
figural form of the dreams themselves would together appear to render
them intractable to the historian's methods.

 As a biographical aside, I will note that my own interest in the Mass-
Observation dream reports involved the frustration of my own theories
about their historical significance. I initially approached them with the
hope of shedding light on the putative "surrealist" influence on Mass-
Observation's formation. Beyond reconfirming the obvious loose ties with
the aesthetic and psychological interests of the founding directors,
however, the dream project does not really confirm a subterranean
surrealism in Mass-Observation. There is very little in the way of
elaborated interpretation or engaging textual montage of dream materials
on the part of Mass-Observation. On the contrary, despite the weaknesses
of their methods, the M-O directors collected dreams in the genuine hope
of using them as sociological data, for the diagnosis and solution of social
problems. Now, as a reader in the archive, one is struck above all by the
sheer facticity of the dream reports rather than the imaginative, aesthetic
interest of their imagery: the enigmatic presence that preservation itself
has lent these sometimes boring, sometimes fascinating little narratives
dutifully written down and sent in by people from all over Great Britain.

Flying in the face of my own suspicions of futility—for what was I really going to do with all those penciled notes and photocopies of dreams dreamed six decades ago?—over three or four successive visits from the United States to the University of Sussex, I worked my way slowly through the archived papers.

Two things continued to hold my attention, and it is these, I would argue, that offer me a thread towards a possible reinterpretation of the dream project that does not merely dismiss its documents as residues of M-O's "ethnographic surrealist" phase, abandoned along the way to a more sound scientific orientation.[11] First, if I may stretch a Freudian distinction beyond any legitimate psychoanalytic construal, I became fascinated by the "form" of the dreams, their *Darstellungsform* qua archival collection, as much as any theme or manifest content that might be represented in any one of them. The mode of the reports and their accumulation seemed to reduce to a common two-dimensional plane the most hilariously silly and terrifyingly vivid dreams, and even within single dreams, to place in a single perspective both thudding banalities and fantastical details. At times, the form of the report itself took on the quality of an oneiric artifact, complete with illegible passages, incongruous interpolations and revelations, and complex layerings. Perhaps my favorite example is in the report of a zealous young male observer, in his waking life a newspaper reporter. His reports reveal a method shaped by his occupation. He regularly abbreviates articles, conjunctions, prepositions, and other function-words with letters or symbols. Moreover, he evidently took abbreviated notes of the dream at the moment of waking, which he often quotes into his report, then explains what he "must have been dreaming." Sometimes, however, the waking notes are obscure to the observer himself. In one instance, he inscribes an unreadable scrawl into his report, imitating what he wrote to himself, noting "The remaining note I can't read, so soon after waking must I have written it. It looks like [scrawl] if that helps you." This obscurity seems to have genuinely weighed on this young man, however, for in a later report, the "repressed" returns, this time in a much weirder form. He writes to Tom Harrisson that there was a note that he hastily jotted down "in a befuddled state" and asks the M-O director to "have a go at it." A triangular piece of paper is stuck to the page, a fragment of the real waking note with the scrawl earlier imitated. And then an appended note (I am unpacking the shorthand): "Not being at the office with a pastepot handy, I'm afraid I've had to stick it to this page with a bit of chewing gum." I could not believe my eyes when I first read this on microfilm; so as the final act of this perverse drama of unintelligibility, I asked to see the original paper, confirming whether he

had indeed stuck the scrap of dream-debris to the page with chewing gum! (He had.)

If the material form of dream reports constituted one pole of fascination for me, the unexpected ways in which the dream reporters fulfilled or failed to fulfill their assignments also gripped me. In some cases, as in the newspaper reporter with his illegible note, or a woman who sent in not only copious dreams but also reports of images she saw in her fireplace, or the correspondents who zealously collected additional dreams from family and friends,[12] the dream-directives of Mass-Observation occasioned an excessive attachment to the project that itself seems socially meaningful. One is led to ask: what sort of desire underlies this kind of hyperfulfillment of the assignment to observe and report on oneself? What sort of pleasure is at stake for the participant? Is there any broader social significance to this "socialization" of intimacy made possible by social science research itself? The "biopolitical" significance of statistical study has been made abundantly clear by the work of Michel Foucault, Ian Hacking, Paul Rabinow, and other recent historians of the sciences. What I am suggesting, however, is that the dream project may provide access to, as it were, the *affective* and *phantasy* life of biopower. In other words, if biopolitical theory has primarily asked how the classification, quantification, and processing of data about life and death has led to new structures of knowledge/power, what Foucault would come to call "govermentality," I am asking what affects might be occasioned in individuals living within the emerging biopolitical order. Precisely because of its amateurish, ineffective organization, the M-O dream project has registered, rather than methodically extirpated this unauthorized dimension of its intended study (a dimension unavailable, for instance, in the American dream study mentioned earlier).

In other cases, the observer fails to fulfill the directive, or s/he otherwise registers irony about or outright resistance to the task of reporting dreams. In many cases, however, reading their apologies and complaints is more revealing than their dreams themselves would have been, for it is often in making excuses for not reporting or not dreaming "in the right way" that observers were most unguarded about their daily life, sexual attitudes, family relations, beliefs, and personalities. Some of the responses, for example, are dutifully regretful at not having satisfied the assignment of reporting particular kinds of dreams:

> I feel I've missed your point—I am not getting at the sort of public images you want. (Male correspondent, 1937)

Unsatisfactory—I'm sorry. I don't think I could make my images intelligible to anybody else. (Female correspondent, 1937)

For one female respondent, the failure to fulfill the task of reporting to Mass-Observation becomes the self-reflexive content of the dream itself:

There was a further chaotic dream in which the National Registration form and MASS OBSERVATION MSS. were involved. I had apparently given too much or too little information in one or both, anyhow trouble was brewing for me with "the authorities." (Female correspondent, 1939)

Another respondent prefaces her report with an epigraph and ironic heading, revealing her sense of silliness about reporting her dreams:

"If there were dreams to sell
What would you buy."
Dreams I wouldn't buy. (Female correspondent, 1939)

Others reveal trepidation about the dreams that they are reporting, suspecting that a clever dream interpreter might be able to read in senses that would be embarrassing:

This dream is completely daft, and contains no sense. But I tremble to think what terrible Freudian complex it may show. (Unidentified correspondent, probably 1940)

In contrast, a young female medical student appears to welcome the chance to hint at the racy action going on in her bed, at least in her dreams:

My dreams have changed enormously. Previously, if I dreamt at all, it was quite innocuous, but since the war began my dreams have become so erotic that it horrifies me sometimes. I dream so much more often than usual and oh boy, do I dream! (Female correspondent, 1940)

A similar tone of winking jocularity is struck by a young male respondent:

Strictly dirty, with B____, reads my note. Freudfulness has nothing to do with horrors of war. (Male correspondent, 1939)

Freud is also the occasion of a female correspondents temporary suspension of her reporting:

Dear Mr. Harrisson,
I have neglected to keep a record of further dreams because, it seemed to
me, that I am becoming as abnormal as some of Freud's patients and that
therefore my dreams were not really typical of the times.
(Female correspondent, 1939)

This same correspondent, having received an encouraging word from
Harrisson, however, writes back eight days later:

Dear Mr. Harrisson,
Your flattery or my natural inclination towards mild exhibitionism urges
me to continue the dream-diary. (Female correspondent, 1939)

A young male correspondent to the 1939 directive remarks with amusing
irony on the culture of dreams among his family and friends:

I've had to listen to recitals of dreams and dissertations upon their
meanings both at home, and, a few times, at work. There is nothing so
utterly boring as the recital of someone else's dream, punctuated by
incoherent explanations and bursts of incomprehensible laughter. But my
own occasionally remembered dreams are very interesting, or so I think,
and so occasionally I inflict them on the rest of the family. (Male
correspondent, 1939)

Still others reveal irritation with the project, suggesting its tautological
influence over the psychic life they are supposed to be observing and
reporting:

I think it's pretty hopeless collecting dreams. Just what do you expect? . . .
. On receiving your letter, I promptly dreamed you a war dream the next
night. + look at it. Hopeless cooked. I bet I never dreamed that. Censor
sitting waiting and all gone literary long before it got to me. (Male
correspondent, 1941)

In a response that reports an absence of war-dreams (a predominant
concern of the M-O dream project during the war), an unidentified
correspondent reveals both the memorial texture of his (or her) dream-life
and the uncanny affect connected to it:

I have had hardly any war-dreams, not even when I have lain awake
shivering lest a Jerry should drop a bomb on the roof. . . . I often see my
father (who died in 1899); also my brothers, one of whom vanished in
1914, and the other died in 1937. He is the only *recent* inmate of my

dreams. I think he must be trying to communicate with me. (Unidentified correspondent, 1942)

Finally, as the last example in this by no means exhaustive sample, the response may become the occasion for a revelation that is unrelated to the dream reported but appears even more pressing for the reporter. Appended to a dream dated 29 September 1939 (hence, in the first weeks after the declaration of war with Germany) is the following "Note":

> From the point of view of research as suggested by T[om] H[arrison]'s letter it is only fair to state that my personal life has been hurricaned in the last month, not by the war particularly, but by having to decide *not* to "live in sin" after trying it for a few days. The decision was forced by personal fastidiousness and a longing for my Mother, both unexpected factors. (Female correspondent, 1939)

Responses to the M-O directives, in short, become the vehicle for communicating a wide range of attitudes, emotions, and personal information. Far from being mere *faux frais* of the "real" dream archive, they should stand on an equal plane as the dreams themselves for the historical interpreter. In *not* properly fulfilling the task of supplying reliable information into the hidden realms of their psychic life for the social-psychological analysis, they leave traces of another sort: indices of an on-going negotiation between individuals and governmental institutions, in which psychic, epistemic, and political spaces are being interlaced in new configurations.

III

> "1 Sept 1939: Woke from nightmare to realise that at least it hadn't happened yet: so until after breakfast.
> 29 Sept 1939: The nightmare quality grows; one thinks one will wake up.
> 23 May 1940: Nightmares. Almost inevitable."
> —Naomi Mitchison, from her wartime diary[13]

I have up to now emphasized the methodological and interpretative problems that may have contributed to the relative failure of the dream project to identify "dominant images" with a social generality and efficacy. I have also suggested that the greatest interest in the project's documentary leavings may be as evidence of something intended neither by the M-O directors nor by their respondents: the affective experience of biopolitical govermentality, in which social and psychological scientists play a crucial role as the interface between individuals and institutions.

The emotional bond created between the observers and the investigation and negotiated in concrete ways by a variety of agents is, I am arguing, readable in the uneven surface of the dream project. I do not, however, mean to imply that within their intended framework that the dream materials are without meaning or value. As statistical material, they probably are unusable; but at the more intimate level of individuals, as "anecdotes" occupying the shifting borderline between the personal and the historical, there is much of interest in the dream reports.

Part of their interest is negative: they provide an important index that Hitler's campaign of terror from the air did not succeed in radically disrupting the domestic life of the British dreaming psyche, the largely private inner life that we might expect to find in a modern, liberal, individualist society. In his book *Living through the Blitz*, Tom Harrisson notes that despite predictions based on psychoanalytic and psychiatric theory, the air raids of 1940 did not really occasion major increases in traumatic psychic states among the populace. Indeed, if anything, the statistics show a decreased incidence of nervous episodes, if the reports of medical professionals reliably reflect the state of affairs at the time:

> Dr. (now Professor) P.E. Vernon recorded under 1.5% out of more than a thousand London shelter hospital patients with any sign of nervous trouble. At a specialist London hospital up to 2.5% of the intake suffered from a malady which could be in some way related psychologically to air-raids. Overall, however, nervous admissions dropped with the end of peaceful nights and then went down further in 1941—as did female suicides during the blitz years.[14]

The dream research of this period supports this picture. In the September 1940 survey already quoted above, the overwhelming majority of respondents reported no change in their dreams since the air-war began, and only a small number of people reported vivid war dreams or significant increases in the number of dreams recalled. Many responses, by both male and female observers, sound a similar note of relative indifference:

Male respondents:

> Frequency of dreams about war, air raids, etc. is not noticeably increased. If anything, I'd say it was less.

> I expected to have a nightmare the night after the lethal raid, not having previously seen corpses, but I slept like a log, probably because I was tired out.

I don't think I dream differently, but my father tells me that for the first time in my life I talk and even succeed in whistling in my sleep.

Female correspondents:

I have fewer "next war" dreams now than I had a year ago. I know of at least one other woman of whom this is true. Actuality destroys fantasy.

I usually dream quite a lot but since the war, I've been ambulance driving each night and therefore have had to make up sleep at odd times such as lunch hour etc. which doesn't seem to induce dreaming.

I get into bed feeling "Oh well thank goodness I can't fuss any more about this until the morning" and sleep without dreaming. I crossed the Channel during the first night of this war, and knew that if I stayed up I should worry about the possibility of torpedoes and raids, so I went below and slept until we landed.

Had Harrisson's respondents reported war dreams in large number and in preponderance over other dreams, we might be able to take this evidence of Hitler's effectiveness in using the blitz as a "propaganda of the deed." But as it happened, the inner psyche may have played its most effective historical role by maintaining its interior distance from the history that was happening all around. Dreams resisted being addressed politically, and the dreaming psyche's relative unresponsiveness to terror may have allowed the British people to maintain the fabric of everyday life—a blessing to the war effort, if a frustration to the dream researchers.

While it is important to emphasize this "negative" background, dreams in which the terror and fear of the historical circumstances find entry into the intimate psychic world are nonetheless far from absent in the M-O reports. Indeed, one might say that this minority of dreamers gives an important index of what the majority managed to ward off and allows us to imagine what a more psychically effective terror might occasion in a populace. In some cases, the internalization of war terror in bad dreams could injure people from within by robbing their ability to refresh themselves through sleep:[15]

In order to get a little peaceful sleep last night had to take sleeping tablets—just a stupor—no dreams. (Female correspondent, 1939)

The bad dreams during the infrequent sleeps—mostly so lousy that they've been censored even in sleep. Begin to dread sleeping, as well as need it. (Unidentified correspondent, 1940)

I used to look forward to my dreams, often continuing them from night to night and pondering them during the day: but I am beginning to dread them and put off going to sleep: which will be useless, really. (Female correspondent, 1940)

War dreams and especially war nightmares, taken as a special subset, do seem to exhibit something of the "dominant images" of the immediate prewar period and the first years of the war. In my archival research, I found myself copying out a number of dreams that could be grouped around common *topoi*, even if the tone and specific narrative articulation of the dreams varied widely. These *topoi* included air raid dreams, invasion dreams, spy ring dreams, dreams in which the dreamer kills or is killed, and dreams in which Hitler appears. Rather than illustrate these various *topoi* separately, I have chosen to provide a series of examples of one sort, the Hitler dreams, to exhibit the range of affect towards this arch-enemy experienced by British dreamers:[16]

He said he dreamt he was at our new library and art gallery which had just been opened. After the ceremony they were looking round the Art gallery, when Hitler marched in, and said in a loud voice, "This is mine." So we all had to clear out, he said. (Man of about 26, recounted by male correspondent, 1939)

I dreamt I saw Herr Hitler standing (at attention) in a Court of Law (the court was quite empty but for him) he was delivering a *silent* speech (speaking without voicing) (do you understand?) perfect silence. He was dressed, square cut, half-way coat and convict's hat. (Female correspondent, 1939)

I was arguing with Hitler, but I don't know what about. (Female correspondent, 1939)

Dreamed of trying to tidy up a room, floor littered by sheets of paper, chiefly brown wrapping paper because I felt Hitler was possibly coming. I awoke before he appeared. (Female correspondent, 1939)

I dreamt that Hitler was going to be hung, and that I was in charge of the proceedings. There was a carriage and a troop of soldiers waiting for me but I was worried as to whether I should wear a lounge suit or evening dress. I asked someone who said, "Evening dress certainly." (Man of 60, recounted by female correspondent, 1939)

Had argument with Hitler in German (I can speak it quite well, but not altogether so fluidly as I did in the dream), ending with a long harangue on

my part as to the rights and wrongs of the present war. He was fairly humble, but obviously unconvinced. (Male correspondent, 1939)

I dreamt that Hitler was kissing me. I had a feeling of disgust as I saw his beady eyes and his small mustache coming towards me, but my disgust didn't last. Later in the dream I thought he was making a fuss of my son who seemed like a little boy again of ten years old. He began to cry and I remembered that I had heard that Hitler had a reputation for liking boys, and I was going to kill him. I then saw him as one of a crowd in a big railway station.—I was grateful to find that it said in a dream book that all would be well if you dreamt an enemy was kissing you. (Female correspondent, 1939)

I saw that a German threw something on to the path by me and I knew as though I were reading it in a paper that this was a scorpion and that they were throwing scorpions among us. I seemed to be pretty annoyed at this and dashed back up the path again towards them and shouted at Hitler who was standing on the path "You swine!" He was quite insulted at this and shouted back "I'll have you reported for that," and began to advance, getting out a revolver. I had no ammunition myself and hurried back again. (Male correspondent, 1939)

I find myself in a desert followed by Hitler and a dog, and go to an earlier school. Here I capture Hitler, and he is arrested by R.A.F. men, and taken to the hall of this school, where the headmaster enters. By this time the Fuehrer has changed into a dish of steak and bacon, in which form he is given to the headmaster, whereat I awake. (Male correspondent, 1939)

I dreamt a man got into the house and it was "Hitler." (Boy of 11, recounted by female correspondent, 1940)

A night or so ago I dreamed, in perfectly real and serious terms, of overhearing the conversation at the Brenner between Hitler and Mussolini. The tenor of the conversation between the two Dictators was, in my dream, alarmed and defeatist. On waking and thinking this over, I suddenly remembered hearing, whilst fully intent on something else, a "rag" version of this interview in "Cockledoodle-doo!" on the wireless. Here there were also two guards, but the words of the guards and the Dictators, in the sketch, were completely absurd. In the dream, there was a terrible brooding sense of fatefulness about the whole scene. (Male correspondent, 1940)

I have just dreamt of Hitler looking aged, with grey hair, humpbacked and round shoulders, dressed in British khaki, and looking cowed and ashamed. (Female correspondent, 1940)

I seemed to be interviewing Hitler. There were some books of which he asked for some, designating one or two. I refused to hand over the books asked for but gave instead, "Christ and the New Age." (Male correspondent, 1942)

The other night I had a dream in which Hitler came here to tea. He spoke, as far as I remember, English. I wondered if he would understand what I meant if I asked for an autograph. (Male correspondent, 1942)

A final example, fascinating for its length, imagistic vividness, and gamut of tones, was submitted in April 1941 by a female correspondent. I will quote it in full as an epitome of the psychic struggle that could be provoked by the enemy's penetration deep into the home front, behind the line of dreams:

I dreamed I went to bed as usual and woke up with a cold resolve—like when the boys were small and tried my patience until I gave way and resulted in a good slapping. I felt THIS HAS GOT TO *STOP* and I got up and dressed myself and also Clifford who was a small sleepy little boy. He said, "Where are we going?"—and I said, "I'll go and see Hitler myself!" We seemingly "flew through the air with the greatest of ease!"—for next thing we were before a big iron door which had a little opening "grill." I was so interested in it for I'd not seen one like it before. And I must have rung or knocked and a tall fair man came out dressed in a black uniform. I heard my voice say curtly, Mrs. L__ to see Mr. Hitler—at ONCE please! He bowed and escorted me into a room where a man was writing at a desk and went out and closed the door. The man looked up and said "Ah Mrs. L___, so glad you got here before sundown and we can have a look around." We went out—it was Hitler himself—and strolled along a road which suddenly started to "slope" steeply and soon we were going up a mountain road. In the far distance were high snow clad mountains but the slopes near at hand were wooded. I walked on the left of Hitler and on my left the sheer drop of the mountain fell and the sound of running splashing water came from the depths. Cliff ran busily on in front—so interested— and Hitler said "you are not afraid then he will fall?" I said "Oh yes, but I've told him to have a care and he must learn to stand alone and choose for himself—I cannot always guard him." The air was sweet and lovely and then I heard singing and round the bend came a group of young men with curiously bulging thighs. I felt so concerned but Hitler said "oh it's with them always walking on a slope and their muscles swell." They were carrying huge branches of lovely berried holly—the brightest and largest berries I had ever seen and I cried how lovely—"do let me have a little piece—I would like to try and 'strike' it in my garden." Hitler said—"I'll send you some with blood red berries for Xmas. I'll not forget." I said "I'd love a little tree too if the woodmen can spare it." And I knew by his frown

I had spoken unwisely somehow. He said "They are MY trees. ALL AND EVERYTHING is MINE" and I felt sorry I had asked for one. The next thing we got to a highly place house where there was quite a crowd of people—all men. Up to now a curious feeling of static well being had wrapped me but now I held Cliff's hand tightly and said "stay close by me darling." His bright eyes twinkled up at me and his wide mouth opened in a flashing smile and he said "only for a little while Dearie." I felt wildly frightened and suddenly I felt danger all around and knew it came from Hitler. I stood so alone with my loved little boy and then I saw a way out and still holding his little hot hand I sauntered carelessly to the open window hearing a queer noise behind of hurry and banging like bombs in the distance. Standing on the edge of the open window—such lovely wide "french windows" that was a living picture of mountain scenery—I stepped calmly and fearlessly out with the feeling I'd chosen my own way. I fell or rather floated downward on gracefully on a parachutist but I lost my little boy and woke with a start *and feeling* of desolation. That was all. (Female correspondent, 1941)

IV

"The history of dreams remains to be written, and offering insight into it means to break through historical elucidation the superstitious bias towards nature. Dreams participate in history. Beyond the charms of the anecdotal landscape, dream statistics would advance into the wasteland of the battlefield."
—Walter Benjamin, "Dream Kitsch"[17]

"I have never had a dream 'come true.'"
—Female M-O Correspondent, 1939

The history of dreams, seventy years after Walter Benjamin's resonant call for their incorporation into historical writing, remains to be written after all. I will conclude with a brief discussion of two contemporary historians who have taken up the challenge of dreams, offering methodological reflections on how they might be used in historical writing.

In an essay published in *Annales* in 1973, Peter Burke advanced the argument that "dreams have a history" and that it should be possible "to write a social history of dreams."[18] Burke argues that the dream can provide social data at two distinct levels. First, in a thesis akin to that of Mass-Observation's notion of the "dominant image," Burke suggests that attention to the manifest contents of dreams in a particular epoch can help reveal the changes in the "psychologically efficacious or pertinent" images and myths of the society. Second, he argues that dreams represent a form

of indirect communication of that which is forbidden or repressed in a society, and hence can serve as testimony to forces and factors that might otherwise remain hidden in more official forms of discourse and documentation. On the basis of a comparison of dreams recorded by clergymen in the seventeenth century and the American study of dreams from the 1950s that I cited earlier, Burke also seeks to suggest that different epochs may exhibit different degrees of unity and transindividual coding of dream contents. The specific documentary basis for Burke's comparison seems to me dubious. The fact that a professional caste like the seventeenth-century clergy would have a certain shared dream-imagery does not let us conclude that this dream-imagery is characteristic of the period; we do not know whether a corpus of dreams from twentieth-century Episcopalian priests would not show a similar cohesiveness of imagery. Nevertheless, the underlying theoretical point seems to me potentially valid. If modernity entails the historical emergence of an unprecedented social mobility, instability of class and caste codes, new forms of intimacy, increasingly nuclear family structures, and so on, then it would be surprising if this development of the modern subject did not leave some traces in the dream-process. For instance, might we not expect a greater privatization and atomistic diversity of dream-content in a modern democracy than in an authoritarian, socially rigid, patriarchal segmentary society? Moreover, if this turned out, upon further study, *not* to be the case for dream life, this in itself would be a significant fact about the historical layering of subjectivity.

I have already made a somewhat covert allusion to Burke's argument in my suggestion that the M-O dream project, in its failure to identify clear-cut "dominant images," may be offering important historical testimony to the psychic differentiation entailed and fostered by modern liberal societies. An interesting contrast may be offered by Charlotte Beradt's celebrated study of dream life in the first years of the Nazi dictatorship, based on dream reports from 1933 to 1939, *The Third Reich of Dreams*.[19] Beradt sees the text she assembles as parodic distortions of reality which, paradoxically, exhibit a peculiar realism in representing the real distortions that Nazism itself imposed on everyday day. "Set against a background of disintegrating values and an environment whose very fabric was becoming warped," she writes—

> these dreams are permeated by a reality whose quality is unreal—a
> combination of thought and conjecture in which rational details are brought
> into fantastic juxtapositions and thereby made more rather than less
> coherent; where ambiguities appear in a context that nonetheless remains

explicable, and latent as well as unknown and menacing forces are all made a part of everyday life.[20]

Beradt's book was the occasion of a far-reaching meditation on historiography by the German historian of political and historical thought Reinhart Koselleck, in his essay "Terror and Dream: Methodological Remarks on the Experience of Time during the Third Reich."[21] Koselleck's reflections take off from an "eighteenth-century experiential shift, in which history was formulated in terms of a new reflexive concept" that made "the line dividing the camps of historians and creative writers. . . osmostically porous."[22] This shift is the "discovery" of the placement of the historian *within* "historical time," now conceived as a kind of flowing medium in which the events that constitute the basis of any historical writing have and will continue to occur. This new conception of historical time entails, however, that the historian in time necessarily writes from a perspectival point that requires him to "compose" history and not merely set it down:

> It was this knowledge of historical perspective which forced historians to become aware of the devices of fiction . . . if they wished to pass on meaningful histories. The historian was confronted with the demand, both in terms of techniques of representation and epistemologically, that he offer not a past reality, but the fiction of its facticity.[23]

Koselleck goes on to argue that given this distinctively "modern" framework for thinking and writing historically, dreams not only cannot be legitimately ruled out as historical sources, but they even, in their problematic status, reveal essential features of the notion of historical evidence. "Dreams do occupy a place at the extremity of a conceivable scale of susceptibility to historical rationalization," he writes. "Considered rigorously, however, dreams testify to an irresistible facticity of the fictive."[24] In other words, Koselleck's argument about dreams as sources is analogous to what I asserted about dreams as "images" in Mass-Observation: not only are they one among many forms of modern historical sources, but they lay bare the very logic of sources as the elements of those factical fictions called "histories."

Koselleck goes on to discuss Beradt's collection of dreams of terror during the early Nazi period, comparing them to other dreams recorded by concentration camp inmates. His conclusions offer a striking contrast to the picture I have sketched out of the M-O dream project. The terror dreams collected by Beradt, Koselleck argues, have an essentially political function; they are, as it were, the political shock troops carrying Nazi

power into the psychic realm of individuals. The dreams of embarrassment, fear, shame, betrayal, self-exposure, and cravenness that are documented in *The Third Reich of Dreams* are not merely narratives in which terror is represented. They are the affective vehicles of terror itself. "They are physical manifestations of terror but without the witnesses having fallen victim to physical violence. In other words, it is precisely as fiction that they are elements of historical reality," Koselleck writes. "Even as apparitions, the dreams are instrumentalisations of terror itself."[25] Concentration camp dreams, in contrast, are radically different. If terror dreams are all too comprehensible in their immediate reference to historical circumstances, concentration camp dreams lose the index of reality almost completely. Koselleck notes that the most utopian camp dreams, which projected a lost past into a hoped-for future, most commonly portended death. In the unreal, yet brutally factical world of the camp, hope for survival lay in a kind of depersonalization, an acceptance of a post-temporal existence in which a few were able to endure the unendurable and survive. Koselleck sees this dissociation of the self as a final form of resistance, in which the inmate saves a margin of himself by no longer offering a self to the operations of power. Yet this also makes concentration camp dreams, in his view, essentially illegible in historical terms. They exist in a realm ontologically outside of the temporal, social, and political dimensions that give definite shape to the "historical":

> The inferential path from individual salvational dreams to general behavior specific to one social stratum is blocked, for they contain no signals of reality that are politically or socially legible. If you like, the whole point of such dreams is to be apolitical. One could even go so far as to see in them covert enactments of a disposition to resistance. But even this anthropological finding can no longer be socially generalized.[26]

Koselleck's provocative essay allows me to venture one final remark about the constraints on the use of dreams as historical evidence: their "availability" for historical writing may be itself socially, politically, and historically circumscribed, which in turn allows them to be used self-reflexively, as indices to these conditioning factors. The dreams reported by the M-O observers proved, in many cases, deficient in their social referentiality, their systematic "mass" registration of historical circumstances. I suggested that this might, indeed, evidence the strong underlying continuity of domestic privacy, individualism, and liberalism, even in the midst of air-raids and wartime hardships. So too, for opposed reasons, the concentration camp dreams that Koselleck discusses are deficient in referentiality—not because the individual, inner self remains

too strong in the face of historical circumstances, but because it disappears to an almost indiscernible point of posthumous survival. It is the range in between these antipodes, perhaps not so wide after all, that offers the historian the greatest promise for her pursuits of generalizable meanings.

Notes

[1] Originally appeared as "In the Blitz of Dreams: Mass-Observation's Dream Research and the Historical Uses of Dream Reports," in "Mass-Observation as Poetics and Science," special issue of *New Formations* 44 (2001): 34-51.

[2] Humphrey Jennings, *Pandaemonium: The Coming of the Machine as Seen by Contemporary Observers, 1660-1886*, ed. Mary-Lou Jennings and Charles Madge (New York: Free Press, 1985) xxxviii.

[3] Cornelius Castoriadis, "The Imaginary: Creation in the Social-Historical Domain," in Castoriadis, *World in Fragments: Writings on Politics, Society, Psychoanalysis, and the Imagination*, ed. and trans. David Ames Curtis (Palo Alto: Stanford University Press, 1997) 11.

[4] Charles Madge and Tom Harrisson, *Mass-Observation* (London: Frederick Muller, 1937) 38.

[5] Charles Madge, "A Note on Images," in *Humphrey Jennings: Film-Maker, Painter, Poet*, ed. Mary-Lou Jennings (London: British Film Institute, 1982) 47.

[6] Charles Madge, "Editorial Tasks and Methods," in Jennings, *Pandaemonium* xviii.

[7] Mass-Observation File Report 3096 (March 1949), Mass-Observation Archive, University of Sussex.

[8] Harrisson personally corresponded with the dream reporters, gently chiding them when they were lax about sending in reports and offering encouraging words about the usefulness of their efforts. By the outbreak of the war, he seems to have taken exclusive charge of this project, even advising in a letter to the Mass-Observers dated 21 September 1939, "for this dream material, though not for anything else, please send in to me personally at the above W.II address."—M-O Directive Replies 1939 (microfilm), Roll 8, July-Sept 1939 (Dreams), in M-O Archive, University of Sussex.

[9] Mass-Observation File Report 492 (14 Nov 1940), M-O Archive, University of Sussex.

[10] Calvin S. Hall, "What People Dream About," *Scientific American* 184/5 (May 1951): 60-63.

[11] For the concept of "ethnographic surrealism" with reference to the development of French anthropology in the 1930s and 40s, see James Clifford, "On Ethnographic Surrealism," in *The Predicament of Culture: Twentieth-Century Ethnography, Literature, and Art* (Cambridge, Massachusetts: Harvard University Press, 1988) 117-151.

[12] For example, the cafe proprietress who reports: "Feeling I was rather letting you down, I rushed round my friends trying to rake up some nice dreams or nightmares

for you, and was rather surprised to find that their dream world was much the same as my own. Even a most deadly bore who used to have whole novels to relate about her dreams complains that her dreams have lost form and shape." (Female correspondent, 1939)

13 Naomi Mitchison, *Among You Taking Notes: The Wartime Diary of Naomi Mitchison 1939-1945*, ed. Dorothy Sheridan (London: Phoenix Press, 1985) 32, 43, 59.

14 Tom Harrisson, *Living through the Blitz* (London: Collins, 1976) 308-309.

15 This exacerbated sleep-loss can be seen as a genuine extension of war by other means. In a poll conducted in early October 1940 in London about how much sleep people had had the night before, 31% reported that they had had none, 32% less than 4 hours, 22% 4-6 hours, and only 15% more than 6 hours. Cited in Leonard Mosley, *London Under Fire, 1939-1945* (London: Pan Books, 1971) 202.

16 In *Living Through the Blitz*, Harrisson singles out this type of dream, which in his view exhibits "love-hate ambivalence (the affectionate enemy)" towards the Germans. Yet dreams in which Hitler or other Nazis appear as benign or reasonable stand alongside dreams in which Hitler is terrifying; Harrisson cites the former selectively to support the thesis of ambivalence.

17 Walter Benjamin, „Traumkitsch," *Gesammelte Schriften* 2/2, ed. Rolf Tiedemann and Hermann Schweppenhauser (Frankfurt a/M: Suhrkamp Verlag, 1977) 620; translation mine. For further discussion of Benjamin's dream historiography see Susan Buck-Morss, *The Dialectics of Seeing: Walter Benjamin and the Arcades Project* (Cambridge, Massachusetts: The MIT Press, 1989), esp. 253-286; and in this volume, "From City-Dreams to the Dreaming Collective: Walter Benjamin's Political Dream Interpretation."

18 Peter Burke, "L'histoire sociale des rêves," *Annales: Économies, Sociétés, Civilisations* 28/2 (1973): 329.

19 Charlotte Beradt, *The Third Reich of Dreams* [German original, 1966], trans. Adriane Gottwald (Chicago: Quadrangle Books, 1968).

20 Beradt 17.

21 Reinhart Koselleck, "Terror and Dream: Methodological Remarks on the Experience of Time During the Third Reich," in *Futures Past: On the Semantics of Historical Time*, trans. Keith Tribe (Cambridge, Massachusetts: The MIT Press, 1985) 213-230.

22 Koselleck 214.

23 Koselleck 215.

24 Koselleck 218.

25 Koselleck 220.

26 Koselleck 224.

SECTION II:

TIME-IMAGES IN MODERNIST AND POSTMODERNIST LITERATURE

CHAPTER SIX

NO MAN'S LAND:
WYNDHAM LEWIS AND CULTURAL
REVOLUTION[1]

In *Culture, 1922: The Emergence of a Concept*, Mark Manganaro points to the coincidence of a number of intellectual and institutional events in Great Britain that helped mark that year as a "revolutionary" one in modern culture. The publication of *The Waste Land* and *Ulysses*, the appearance of two classics of a new cultural anthropology, Bronislaw Malinowski's *Argonauts of the Western Pacific* and A.R. Radcliffe-Brown's *The Andaman Islanders*, the death of the ethnographer W.H.R. Rivers, and T.S. Eliot's founding of *The Criterion*, are among the instances he notes. In both literature and anthropology, he suggests, a parallel "revolution" in the conception of culture was underway, which over the next decade-and-a-half would consolidate itself and pass from its charismatic to its routinized, disciplinary phase in academically respectable social science and institutionalized New Criticism. The concept of culture that these modernist innovators put in play, Manganaro argues, was both the pivot and the major stake of this revolution.[2]

In an analogous way, Virginia Nicholson, in her amusing and amply documented book *Among the Bohemians: Experiments in Living, 1900-1939*, charts out what she describes as a capillary revolution in domesticity due to the slow, tentative acceptance of new behavioral norms introduced by the bohemian milieu of the first few decades of the twentieth century. Behind the extravagances and excesses of the bohemian, she argues, was a serious ethical demand, that life be remade into something more fulfilling, more joyful, and more free. The new society that bohemia envisaged—and in part, prefigured—would be modeled on the creative image of the arts and the artist:

> The artistic community in England and elsewhere was embarked upon an imaginative attempt to dismantle society as they knew it, and remake it in a new image. In their daily lives as in their art, these people lived experimentally, in what amounted to a domestic revolution.[3]

For Nicholson's purpose, which is to explore the nature and social effects of this bohemian current, the quality of the art works ultimately produced by the bohemians, that motley crew of artists, would-be artists, failed artists, and fellow travelers, is secondary. Its primary importance, rather, resided in a work of *social* formation, of projecting and giving shape to new patterns of behaviour, new arrangements of life and its spaces, and new performances of pleasure and freedom. "We have a tendency to judge artists by the durability of their creations," Nicholson writes. "My approach is to judge them by the quality of their daily lives…. Often their idealistic experiments went disastrously wrong, and sometimes they felt cast adrift on the sea of new freedoms. And yet gradually, imperceptibly, they changed society. This book testifies to that quiet revolution."[4]

Lewis clearly is an active participant in this early twentieth-century "revolution" in culture, both in its intellectual and its bohemian manifestations, which we can think of as together encompassing a broad modernist front of the arts, literature, criticism, morals, lifestyles, and humanistic scholarly disciplines. Yet it is not this broad concept of a modernist revolution in culture that I want to take here as my focus, but a more specific notion of "cultural revolution" that emerged especially in the left-wing intellectual circles associated with the socialist revolutions in Russia, Hungary, and Germany at the end of the First World War and among the intellectuals who articulated a militant ideology in the early fascist movement in Italy. Both for its left-wing communist or anarcho-communistic version and for its fascist manifestation, in the notion of cultural revolution, culture is assigned an essential, active agency in the revolutionary transformation of collective and individual life. In turn, for cultural revolutionaries, culture also serves as the object of revolutionary change—through its own self-revolutionizing dynamic and agency, a new culture becomes the measure and medium of a revolutionized social life.

Culture in this sense does not correspond to either élite notions of culture as a heritage of the best that has been thought and said, nor to an anthropological one that sees in culture the whole nexus of meaningful practices and symbolic activity. Hence, too, if "cultural revolution" represents a particular modality of modernism in the conception of culture, its revolution is rather different than that evoked by either Manganaro or Nicholson. For the cultural revolutionist, of either left-wing or right-wing stripe, the conception of "culture" derives from a specific theoretical displacement occasioned by the crisis of Marxism that began after the turn of the century and culminated in the communist and fascist revolutions that followed the First World War.

This displacement can be summed as follows: revolutionary culture represents the superstructure made active through a new, unitary fusion of culture and politics. According to this vision of culture, the cultural-political superstructure is even more effective and subject to revolutionary acceleration than economic forces and thus provides the means by which the latter may be definitively liberated from their capitalistic constraints. Yet in order to take on this role, culture must overcome its association with civil society and become the very substance of dictatorial state power, abolishing the liberal division of culture into anarchic, competing, private, and partial spheres. Culture, to be effective, must become unitary, monumental, and totalizing. In a word, to quote a statement by the Hungarian painter Béla Uitz during the Hungarian Commune of 1919, "Dictatorship is needed in painting as much as it is needed in today's society.... The only art needed by the dictatorship of the proletariat is art with a social revolutionary worldview. Let the others step aside, for the duration of the dictatorship; even if they are well meaning and wish to help, they will only do harm to the dictatorship of the proletariat and to pure art as well."[5] This statement, and numerous ones that could be quoted alongside it, does not simply represent the age-old devil's pact of the artist and the tyrant, the placement of art in the service of power. Rather, it expresses a radically new vision of art as the co-substantial essence of dictatorial power. Art is consummated in its becoming the most concentrated expression of a unitary power that is itself no more than the generalized form of art's power to impose meaningful order on material chaos. This vision is most transparently represented by El Lissitzky's geometrical allegory *About Two Squares,* a children's book entitled *Of Two Squares*, in which red and black suprematist squares crash down on earth's ugly chaos, at once pulverizing the old order and imposing a new, spatialized architectural utopia on a planetary scale.[6]

Over the crucial years between about 1915 and 1925, which coincide with the most intensive period of cultural revolutionary thought in Central and Eastern Europe as well, Wyndham Lewis was the figure in Britain in closest proximity to a cultural revolutionary position. It is also, therefore, not accidental that when his position begins to change under the pressure of circumstances and intensive critical reflection in the early 1920s, Lewis, more than any of his contemporaries, also becomes an explicit, articulate *critic* of the conceptual framework of cultural revolution. Yet Lewis, as a critic of cultural revolution, continues to occupy the cultural revolutionary position negatively from within, exploring its parameters, limitations, and implications, and turning it into his own instrument of struggle against a liberal culture that he remained convinced was justifiably disappearing.

Lewis viewed certain actual cultural transformations—from feminism and post-war youth cult to the mediatizing of politics and popular culture—as outgrowths of liberalism, and these in turn he interpreted as precursors, training grounds, for a new society of post-individual subjects. Opposing the commanding logic of the arts to this liberalist, non-centralized, unconscious form of cultural revolution, he prises apart the unity of the political and artistic dimensions of cultural revolution, but in the name of preserving art's authentically revolutionary role. It is his conscious, articulate occupation of, as it were, a negative horizon of cultural revolution that defines one of the major points of difference between Lewis and others of his modernist contemporaries.

What Is Cultural Revolution?

At the outset of his controversial historical study *The Birth of Fascist Ideology*, Zeev Sternhall argues that fascism arose out of a cultural rebellion that redefined the terms of revolutionary politics and allowed it to compete with Marxism, at least in part, on a terrain once believed to belong only to the left. He argues that "fascism, before it became a political force, was a cultural phenomenon . . . and the Fascist seizure of power in Italy became possible only because of the conjunction of the accumulated influence of that cultural and intellectual revolution with the political, social, and psychological conditions that came into being at the end of the First World War."[7] Following from this first assumption, he derives a second: "In the development of fascism, its conceptual framework played a role of special importance. There can be no doubt that the crystallization of ideology preceded the buildup of political power and laid the groundwork for political action."[8] As he construes the specifics of the proto-fascist conceptual framework, the syndicalist vision of the moral role of conflict and violence, the valorizing of the nation as the basis of moral unity, and the mobilizing force of myth, combine to activate culture with a new, directly political force. Georges Sorel, whom Lewis, not wholly approvingly, but neither dismissively, characterized as "the key to all contemporary political thought,"[9] is also the linchpin in Sternhall's account of fascism's cultural revolutionary formation. Sorel, Sternhall argues, offered the conceptual basis by which Marxism's status as a science analyzing the operations of capitalist economy was transmuted into a motivational myth of class conflict, an instrument to define and sharpen the cultural and moral distinctness of the proletariat from a decadent bourgeoisie. From there, for the fascist movement, it was a short step to cutting this revisionary anti-bourgeois, anti-liberal ideology of

militant struggle free from its last ties to the working class, which was for them an unnecessary historical residue rather than an essential social basis. Cultural revolution was necessary to give shape to a new moral and spiritual type, the fascist new man, passionate, active, and physically powerful, rather than simply to provide support for practical gains in the parliamentary or contractual arenas.

The idea of cultural revolution, however, is even more often closely associated with avant-garde positions within early Soviet culture, whether among the representatives of futurist and constructivist tendencies, or among the advocates of "proletarian culture" or Proletcult. Critics such as Katarina Clark, Boris Groys, Richard Stites, Susan Buck-Morss, and Vladislav Todorov have explored the "mass utopias" that emerged in the Soviet Union when the avant-garde hitched its black and red squares to the horses of socialist revolution and—until the Stalinist night fell upon them—sledded wildly through uncharted fields.[10] Their visions of cultural revolution and the utopian orders to which they should give rise varied widely. But as Clark notes:

> Many of those Russians who in the 1910s and 1920s sought to realize a culture that might transform society were looking for a medium that was the purest and the most authentic: the purest movement, sound, language, or organization of space. It was felt that by finding (or recovering) this distilled essence of culture, society would be able to transcend the profane and regain its lost wholeness. Thus the prescriptions were for a kind of revolution—a radical transformation—whether or not they were conceived within the framework of political revolution.[11]

Once the framework of political revolution became a present fact, Boris Groys argues, this logic of viewing cultural transformation in revolutionary terms was heightened. The avant-garde consistently identified artistic acts with political decision, giving rise to a specific discourse within which their inter-artistic rivalries entered into the larger domain of the state and the struggles for power within it. As Groys writes:

> Because there are many artists and projects and only one can be realized, a choice must be made; this decision is in turn not merely artistic but political, since the entire organization of social life is dependent upon it. Consequently, in the early years of Soviet power the avant-garde not only aspired to the political realization of its artistic projects on the practical level, but also formulated a specific type of aesthetico-political discourse in which each decision bearing on the artistic construction of the work of art is interpreted as a political decision, and conversely, each political decision is interpreted according to its aesthetic consequences.[12]

We need a dictatorship, not only of politics but of painting, precisely because the actualization of a single worldview and the end of cultural division in the anarchy of competing spheres depends on the convergence of art and the state in a new, total aesthetico-political unity. This unity is the cultural revolutionary's utopian dream. For it is in the workshop of this fusion of power and artistic vision, he believes, that the new human type will be forged.

The example of the Bolsheviks and a particular analysis of what they had achieved in seizing the reins of power in backwards Russia had a potent effect among Western Marxists, and leftist avant-garde artists as well. It is on the surface not easy to understand why this would be so, beyond a general enthusiasm for the destruction of Tsarism and the practical example of socialist power the Bolsheviks offered. If Lenin was not without his utopian moments, he was in general a very practical, ruthless politician, muddling through from day to day in a crisis-ridden, war-torn society. And as his *Left-Wing Communism: An Infantile Disorder* showed, he had very little patience with the messianic fantasies of intellectuals and could be quite a wet blanket. Nevertheless, the Bolshevik revolution, to Marxist theorists as brilliant as Georg Lukács and Antonio Gramsci, seemed to have forced on the attention of socialists a new situation, and the logical conclusion they drew from it was to embrace the idea of cultural revolution.

Lenin and Trotsky, these young Marxists in the West saw, had achieved a proletarian revolution in Russia, where it had been judged, by the best canons of orthodox historical materialism, to be impossible. They boldly took the next step of the argument: if this is so, then it is because the hold of material conditions rooted in economic life, one of the pillars of classical Marxism and an item of belief for the whole socialist movement up to this point, cannot be as binding as previously thought, even by Marx and Engels themselves. At most, the founding fathers of socialism saw a culture of unified collective decision to be a possible *outcome* of overcoming capital, but certainly not its privileged precondition. For the cultural revolutionaries, in contrast, the historical constraint of the economy could be overcome by a new highly focused and closely organized cultural-political unity; this was represented in revolutionary Russia by Bolshevism itself.

It is on this basis that we find Antonio Gramsci, in an article of 24 December 1917, characterizing the Russian Revolution as a "revolution against Marx's *Capital*." This revolution was carried to completion primarily by the Bolsheviks' disciplined, militant culture of socialist propaganda:

> Socialist propaganda has put the Russian people in touch with the experiences of other proletariats. Socialist propaganda brings the whole history of the proletariat to life in one dramatic instant: its struggles against capitalism, the lengthy series of efforts it has had to make in order to free itself, in thought, from the chains of servility which made it so abject, and to become the new conscience of the world and a testimony today of a world yet to come. . . .The Russian people has passed through all these experiences in thought, even if only in the thought of a few. It has overtaken these experiences.[13]

This new culture, forged and brought into power by the iron will of Bolshevism, activated and diffused by new institutions of socialist publicity, is the future now, the means of traversing history at the speed of thought and freeing oneself from its material constraints. Cultural power is both the instrument and the index of freedom. Georg Lukács too, in his article "The Old and New Culture," originally published in June 1919 in the midst of his activities as a cultural commissar in the Hungarian Commune, evokes a liberation of culture from the constraints of production. "Liberation from capitalism," he writes—

> means liberation from the rule of the economy. Civilization creates the rule of man over nature but in the process man himself falls under the rule of the very means that enabled him to dominate nature. Capitalism is the zenith of this domination; within it there is no class which, by virtue of its position in production, is called upon to create culture. The destruction of capitalism, i.e. communist society, grasps just these points of the question: communism aims at creating a social order in which everyone is able to live in a way that in precapitalist eras was possible only for the ruling classes and which in capitalism is possible for no class.[14]

Capitalism, unlike previous class orders, is without any authentic culture, since even its ruling class devotes itself to a system of values that are abstract and derived from economic processes. It is communism that will redeem the capitalist present from its condition of culturelessness, raising all members of society collectively to the condition of an aristocrat who can pursue moral or spiritual or cultural values that cannot be reduced to a price.

Gramsci believed that the formation of an individual personality was a process of clarifying the relations of the very "group" elements that left their deposits in the self:

> The personality is strangely composite: it contains Stone Age elements and principles of a more advanced science, prejudices from all past phases of history at the local level and intuitions of a future philosophy which will be

that of a human race united the world over. To criticize one's own
conception of the world means therefore to make it a coherent unity and to
raise it to the level reached by the most advanced thought in the world.[15]

He even goes so far as to extend the notion of "hegemony" to the process
of individual formation:

> Critical understanding of self takes place . . . through a struggle of political
> "hegemonies" and of opposing directions, first in the ethical field and then
> in politics proper, in order to arrive at the working out at a higher level of
> one's own conception of reality. . . [T]he unity of theory and practice is not
> just a matter of mechanical fact, but a part of the historical process, whose
> elementary and primitive phase is to be found in the sense of being
> "different" and "apart," in an instinctive feeling of independence, and
> which progresses to the level of real possession of a single and coherent
> conception of the world.[16]

We might say that for Gramsci, as for Lewis, the individual is firstly "a
crowd," then an "enemy," and finally a victorious "dictatorship" with a
single aim. It is only by allowing, even exacerbating, the struggle of the
different elements vying to sway this crowd that a definite direction and
leadership is established. Culture is the record of this struggle to make this
"ideal giant," as Lewis in 1917 would call the artist conceived as the most
achieved form of unity of "the Many."[17]

Though clearly Lewis's political aims were obviously quite different
from Gramsci's, they shared in the assumption that both personality and
culture could be viewed as a spectrum ranging from eclectic disunity to
totalizing unity, and these two levels were inter-translatable. In his
extended criticism of Picasso in *The Caliph's Design* of 1919, Lewis
utilized a distinction between "creators," who bring something new into
the world, and "interpreters," who take up, often with great virtuosity, the
creations of others and re-present them to the world. Picasso's talent is of
the latter sort, in Lewis's view, and this secondary relation to creation also
underlies the eclectic variousness of his subject-matter, which is often just
the occasion for a tour-de-force of stylistic performance. In my view,
however, much more important than Lewis's distinction between
"creators" and "interpreters," which is a tendentious polemical evaluation,
is his accurate and politically significant characterization of Picasso as a
"non-centralized" talent.[18] "Non-centralized" means, speaking in
Gramscian terms, that Picasso formed his artistic personality as a
composite of cultural elements without an overriding "hegemony." In
Lewis's diagnosis, Picasso is a symptomatic figure—an artist of
extraordinary technical capacity and creative energy who has set up an

aimless liberalism in the governance of his artistic soul. Lewis himself, however, is at this moment convinced that what is needed is a dictatorial leader within, to mirror or even prefigure—here is the cultural revolutionary moment—a revolutionary, anti-liberal political authority. Hence, he writes:

> A great vivacity seemed to spring up some ten years ago in the art of painting; and a number of the younger painters are embarked on an enterprise that involves considerable sacrifices and discomforts, an immense amount of application, and eager belief. This local effort has to contend with the skepticism of a shallow, tired, and uncertain time; there is no great communal or personal force in the Western World of to-day, unless some new political hegemony supply it, for art to build on and to which to relate itself.
>
> It is of importance, therefore, to a variety of painters, who have put their lives into this adventure, that it should not be, through the mistakes, the cupidity, or the skepticism of their leaders, or one mischance or another, be brought to wreck. (*CD* 120)

Lewis as Cultural Revolutionary

Lewis's cultural aspirations were never oriented, even nominally, towards the egalitarian end-goals that many of the communist avant-garde artists professed, however élitist their actual practice and however authoritarian the means they embraced to realize these ends. Nor, even at his most activist, did he ever give himself over so whole-heartedly to the missionary zeal that we find expressed in the most utopian artist of either the left or right. He retained from the very beginning a strong scepticism about eudaemonistic schemes. His basic anthropology was pessimistic, and hence—in general, though not always—he viewed human and physical nature as far less pliant than left-wing communists generally believed. That acknowledged, however, Lewis's writing from *Blast* up to *The Caliph's Design* nonetheless reveals strong traits of a cultural revolutionary vision and even some programmatic calls for its practical implementation by artists.

The first component of Lewis's cultural revolutionary inclination is a powerful faith in the anarchic freedom and creative power of the true artist, who for Lewis is a living exemplum of a higher human type. As a founder and renewer of culture, as opposed to a mere functionary or consumer of an already given culture, the true artist is the authentic true index of freedom over historical necessity. Economic circumstances—as Lewis surely saw from his own life—could unquestionably constrain or

facilitate the artist in making new culture. But they could not determine his creative impulse or subordinate his anarchic power to its law. The artist's value lies in his repeated exceeding of a deterministic social framework, his embodiment of the permanently revolutionary condition of new creation. Even as late as his polemics with *transition* in *The Diabolical Principle*, which sniffs out communism in some pretty unlikely places, Lewis retained his basic premise that the true artist is by definition revolutionary:

> The greatest confusion perhaps of all centres round the term "revolutionary." It is absolutely necessary to make an absolute distinction between (1) *political* revolution . . . [and] (2) on the other hand, all thought and activity that is certainly revolutionary, and so disturbing to the comfortable average, but not committed to any particular *political* doctrine—that is to say any practical programme of change . . . I am of that latter kind, but not of the former.[19]

Naturally, even here Lewis's professions of neutrality with respect to practical politics should be taken with a grain of salt. Though Lewis did not believe that a social order could be established that would universalize the creative artist as the general type of humanity, he did believe that a different political order could help foster—or at least, minimize the interference with—the artist's work and contribute in that way to the shared human legacy of culture. He thus had a motive to embrace revolutionary political change, even without the Marxist revolutionary premise of redeeming the masses from their present condition.

Secondly, in keeping with his focus on the figure of the artist, the difference of the artist is for Lewis marked by his *practical* demonstration of a power to make and remake his environment. Unlike his socialist peers, for Lewis these interventions need not justify themselves on functional or eudaemonistic grounds, for example, by delivering better urban services or increasing economic efficiency. Nor did he subscribe to the futurist drive to remake the lived environment in the name of the new subjective intensities made possible by technology, modern warfare, and metropolitan life. Rather, for Lewis the interventions are reflexively important as "manifestos" in space: as indexical signs of that very originary power, the anarchic freedom, that they manifest against the banal backdrop of everyday life. The artist's interventions do not so much aim at changing the world in some determinate way, as demonstrating his reserve capacity to do so again and again, making and unmaking it at his creative will. Yet at the same time, Lewis claims that the artist's interventions into the everyday environment, the materialized sum of "culture," are not

directly enjoyed by the artist, whose dwelling-place is the intellect and spirit, but rather by the non-artist, the public. If the artist were allowed to carry out a cultural revolution, the public would gain a new cultural environment. The artist, in contrast, would gain nothing more than a world in which he can more comfortably live, work, and keep culture vital as a by-product of his creative activity:

> So when I say that I should like to see a completely transfigured world, it is not because I want to *look* at it. It is *you* who would look at it. It would be your spirit that would benefit by this exhilarating spectacle. *I* should merely benefit, I and other painters like me, by no longer finding ours in the position of freaks, the queer wild men of cubes, the terrible futurists, or any other rubbish that the Yellow Press invents to amuse the nerves of its readers. (*CD* 39)

Culture, in this vision, is alive so long as the artist can mark his own superiority to culture, to the sum of objects and automatisms that make up the everyday context. Paradoxically, art must be interventionist—yet on ontological grounds, not instrumental ones. It must mark and remark the true artist's difference in order to continue to *be* at all, and as soon as "everybody is an artist"—which is the nightmare scenario of *The Apes of God* and other Lewisian satires—so too art's very existence is threatened.

Third, for Lewis, the major problem of art is how to render meaning effective, how to make the idea, the selection of subject-matter, and its interpretation into a demonstration of the creative freedom of art. I believe we can identify a trio of ways in which Lewis, over the course of his career, sought to do this: the constructive, the satirical, and the theo-political. The theo-political pertains mostly to Lewis's late work and refers to his reflections of myths and theologies that represent relative constants of order to the human world, within which the artist is a cosmic factor in a larger process of symbolic destruction and recreation. Even in as early a text as *The Caliph's Design*, it makes a brief appearance, when Lewis alludes to the capacity of a few rare men "to gaze at a number of revolutions at once, and catch the static and unvarying eye of Aristotle, a few revolutions away, or the later and more heterodox orb of Christ." (*CD* 81) This fleeting glance at a static, archetypical view of deep time would become increasingly strong in Lewis's later life.[20]

But it is the two former two categories that are of greater interest to my present topic, however. The satirical marks the artist's distinction by an aggressive act of reduction of the object to its mechanistic qualities, forming a background against which the artist's creative freedom appears projected in enlarged scale, as upon a screen. The constructive marks this

freedom by reshaping the environment, by lending it sublimity and monumentality; these qualities, in turn, are the most tangible signs of externalized mind, of consciousness, of "conscious pattern." As Lewis writes in *The Caliph's Design*, "A gusto, a consciousness should imbue the placing and shaping of every brick" (*CD* 28). The satirical and the constructive are densely intertwined in a project such as *Blast* and in the wide-ranging critical discussion included in *The Caliph's Design*. By the time Lewis turns to his Tyros in the early 1920s, the satirical has largely displaced his constructive impulses. But the constructive element, admixed with and building on the ground cleared by the destructive energies of satire, provides the platform for Lewis to conceive, for a few years, the possibility of a cultural revolution. Moreover, when Lewis turns to the "Man of the World" fiction and cultural criticism and withdraws his hopes from the constructive orientation, cultural revolution does not simply disappear, but remains as a kind of monitory afterimage in his most virulent satire. As the anatomist of his various objects of disdain and disgust, he also becomes, as it were, the satirist of his own earlier constructive hopes, the fusion of artistic and political wishes, as he hollows out the utopian program of cultural revolution from within and defensively harbors the artist's freedom in its conceptual shell.

Posters for a Cultural Revolution

For the cultural revolutionary, the revolutionary poster was at once a key visual instrument and a general figure for an art that had left the studio and entered into the life of the streets. Moreover, it accomplished a key mediation of—or suspension of difference between—abstract form and discursive content, investing it with at least the dream of a communication that would be at once ideologically determinate and aesthetically immediate. As T.J. Clark has written in reference to El Lissitzky, "one of the tasks of the poster in a time of revolution is precisely to transform the conditions and possibilities of reading—to give the reader back reading as an activity of construction (and deformation) rather than reception of the ready-made. . . .The difference between reading and seeing. . . is just for a moment suspended."[21] The revolutionary poster not only communicates an ideological content, it also transforms the channel through which this content is communicated.

For the Hungarian avant-garde, where cultural revolutionary ideas for a short time became reality through their participation in the 1918 democratic and 1919 communist revolutions, the poster was paradigmatic for the overcoming of art's contemplative status and its activation within

cultural revolutionary struggle for a new, collective individual. In an influential essay published in the journal *Ma* (Today) already in November 1916, "The Poster and the New Painting," the poet and avant-garde impresario Lajos Kassák praised the poster precisely for the way it concentrated its message and marshaled all its aesthetic resources into an aggressive act of persuasion:

> The successful poster need not (and does not) carry an image of the consumer item. It *wrests* the desired effect solely by means of its power of suggestion. The successful poster is always conceived in a spirit of radicalism (its creator always intends to break through a settled mass or overcome an opposing current). For this reason it always leaps onto the stage as a unique and absolute force, and never one of an anonymous crowd. It is always agitative by nature, and essentially impossible to constrain within bounds.[22]

So too the new painting, which should take the poster as its model, must emphasize efficacy, monumental reduction, and persuasion, so that it may overcome its role as "interior decoration" and "purport to be so many live questions and exclamation marks for the thinking masses."

Hence, too, Kassák entitled a poem "Poster," a work which he included in his 1918 collection *With an Advertising Column*.[23] The poster, like the advertising column, projects the word and image into the street and communicates with the masses, and this becomes the metaphor for an avant-garde poetry participating directly in collective life:

Poster

at dawn from the fifth floor

Five AM. The square circles. And I see you from the gaping window,
o City. The minutes squeeze golden milk upon you.
The gong sounds. The houses, gullets wide, gargle the silence.
Stone bellies of chimneys sputter. Windows like huge bronze sheets,
and under them gallop and whinny the motley currents of the streets,
a fool of the times, an unbound mane of colors, hurtling. . . hurtling,
a hundred broken poses, cars, shop signs dangling, Cain's scarred face,
burning banners of letters, dogs, a porter's flying cap,
and the rhythm of shoulders and shoulders and legs and legs
and arms and shoulders and legs plash against my thoughts:
separate, titanic drops washing my body,
as now on the anvil, some wild smithy sounds out the Marseillaise
while my hairy, hot chest pants and glistens in the light:
and already there is nothing else: only me and this fireheaded smithy,

one raging smithy and I, bathed in the color of words,
I, I, I and the city's lewd, morning mood,
like a red cap jangling, thrown up in space.

This is a perfect instance of what Lewis would in 1925 critically term the "dithyrambic spectator."[24] The poet, watching the city rise from his fifth floor window, joins in sympathetic chorus first with the waves of passers-by, then with the chaotic activity of the street, and finally with the rhythmic hammering-out of a revolutionary song together with the young worker. Notably, however, he metaphorizes this poetic state of collective participation, this dithyrambic spectatorship, with the generic label of "poster."

In the midst of the Hungarian Commune of 1919, which saw an unprecedented realization of the program earlier spelled out in Kassák's essay, as several members of the Hungarian avant-garde contributed their talents to the propaganda and administrative effort for the revolutionary government, Kassák's colleague Iván Hevesy even further intensified the identification of painting with the poster. In his essay "The New Poster," Hevesy argued that the spiritual content of painting and the new poster were one. However, the painting with which the poster was paired was no longer easel painting, executed in the studio and displayed in the gallery and parlor, but the public fresco, massive in size and collective in its address, a form which in Hevesy's view was seeing its rebirth in the construction of large-scale decorations for street celebrations and in nationalized buildings. Poster and fresco, both intended to foster popular belief, were fundamentally one and the same mode of art, only projected onto different time-scales: "The poster becomes the fresco of the present," Hevesy writes, "while the fresco is the poster with the most immanent content, addressing itself to the centuries."[25]

Though not as closely oriented to practical politics as the Hungarian avant-gardists or their Russian counterparts, the analogously activist orientation of *Blast* and its translation into a symbolically violent, provocative public idiom is obvious enough. Moreover, in his catalogue note for the "Vorticist Exhibition" at the Doré Galleries in June 1915, Lewis explicitly drew the link between the artistic model of the modern poster and the efforts of the Vorticists to clear away the culture of the recent past. Vorticist art, he suggests, rejects the intimacy of Victorianism and impressionism and the commercialism of popular kitsch in favor of the monumentality and openly hortatory quality of the civic art of classical times:

A point to insist on is that the latest movement in the arts is, as well as a great attempt to find the necessary formulas for our time, directed to reverting to ancient standards of taste, and by rigid propaganda, scavenging away the refuse that has accumulated for the last century or two.[26]

In a surprising turn of the argument, however, he evokes a cityscape more like a post-revolutionary Soviet city decorated by the followers of Malevich and El Lissitzky:

Let us give a direct example of how this revolution will work in popular ways. In poster advertisement by far the most important point is a telling design. Were the walls of London carpeted with abstractions rather than the present mass of work that falls between two stools, the design usually weakened to explain some point, the effect architecturally would be much better, and the Public taste could thus be educated in a popular way to appreciate the essentials of design better than picture-galleries have ever done.[27]

What is the message these advertisements carry? Nothing more than the distilled message of cultural revolution itself: the power of the artist to impose, by means of a "rigid propaganda," the patterning of public space, the canons of taste and education. It is the power to abolish the existing chaos of urban space, chattering with the messages of commercial advertisement that by contrast a sentimental, impressionistic art and aesthetic ideology is powerless to silence. Hence, in the chapter entitled "'We Fell in Love with the Beautiful Tiles'" from *The Caliph's Design*, Lewis parodies the art establishment of Roger Fry and the South Kensington School by conjoining them with a saccharine Tube advertisement:

[W]e have a little picture of the young students of the South Kensington School eating buns and milk in the Museum Refreshment Room, and oozing infatuated nothings about the tiles they find there; and going back with naughty, defiant minds to their academic lessons, their dear little heads full of the beautiful tiles they have seen while at lunch. "WE FELL IN LOVE with the beautiful tiles in the South Kensington Refreshment Room," to parody the famous advertisement. We think of the sugary couple on the walls of the Tube, that utter their melancholy joke and lure you to the saloons of the Hackney Furnishing Company; and we know that Mr. Fry's picture is as sentimental a one as that—the student "getting excited," the gush, the buns, and the tiles. (*CD* 132)

In a sense, to return to Lewis's 1915 statement, what the hypothetical Vorticist advertisements would announce is precisely the devolving of the authority of the state onto the artist and his cultural products. Moreover, the context to which Lewis refers his reflections makes this hyper-political role of art explicit: the War and the urgency of organizing culture for national cohesion during wartime. Art and political concentration, in this argument for cultural revolution, are ciphers of one another. The War will destroy all the residues of the artistic correlates of a pre-war liberalism, and from here on out, art's organization will become an essential *political* task. "England," he writes, "cannot make herself too strong in those idealer ways in which Germany traditionally excels."[28]

Towards Architecture: Constructing Cultural Revolution

As Ivan Hevesy's connection of poster and fresco suggests, the metaphor of architecture as a synthetic, immediately effective, public form of art was already hovering in the background of the revolutionary poster. In his recentering of the arts on the terrain being so poorly served by architects, according to the argument of *The Caliph's Design,* Lewis would share in a typical discourse of the European avant-garde, encompassing the translation of the minor cubist painter Jeanneret into the architectural genius Le Corbusier, the emergence of a utopian "picture architecture" that formed the Hungarian version of constructivism, the Bauhaus's linkage of a holistic art pedagogy to architecture and design, and the shift in El Lissitzky's practice from painter and illustrator towards constructivist visions of socialist architecture and urbanism. Among the British artists, however, Lewis's orientation was singular, and it can be profitably contrasted with the experiment in applied arts from which he and his Vorticist followers had seceded, the Omega Workshops. As Isabelle Anscombe notes, Roger Fry neither shared the socialist orientation of his Arts and Crafts predecessors nor the modernity of the continental avant-gardes. He never, Anscombe writes, "considered the Omega products in relation to architecture. His only interest was painting and his stress on design was connected solely with his aesthetic theories, never with design in a formal structural sense, as it was to be interpreted later by the Bauhaus or by Le Corbusier."[29] Lewis himself marked his divergence from the Omega workshops by lumping their productions together with cubist collage and still-life, all of which stand for the antinomy of his vision of a monumental, rhetorically persuasive, and actively creative modern art:

> Now all the colour-matching, match-box-making, dressmaking, chair-
> painting game, carried on in a spirit of distinguished amateurish gallantry
> and refinement at the Omega workshops, before that institution became
> extinct, was really *precisely the same thing*, only conducted with less
> vigour and intelligence, as the burst of abstract nature-mortism which has
> marked the last phase of the Cubist, or Braquish, movement in Paris. These
> assemblings of bits of newspaper, cloth, paint, buttons, tin, and other
> debris, stuck on to a plank, are more "amusing" than were the rather jaded
> and amateur tastefulness of the Omega workshops. But as regards the
> Nature-mortists and Fitzroy tinkerers and tasters, one or other have
> recognized the affinity. Both equally are the opposite pole to the credence
> or intensity of creative art. (*CD* 124-125)

Already by the publication of the short-lived journal *The Tyro* (1921-22),
we can see the beginning of what I have referred to as the hollowing out of
this position. In his statement "Dean Swift with a Brush. The Tyroist
Explains His Art," Lewis still professes a radical goal for his art:

> Art needs waking up. I am sick of these so-called modern artists
> amiably browsing about and playing at art for art's sake.
> What I want is to bring back art into touch with life—but it won't be
> the way of the academician.[30]

The radical themes are still there: art as provocation, the destruction of
aestheticism, the rejection of naturalistic or impressionistic mimesis. So
too, as his forward to the catalogue of the 1921 "Tyros and Portraits"
exhibition shows, Lewis rejects any "plastic" formalism that avoids the
engagement with ideas and the conflict of ideologies:

> The principle point of dispute is, I think, the question of subject-matter in a
> picture; the legitimacy of consciously conveying information to the
> onlooker other than that of the direct plastic message.[31]

Lewis's commitment to a communicative, "rhetorical," performative
conception of visual arts remained steady. But though still deploying an
aggressive, poster-like typography and cartoon-like caricature in the
imagery, the Tyro series seeks less to utilize this rhetorical power to
construct a new reality as to heighten satirically the dissonance between
the artist's intellect and the sinister automatic grin of the outer world. Its
"subject-matter" is largely negative, as Lewis uses his art to circumscribe
an intellectual void, the shocking vacuity of the machines that populate the
Tyronic world.

 It is, however, with the second issue of *The Enemy,* in September 1927,
that we can point to a more directly satirical reference to the cultural

revolutionary program. In Lewis's drawing for the cover and title page, which references his withering analysis of modernist primitivism in the essay *Paleface: The Philosophy of the Melting-Pot* that appears within, Lewis takes various phrases from D.H. Lawrence and Sherwood Anderson and inscribes them like banners in architectural space. If Lewis once again takes up the tools of the cultural revolutionary—the shouting posters, the dramatization of ideological conflict in space, the monumental force of architecture—it is now at a satirical remove. For Lewis does not so much want to carry out a cultural revolution as to arrest and bring to the surface one that is being conducted without our full awareness of its means and goals.

In *The Art of Being Ruled*, in which he laid out the underpinnings of his subsequent cultural polemics, Lewis offers a characterization of cultural revolution that is as radical as any to be found in the most headily utopian and mystical pronouncements of the left-wing communists. However, Lewis sets out the cultural revolutionary program as a kind of equation that he encloses in parenthesis, placing an evaluative negative sign in front of it. His insight into and his opposition to cultural revolution are equally radical. Its world is the one he lives in and reports on from intimate knowledge, like an enemy spy hidden in a hostile camp:

> I can very briefly offer an interpretation of the great cluster of movements disrupting our time. The first thing to notice about it is its implacableness, inasmuch as no local success will satisfy it. It is not any personality, nation, or even particular ruling class that is aimed at, but an entire human revaluation. That is, of course, why it is more like a religion than a rebellion. It is as though a mind had placed itself over against the world and formed the resolve to reconstitute the human idea itself. It is the whole of humanity this time that is at stake. The philosopher's dissatisfaction with the human animal expresses itself at the heart of this disturbance, rather even than the outraged prophet's disgust at the way men treat each other.[32]

To carry out a radical remaking of humanity, Lewis believed, the basic human material would have to be broken down into a malleable form, into what the Hungarian journalist René Fülöp-Miller called in the opening pages of his classic book *The Mind and Face of Bolshevism* the "dividual," which was the fissive product of the human *in*dividual.[33] Lewis found in confrontation with the material of that book, full of impressive illustrative material collected by Fülöp-Miller with the cooperation and aid of the Bolsheviks, a challenge to the idea of cultural revolution, not only as it was understood by the communists, but also by his rival avant-garde artists and by Lewis himself:

> I have now come to believe that Russian Communism not only should not, but cannot, become the creed of the Western peoples. In a popular way such a book as Fülöp-Miller's should serve not as propaganda for Communism, but the reverse. If you take up that book, which is profusely illustrated, you will find that those admirable politicians, the Soviet leaders, make use of a very effective and "vital" form of art to advertise their regime. It is the same used by their fellow-workers of *Super-Reality*. It is also the direction in art that I believe in, and that anybody with eyes in their heads, whatever their politics, must favour.[34]

In Lewis's psychology, however, the unity of a personality was a kind of hegemony with its correlates in the political and ideological field. Thus, a potential obstacle to the "dividualization" process through which the communist new man would be made ready might be the individual's capacity to take on an integral, resistant wholeness in a strong communal identification: especially, Lewis believed, identification with a nation or even more cohesive though presently less politically organized, a race. "There is," he writes in a 1926 essay entitled "The New Roman Empire," which explores the possibility of an imperial alliance of Britain and France with Fascist Italy, "an unorganized unity which is *the race*—the white race, for instance—which is often far more real, and would be much more powerful if it had an objective political existence, than that curious mongrel we call a nation."[35] In *The Enemy* 2, he argues for an appropriation of communist cultural-political methods, but stripped of their racially foreign elements and adapted to "European man":

> [M]uch that the communist party advances, where it advocates radical change in our habits, I am equally in agreement with. But I believe that all this should be taken out of their hands—all that is not specifically *communist* and Asiatic—and placed entirely in the hands of disinterested leaders of our race and traditions; and all that is alien to our traditions and race cut away from it, and handed back to Asia.[36]

Lewis did not step back from the conclusion that a new preemptive form of cultural revolution—a cultural *counter*-revolution to that of communism—would have to be launched, one based on the powerfully cohesive force of race. "I am suggesting," Lewis writes, "that we should take the intellectual initiative, in the anglo-saxon countries, and create a new 'radicalism,' if you like, and so steal the apocalyptic thunders of Moscow, and put 'revolution' to the uses of our whole Western community; using it to racial, instead of to class, ends, and no longer let it cut us up into innumerable 'classes,' sexes, and so forth, especially designed to tear each other to pieces."[37]

Lewis, then, employed the totalizing framework of cultural revolution hermeneutically, to read in directly political terms a whole range of literary, artistic, and cultural manifestations that were tending to disperse or countervail the concentrative force of strong unifying cultural-political myths. A hundred different lines of fracture led to the "dividual," and Lewis found himself foraying from all sides, as an "enemy" of uncertain number and position. Returning to the cover of the second number of *The Enemy* (1927), we can see this crisis situation illustrated. Through the allegorical use of the colors black, white, red, and yellow, Lewis's design takes up the racial codes, the color lines, that his literary criticism finds to be blurred in primitivist writing by racial mimicry and by eroticized participation in racial otherness. On the left, perhaps again in a kind of political allegory, the phrases of Lawrence and Anderson are inscribed vertically in black and red over white; on the right, and at the top and base of the page, Lewis's name and publication information jut forth horizontally, confronting and contradicting the exclamatory sentences across a void of white at the centre. We can imagine these architectonic-textual blocks as occupying the place of the conflicting colored masses in a Vorticist "plan," but now this racialized ideological warfare appears more explicitly in its public discursive and architectural contexts. Yet the most important part of the design is neither the text nor the architectonic forms, but rather the white void in the middle, a space encroached upon and aggressively penetrated from "Lewis's" side, while mimicked and redoubled and written over on the side of Anderson and Lawrence. At stake, for Lewis, finally, was nothing less than the unorganized and threatened destiny of the "white race," of "European humanity," over which one cultural revolution or the other would inevitably win hegemony and gain the right to design its future in the space opened by its still blank present.

Notes

[1] "No-Man's Land: Wyndham Lewis and Cultural Revolution," *Wyndham Lewis Annual* 12 (2005 [published 2007]: 12-28.

[2] Marc Manganaro, *Culture, 1922: The Emergence of a Concept* (Princeton, New Jersey: Princeton University Press, 2002).

[3] Virginia Nicholson, *Among the Bohemians: Experiments in Living, 1900-1939* (New York: William Morrow, 2002) xvii.

[4] Nicholson xviii.

[5] Béla Uitz, "We Need a Dictatorship!" (1919), in *Between Worlds: A Sourcebook of Central European Avant-Gardes, 1910-1930,* eds. Timothy O. Benson and Éva Forgács (Cambridge, Massachusetts: The MIT Press, 2002) 225.

[6] El Lissitzky, *About Two Squares*, with Patricia Railing, *More About Two Squares* (Cambridge, Massachusetts: The MIT Press, 1990). An annotated version of work is viewable on-line at http://www.ibiblio.org/eldritch/el/pro.html (Accessed September 2006).

[7] Zeev Sternhell, with Mario Sznajder and Maia Asheri, *The Birth of Fascist Ideology: From Cultural Rebellion to Political Revolution*, trans. David Maisel (Princeton, New Jersey: Princeton University Press, 1994) 3.

[8] Sternhell 3.

[9] Wyndham Lewis, *The Art of Being Ruled*, ed. Reed Way Dasenbrock (Santa Rosa: Black Sparrow Press, 1991) 119.

[10] Katerina Clark, *Petersburg: Crucible of Cultural Revolution* (Cambridge, Massachusetts: Harvard University Press, 1995); Boris Groys, *The Total Art of Stalinism: Avant-Garde, Aesthetic Dictatorship, and Beyond*, trans. Charles Rougle (Princeton: Princeton University Press, 1992); Richard Stites, *Revolutionary Dreams: Utopian Vision and Experimental Life in the Russian Revolution* (Oxford: Oxford University Press, 1989); Susan Buck-Morss, *Dreamworld and Catastrophe: The Passing of Mass Utopia in East and West* (Cambridge, Massachusetts: The MIT Press, 2000); Vladislav Todorov, *Red Square, Black Square: Organon for Revolutionary Imagination* (Albany: State University of New York Press, 1995).

[11] Clark 23.

[12] Groys 21.

[13] Antonio Gramsci, "The Revolution against Capital" (24 December 1917), in *Pre-Prison Writings*, trans. Virginia Cox, ed. Richard Bellamy (Cambridge: Cambridge University Press, 1994) 41.

[14] Georg Lukács, "The Old Culture and the New Culture," in *Marxism and Human Liberation: Essays on History, Culture, and Revolution*, ed. E. San Juan Jr. (New York: Delta Books, 1973) 5.

[15] Antonio Gramsci, *Selections from the Prison Notebooks,* eds. and trans. Quintin Hoare and Geoffrey Nowell Smith (New York: International Publishers, 1971) 324.

[16] Gramsci, *Selections from the Prison Notebooks* 333.

[17] Wyndham Lewis, "The Ideal Giant," in *Collected Poems and Plays*, ed. Alan Munton (New York: Persea, 1979) 121-139.

[18] Wyndham Lewis, *The Caliph's Design: Architects! Where Is Your Vortex?*, ed. Paul Edwards (Santa Barbara: Black Sparrow Press, 1986) 112.

[19] Wyndham Lewis, "The Diabolical Principle," *The Enemy* 3 (1929) 74. I cite from the facsimile edited by David Peters Corbett and published by Black Sparrow Press (Santa Rosa), 1994.

[20] The best treatment of this tendency in Lewis can be found in Chapters 11, 13, and 14 of Paul Edwards's authoritative study *Wyndham Lewis: Painter and Writer* (New Haven: Yale University Press, 2000). See also Daniel Schenker, *Wyndham Lewis: Religion and Modernism* (Tuscaloosa: University of Alabama Press, 1992).

[21] T.J. Clark, *Farewell to an Idea: Episodes from a History of Modernism* (New Haven: Yale University Press, 1999) 256.

[22] Lajos Kassák, "The Poster and the New Painting," in Benson and Forgács 165.

[23] Lajos Kassák, "Plakát" (Poster) in *Összes Versei* I (Budapest: Magvetö, 1969) 48-49. The English translation that follows is mine.

[24] Lewis's essay "The Dithyrambic Spectator: An Essay on the Origins and Survival of Art," *The Calender of Modern Letters* 1/2 (April 1925) critically considered Elliott Smith's and Jane Harrison's ritualistic conceptions of the origins of art. Influenced by both Whitman and expressionist poetics, Kassák here exemplifies a contemporary, avant-garde version of this ritualistic view of art, presenting poetry as the space of communion and ecstatic fusion with the worker and the popular life of the big-city street.

[25] Iván Hevesy, "Az Új Plakát" (The New Poster), in *Az Új Müvészetért* (Budapest: Gondolat, 1978) 57.

[26] Wyndham Lewis, "Note for Catalogue" for "Vorticist Exhibition," Doré Galleries, June 1915, in Walter Michel, *Wyndham Lewis: Paintings and Drawings* (Berkeley and Los Angeles: University of California Press, 1971) 432.

[27] Lewis, "Note for Catalogue" in Michel 432.

[28] Lewis, "Note for Catalogue" in Michel 433.

[29] Isabelle Anscombe, *Omega and After: Bloomsbury and the Decorative Arts* (London: Thames and Hudson, 1981) 31.

[30] Wyndham Lewis, "Dean Swift With a Brush. The Tyroist Explains His Art," in *The Complete Wild Body*, ed. Bernard Lafourcade (Santa Barbara: Black Sparrow Press, 1982) 359.

[31] Wyndham Lewis, "Tyros and Portraits," in *The Complete Wild Body* 353.

[32] Lewis, *The Art of Being Ruled* 76.

[33] "With unheard of boldness, an attempt is being made in Russia to make a correction in the archetype of humanity itself, to wipe out the former type of the lord of creation, that 'soul-encumbered individual creature,' and to replace it by a 'higher type,' by what is believed to be a new a more valuable species of living being, by the 'collective man,' to replace this individual by the 'dividual.'"—René Fülöp-Miller, *The Mind and Face of Bolshevism*, trans. F.S. Flint and D.F. Tait (London and New York: G.P. Putnam's Sons, 1927) 4-5.

[34] Wyndham Lewis, "The Paris Address," in *The Enemy* 2 (1927) xxx.

[35] Wyndham Lewis, "The New Roman Empire," *The Calender of Modern Letters* 2/12 (February 1926) 418.

[36] Lewis, "The Paris Address" xxv.

[37] Lewis, "The Paris Address" xxvi.

CHAPTER SEVEN

DOCUMENTARY / MODERNISM: COMPLEMENTARITY AND CONVERGENCE IN THE 1930s[1]

I

As terms that share their provenance in the cultural upheavals of the first half of the twentieth century, "modernism" and "documentary" nevertheless appear to belong to distinct art-historical, literary, and aesthetic domains. As we have come to understand them, they seem to indicate opposed sets of beliefs about the nature of artistic communication, embodying different assumptions about the artwork's public role and in many cases representing strongly divergent political commitments on the part of their practitioners. Modernist artists and writers, as commonplace has it, attacked the conventions of mimetic visual and literary representation, laying bare the semiotic, social, and psychological conventions that allowed traditional artworks to be seen as verisimilar pictures of reality. Modernists interrogated the ways in which subjective perception and thought mediated any possible apprehension of the world, and they sought to account for the decisive material role that media such as language, paint, and bodily movement played articulating the artwork's relation to reality. From this basic stance of modernist artists ultimately derived many of the defining features of the modernist artwork: its tendency towards difficulty, fragmentation, and abstraction; its self-reflexivity and heightened self-consciousness; its prominent display of artistic technique; its polemical, often mandarin withdrawal from everyday life and culture.

Documentary, in contrast, seemed to draw its energy and inspiration from the antithetical realm of the everyday, the popular world upon which modernist art and writing had demonstratively turned its back. In reportage, reports, photographs, and films, the documentary artist attempted to register the teeming multiplicity of movements of labor, daily routine, and city life. Honesty, accuracy, and openness to the contingent details of the empirical world were premium values in the documentary

aesthetic, and objectively-existing "reality" its formal touchstone. In pursuing its goal of representing reality truly, documentary took up the aspirations of nineteenth-century realist and naturalist artists to reveal the face of the common life that less rigorous modes of art tended to mask. Documentary, in sum, is frequently thought to represent the furthest development of naturalism in the arts, just as modernism, its aesthetic antipode, is seen as the acme of anti-naturalist impulses.

This story is familiar to the point of near-banality, and like most folk wisdom, it has the virtue of being plausible if not precisely true. Once it is given closer scrutiny, however, several problems nag this account. First, evidently, the basic terms upon which it rests are unstable and difficult to define with precision: for example, the opposition of modernism's "subjectivity" to documentary's "objectivity," and of "modernism" itself to the "realism" and/or "naturalism" with which documentary is aligned. It is pertinent to recall here Roman Jakobson's terminological scruples concerning the multiple senses of "realism" and easy to concur with him that "those who speak of artistic realism continually sin against it."[2] Yet I want to pursue a somewhat different line of theoretical and historical argument than such terminological skepticism. In the conceptual frameworks taking shape around both modernism and documentary, I wish to suggest, formally innovative experimentalism and naturalistic explorations of everyday life were not so much opposed as instead *complementary* moments of a broader modernist poetics. Only from this perspective, I argue, do the mixtures of radical montage, reportage, state- or commercially-oriented advertising, and surrealist defamiliarization in the documentary works of John Grierson's filmmaking team and the texts of Mass Observation reveal their underlying coherence. Similarly, such a perspective, which implies that documentary arose in close relation to the later development of modernism in the late 1920s and 30s,[3] helps explain the significant presence of modernist writers, visual artists, and musicians in the documentary film movement and the amateur ethnographic organization called Mass Observation. These movements involved such modernistically-oriented writers as Charles Madge, David Gascoyne, William Empson, Kathleen Raine, Naomi Mitchison, W.H. Auden, and even E.M. Forster; artists, photographers, and experimental filmmakers such as Humphrey Jennings, Julian Trevelyan, Humphrey Spender, and Len Lye; and musicians such as Benjamin Britten. On the part of those modernists not directly associated with the institutions of documentary, documentary culture was nevertheless followed with intense interest. For example, journals such as *Close Up*, which involved such writers as H.D., Bryher, and Dorothy Richardson, offered readers critical discussions of

Vertov's and Eisenstein's most recent productions. Similarly, Eugene Jolas's Paris-based expatriate journal *transition* set stills from Paul Strand's *Nets* and László Moholy-Nagy's *English Zoo Architecture* alongside the latest installments of Joyce's *Work in Progress*, translations of stories and poems by Franz Kafka and Gottfried Benn, and visual works by Joan Miro and Marcel Duchamp.[4]

A useful theoretical point of departure for considering the interconnections of modernism and documentary is the writings of the communist philosopher and literary critic, Georg Lukács, one of the most important critics of modernism and a formidable advocate of classical and socialist realism. In his 1958 study, *The Meaning of Contemporary Realism*, Lukács identifies the first "modernistic" break with realism—in his view, regrettable—not with the manifestly modernist writings of Kafka, Joyce, Benn, and Musil, but already a generation or two earlier, with the naturalism of Zola. He goes on to attack critics who glorify modernism, damning them for failing to distinguish between realism and naturalism. "This distinction," Lukács writes—

> depends on the presence or absence in a work of art of a "hierarchy of significance" in the situations and characters presented. Compared with this, formal categories are of secondary importance. That is why it is possible to speak of the basically *naturalistic* character of modernist literature. . . . [T]he particular form this principle of naturalistic arbitrariness, this lack of hierarchic structure, may take is not decisive. We encounter it in the all-determining "social conditions" of naturalism, in symbolism's impressionist methods and its cultivation of the exotic, in the fragmentation of objective reality in futurism and constructivism and the German *Neue Sachlichkeit*, or, again, in surrealism's stream of consciousness.[5]

Rather than dismissing Lukács's naturalism-modernism continuum as a dark night in which all cows are gray or accepting his anti-modernist evaluative spin, I wish to explore his hypothesis somewhat against the grain of his intentions and to draw out its implications. Lukács's pinpointing of the "basically naturalistic character of modernist literature," I suggest, offers a way to understand modernism and documentary as complementary and, at the same time, helps reveal the ambivalence within documentary poetics between "realist" social representation and "naturalistic-modernistic" erosion of this representational "hierarchy of significance."

Lukács's critique hinges on the key role of socially significant "types" in realism and the displacement of typicality in both naturalism and modernism through the hypostatization of the particular and the detail. He

develops this argument by way of commentary on Walter Benjamin's theory of allegory, which Lukács takes as reflecting modernism's ideologically conditioned failure to grasp the real as rational from the perspective of a substantive totality (represented for Lukács by official communist Marxism):

> In realistic literature each descriptive detail is both *individual* and *typical*. Modern allegory and modernist ideology, however, deny the *typical*. By destroying the coherence of the world, they reduce detail to the level of mere particularity (once again, the connection between modernism and naturalism is plain). Detail, in its allegorical transferability, though brought into a direct, if paradoxical connection with transcendence, becomes an abstract function of the transcendence to which it points. Modernist literature thus replaces concrete typicality with abstract particularity. (304)

A remark by Lukács's heterodox Soviet contemporary, Viktor Shklovsky, associated with the left modernist groups "Lef" and "New Lef" in the 1920s, suggests that one could employ this basic distinction even without endorsing Lukács's prescriptive demand to suppress modernism and reconstruct realism. Thus, in a symposium on Soviet documentary in 1927, which included Sergei Tretiakov, Esther Shub, Osip Brik, and Shklovsky, the formalist literary critic and screenplay writer appealed to a historical dialectic of modernist form and naturalistic actuality of content to establish the tasks of current Soviet film. Rather than such typical oppositions as fiction and non-fiction or, by extension, modernist and realist treatment of the film narrative, Shklovsky emphasized the intensive engagement with new "raw material" as that which would advance Soviet film work in both its aesthetic character and its social function:

> What Shub is doing and Dziga Vertov is getting ready to do has a huge number of analogies in literature. . . . We should not exaggerate the fictional side of art. The fact of fiction is established, but art periodically undergoes a re-emphasis on raw material.
> And the mistaken newsreel-makers were right about this and they are right now when they promote raw material. The priority of material is the result. . . .
> Lef's task is broader than the problem of the fiction and non-fiction film. Our problem is the priority of raw material.[6]

Shklovsky thus saw the documentary film in the same broadly modernistic framework as he viewed literature in his formalist criticism.[7] Filmic expression, documentary and fictional, he was arguing, needed regular freshening through "defamiliarizing" means. These means included *both*

new stylistic "devices" and the disturbing force of up-to-date, often "low" social contents appropriated directly from extra-artistic domains ("raw materials"). Or to put it more abstractly, in Shklovsky's theory of literary and filmic innovation, "modernistic" and "naturalistic" impulses appear equally valuable and complementary, not antithetical.

In his review of Paul Rotha's book *Documentary Film,* for the 19 February 1936 issue of *The Listener,* W.H. Auden specifically pointed to precisely the problem of the "realistic" typical narratives and "naturalistic-modernistic" particulars as an unresolved tension in the documentary form. Indeed, in an almost Lukácsian fashion (though terminologically more loose), Auden drew out the contradictions between two forms of "realism": realism as verisimilitude and realism as close mimetic reproduction of real things. "The only genuine meaning of the word 'documentary'," Auden begins, "is true-to-life. Any gesture, any expression, any dialogue or sound effect, any scenery that strikes the audience as true-to-life is documentary, whether obtained in the studio or on location."[8] He goes on to note, however, that "Because of the irreversibility and continuous unvaried movement of the film, it is not the best medium for factual information. . . . The effect of a film is to create a powerful emotional attitude towards the material presented" (355). Finally, he notes, "Because of the mass of realistic detail which the camera records, no medium has ever been invented which is so well suited to portray individual character, and so badly suited to the portrayal of types. On the screen you never see *a* man digging in *a* field, but always Mr. Macgregor digging in a ten acre meadow" (355).

Although Auden does not fully spell out the consequences of his critical caveats to the documentary aesthetic, his implication is clear enough. On the one hand, insofar as the term "documentary" lays claim to the verisimilitude of classical realism, it must give up its adherence to a photographically-grounded naturalism capturing events in real time and on location (since true-to-life "documentary" representations could just as easily be made in the studio). Yet insofar as the documentarists insisted on the precise registration of details, especially photographically and cinematographically, they verged over into the emotionally intense, often surreal depiction of the autonomous fragment of reality characteristic of radical naturalism and modernism alike. Rotha himself, it should be noted, argued strongly against the tendency of the documentary mode to fragment into striking details, thus taking on modernistic, aestheticizing features to the detriment of its social function. Accordingly, he criticized "Continental Realists" such as Walter Ruttmann and Dziga Vertov for their "superficial," "pseudo-realist" treatment of the rhythms and movements of

the city, and he rejected conventional visual beauty in favor of a new aesthetic of factuality and social aim:

> Beauty is one of the greatest dangers to documentary. Beauty of individual shots is not only insufficient but frequently harmful to the significant expression of content. Beauty of purely natural things . . . is unimportant unless related to purpose and theme. Beauty of symphonic and rhythmic movement is . . . nothing in itself. What is important is beauty of idea, fact, and achievement, none of which have anything to do with the actual filming of individual shots.[9]

Yet Rotha's polemic, whatever the merits of his position, at the same time points to the precise sore spot that Auden touched upon. The documentary, Rotha and Auden imply, is potentially torn between two basic aesthetic tendencies: a "realist" typicality that allows the documentary to be "true-to-life" and hence socially functional; and a naturalistic or modernist particularity of the photographically-rendered detail, which threatens to overrun verisimilitude in favor of the effective emotional or aesthetic impact of the image.

One of the most apparent sites in which one can observe this tense complementarity of modernist and documentary modes is the new prose poem genre that emerged in the 1930s in the work of writers involved with the documentary and Mass Observation movements. Broadly speaking, this prose poem was surrealist in its inspiration, yet this surrealism was in turn decisively shaped by these writers's idiosyncratic reading of the documentary aesthetic, particularly their filtering of it through Marcel Duchamp's use of everyday objects in his "readymades." In offering her assessment of the successes and failures of the Mass Observation movement, Kathleen Raine suggested that it had provided a point of convergence between the rational and the irrational, the objective and the dream-like in a single fund of images. She went on to single out David Gascoyne, along with Charles Madge and Humphrey Jennings, as Mass Observation participants who had realized a poetry based on such a convergence, "in which an imagery of precise and objective realism, gathered from the daily human (and therefore especially urban) scene . . . is informed with a content not only supremely imaginative, but infused with the imagination of the collective mind of which it is an eloquent, if unconscious, expression."[10] Raine, no doubt, has in mind particularly the "reports" of Jennings and Madge and the analogous prose poetry of Gascoyne. There are, however, significant differences between these three poets's work within the basic genre of the surrealist prose poem—differences that relate closely to how they interpret the conjunctions of

surrealism, readymade, and document that span their poetic and documentary activities. In what follows, I will consider in greater detail the work of these three poets and documentary artists, concluding with a discussion of the analogous writing of a fourth artist, the filmmaker and animator Len Lye.

II

In September of 1937, Humphrey Jennings—poet, documentary filmmaker, surrealist painter, and founding member of the fledgling ethnographic movement Mass Observation—was charged with the task of writing up the results of the surveys and reports done by the Mass Observers on the recent events of Coronation Day, May 12th. Typical of these reports in both the scene observed and the style in which it is presented was the following, out of London:

> Lancaster Gate. 2.20. Kensington Garden shut, full of soldiers, girls leaning over park railings calling to them, soldiers indicate guards at gate despairingly.
> Indians arguing in tube about the necessity of the Bakerloo extension to Stanmore, one says, "People in suburbs are scarcely human, they should be kept as far out of London as possible." Every time train enters tunnel people make animal noises. Others unscrew light-bulbs; they are all doing the sort of things Undergraduates do when canned, but they are not Undergraduates, they seem to be aged between about 25 and 35 and they look like clerks, typists, etc.
> Terrific jam at Oxford Circus, takes about 15 minutes to get up escalators. Singing coming from every part of Oxford Street. Fruit barrows, sellers of rosettes and newspapers, no motors. People camping on the pavement all the way down Regent Street, four deep from the pavement edge.
> Young man to girls, "Hey, have you got to go home tonight?"—This seems to be the most frequent question asked, answer always in the negative; apparently even in moments of great excitement people are still thinking of their homes as their centres of life.[11]

This report appeared along with hundreds of others in the Mass Observation edited volume, *May the Twelfth*, published under the prestigious Faber and Faber imprint. Presented as a slice of life captured in a moment of intense "actuality," it bristles with paratactic energies and estranges the banal urban landscape with surreal bundles of isolated sights, sounds, faces, and voices. About a year before the Coronation Day events,

Jennings had published another report, the first of the three short paragraphs collected together under the generic title "Three Reports":

> The conditions for this race, the most important of the Classic races for three-year old fillies, were ideal, for the weather was fine and cool. About one o'clock the Aurora again appeared over the hills in a south direction presenting a brilliant mass of light. Once again Captain Allison made a perfect start, for the field was sent away well for the first time that they approached the tapes. It was always evident that the most attenuated light of the Aurora sensibly dimmed the stars, like a thin veil drawn over them. We frequently listened for any sound proceeding from this phenomenon, but never heard any.[12]

Unlike the Mass Observation report, however, this text appeared in a literary magazine, in the "Double Surrealist Number" of the journal *Contemporary Poetry and Prose*.

Both passages lay claim to the genre of "report," which suggests a correlation between the order of the text and the order of events and a descriptive fidelity to a real situation witnessed by an observer. The Mass Observation report, for all its paratactical disjointedness, is a coherent fragment of urban experience, a temporally- and spatially-limited, perspectival view of an extraordinary event. Whatever broader context or narrative completion might be possible for any individual bit, it will receive from the organized accumulation of other reports—from "more than two hundred observers" in London, Lancashire, Cambridge, Swansea, and elsewhere—and from the editorial synthesis seeking to frame the individual reports into a verbal mosaic of collective experience. In contrast, Jennings's poetic report on the horserace has little of the telegraphic breakup of narrative and syntax found in the observer's rapid jottings. Its diction seems contrivedly literary and a little dated: "It was always evident that the most attenuated light of the Aurora sensibly dimmed the stars, like a thin veil drawn over them." Yet the difficulties the text poses us as readers are far greater than the fractured report of the Coronation Day observer—basic difficulties of context and significance, of the very status of the text generically and ontologically.

Jennings's prose poem appeared among several other instances in the same special surrealist number of *Contemporary Poetry and Prose*. For example, immediate preceding Jennings's reports were four prose works of various characters and qualities. First came a page-long excerpt from André Breton and Paul Eluard's collaborative work of surrealist automatism, "The Pre-Natal Life of Man" (an excerpt from *L'Immaculée conception*).[13] This text is followed by a surrealist "Story" about a dog, a

ghost, and lepers by the Breton protégée, Gisèle Prassinos. Then appear "An Adventure" written by "A Five-Year-Old Boy" and "The Tea Party" by "A Seven-Year-Old Girl." Finally, immediately following Jennings's "Three Reports" is a screenplay by the surrealist filmmaker Luis Buñuel, "The Giraffe." According to the script, this film is to consist of a giraffe cut out of wood in life-sized profile, with each spot hiding a lid that can be opened onto things visible "behind" the spots.

By comparison, then, to the May 12th Mass Observation report quoted above, Jennings's "Three Reports" shares no common reference with those prose texts surrounding it and thus obviously forms no larger unit of narrative meaning with them. Yet there is a common feature binding these various texts of Breton, Buñuel, Prassinos, Jennings, and the anonymous children: the *generic* inclusiveness of the surrealist prose poem. Drawing inspiration from a heterogeneous set of influences, ranging from precursors such as Rimbaud, Lautréamont, and Roussel to Freudian dream-texts and flea-market kitsch, this genre can embrace oneiric narrative, found objects, irrational juxtapositions, satirical mimicry of outmoded books, dysfunctional machines, and distortions of textual logic introduced through chance and automatic practices. Jennings himself appears to have understood this generic consistency—despite his prose poems's lack of narrative, thematic, and referential cohesion—insofar as he projected a larger collection ironically suggesting "reportage": the August-September 1936 issue of *Contemporary Poetry and Prose* carried an advertisement promising a book by Jennings entitled *Popular Narratives*, while in another announcement in the December 1936 issue it bore the projected title *Reports and Photographs*. It was to have appeared in Spring of 1937 in their special editions series, but the plan was not realized before the journal folded with the Autumn 1937 number.

Jennings's "reports" are puzzling so long as we are seeking to make them "reports of" something and do not see that these are "reports" to be viewed as objects whose referential or functional aspects have been rendered ambiguous, though not fully effaced. These texts, as Kathleen Raine pointed out in her preface to Jennings's posthumous collected poems, can be seen as akin to Marcel Duchamp's appropriation and reinscription of readymade domestic objects.[14] In this light, Jennings's reports appear less like the rapid jottings of a witness on the spot than like pages torn out of old books and reframed into "poems in prose"—that literary genre in which Duchamp recognized a detouring of poetry akin to his own deflection of painting through a "delay in glass."[15]

III

Jennings's "readymade" report-poems found a resonance with two other poets, Charles Madge, with whom Jennings would help to found the Mass Observation venture, and the British surrealist poet David Gascoyne (also involved in M-O). Madge, like Jennings, was a regular contributor to *Contemporary Poetry and Prose* and had presided over the special feature on surrealism in the December 1933 issue of Geoffrey Grigson's journal *New Verse*, to which he contributed a programmatic essay, "Surrealism for the British." Madge argued that British artists and writers should not merely imitate a Parisian fashion that was already a decade old by the time it was being discovered in Britain; rather they should adapt the lessons of surrealism in light of the national particularities of the English language, literary tradition, and daily culture.[16] One direction in which Madge took this basic orientation was anthropological: the observation of the British *en masse*, to learn about the unknown rituals, magical modes of thought, taboos, and wish-images that were rooted in the everyday life of this industrial nation. In a letter of 30 January 1937 to *The New Statesman and Nation* entitled "Anthropology at Home," Charles Madge and Humphrey Jennings, together with the anthropologist and ornithologist Tom Harrisson, set forth their program to understand the British and their peculiar collective rites:

> Mass Observation develops out of anthropology, psychology, and the sciences which study man—but it plans to work with a mass of observers … The following are a few examples of problems that will arise:
>> Behavior of people at war memorials.
>> Shouts and gestures of motorists.
>> The aspidistra cult.
>> Anthropology of football pools.
>> Bathroom behaviour.
>> Beards, armpits, eyebrows.
>> Anti-semitism.
>> Distribution, diffusion and significance of the dirty joke.
>> Funerals and undertakers.
>> Female taboos about eating.
>> The private lives of midwives.
> In these examples the anthropological angle is obvious, and the description is primarily of physical behaviour. Other inquiries involve mental phenomena which are unconscious or repressed, so that they can only be traced through mass-fantasy and symbolism as developed and exploited, for example, in the daily press. The outbreak of parturition-images in the press last October may have been seasonal, or may have been caused by

some public stimulus: continuous watch on the shifting popular images can only be kept by a multitude of watchers.[17]

Two things are notable about Madge's and Harrisson's list. First is the almost Swiftian distance from which the British people are surveyed, training on the domestic front the detached gaze of the anthropologist on an exotic people. Second, the features that are seen as providing privileged points of entry into the British collective character are an incongruous—indeed, "surreal"—heap: a kind of categorial *Merzbau* assembled out of the detritus of everyday life, newspaper fads, kitsch, body culture, leisure, and consumerism.

Like Jennings, Madge also detoured the activity of documentary finding and reporting through the literary practice of the prose poem. Jennings had juxtaposed his found fragments of texts, his secondhand "reports," in order to estrange the claim to reality of the document and to release its aura of outmodedness and oneiric meaning. Jennings's adoption of the "readymade" model moved it distinctly towards the *hermeneutic* concerns of surrealism rather than the cool, derisive mechanization of Duchamp's "pseudo-machines" (as Jennings called them). David Mellor suggests that Jennings, akin to his exiled German counterpart Walter Benjamin, was seeking to find in urban, mass media, and commodity culture the dream- and wish-hieroglyphics of a collective unconscious.[18] Jennings had translated André Breton's "Lighthouse of the Bride" essay on Duchamp for the 1936 Surrealist Exhibition in London, and in his text "The Iron Horse" for the 1938 exhibition "The Impact of Machines," he presents Duchamp's work as an artistic *counterdiscourse* to the machine: "The so-called 'abstract' painter identifies himself or the person in his picture with a machine. . . . Not to be confused with abstract painting is the anti-artistic creation of pseudo-machines by Duchamp, Picabia, Ernst, Baargeld, Man Ray."[19] Jennings goes on to juxtapose a note from Duchamp about the *Large Glass* to a letter written by James Watt in 1769 about the Kinneil Engine, concluding with a distinction: "The point of creating pseudo-machines was not as an exploitation of machinery but as a 'profanation' of 'Art' parallel to the engineers' 'profanation' of the primitive 'sacred places' of the earth."[20] Yet the artist-engineer, in this view, retains a residual connection with the sacred as well—like a modern magician presiding over the final descent of magic into profane life. In contrast, Madge, who in the inaugural pamphlet of Mass Observation praised Duchamp for having achieved the leap from modernist to scientist, seemed especially attracted to the estranging quality of things presented through the affectless voice of the scientist and technical specialist.[21]

Compared to Jennings's "Reports," the prose poems included in Madge's first collection of poems, *The Disappearing Castle*, appear more directly to mimic the reports of biologists, social scientists, geographers and surveyors, and journalists. In some cases, as with the "Landscape" series, the poems and their titles together seem to represent labeled "specimens" of prose, found in prospecting within the discursive spaces of a specialized discipline.[22] Thus, for example, in "Landscape IV," the landscape evoked is more like a depiction in a geology textbook than an actually observed geological formation:

> Caverns may be divided into three classes. Some have the form of large clefts or crevices, like veins not filled with ore. Other caverns are open to the light at both ends. These are rocks really pierced; natural galleries which run through a solitary mountain. A third form exhibits a succession of cavities, placed nearly on the same level, running in the same direction, and communicating with each other by passages of greater or less breadth. Their almost perfect horizontality, their gentle and uniform slope, appears to be the result of a long abode of the waters, which enlarge by erosion clefts already existing. They act in the economy of nature as vast reservoirs of water, and of elastic fluids.[23]

In other cases, the title operates like a kind of Duchampian pun, taking the appropriated prose object through the delay of its remapping onto another referent, order of categories, and hierarchy of values (for example, Duchamp's inversion of a urinal into the visual-verbal pun "Fountain). In Madge's poem "Division of Labour," for example, the title has theoretical overtones from Karl Marx and Émile Durkheim, as well as connotations of industrialism and technical organization. Yet in the poem, the technicity exists solely at the level of discursive style, rather than in the object portrayed:

> The Alpine marmots are said to act in concert in the collection of materials for the construction of their habitations. Some of them, we are told, cut the herbage, others collect it into heaps; a third set serve as waggons to carry it to their holes; while a fourth perform all the functions of draught horse. The manner of the latter part of the curious process is this. The animal who is to serve as the waggon lies down on his back, and extending his four limbs as wide as he can, allows himself to be loaded with hay; and those who are to be the draught horse trail him thus loaded by the tail, taking care not to overset him. The task of thus serving as the vehicle, being the least enviable part of the business is taken by every one of the party in turn. "I have often," says Mr Beauplan, in his *Description of the Ukraine*, "seen them practise this, and have had the curiosity to watch them at it for days together."[24]

Juxtaposing the found prose with its suggestive title, Madge sets in oscillation the apparently opposed poles of nature and technology, inviting us to see our own industrial organization as a form of "metabolism with nature." Industrial workers, implicitly, are reduced by the industrial system to a level in which they become comparable to industrious rodents; indeed, the organization of the rodents seems much more "humane" and equitable than the putatively human form. Their system is strikingly close to the ideal of communism, a connotation further reinforced by the contrived name of the cited expert ("Mr. Beauplan"=beautiful plan) and the location of his scientific fieldwork in the Ukraine.

IV

Jennings, as I have noted, emphasizes the auratic quality of the outmoded found text, while Madge draws satirical and critical resources from the estranged coolness of technical and journalistic language. David Gascoyne, in turn, seeks to turn the prose poem into a fantastic, oneiric object itself, abandoning the Duchampian problematic of the readymade in favor of surrealist expressiveness. The most striking point at which this distinction can be seen is precisely in Gascoyne's most explicit attempt to assimilate the lessons of Jennings's "reports," in the prose poem sequences entitled "Automatic Album Leaves" and "Three Verbal Objects." In his introduction to his *Collected Poems*, Gascoyne notes that "Three Verbal Objects" were—

> first published in the catalogue to an Exhibition of Surrealist Objects at the London Gallery in the winter of 1937, by which time I had moved to a Paris attic and virtually ceased writing in the surrealist vein. They are posthumously dedicated to Humphrey Jennings, in acknowledgement of the influence that his "Reports" and other admirable short texts, first published by Roger Roughton in *Contemporary Poetry and Prose*, undoubtedly had on me.[25]

Gascoyne's sincere appreciation of Jennings's pieces, however, cannot obscure the enormous difference in the fundamental modes between Jennings's anachronistic-sounding found prose fragments and the visionary lyricism of Gascoyne's "verbal objects." For Gascoyne, the "objecthood" of the verbal passage does not mean that the language has been subjected to a dissolution of its narrative and referential codes, but rather just the opposite: their rematerialization as an enduring ritual, mythic, or cosmic entity. Similarly, whereas Jennings's "reports" suggest the disturbing role of chance in historical life, the contingency and

partiality of our documentary comprehension of events, Gascoyne envisions an apocalyptic reversal of meanings, symbolically portrayed in images in which violent destruction is transfigured into cosmic signs of rebirth:

> From the tower of a quietly blazing mansion whirled a flock of doves, and the smell of their half-scorched feathers became confused with the scent of the countless damp and trampled plants that lay a-rotting on the terraces. And the sky flung a column of wind like a wide-flung scarf into the distance, where the earth was turning on its never-ending hinge.[26]

In contrast to Jennings's and Madge's use of found prose to fold aspects of context back into their poetic texts, Gascoyne's prose-poetry, though skillful and symbolically dense, lends itself to a fairly conventional exegesis. The burning mansion suggests a revolutionary attack on the ruling classes, with the half-scorched doves being images of the beauty that resided in these luxurious houses, released through a violence that liberates but scars them. The rotting plants suggest the moribund nature of these aristocratic houses, the stagnancy and inability of the wealthy to sustain any genuine life. And on the horizon of change—the edge of the turning world—the sky seems to lift a banner in approval and to communicate the demand for revolution worldwide.

The sequence "Automatic Album Leaves" is equally divergent from the "reports" of Jennings and Madge, even though its title suggests the second-order representation that characterized their use of found prose. The modifier "automatic" has particular connotations in the surrealist vocabulary that suggest the very opposite of the usual sense of mechanical and habitual. For André Breton, psychic automatism was intended to express the spontaneity and secret processes of the unconscious in as uncensored and directly transcribed fashion as possible. Thus, in Gascoyne's poem, the title functions as an inventive catachresis: the free-ranging "automatism" of the unconscious mind struggling against the confining limits and "cut-out" character of the "album leaf." The tensions of this poem, in fact, show Gascoyne at his best; the diminutiveness and delicacy of the form help tame his propensity towards bathos, while he is able within these tiny frames to dance playfully across registers of language and rhetorical modes. For example, in "leaf" 5, he animates with charming wit the crumbs left on a plate or table:

> How historic and full of resonance are these crumbs! With their delightful bell-shaped dresses and their little heads like daggers they are capable of performing all kinds of aquatic tricks, such as high-life bicycling and shoe-

blacking, and they are able to peer down at leisure into the great globe that
stands in the garden. That they are energetic and truthful I can only guess,
but that their music is sweeter than parsley basins or mesmeric influences I
am certain. Observe the way they glide out of the churches, lifting their
skirts with lobster-like delicacy, watch how carefully they transform
themselves into Japanese plants and begin to scrub the floor of the travel
bureau! Every moment would be disastrous if they took no precautions
against breathing, but happily for us they have deeply-ingrained sense of
gratitude to the human race. They will never risk thinking in the ordinary,
mediocre and *sensible* way that people like ourselves do![27]

In the next "leaf," however, he inverts this rhetorical procedure of
imputing animate qualities to objects and now gives animate objectivity to
a normally inanimate abstraction. "Suffering," in "leaf" 6, becomes a
mythic character, like a dragon or sea monster:

Suffering has abundant hair and lives alone on a cliff. The walls of its
house are round and they move up and down like birds' eggs in a mirage.
Bunches of smoke like umbrellas live nearby, with trembling fingers like
glass keys on each of which some date famous in history has been written.
They shake their rattling wrists and Suffering flies up the chimney and
opens its green chemical head like a work-box. [28]

We might see in Gascoyne's "leaves" a kind of fantastic children's book,
in which the panels have become miraculously animated, like a magic
lantern show. Yet once again this "automatic" character, imparted to the
verbal or pictorial object, would be precisely the opposite of the
readymade automatism of the "reports"—akin, as Jennings recognized, to
the petrifying and fragmenting snap of the camera shutter. Gascoyne
pushes surrealist lyricism to a magical point of reversal where the limits of
the printed word are overrun and reading takes on a new physicality and
dynamism. He seeks to invest language with a dream-like animation, so
that, as he recounts in "Phenomena," one might say "the words rose from
the places where they had been printed, hovered in the air at a distance of
about six inches from my face and finally, without having much more than
disturbed my impression of their habitual immobility, dissolved into the
growing darkness."[29]

V

In concluding my discussion of the British modernist prose poem and
its ties to the documentary aesthetic of the "report," I want briefly to
discuss the animator, illustrator, documentary filmmaker, and poet Len

Lye. Although Lye was neither officially a surrealist nor a Mass Observer, his ties with both groups were substantial. Moreover, he had directly collaborated with Humphrey Jennings in Grierson's G.P.O film unit, where individually both brought an innovative, poetic impulse to the genre of the documentary: Jennings in films such as *Spare Time* and *A Diary for Timothy*, Lye in *Cameramen at War* and a number of short films. The two artists, in fact, worked together in 1936 on an advertising film for Shell-Mex and British Petroleum, *The Birth of the Robot*, with Lye directing and Jennings producing and providing the color decor. Lye's poetic output, like his fellow filmmaker and painter Jennings, was small but daring. In two successive issues of the journal *Life and Letters Today*, in spring and summer of 1938, Lye published a prose poem sequence entitled "Song-Time Stuff" that offers an instructive counterpoint to the writings of Jennings, Madge, and Gascoyne.

Lye's sequence plays off a free-wheeling meditation on visual aesthetics, thought, and language against two basic discourse forms: the newspaper article or column and the popular song. The poem is a succession of short paragraphs, playfully titled in bold face like a headline or song title, and the texts waver between essay-like statement and avant-garde prose on the models of Gertrude Stein, William Carlos Williams, and the James Joyce of *Work in Progress* (soon to become *Finnegans Wake*):

CHAIR IN YOUR HAIR

Painting painting where is thy mind sting: there there under the chair: not *under* the chair says poppa Cézanne in the legs of the chair says poppa Cézanne: that old chair? Chair in you hair Cézanne Cézanne. A chair in the mind is worth none in the bush. A chair is a chair so leave it there. [30]

The underlying "argument" of this poetic text is a familiar one: Lye's own particular version of what Ezra Pound called in his imagist writings, "direct perception of the thing" or of William Carlos Williams's slogan "No ideas but in things." Yet what gives Lye's otherwise rather unoriginal aesthetic meditation its interest is his self-conscious spinning out of these thoughts on artistic originality within the "readymade" discursive frames of the newspaper and song.[31]

Typographically, the sequence strongly resembles those sections of newspapers in which tidbits of news, society gossip, or letters appear beneath a caption. In fact, the journal in which Lye's poem appears had an editor's "news in brief" section that was called "News Reel" that also alluded typographically to this format. Lye, who published regularly in

Life and Letters Today and who went on to become a director in the *March of Time* newsreel series,[32] may well have been playing off this journal's "news" format, which in turn mimics the typical layout of a daily or weekend paper. This allusion to reportage forms, then, suggests that we should see "Song-Time Stuff" as a kind of newspaper page or sequence of newsreels taking up various topics from the shifting thoughts of the painter as he meditates on his art. Here, for example, the "reporter" portrays the triviality of outer incident (a sneeze) interrupting the psychic eventfulness of dream:

EFFERVESCENT NIGHT SNEEZE

So reality brazens out conclusions for the mind till sleep is the only eno for thought. The ebb of thought is the flow of self contacting living reality in one life time. The more impinge the less the flow.[33]

As with Joyce's playing of newspaper headlines against subjective stylization in the "Aeolus" chapter of *Ulysses*, however, Lye's fictive reportage of an argument for the mind's wordless apprehension of the primordial real generates tensions and ironies.

At first glance, the irony would seem to be turned, negatively, against the discourse of journalism. In the section entitled "A HOOK UP FOR THE HUMAN LINE UP," for example, Lye directly addresses the socially and culturally leveling effects of the newspaper:

Take newspaper the far-flung human what's-on: a precise analogy with another index. After the average truth hook up some sort of general line up. Not until the last line up will average mind inherit mind as its own best footprint.

Take it now take newspaper take man about uniforms about station italian delegation man about town or philosophers' hilltop or pub and bets in the park: within some four walls each has his gall. Take inquisition lore was evermore man about sex about witches or national sploor. But now the poor are excited to read: horses and new flesh: reading is good for the poor.

Daily doings reflect personal flesh: flesh fascinates flesh according to glow with entrail revulsion fascination fascisti bathroom altar sacrificisation body beautiful personal heartthrob commune problem relation international.

When entrails are spilt the news fascination arrays them right in the readers lap.[34]

Not unlike Joyce, Lye is presenting a kind of excremental flow of events, predigested and blended into mental waste by the newspaper. He punningly

apposes the fascination of the newspaper reader with sex and violence to the more literal, scatological, and coprophagic connotations of such phrases as "Daily doings reflect personal flesh," "When entrails are spilt," and "the reader's lap." Lye's newspaper is taken into the toilet, kept on the lap during the "daily doings," and disposed of properly: "I'll leave it."[35]

Yet this rather straightforward satire is complicated by the very quality that the newspaper embodies and that seems to draw Lye's fire, its ephemerality and the mobility of its reference. For Lye also admits that he values precisely change and time. It is, then, to the song-form, with its ability to adjust itself to and artistically register the flow of time without being constrained to naturalistic reportage that Lye turns. Song—here signified by the fragmentation of words and syntax into rhythmic sound-patterns—represents for Lye a form of thought that is concrete, non-conceptual, yet fundamentally attuned to time and change. In Lye's sequence, song is given the outer form of the newspaper article but disrupts it from within. Reportage is delayed through the web of sound associations and puns, deflected from its mimetic correspondence to the mundane, and detoured out of the documentation of "daily doings" onto the pathways of mind and thought.

This deformative forming of referential language through song turns reportage into the material hum of time, a "song-time-stuff" as a de-differentiated medium that is not verse poetry nor music nor painting nor reportage. Only within this new prose-song medium, Lye suggests, can any genuine report of the mind can be given. But it will not resemble the language of journalism or even of the more subversive reportage of Mass Observation and its concern with the rituals and customs of that foreign folk, the British. It will be a new modernist-documentary hybrid, that "other report" that Jennings, Madge, and Gascoyne in their own idiom and in their own approach to the prose poem also sought to deliver—a report of the mind in its workings, or at least, as the title of one of Lye's sections indicates, "AN O.K. ECHO" of its complexities and perplexities.[36]

Notes

[1] Tyrus Miller, "Documentary/Modernism: Convergence and Complementarity in the 1930s" *Modernism/Modernity* 9:2 (2002), 225-241. © 2002 The Johns Hopkins University Press. Reprinted with permission of The Johns Hopkins University Press.

[2] Roman Jakobson, "On Realism in Art," in *Language in Literature*, eds. Krystyna Pomorska and Stephen Rudy (Cambridge, Massachusetts: The Belknap Press of Harvard University Press, 1987) 19-27.

[3] For a broader account of these developments, see my book *Late Modernism: Politics, Fiction, and the Arts between the World Wars* (Berkeley and Los Angeles: University of California Press, 1999).

[4] For an anthology of texts from *Close Up*, see *Close Up, 1927-33: Cinema and Modernism*, ed. James Donald, Anne Friedberg, and Laura Marcus (Princeton, New Jersey: Princeton University Press, 1998). For background on *transition* and an issue-by-issue contents list of all articles published in the journal, see Dougald McMillan, *Transition: The History of a Literary Era, 1927-1938* (New York: George Braziller, 1975).

[5] Georg Lukács, "The Ideology of Modernism," in *Marxism and Human Liberation*, ed. E. San Juan, Jr. (New York: Delta Books, 1973) 294-295.

[6] Viktor Shklovsky, "Symposium on Soviet Documentary: S. Tretyakov, V. Shklovsky, E. Shub, and O. Brik," trans. Elizabeth Henderson, in *The Documentary Tradition* , ed. Lewis Jacobs, 2nd Edition (New York: W. W. Norton and Company, 1979) 33.

[7] See, for example, the essays collected in Viktor Shklovsky, *Theory of Prose* , trans. Benjamin Sher (Normal, Illinois: Dalkey Archive Press, 1990) and the futurist-influenced text "On Poetry and Trans-Sense Language," *October* 34 (1985): 3-24. Shklovsky's film-writing includes work on such major films as *Dura Lex, The House on Trubnaya Square,* and the hilarious comedy of everyday life and sex in the new society, *Bed and Sofa.*

[8] W.H. Auden, *"Documentary Film. By Paul Rotha"* [1936], in *The English Auden: Poems, Essays, and Dramatic Writings, 1927-1939*, ed. Edward Mendelson (London: Faber and Faber, 1977) 355.

[9] Paul Rotha, *Documentary Film*, 3rd edition (London: Faber and Faber, 1952) 153.

[10] Kathleen Raine, quoted in Paul C. Ray, *The Surrealist Movement in England* (Ithaca: Cornell University Press, 1971) 178.

[11] *May the Twelfth: Mass Observation Day-Surveys 1937*, eds. Humphrey Jennings and Charles Madge (London: Faber and Faber, 1937) 95.

[12] Humphrey Jennings, "Three Reports," *Contemporary Poetry and Prose* 2 (June 1936): 39.

[13] André Breton and Paul Eluard, "The Pre-Natal Life of Man," *Contemporary Poetry and Prose* 2 (June 1936): 38.

[14] Kathleen Raine, Preface to Humphrey Jennings, *Poems* (New York: The Weekend Press, 1951) unpaginated.

[15] Marcel Duchamp, *The Writings of Marcel Duchamp*, eds. Michel Sanouillet and Elmer Peterson (New York: Da Capo, 1973) 26: "Use 'delay' instead of picture or painting: picture on glass becomes delay in glass—but delay in glass does not mean picture on glass—It's merely a way of succeeding in no longer thinking that the thing in question is a picture—to make a delay of it in the most general way possible, not so much in the different meanings in which delay can be taken, but rather in their indecisive reunion 'delay'—/a delay in glass as you would say a poem in prose or a spittoon in silver."

[16] Charles Madge, "Surrealism for the British," *New Verse* 6 (December 1933): 14-18.

[17] Tom Harrisson, Humphrey Jennings, and Charles Madge, "Anthropology at Home," *The New Statesman and Nation* (30 January 1937): 155.

[18] David Mellor, "Sketch for an Historical Portrait of Humphrey Jennings," in *Humphrey Jennings: Film-Maker, Painter, Poet*, ed. Mary-Lou Jennings (London: BFI, 1982) 68-69.

[19] Humphrey Jennings, "The Iron Horse" in *The Humphrey Jennings Film Reader*, ed. Kevin Jackson (Mancester: Carcanet, 1993) 227.

[20] Jennings, "The Iron Horse" 229.

[21] "Only Marcel Duchamp has taken the logical step of continuing his work as a scientist, instead of using science as material for art, and Duchamp's gesture has been lost on a world which can see no difference between his experiments on optics and those of the professional physicist."—Charles Madge and Tom Harrisson, *Mass Observation* (London: Frederick Muller, 1937) 26. See also David Alan Mellor, "Mass Observation: The Intellectual Climate" in *The Camerawork Essays: Context and Meaning in Photography*, ed. Jessica Evans (London: Rivers Oram Press, 1997) 141.

[22] The Charles Madge papers at the Mass Observation Archive, University of Sussex, contain a suggestive montage of newspaper articles entitled "In Honour of La Fontaine" (Charles Madge Papers, 19 / 3). A typed note points out that "the following observations on the human animal are all taken from the *Observer* of August 5, 1934." The eight clippings pasted to the two sheets include texts on Hitler, the police in Madrid, a diplomatic warning by Japan to the Soviet Union, British motor travel, stinging jellyfish, the importation of cats to combat a plague of mice in Italy, an attack by storks on vultures in Turkey, and the breeding habits of land crabs. Although this montage corresponds to no published prose poem text, and I have been able to locate no source material for the published report-poems, it is plausible to speculate that "In Honour of La Fontaine" represents a stage of a projected prose poem in which the newspaper material was meant to be cited or mimicked and recombined into a surrealistic mélange of natural and historical faces of the "political animal." I am grateful to Dorothy Sheridan and the staff of the M-O Archive for making these papers available to me.

[23] Charles Madge, "Landscape IV," in *Of Love, Time and Places: Selected Poems* (London: Anvil Press, 1994) 55.

[24] Madge, "Division of Labour," in *Of Love, Time and Places* 34.

[25] David Gascoyne, *Collected Poems 1988* (Oxford: Oxford University Press, 1988) xvi-xvii. Cf. Gascoyne's celebratory review of Jennings's posthumously published montage of text citations about the industrial age, *Pandaemonium 1660-1886: The Coming of the Machine as Seen by Contemporary Observers*, edited by Mary-Lou Jennings and Charles Madge and published in 1985: David Gascoyne, "Humphrey Jennings," in Gascoyne, *Selected Prose 1934-1996*, ed. Roger Scott (London: Enitharmon Press, 1998) 332-336.

[26] Gascoyne, "Three Verbal Objects", in *Collected Poems* 66.

[27] Gascoyne, "Automatic Album Leaves," in *Collected Poems* 32-33.

[28] Gascoyne, "Automatic Album Leaves" 33.

[29] Gascoyne, "Phenomena," in *Collected Poems* 40.

[30] Len Lye, "Song Time Stuff I," *Life and Letters Today* 18/11 (Spring 1938): 77-78.

[31] For the association of Williams's poetics with Duchamp, see Henry M. Sayre, "Ready-mades and Other Measures: The Poetics of Marcel Duchamp and William Carlos Williams," *Journal of Modern Literature* 8/1 (1980): 3-22; for Gertrude Stein and Duchamp, see Marjorie Perloff, "Of Objects and Readymades: Gertrude Stein and Marcel Duchamp," *Forum for Modern Language Studies* 32/2 (1996): 137-153.

[32] See Raymond Fielding, *The March of Time, 1935-1951* (New York: Oxford University Press, 1978) 93-97.

[33] Len Lye, "Song Time Stuff I" 78.

[34] Len Lye, "Song Time Stuff II," *Life and Letters Today* 18/12 (Summer 1938): 95.

[35] Lye, "Song Time Stuff II" 95.

[36] Len Lye, "Song Time Stuff I" 80.

CHAPTER EIGHT

DISMANTLING AUTHENTICITY:
BECKETT, ADORNO, AND THE "POST-WAR"[1]

"You don't even live once."
—Karl Kraus

I

Against a dominant background of "absurdist" readings of Samuel Beckett's work in the 1960s, Theodor Adorno sounded a new note in his late critical essays and philosophical writings. Flying in the face of the Irish playwright's seeming lack of social concern, Adorno's readings sought to uncover precisely the historical and political dimensions of Beckett's writings. For Adorno, Beckett's works both accurately figured the historical situation after the Second World War and provided a model for a critical—that is, *political*—art of that period. Accordingly, Adorno measured other artistic and cultural stances against Beckett's austere standard. He explicitly counterposed Beckett's uncompromising outlook and technique to three of the most influential post-war cultural tendencies: German existentialism, committed literature, and socialist realism.

Adorno's most sustained discussion of Beckett is his 1961 essay entitled "Trying to Understand *Endgame*." This text bore the dedication "To S.B. in memory of Paris, Fall, 1958," indicating at least one personal contact between the pessimistic philosopher and the tragi-comic writer.[2] Beckett stands at the centre of two other key essays as well: "Reconciliation under Duress," a polemical review in 1958 of Georg Lukács's influential defense of socialist realism, *The Meaning of Contemporary Realism*; and a critical blast called "Engagement" ("Commitment").[3] This latter article, first delivered as a radio lecture in March 1962 and published later that year in *Die Neue Rundschau*, was Adorno's response to the German translation of Jean-Paul Sartre's notorious call to engaged literature, *What Is Literature? (Was Ist Literatur?* Hamburg: 1958). The first French version of Sartre's essay had appeared over a decade earlier and registered

Sartre's position in the immediate post-war situation in French literature and society. Its belated appearance in Germany gave Adorno the opportunity not simply to consider the ostensive issue of committed literature, but also to explore a more general problem: the symptomatic *Nachträglichkeit* in German (and ultimately, European) cultural responses to the war.

Beckett's emergence as a cultural figure in Germany, including his strong personal involvement with German productions of his plays, began in the early 60s (although *Waiting for Godot* made its German debut in 1953-54).[4] It is at this point, too, that Adorno appears to have drawn Beckett's work into his general horizon of concerns, which at that moment also included the construction of the Berlin Wall in 1961 (alluded to in his discussion of Beckett's "rival" playwright in "Commitment," Bertolt Brecht) and the commencement of the Auschwitz trials in Adorno's home city of Frankfurt in 1964. A flurry of activity by Beckett coincided with these crucial political events. The year 1961 saw the publication of Beckett's first novel since the trilogy, *Comment c'est*. In the fall of that year, Beckett's *Happy Days* was staged at the Schiller Theater Werkstatt to mixed but generally positive reception.[5] In 1963, Beckett made a lengthy trip to Germany to oversee the production of *Play* in Ulm-Donau.[6] In 1964 Beckett's *Comment c'est* appeared in his own English "translation" as *How It Is*. While it is wise to observe Jack Zipes's cautionary note about linking the *facts* of Beckett's German reception to "an overall social and political temper,"[7] Adorno nevertheless makes very bold claims for the social *significance* of the work itself, independent of questions of reception. Indeed, from a sociological perspective it would appear ludicrous to consider these political and literary events as equally consequential; yet Adorno's allegorical interpretations do precisely that. His interpretive procedures wrest from a seemingly detached cultural fragment—a Beckett play, for instance—a much vaster significance than is immediately manifest.

Adorno sought in his work of the sixties to illuminate the lingering presence of the war in the "post-war" society through the dark lens of Beckett's art. The three essays I have mentioned are essential for Adorno as programmatic statements of his post-war politics of art. Nevertheless, they are less important than Adorno's last several books in exhibiting the profound impact Beckett had on his thought, even in those books which do not refer directly to Beckett. Especially in *The Jargon of Authenticity*, *Negative Dialectics*, and his unfinished *Aesthetic Theory*, which was to have been dedicated to Beckett, Adorno took Beckett's radical negativity

and resistance to any consoling reconciliation with the world as a model of the proper critical stance towards the culture of the post-war.

In these books, Adorno strove to catch up in theory to Beckett's artistic insight into contemporary historical reality, as well as into the reality of history as such after the Year Zero, 1945: the end of history or its new beginning, depending on how one interpreted the figure. Moreover, Beckett constituted for Adorno undeniable proof of the possibility of autonomous art in the post-war period. Beckett's work occupied a structural position in society for art which Adorno was at pains to defend, against the kitsch of the culture industry on one side and the subordination of art to social function in committed literature and socialist realism on the other. At the same time, Beckett was painfully honest about the difficulties this position entailed. He made no attempts to conceal its precariousness, teetering at the brink of a self-abdication of art altogether.[8]

II

It is this situation that Adorno addresses in his now notorious opening to the *Aesthetic Theory*: "It is self-evident that nothing concerning art is self-evident anymore, not its inner life, not its relation to the world, not even its right to exist."[9] Yet this problematic nature of art defines for Adorno its truthfulness in a world where the systematic liquidation of civilization was a fact of the recent past and in which the continuation of the human species was in doubt due to the nuclear inheritance of the last war. Although art remains weak and at time even serves the interests of domination, Adorno insists that "in an age of incomprehensible horror, Hegel's principle, which Brecht adopted as his motto, that truth is concrete, can perhaps suffice only for art. . . . The darkening of the world makes the irrationality of art rational: radically darkened art."[10]

I do not intend here to explicate the battery of complex and interwoven arguments Adorno employs to justify these claims for art. I want to focus instead on just two local aspects of Adorno's argument, crucial for his understanding of Beckett: the conception of *form*, which articulates the "inner historicity" of the artwork with the external history of nature and society; and the conception of *mimesis*, which relates the artwork's form and the situation of the human subject in nature and society.

Adorno argues in the *Aesthetic Theory* that aesthetic form mediates between the "internal" features of the artwork (its inner consistency and its relation to a history of other related works) and its "external" context (its situation in social history and the history of the human appropriation of nature). At first, Adorno appears to have taken up the old form-content

polarity of traditional aesthetics. Yet he works immediately to dissolve the
rigidity of that opposition. The artwork, he argues, is not self-identical, but
a tense yoking of irreducible antipodes. It appears at once as a self-
contained artifact *and* as a vehicle of meaning, a mimetic internalization of
a content heterogeneous to art. The creation of forms that can bring these
two aspects together in single works is the task of the artist—a task no less
impossible to fulfill than necessary to pursue, if art is to exist at all.

 This paradoxical status of artworks forces us to think of them not as
static objects, but as dynamic force fields that develop, intervene, produce
effects, yield to historical pressures, fracture, and perhaps eventually pass
away. Adorno writes:

> It is an implicit part of artworks that they are artifacts. The configurations
> sedimented in each address the context from which it issued. In each its
> likeness to its origins are thrown into relief by what it became. This
> antithetic is essential to its content. . . . This is not the least of the reasons
> why an artwork is adequately perceived only as a process.[11]

If we valorize one pole of artistic form without the other, we betray what
for Adorno is the essence of art: its very occupation of a fragile space
between self-sufficiency and subordination to social function. If we
overemphasize the artifactual nature of art, which grants the artwork its
inner consistency, we make of the object a fetish and lapse into the cult
function from which art had earlier won its autonomy. Yet neither should
one hypostasize form as a mere container for social content: artworks
should not be treated as nothing more than documents. For Adorno, the
significance of the artwork's artifactual character is its resistance to
instrumental puposiveness. The artwork as artifact insists on its singularity
as object, and thus represents the structural difference of art itself: its
endurance as a social practice that cannot be reduced to the instrumental
complex of state and economy.

 How does Adorno conceive of the relations between these two poles of
the artwork's existence? In what way do artworks express a social truth
value? Adorno uses the metaphorical terms "crystallization" or
"sedimentation" to describe the figuration of social content in form. These
terms describe the production process of artworks, which takes place in the
context of broader social antagonisms, a given technology, and a particular
stage of the human domination of nature through rational thought. Without
being copied or directly reproduced in artworks, these contextual
parameters limit and shape the artistic production process. Yet while
Adorno's concept of form relates artistic labour and its products to social
relations of production as a whole, it does not explain the figural

correspondences that Adorno claims exist between artworks and social relations. To understand the figural dimensions of the works, we must consider a second element of Adorno's aesthetics: his peculiar theory of mimesis.

Adorno argues that mimesis was the means by which humanity first individuated itself from a nature that constantly threatened to engulf it, nature conceived as the site of unnamed, terrifying forces. Mimesis was the basis of the mythologization of nature, the "name's breaking into the chaos of the unnamed" (in Franz Rosenzweig's phrase): the first appearance of human rationality, at the heart of the mythic world. For Adorno, the paradigm for mythic behaviour is Odysseus's deceptive escape from the Cyclops in Book Nine of *The Odyssey*. Odysseus escapes from the Cyclops by miming the sound of his own name; he calls himself Udeis, "Nohbdy," in order to ensure his concealment from the already blinded Cyclops:

> Out of the cave
> the mammoth Polyphemos roared in answer:
> "Nohbdy, Nohbdy's tricked me, Nohbdy's ruined me."
> To this rough shout [the others] made a sage reply:
> "Ah well, if nobody has played you foul
> there in your lonely bed, we are no use in pain
> given by great Zeus" So saying
> they trailed away. And I was filled with laughter
> to see how like a charm the name deceived them.[12]

Here Odysseus has appropriated the mythic power of the great Zeus himself, to give pain, by miming his own name and using it magically, as "charm" or "spell." Yet in a more profound sense, Odysseus also mimics the Cyclops himself, who only gets his mythological name in Homer's epic because Odysseus has already won, because he has preserved himself from death at the hands of the unnamed mythic terror and survived to tell his tale. Hence, Adorno writes:

> The calculation that, once blinded, Polyphemus would answer his tribesmen's questions as to the source of his anguish with the word "Nobody!" . . . is only a thin rationalistic covering. In reality, the subject Odysseus denies his own identity, which makes him a subject, and keeps himself alive by imitating the amorphous. He calls himself Nobody because Polyphemus is not a self[.][13]

The Cyclops wants literally to assimilate Odysseus: the Ithacan will be the monster's dinner. Odysseus saves himself by pre-empting the Cyclops, by

shamming his assimilation to the Cyclopean "no-man" through word-play with his own name. Odysseus grasps the form of his name, which allows him to distance himself from immediate reality, just as artistic form will later bracket its content into the virtual existence of the work. Odysseus's stratagem, Adorno notes, is a "linguistic adaptation to death": "he saves himself by losing himself."[14] To anticipate my concluding discussion, I would argue that it is possible to understand *Endgame*'s "gaming" aspect, its internal staging of theatricality, and perhaps the historical existence of Beckett's play itself as a recapitulation of Odysseus's mimetic play—a forestalling of death in the face of unnamable terror, not the creaturely excess at the dawn of human history but the mineral emptiness looming beyond its twilight.

Works of art, both structurally and historically, embody and rationalize mimetic behaviour; we can reflect on Odysseus because Homer sang about him in an epic poem. In being incorporated by the rational, form-giving element of artistic practice, mimesis becomes modified and takes up a potentially critical position with respect to the constellation of the subject and nature in which mimetic behaviour originated. Hence, in the *Aesthetic Theory*, Adorno draws a clear distinction between mimetic behaviour as an equivocal mastery of a terrifying nature and mimesis as a component of art. He writes:

> If mimetic comportment does not imitate something but rather makes itself like itself, this is precisely what artworks take it upon themselves to fulfill. In their expression, artworks do not imitate the impulses of individuals, nor in any way those of their authors; in cases where this is their essential determination, they fall as copies precisely to the mercy of that reification that the mimetic impulse opposes. At the same time artistic expression enforces on itself history's judgment that mimesis is an archaic comportment, that as an immediate practice mimesis is not knowledge, that what makes itself like itself does not become truly alike, that mimetic intervention failed. Thus mimesis is banished to art that comports itself mimetically, just as art absorbs the critique of mimesis into itself by carrying out the objectivation of this impulse.[15]

In the art object, art distances itself both from the rational domination of nature which criticizes mimesis and from the irrational assimilation to nature which mimesis entails. Like mimetic behaviour, by which the subject first comes into being, the artwork must master unformed material through the rationality of form; the work in turn becomes the vehicle by which mimesis is framed and preserved.

Adorno specifically applies his analysis of mimesis to Beckett's work, both in his *Endgame* essay and in the *Aesthetic Theory*. Beckett's

Endgame, Adorno argues, stages a situation in which the work of art has become impossible, in which the characters can no longer impose rational form on their play and fall back into anxious mimetic adaptation to invisible terror. It is the drama of the self-abdication of the Western subject:

> The iron ration of reality and people, with whom the drama reckons and keeps house, is one with that which remains of subject, mind, and soul in the face of permanent catastrophe: of the mind, which originated in mimesis, only ridiculous imitation; of the soul—staging itself—inhumane sentimentality; of the subject its most abstract determination, actually existing and thereby already blaspheming. Beckett's figures behave primitively and behaviouristically, corresponding to conditions after the catastrophe, which has mutilated them to such an extent that they cannot react differently—flies that twitch after the swatter has half smashed them.[16]

Similarly, in the *Aesthetic Theory*, Adorno stresses Beckett's figuring of the contemporary situation of subjectivity, a situation characterized in his view by dehumanization, loss of individuation, and mimetic adaptation to the historical horizon of war and its aftermath:

> Because the spell of external reality over its subjects and their reactions has become absolute, the artwork can only oppose this spell by assimilating itself to it. At ground zero, however, where Beckett's plays unfold like forces in infinitesimal physics, a second world of images springs forth, both sad and rich, the concentrate of historical experiences that otherwise, in their immediacy, fail to articulate the essential: the evisceration of subject and reality. This shabby, damaged world of images is the negative imprint of the administered world. To this extent Beckett is realistic.[17]

In the end, Adorno concludes, Beckett's work is an attempt to establish through art a perspective from which the subject can reflect on the damage that has been inflicted upon it—a place from which consciousness can begin "to look its own demise in the eye, as if it wanted to survive the demise."[18]

III

Taken together, the two elements of Adorno's aesthetics I have discussed—the sedimentation of historical content in the artifact through form; and mimesis, which relates artworks to more general structures of

subjectivity—lead me to my own reading of *The Lost Ones* and *Endgame*. In the remainder of this chapter, I will extend Adorno's explication of Beckett's work as a sign on the post-war historical horizon. At the same time, I want to underscore the link between Adorno's critique of existentialism and his understanding of the historical problematic of Beckett's work.

In *Endgame* and *The Lost Ones*, Beckett responds to the historical and experiential fact of *mass* death, which reached an unprecedented intensity in the Second World War. Edith Wyschogrod, in *Spirit of Ashes*, argues that the mass death signified by the names Auschwitz and Hiroshima "cannot be avoided: present-day life is related to them as figure to ground."[19] "[T]he meaning of self, time, and language are all affected by mass death: from now on the development of these themes and the meaning of man-made mass death wax and wane together."[20] In particular, mass death throws in doubt a conception of death present in Western culture at least since Socrates, which continues through Christianity into existentialism: what Wyschogrod calls the "authenticity paradigm."[21]

The authenticity paradigm, briefly stated, is the belief that the moral quality of a person's life and the meaningfulness of his or her death stand in a direct relation to one another. If one has lived a good life, one also may die a good death. In *Being and Time*, Heidegger radically recasts this paradigm, while ultimately retaining its basic structure. In being-towards-death, Heidegger claims, *Dasein* achieves its mode of authenticity. Death, anticipated, reveals *Dasein*'s ownmost possibility for existence.[22] But how does this authenticity, this meaningful relation between life as lived and its final end, come about?

Being-towards-death, in Heidegger's view, establishes the radical finitude of an individual's being within the transcendental horizon of time itself, concretely embodied in the tradition of a community, people, or nation. The individual's fate is unique and unsharable in so far as only s/he alone can experience the necessity of her or his own coming to an end. Yet whether the individual's fate conflicts or harmonizes with the goals of the community, it is always against the trans-individual duration of the community that the meaning of an individual's being—*Dasein*—emerges. As that which necessarily outlives the individual, the community confronts the individual as the embodied anticipation of his or her death. Authenticity emerges when the individual grasps these two perspectives at once, the closure of the individual's being within the openness of communal time. Authenticity allows *Dasein* to recognize its ownmost possibility as inseparable from the historical tasks of a nation or people. The individual's being-towards-death becomes the highest expression of a

will to community.[23] In particular, Heidegger's thought here draws on a tradition of reflection on tragedy, a crucial philosophical topic since the heyday of German idealism. Heidegger's authenticity is first and foremost a tragic view of existence.[24] In the necessary downfall of the tragic hero, here *Dasein* itself, its very individuation through death, an individual fate fulfills a communal destiny.

The historical significance of Beckett's texts and their importance to Adorno in his polemic against existentialism lies in their exploration of the rupture of this key cultural paradigm under the pressure of the war. Existentialism, according to Adorno, takes death as something fundamental, radically individual and individualizing—hence, not itself open to investigation. It remains an ontological axiom—in Heidegger's words, "Death *is*"—which is used to ground other concepts like authenticity. In Adorno's view, however, the individual's relation to mortality is not, as the existentialists would have it, primordial. In an epoch of mass death, the possibility of a morally indifferent death interposes itself between individual lives and their possible posterity in death. Death now becomes an administered, impersonal, and collective fiat, in which neither the individual nor the community has any real say. In such circumstances, the individual's relation to mortality derives from the social conditions that mediate between individuals and death, conditions that include both the extreme technological domination of nature and intense political and technical domination of human beings. Within this horizon, death itself may be collectively organized and, in the case of the concentration camps, even mass-produced in the interest of political and economic power. Moreover, when the future of the community as a whole (or perhaps even of the human species) may no longer be casually assumed, one's commemoration by generations to come makes uncertain compensation for present suffering. The profound credit of posterity devalues to a dubious paper money.

Beckett's *Endgame* and *The Lost Ones* register, both formally and thematically, the implications of man-made mass death for the human subject. As Edith Wyschogrod has characterized them, these manifestations include the general "death event" as well as a specialized aspect of that event, the "death-world."[25] She defines the "death event" in terms of three elements:

recent wars which deploy weapons in the interest of maximum destruction of persons; annihilation of persons, through techniques designed for this purpose (for example famine, scorched earth, deportation) *after* the aims of war have been achieved or without reference to war; and the creation of death-worlds, a new and unique form of social existence in which vast

> populations are subjected to conditions of life simulating imagined
> conditions of death, conferring upon their inhabitants the status of the
> living dead.[26]

For Beckett's works, the death event (such as Wyschogrod describes) is
almost presupposed as a "normal" horizon. A catastrophe of nature, of the
body, of narration, of language, has already occurred, even in those works
which seem to have nothing to do with the war: *Watt*, for example, written
in 1944 while Beckett was hiding out in southern France; or the post-war
trilogy, in which the "shambles," the slaughterhouse, is the constant
backdrop of the narrator's ongoing attempt to die. But in *The Lost Ones*
and *Endgame*, Beckett systematically explores the experiential
implications of a new, concrete historical phenomenon arising out of the
Second World War: the organization of death-worlds.

A death-world, as Wyschogrod defines it, is an "attempt to make
whole the broken cosmos by an imaginative act of radical negation, the
destruction of the embedding matrix for all social forms, the life-world,
and by consigning to itself all that seems worthy of death."[27] The creation
of death-worlds presupposes a principle of selection, by which a group is
constituted as the object of systematic annihilation. In one version, as in
the concentration camps, the death-group is spatially removed from
familiar surroundings, enclosed, compressed, reduced to a narrow circle,
and gradually eliminated. Adorno notes that this same formal principle
underlies Beckett's constructions:

> Beckett, indifferent to the ruling cliché of development, views his task as
> moving in an infinitely small space toward what is effectively a
> dimensionless point. This aesthetic principle of construction, as the
> principle of *il faut continuer*, goes beyond stasis; and it goes beyond the
> dynamic in that it is at the same time a principle of treading water and, as
> such, a confession of the uselessness of the dynamic.[28]

Beckett's *récit The Lost Ones* narrates the gradual capitulation of the
inhabitants of a confining cylindrical chamber. Its construction, from a
series of paragraphs of varying length, is totally determined through the
bit-by-bit articulation of the machinery by which these "lost ones" are led
to bow their heads and remain still. In a cold, almost scientific language,
Beckett describes the space, its environment, its inhabitants, the customs
and unofficial rules that govern in the crowded chamber. He progressively
reveals an elaborate organizational structure with distinct divisions
between the mobile and the static, and a ranking system that corresponds
to spatial zones: searchers, who wander the center of the chamber;

watchers, who move slowly around the periphery; climbers, at the wall, who use ladders to climb to niches set into it; and the vanquished or dead scattered here and there. The last paragraph imagines the final end:

> So on infinitely until towards the unthinkable end if this notion is maintained a last body of all by feeble fits and starts is searching still. There is nothing at first sight to distinguish him from the others dead still where they stand or sit in abandonment beyond recall. . . . But the persistence of the twofold vibration suggests that in this old abode all is not yet quite the best. And sure enough there he stirs this last of all if a man and slowly draws himself up and some time later opens his burnt eyes. . . . [He] opens then his eyes this last of all if a man and some time later threads his way to that first among the vanquished. . . . He himself after a pause impossible to time finds at last his place and pose whereupon dark descends and at the same instant the temperature comes to rest not far from the freezing point. Hushed in the same breath the faint stridulence mentioned above whence suddenly such silence as to drown all the faint breathings put together.[29]

Beckett builds up his text by relentlessly stripping away meaning. Its considerable complexity ultimately serves to annihilate its characters, impoverished even at the story's beginning. The regulative formal principle of his text is thus, as in the death-world itself, the null point.[30]

Endgame, while characterized by a restriction of space analogous to that in *The Lost Ones*, nevertheless emphasizes the *temporal* immanence of total annihilation. While the survivors are separated from the dead by their enclosure in the shelter—"Outside of here," Hamm reminds Clov, "it's death!"[31]—the main point seems to be the impossible paradox of living on while anticipating extinction. Beckett originally had in mind a more spatially and temporally determinate setting for the play, as an earlier version of the text reveals. That draft, now in the Reading Library, situates the action in Picardy, where a catastrophe had mysteriously occurred between 1914 and 1918, thus during the First World War.[32] Once these spatial and temporal markers are erased, however, Hamm's "outside" may refer as much to being free of the stalled no-time of the endgame, as being no longer confined to the shelter. Spatial figures and temporal figures signify only the collapse of signification into the emptiest of signifieds, death:

> *Hamm*: And the horizon? Nothing on the horizon?
> *Clov*: What in God's name could there be on the horizon?[33]

As Wyschogrod notes, this emptying out of language is a characteristic phenomenon of the death-world. Words like "work," "shower," "loading platform," "infirmary," "transfer," even proper names like "Bach" and "Mozart" all signify for the inhabitant of the extermination camps the same thing: death.

In *Endgame*, Beckett explores the relation between two distinct modalities of death. In the first instance, death appears as the general figure for negativity, the motor of the dialectic of history, and hence the general condition for any trans-individual horizon of meaning. In contrast, death is also mere creaturely decay, the crumbling of the organism. Hamm and Clov appear singled out to survive the end of negativity, the *death of death* (in the first sense), which would nevertheless not be the redemption that Christianity promised in Christ under the slogan: "and death will die and death will be no more." Mere death, as Hamm and Clov seem to say, is unbearable to consciousness, no matter how desirable it might be to the body, without any possibility of absorbing it into a context of shared meanings, in order to lend the event value. That context is precisely what is missing with the collapse of history and nature in *Endgame*.

What is left at the end of history?—Play. Malone had already, in 1946, named that time without horizon: "I knew there would be an end to the long blind road. . . . It is playtime now."[34] Hamm and Clov restage again and again the primal drama of self-assertion through play, through mimetic behaviour, but now in the face of an unnamable terror that waits beyond the end. They play at dying so as not to have to die. The circular structure of their play, of Beckett's play, which poises Clov at the threshold of the door, leaves open the possibility of an infinite repetition, just as Krapp can rewind his "last" tape and play it again and again. Art becomes implicated in this deferral of death through mimesis. For the ideality of form (as with Odysseus's name) would protect the players and their game from the destructive touch of empirical reality. As Adorno puts it, "autonomous art is a work of contrived immortality."[35] Hamm, in attempting to write his story, in his constant "hamming," in his Shakespearean antics, at once the histrionics of King Lear and the melancholic eloquence of Prince Hamlet, desires to enshrine his dying in a work of art, to disappear into it wholly, without residue. The real "refuge" would then become the play itself: the play of Hamm and Clov in the room, and the play *of* Hamm and Clov, *Endgame*.

The catastrophe that has occurred, however—the abolition of historical negativity, the end of history—likewise undermines the very conditions of autonomous art. Hamm wants to stage his suffering as a great tragedy. But

tragedy presupposes the distinction of individual suffering, whereas in the death-world, all suffering is impersonal, equivalent—equally meaningless:

> *Hamm*: Can there be misery—
> —loftier than mine? No doubt. Formerly.
> But now?
> My father?
> My mother?
> My . . . dog?
> Oh I am willing to believe they suffer as much as such creatures
> can suffer. But does that mean their sufferings equal mine?
> No doubt.[36]

Nietzsche one claimed that man invented the gods and genii of the air in order to play the role of spectator to his own suffering. So long as it was visible, a spectacle for others, suffering could be thought to have meaning. But Hamm suffers not so much from suffering, as from the meaninglessness of suffering in a world in which no spectators are left to witness his dying.

The absence of the horizon represents the loss of that posterity which once served as a spectator of suffering, that collective transfiguration of the work of dying into an artful spectacle for the future. It makes all the difference in the world that Lear has a survivor to witness his suffering and say: "O, let him pass! He hates him / That would upon the rack of this tough world / Stretch him out longer." Hamlet's body, similarly, is literally put on stage after his death and spoken over. But meaning is foreclosed when the spectacle plays to an empty house:

> *Hamm*: We're not beginning to . . . to . . . mean something?
> *Clov*: Mean something! You and I, mean something!
> Ah that's a good one![37]

This absence of horizon, however, is not simply symbolic, something thematized and represented in the play as absent. It is also literally absented by Beckett, who insists on the total immanence of the theatrical space. In fact, the horizon is trebly absent: for Clov, who looks out the window, it is not there; for Hamm, who is blind and cannot see what Clov does not see; and for the spectator, who is positioned perpendicular to the windows at stage right and left, and hence is barred from seeing what Hamm cannot see and Clov does not see. Everyone—Clov, Hamm, and the audience—stares into the blind not-eye of the horizon, in order not to see what was not there to see in the first place. By underscoring in this way the invisibility of that which is not there to see, Beckett also points to

the absence of the invisible as such. There is nothing that is not there to be seen, right there on stage; it is only that there is so little to be seen there as well. Thus even palpably bad things have disappeared into the single terrifying not-yet of death:

> *Clov*: There are so many terrible things.
> *Hamm*: No, no, there are not so many now.[38]

The chessboard suggested metaphorically in the title has its real analogue in the structuring of the space in the play: its progressive stripping away of image, and its gestures to the *grid* which the characters still partly conceal, so long as they survive. The grid: a purely conceptual, infinitely replicable, infinitely divisible, and most importantly, radically inhuman figure. As Rosalind Krauss notes, the grid has haunted modernism, announcing "among other things, modern art's will to silence, its hostility to literature, to narrative, to discourse."[39] It is anti-mimetic, anti-empirical, totally conventional and rational. It does not develop. Its "bottom line . . . is a naked and determined materialism."[40] Its appearance in Beckett announces "no more play": the end of theatre, of the endgame, of *Endgame*.

Krauss also points out that the grid "states the autonomy of the realm of art."[41] In this light, then, it is significant that the grid is precisely *not* realized in *Endgame*: the play goes on, able neither to transcend itself nor to abolish play altogether. In essence, what is staged in *Endgame* and through *Endgame* is the impossible position of autonomous art itself in the post-war period; this impossibility becomes the substance of the work. As Adorno writes:

> In *Endgame* the tellurian partial catastrophe . . . is presupposed both thematically and formally in that it has obliterated art's constituent, its genesis. Art emigrates to a standpoint that is no longer a standpoint at all because there are no longer standpoints from which the catastrophe could be named or formed, a word that seems ridiculous in this context. *Endgame* is neither a play about the atom bomb nor is it contentless; the determinate negation of its content becomes its formal principle and the negation of content altogether.[42]

In negating any ascertainable historical reference, Beckett manages to place at the centre of his work the unmanifest, because unmanifestable, reality of history in the post-war epoch: its absence, its horizonlessness. At the same time, Beckett squeezes one last "I'll go on" out of an autonomous art, by giving artistic form to its penultimate "I can't go on."

Beckett manages to circumscribe the abolition of history into a structured work of art. His play thus represents an anticipatory fulfillment of something that has not yet happened in our history, because it cannot happen *in* history. The critical function of Beckett's work lies not in anything it presents, but in that which as art it withholds from the manifest, the historical world. Here art defends that utopian reserve of history that can only be thought differentially: as the non-phenomenal, the un-present. For Beckett's art makes available for thought the truly unrepresentable checkmate, an end of history that would coincide with the death of each individual, an historical apex that inaugurates the unhistorical, oblivious night. *Endgame* plays in a paradoxical time both before the end of history, in the time of waiting for the end to arrive, and after it, in the horror of surviving that catastrophe and having still to die. We, Beckett's readers, are both those who wait and those who have, unaccountably, unjustifiably, survived. It is this untimeliness—both Beckett's and our own—that grants its work its historical voice.

Notes

[1] Originally published as "Dismantling Authenticity: Beckett, Adorno, and the 'Post-War'." *Textual Practice* 8/1 (Spring 1994) 43-57.

[2] Theodor Adorno, "Trying to Understand *Endgame*," trans. Michael T. Jones, *New German Critique*, 26 (1982) 119.

[3] Both essays appear in *Aesthetics and Politics* (London: New Left Books, 1977) 151-76.

[4] Jack Zipes, "Beckett in Germany/Germany in Beckett," *New German Critique*, 26 (1982) 153.

[5] Deirdre Bair, *Samuel Beckett: A Biography* (New York: Harcourt Brace Jovanovich, 1978) 538.

[6] Bair 560.

[7] Zipes 154.

[8] For an insightful full-length study of the relation between Adorno and Beckett see Martin W. Lüdke, *Anmerkungen zu einer "Logik des Zerfalls": Adorno-Beckett* (Frankfurt a/M: Suhrkamp Verlag, 1981). Lüdke's study concentrates, however, on tracing through Adorno's work this "logic of decay," which he in turn discovers permeating Beckett's artistic work as well. His discussion of key themes like mimesis and the philosophy of nature in Adorno has been helpful to me; his discussion of Beckett, in contrast, is much more limited in scope and focused on themes different from those I treat here. For this reason, in spite of its value, I have not cited this work more specifically in this paper. A more limited, English language treatment of the Beckett-Adorno relation is W. J. McCormack's essay "Seeing Darkly: Notes on T. W. Adorno and Samuel Beckett," *Hermathena* 141 (1986) 22-44. Other works that focus on Adorno's conception of mimesis include

Josef Früchtl, *Mimesis: Konstellation eines Zentralbegriffs bei Adorno* (Würzburg: Königshausen & Neumann, 1986); Karla L. Schultz, *Mimesis on the Move: Theodor W. Adorno's Concept of Imitation* (Berne: Peter Lang, 1990); Michael Cahn, "Subversive Mimesis: T. W. Adorno and the Modern Impasse of Critique," in *Mimesis in Contemporary Theory: An Interdisciplinary Approach*, vol. 1: The Literary and Philosophical Debate, ed. Mihai Spariosu (Philadelphia/Amsterdam: John Benjamins Publishing Company, 1984) 27-64; and Gunter Gebauer and Christoph Wulf, "Lebendige Erfahrung (Adorno)," in *Mimesis: Kultur-Kunst-Gesellschaft* (Reinbek bei Hamburg: Rowohlts Enzyklopädie, 1992) 389-405.

[9] Theodor W. Adorno, *Ästhetische Theorie*, ed. Gretel Adorno and Rolf Tiedemann, *Gesammelte Schriften*, Bd. 7 (Frankfurt a/M: Suhrkamp Verlag, 1970) 9; hereafter cited as *ÄT*. English Translation: *Aesthetic Theory*, trans. Robert Hullot-Kentor (Minneapolis: University of Minnesota Press, 1997) 1.

[10] *ÄT* 35; *Aesthetic Theory* 18-19.

[11] *ÄT* 446; *Aesthetic Theory* 301.

[12] Homer, *The Odyssey*, trans. Robert Fitzgerald (Garden City, NY: Doubleday, 1961) 157.

[13] Max Horkheimer and Theodor Adorno, *Dialectic of Enlightenment*, trans. John Cumming (New York: Continuum, 1982) 68.

[14] Horkheimer and Adorno 60.

[15] *ÄT* 169-170; *Aesthetic Theory* 111.

[16] Adorno, "Trying to Understand *Endgame*," 128

[17] *ÄT* 53; *Aesthetic Theory* 31.

[18] "Trying to Understand *Endgame*," 150.

[19] Edith Wyschogrod, *Spirit in Ashes: Hegel, Heidegger, and Man-Made Mass Death* (New Haven: Yale University Press, 1985) ix.

[20] Wyschogrod ix.

[21] Wyschogrod 3.

[22] Martin Heidegger, *Being and Time*, trans. John Macquarrie and Edward Robinson (New York: Harper & Row, 1962), II.1, especially para. 53; also II.3, para. 62.

[23] For a subtle discussion of the political decisionism implicit (and at key moments, explicit) in Heidegger's philosophy of the *Time and Being* period, see Philippe Lacoue-Labarthe, "Transcendence Ends in Politics," in *Typography: Mimesis, Philosophy, Politics*, ed. Christopher Fynsk (Cambridge, Mass.: Harvard University Press, 1989) 267-300. Cf. Lacoue-Labarthe, *Heidegger, Art and Politics*, trans. Chris Turner (Oxford: Basil Blackwell, 1990), for an extension of these arguments in the context of the debates which followed the publication of Victor Farias's *Heidegger et le nazisme*.

[24] Gerald Bruns makes this argument with respect to both Heidegger's and Hans-Georg Gadamer's conception of hermeneutical experience: "On the Tragedy of Hermeneutical Experience," *Research in Phenomenology*, XVIII (1988): 191-201.

[25] Wyschogrod 15-16.

[26] Wyschogrod 15.

[27] Wyschogrod 28.

[28] *ÄT* 333; *Aesthetic Theory* 224.

[29] Samuel Beckett, *The Lost Ones* (New York: Grove Press, 1972) 62-63.

[30] Wyschogrod 38. Cf. my discussion of the logic of torture in Beckett's late drama in "Beckett's Political Technology: Expression, Confession, and Torture in the Later Drama" in *Singular Examples: Artistic Politics and the Neo-Avant-Garde* (Evanston, Illinois: Northwestern University Press, 2009) 189-214.

[31] Samuel Beckett, *Endgame* (New York: Grove Press, 1958) 70.

[32] Charles R. Lyons, *Samuel Beckett* (New York: Grove Press, 1983) 68.

[33] Beckett, *Endgame* 31.

[34] Samuel Beckett, *Malone Dies*, in *Three Novels: Molloy. Malone Dies. The Unnameable* (New York: Grove Press, 1955, 1956, 1958) 182.

[35] *ÄT* 209; *Aesthetic Theory* 139.

[36] Beckett, *Endgame* 2.

[37] Beckett 32-33.

[38] Beckett 44.

[39] Rosalind E. Krauss, "Grids," in *The Originality of the Avant-Garde and Other Modernist Myths* (Cambridge, Mass.: MIT Press, 1985) 9.

[40] Krauss 10.

[41] Krauss 9.

[42] *ÄT* 371; *Aesthetic Theory* 250.

CHAPTER NINE

THE ASHES OF CIVIC POETRY:
PASOLINI AND PHILOLOGY AFTER GRAMSCI

In a rather unassuming note in the *Prison Notebooks* of the early 1930s, Antonio Gramsci responded to a review of a book by Enrico Sicardi entitled *La lingua italiana in Dante*. He notes that Sicardi argues that if one wishes to interpret an author's "poetic world" correctly, one must study his or her "language" (a word that Gramsci puts in quotation marks, to indicate that it refers to an author's particular ideolect and sociolect in historical context). Gramsci remarks in response to this methodological precept as follows:

> I do not know if everything Sicardi wrote is correct, especially whether it is "historically" possible to study the "particular" languages of individual writers, *given that* an essential document is missing: i.e., there exists no extensive evidence about the spoken language of these writers' times. Nevertheless, Sicardi's methodological reminder is correct and necessary.[1]

In turn, I myself can't be sure if poet and filmmaker Pier Paolo Pasolini, a passionate reader of Dante, Gramsci, and linguistic theory, was familiar with this passage when he wrote his 1965 essay on language entitled "From the Laboratory (Notes *en poète* Towards a Marxist Linguistics)," of which he devoted the first two sections to an extraordinary meditation on Gramsci.[2] Extraordinary less for the rigor of analysis or his conclusions, than for the very question he was inspired to ask, namely: What did Gramsci sound like? And how did the sound and style of Gramsci's speech differ from the way he wrote? And finally, what did this Sardinian communist sound like when he spoke and when he read his writings aloud? Lacking recordings as evidence, Pasolini went on to attempt a speculative reconstruction, which presents Gramsci as a sort of linguistic composite of Italian geographico-social history, the veritable image in discourse of the uncertain hegemony that held the modern Italian nation in uneasy equilibrium. I do not believe that any of Gramsci's interpreters before Pasolini had ever thought that this was a worthwhile question even

to pose. To conceive of it, it took a poet fanatical enough about the poetics and politics of dialect to learn, first, Friulian dialect as a foreign language and write poetry in it, and second, to master the argot of subproletarian Rome and write novels depicting in neo-realistic detail the life and speech of this peripheral milieu. But from Gramsci's note we can see that Pasolini, in asking this question about Gramsci's living speech as a context of his writing, was being perfectly faithful to Gramsci even as he subjected Gramsci's work to stylistic critique. This double relation to Gramsci, filial and philological, distantiating and mimetic, is characteristic of Pasolini's appropriation of Italy's greatest Marxist thinker. Or as Pasolini would put it in his most direct confrontation with Gramsci prior to these linguistic notes, in his 1954 elegy "The Ashes of Gramsci," Pasolini lived in "the scandal of contradicting myself, of being / with you"— Gramsci—"and against you."[3] This double relationship also becomes for Pasolini a general model of philology, understood as a cultural diagnostic that should focus on the mutations and evasions in the field of language in which intellectuals confront the social contradictions of their role at particular historical junctures.

Recognized internationally primarily as a filmmaker and practicing artist-theorist of cinema, Pasolini was also one of Italy's most gifted and ideologically articulate poets, critics, and public intellectuals, whose career spanned the period from the Liberation and partisan myth of the 1940s to the Historic Compromise that brought the Italian Communist Party to the brink of a governing role in the 1970s. He first came to the attention of a literary public with his early poetry written in Friulian dialect and went on with "The Ashes of Gramsci" to reanimate the nineteenth-century tradition of civic poetry, which paralleled his programmatic activity as one of the figureheads of the Marxist literary journal *Officina*. He had written his important Roman novels, *Boys of Life* and *A Violent Life*, as well as screenplays for several major directors, before turning to the cinema himself in the early 1960s. From this point on, Pasolini produced constantly in several different media and genres, from lyric poetry to journalistic polemics to semiotic theory to drama to films and film scripts.

At each of the major phases of this thirty-year history, Pasolini's literary and critical activity took controversial and polemically accentuated turns, not merely registering and reflecting larger social changes, but also exploring the existential tensions by which a singularly intense intellectual, Pasolini himself, was living and responding to these transformations. Along the work of the philologist and literary scholar Gianfranco Contini, Pasolini's reading of Gramsci when the prison notebooks and letters emerged in the public eye in the late 1940s furnished

him with a conceptual basis for what would become a consistent, even obsessive motif in his literary work up to his violent death in 1975: the inter-translatability of questions of language, central to the practice of the poet, and the conflictual stratifications of society according to class, profession, region, and social function. Pasolini, in fact, referred to Contini and Gramsci as his "two masters," thus bringing philology and cultural politics in direct conjunction in an integral literary activity. From Contini, he derived a powerful way of understanding Italian literary tradition as being a product of two main tributary streams, one being the "monolingual" lyric tendency that bears the name of Petrarch, the other being the "polylingual," narrative, multivocal heritage of Dante. From Gramsci, Pasolini gained an understanding of the historically symptomatic character of the literary traditions that Contini had analyzed. From the 1950s on, Pasolini's poetry and criticism followed the characteristically Gramscian procedure of referring questions of both style and content to the *location* of culture-producing intellectuals within a complex bloc of concatenated and interpenetrating social groups. Alliances, antagonisms, and compromises in the social domain found their corollaries in the mingling of poetic idioms, the struggle to stylize, and the appropriation of traditions. To put it more epigrammatically, for Pasolini, the language of poetry mirrored the physiognomy of social hegemony.

In his notes "From the Laboratory," Pasolini proceeds to treat Gramsci's language in a way analogous to a philological analysis of poetic style, characterizing the various cultural hegemonies, largely discontinuous, that gave direction to the various milieux in which Gramsci came to intellectual and political maturity. Each of these hegemonies would have entailed, Pasolini suggests, mastery of a different set of linguistic tasks, and Gramsci's development can be understood as an accumulation of linguistic-cultural strata, at first merely juxtaposed and chaotic, but gradually achieving a higher degree of organization, thus aiming at the lodestar of a new hegemonic orientation. Pasolini begins by imagining Gramsci's boyhood, his stigmatization as a poor Sardinian. In a kind of sketch for a fictional biography of Gramsci, Pasolini ascribes to him an overcompensation towards the official national language, psychologically manifesting the characteristic "subaltern" mentality that post-colonial criticism, using Gramsci's term, has also so aptly explored.

"All the youthful pages of Gramsci are written in an ugly Italian," Pasolini writes:

> Gramsci was not precocious; he passed through all the phases typical of a Southern youth Italianized in Turin. The maternal contributions were those strictly particular to Sardinia, the paternal ones were an Italianization of

the Roman country man, of a father employed by the State; Gramsci's childhood and first adolescence are of the rural environment, and Italian must have sounded like a foreign language to the non-Italophonic Sardinians of Ghilarza Gramsci must have heard his first Italian resound in the mouths of those "self-styled" professors of letters who taught at the private high school of Santu Lussurgiu. And, given that they had to exhibit their diplomas even if it wasn't asked for, it must have been a continual and caricature-like attempt at the approximation of purity and emphatic humanism. Gramsci, branded as a poor boy, lived and interiorized every event of his childhood deeply, so much so that for his whole life he had to suffer his attachment to it as a disgrace and impediment. He must therefore have profoundly absorbed even this first official Italian, which represented culture, liberation. (50, corrected)

Pasolini goes on to suggest that this overlay of Sardinian and rural dialect with a pompously academic Italian received a further inflection when Gramsci moved to Turin, where he came in contact with a Frenchified Italian. "The French influence," Pasolini writes, "acting on a linguistic body so fragile, inconsistent, and empty as the Italian of Gramsci was, once more had extreme and dramatic effects. Not so much through the presence of direct Frenchisms, as through the insecurity that the communicative and scientific French imparts to the expressive and irrationalistic Italian" (51).

With the help of the founding communist Umberto Terracini (who was jailed with Gramsci, but lived until 1983), Pasolini imaginatively reconstructs Gramsci's spoken language. He imagines a Gramsci whose tongue is divided in a way that almost makes his speech a sonorous allegory of Italy's political history:

Gramsci, when speaking . . . used simultaneously two spoken languages or two oral linguistic traditions in diachrony.
When he read his writing aloud, on the one hand he pronounced the written words orally, which were presented as such to the listener . . . ; on the other hand, he aligned phonemes according to diagrams, accentuations, voice supports, . . . so that they stood in a purely formal relationship of co-existence with that written language: like poor relatives dressed in the clothes of rich relatives.
The three fundamental elements of the Italian pronunciation of Gramsci—that is, the pronunciation of the Sardinian dialect, the pronunciation of the Piedmontese dialect, the pronunciation of the bureaucratic-professional petite bourgeoisie that had begun to create an also oral koinè for itself around the oral Florentine canon—are all elements of Gramsci on a level immensely inferior to that of the "written

language" (Hegel and Marx, the most advanced French culture, a deep and
in its way perfect reading of the Italian classics, etc.)

 The uncertainty, the poverty, the misery, the lack of precision of
Gramsci's spoken language (like that of every Italian man of culture from
then to today) are not proportional to the self-assuredness, to the richness,
to the absoluteness of many of his written pages. (53)

Gramsci's written language oscillates, Pasolini suggests, between a rather
grey, unbeautiful, but sharply functional prose, and outbreaks of the
schoolboy floridness through which Gramsci expressed emotion in his
writing. These outbreaks, however, are more than occasional lapses of
taste and style; they are evasions of thinking and, ultimately, symptoms of
organic political shortcomings. "[F]rom his youth," Pasolini concludes,
"Gramsci hid the gaps of political inexperience, or, more precisely, the
gaps in the socialism to which he adhered, within the expressive
casualness of his Italian" (52). Pasolini's implication is clear: Gramsci was
the living expression of the larger social and geographic divisions that his
pattern of language acquisition exemplifies. Gramsci's political goal was
to overcome these divisions in a new national-popular alignment of social
classes, organized groups, and regions. In turn, however, the flaws of his
usage and style are also symptoms of the incompleteness of his ability to
conceive and realize a new hegemony in Italy. An achieved socialism
would necessitate a new linguistic synthesis as well; yet a crucial part of
organizing this hegemony would be painstaking work on the modes of
thought and expression and address in the written language. But the vision
of socialism corresponding to this new stratification of language might no
longer be that of Gramsci; alternatively, it might no longer be socialism at
all.

 * * *

 Pasolini responded in 1962 to an inquiry of the journal *Nuovi
Argomenti* about whether there was a "crisis of poetry" with a rhymed
couplet: "Nella storia nostra—e nella specie mia— / non la poesia è in
crisi, ma la crisi è in poesia" (In our history, and especially in mine /
poetry is not in crisis, but rather crisis is in poetry). To write a poem in
dialect or in the so-called "aulic" diction of erudite literary style, to write
lyric or narrative, to attend to interior states of the solitary individual or
engage in polemics, to resist or embrace public communication, to choose
verse forms or prose paragraphs—each of these were seen by Pasolini as
typical positional acts of literary intellectuals, offensive forays or
defensive evasions in a perpetual war of position between a possessing

class and the masses of dispossessed workers and peasants, between city
and countryside, between the centralized state and the semi-autonomous
region, between North and South. As intellectual, the poet lives in the
crises of his society, and the crises come to live in his poetry, in its
historically and socially located diction, its confrontation or evasion of
ideological themes, its formal references to tradition, and the judgments it
reflexively renders on its own materials and address.

Pasolini's philological recasting of Gramsci's notion of hegemony
entailed his embracing of polylingual, polyvocal complexity—what
Bakhtin would call "heteroglossia." One direction in which he took this
commitment to the polylingual was to criticize, in the strongest terms
possible, the subjective hermeticism of modernist poetry. Thus, in the
journal *Officina*, Pasolini presented both Benedetto Croce's conservative
idealism and Gramsci's materialism as converging in their opposition to
the mainstream of Italian poetic modernism (called by Pasolini
"novecentismo"). In a 1956 essay entitled "La Posizione," he writes:

> after the collapse . . . of that conservative envelope that the centralist
> regime was—with the consequent acquisition, on the part of the youngest,
> of the existence of diverse conceptions of life, and an almost religious
> reinvention of the objective social world—it became clear that the
> twentieth century could in no way be exhausted by modernism
> ("novecentismo"). That indeed, even in the narrow literary field, not to say
> the cultural one, the errors of method implicit in it were infinite. And that,
> strange to say, beyond the university culture, Croce and Gramsci concurred
> perfectly in condemning it. In different ways and for different, in fact,
> divergent reasons, the traditionalistic culture of right-minded people, the
> idealistic Crocean culture, and the nascent Marxist culture were all
> opposed to modernism. In the public world . . . through a mania of stylistic
> rigor, the "modernists" carried to extreme consequences, the experiences
> of the decadent European culture, while in a clandestine and unknown
> world there were people who died in prison for a different ideology, or for
> other different ideologies.[4]

Through his evocation of the intellectual antipodes of Croce and Gramsci,
and particularly of Gramsci's imprisonment as the cost of dissent from the
hegemonic intellectual orientation embodied by "novecentismo," Pasolini
was thus criticizing a stance that he believed acquiesced in fascism and
facilitated the literary intellectuals' consent to its rule.

In an essay more directly addressing questions of the language and
style of poetry, however, Pasolini would sound an existentialist and
experimentalist note in his essay "La libertà stilistica," published in 1957
in *Officina*. In this essay Pasolini attempts to hold onto his Gramsci-

influenced philological critique of modernist literary novelty, while at the
same time asserting the need for a new freedom of stylistic experimentation
that in the name of cultural renovation would resist correlating literary
style with ideology or political tendency. The relation to Gramsci here is at
once more fraught and more fragile:

> The freedom of research that [stylistic experimentalism] requires consists
> above all in the awareness that style, in so far as it is an institution and
> object of a vocation, is not a "class privilege": and that thus, like every
> freedom, this freedom is interminably painful, uncertain, and anguishing.
> We resist every mysticism, and hence also that courage for courage's own
> sake, of stoic thinking: but in the end we know that this series of
> experiments will turn out to be a pathway of love—of physical and
> emotional love for the phenomena of the world, and intellectual love for
> the spirit of these phenomena: history.[5]

In this essay Gramsci himself provides Pasolini with his exemplum of
existential independence and lonely heroism that stylistic experimentalism
must entail, but notably not the militant Communist journalist and
organizer, but rather Gramsci the solitary prisoner, jailed for his dissent
from fascism, Gramsci the author of the notebooks and perhaps even more
crucially the letters to his family and friends. Pasolini writes: "With good
reason, in our political life the spirit of Gramsci dominates over that of
Croce both loved and hated, over Gobetti, over any other figure: but the
spirit of the imprisoned Gramsci, who was all the freer the more
segregated, the more outside he was from the world, in a situation which
despite Gramsci himself was Leopardian, a Gramsci reduced to the pure
and heroic thinker."[6]
 Already in such polemical affirmations of linguistic multiplicity and
spiritual heroism, another, religiously inflected note has entered Pasolini's
poetry and criticism, strongly diverging from its Gramscian point of
departure. Thus in his poem "La reazione stilistica," in his series "Poesie
incivile" from April 1960, the terms of judgment against "reaction" have
shifted from political to moral ones, from ideological error to sin:
"Everyone declares himself pure: / pure in language. . . naturally: / a sign
that the soul is dirty. / It was always / this way. To lie you don't need to be
obscure."[7] In contrast to the "sin" concealed within a false linguistic
purity, Pasolini advocates a joyful linguistic multiplicity that is valuable
not only as the bearer of an ideological position or historical tendency, but
also in itself, insofar as it testifies to the ineluctable advent of life and
historicity to the world: "Infinite are the dialects, the jargons /
pronunciations, because the forms of life / are infinite: / one must not

silence them, one must possess them / but you don't want them / because you don't want history, arrogant / monopolists of death" (570).

This affirmation of sheer linguistic diversity derives from a love for the popular that Pasolini himself called religious, and it stands in contrast, or opposition even, to the ideologically educative stance that Gramsci always maintained, even at his most generous and embracing. But Pasolini was not merely an exemplary Gramscian intellectual, practicing a socially-conscious philology and writing a philologically-informed and ideologically-engaged poetry. He also became Italy's earliest and most uncompromising "meta-Gramscian." At the acme of Gramsci's prestige among left intellectuals in Italy, Pasolini became the disquieting herald who announced that Gramsci's ashes could no longer be conjured back to life by a ritual of fidelity and commemoration, even if these rites took the names of "Party discipline," "engagement," and "duty to the future." His 1954 poem "The Ashes of Gramsci" had dramatized the predicament of an exemplary Gramscian intellectual psychically lacerated by the increasing awareness of the impossibility of his own existence, of being—an exemplary Gramscian intellectual. Set in the Protestant cemetery of Testaccio in Rome and apostrophizing Gramsci's grave draped with May Day honors, this six-part elegy in terza rima complexly negotiates the dilemmas of action and passion, of consciousness of history and desire for spontaneity, of the demands of tradition and the attraction of a new life. The poet's farewell to Gramsci, however, literally as he leaves the cemetery, opens into the cacophony of the Roman streets, which Pasolini characterizes as having an *absolute* character that invites intoxicated participation rather than analysis and organization.

Thus addressing Gramsci as if the choice to accept the asceticism of Communist commitment were also a decision between the world of the living and the dead, between the purity of the recumbent corpse and the vital impurity of the restless body, Pasolini writes:

> I'm leaving, leaving you in the evening
> which though sad descends so sweetly
> for us the living, as its waxen light
>
> curdles in the twilit neighborhood.
> And stirs it, makes it everywhere larger,
> emptier, and, in the distance, rekindles it
>
> with yearning life, which, using harsh
> rumbling trams and human shouts
> in dialect, performs a faintly heard, absolute

concert.[8]

Over the ten years between "The Ashes of Gramsci" and his 1964 essays "New Linguistic Questions" and "Comments on Free Indirect Discourse,"[9] Pasolini would see the gap between himself and Gramsci widen, even as he continued to analyze the disintegration of (his own) Gramscianism in terms that harken back to his earlier reading of Gramsci. In "The Ashes of Gramsci," Pasolini primarily explored his problematic relation to Gramsci by putting in crisis "in the poem" two divergent, conflicting, but for him equally compelling relations of the intellectual to the populace: a Marxist, activist relation to the proletariat as a history-bearing class; and a religiously-tinged, passional relation to the "poor," both socially impoverished and poor in spirit in the sense of the Gospels. This conflict plays itself out over the course of several pages of verse in the tension between Pasolini's self-consciously anachronistic choice of diction, classicizing syntax, and stanzaic forms of nineteenth-century civic poetry, from Leopardi to Carducci, and his thematic meditation, which, if taken seriously, would imply that precisely this formal tradition has become no more than a hollow literary tomb of an historical dream, with no more relation to an authentic national-popular life than the urn holding Gramsci's ashes has to the thinking, suffering man in the Turi Penitentiary.

As moving as the existential drama of Pasolini's self-questioning was, however, it was ultimately this poetic dislocation of the alignment of language and social-historical position, his performative deployment here of literary language as self-undermining ruin, the display of a poetic death-mask of an hegemony rather than the living physiognomy of one, that would prove more consequential in his later work. In the 1964 essays, Pasolini postulates the progressive homogenization of the various regional and social dialects under the unifying pressure of a generalized consumer and mass-media culture. As Pasolini argued:

> Today . . . we find ourselves in the midst of an ongoing linguistic diachrony absolutely without precedent, through a historical fact of an importance in some way superior to that of Italian unity in 1870 and of the subsequent governmental-bureaucratic unification: the new linguistic stratification, the technicoscientific language, does not fall into line with all the preceding stratifications but presents itself *as the homlogator of the other linguistic stratifications and even as the modifier of languages from within.*[10]

In other words, language, which had once been a heterogeneous mixture of different historical and social elements is subjected to reorganization and rationalization according to technical and commercial criteria—that is, "non-historical" criteria, at least in the traditional sense, even if this effacement of historical depth *is* the horizon of contemporary historicity, in another sense. If Pasolini's diagnosis has any validity, however, both the philologist and the poet may be losing one of the key instruments of their science and art. Due to the increasing technical homologization from within of even the historical strata of language, the philologist can no longer rely on the translatability of linguistic facts into social-geographical location and vice versa. And for the ideologically engaged poet, choices of style, form, and idiom, particularly those that involve mimesis across class, ethnic, or regional divides, acts of social-linguistic mimesis that Pasolini would characterize under a very broad notion of "free indirect discourse"—no longer reliably anchor the poet's symbolic acts in the social-political field in ways that philology can authoritatively reveal.

I will conclude with a quote from a poem of 1963, "Plan of Future Works," where Pasolini's title refers parodically to socialism's pretenses to a scientific control of the future, while his signature style is heightened to a clownishly manic lament. But the self-ridiculing tone does not make this passage any less of an important index of a change in Pasolini's philological stance. Philology has gone from being an analytical tool by which the intellectual locates himself within historical struggles, to an experimental pathway of love for the world that entails the sacrifice of the self. And the model of the sacrificial hero also shifts from Gramsci the Leopardian pessimist despite himself to a theatricalized, queer "Pier Paolo Pasolini," a manically clownish performer of tightrope walks, suddenly graceful somersaults, violent rages accompanied by undignified toots of bicycle horns, tenderly offered roses, exaggeratedly painted tears, and pratfalls, which to Pasolini had come to seem the only authentically philological way in which to relate to tradition and history, to express one's love for the Logos binding creation and word:

> . . . Stop, my blind love!
> I'll employ you in translinguistic
> research, and to one text I'll oppose a veto,
>
> to three texts three saints, to a literary
> circle, traditions of cooking, border
> disputes; and in the year of the discovery
>
> of a ratified text, by copyists

of the Paduan language, I'll search, driven by
stupidity or vanity, for what the painters were doing,

from farm to farm in the green-sublime light
of the lands of the Po . . . but above all for what
the ruling class wanted, whatever, I don't know.

I'll turn it into a monstrous work, contemporary
with the *lettura 22*'s Anti-Works, very latest fashion,
old figurative mode stuck in the side of the young.

But one has to disappoint. Only a noble mismash
of mixed inspirations can demystify
when chaos miraculously comes up on

a plastic clarity of, for instance, Romanesque
griffins—huge thighs, necks, and thoraxes
swollen like breadloaves, grey stone to codify

full Reality. Shut up, shut up, voices
of Everything Official, whatever you are.
One must disappoint. . . one must hop onto the coals

like roasted ridiculous martyrs: the Way
of Truth passes through even the most appalling
places of aestheticism, hysteria,

foolish erudite refashioning!¹¹

Notes

¹ Antonio Gramsci, Notebook 5, ¶ 151, *Quaderni del carcere*, Vol. 1 (Torino: Einaudi, 1975 and 2001) 678.
² Pier Paolo Pasolini, "From the Laboratory," in *Heretical Empiricism*, ed. Louise K. Barnett, trans. Ben Lawton and Louise K. Barnett (Bloomington: Indiana University Press, 1988) 50-76.
³ Pasolini, "Le Ceneri di Gramsci," in *Bestemmia: Tutte le Poesie* (Milan: Garzanti, 1993) 227. Translation by Norman McAfee, *Pier Paolo Pasolini: Poems* (New York: Vintage Books, 1982) 11.
⁴ Pier Paolo Pasolini, "La posizione" in *Saggi Sulla Letteratura e Sull'Arte*, eds. Walter Siti and Silvia De Laude (Milan: Mondadori, 1999) 628. Cf. Gian Carlo Ferretti, *Officina: Cultura, Letteratura e Politica Negli Anni Cinquanta* (Torino: Einaudi, 1975).
⁵ Pasolini, "La libertà stilistica," in *Saggi Sulla Letteratura e Sull'Arte* 1237.
⁶ Pasolini, "La libertà stilistica" 1236-37.

[7] Pasolini, "La reazione stilistica," in *Bestemmia* 569.

[8] Pasolini, "Le Ceneri di Gramsci," in *Bestemmia* 232. Translation by McAfee, *Pier Paolo Pasolini* 19.

[9] In *Heretical Empiricism* 3-22 and 79-101, respectively.

[10] "New Linguistic Questions" 16.

[11] Pasolini, "Progetto di opere future," in *Bestemmia* 799-800. Translation by McAfee, *Pier Paolo Pasolini* 185-187.

SECTION III:

MOVING IMAGES OF TIME

CHAPTER TEN

THE BURNING BABE:
CHILDREN, FILM NARRATIVE,
AND THE FIGURES OF HISTORICAL WITNESS[1]

In a climactic scene of his 1985 film *Come and See*, a harrowing account of a thirteen-year old's passage from boy to seasoned partisan during the Nazi occupation of Byeloruss, Elem Klimov breaks with the basic realism of the rest of the film and inserts a shockingly irrealistic device. While the battered and traumatized youngster Flor shoots at a picture of Hitler left behind by the marauding S.S. troops, viewers watch interpolated newsreel footage of Stuka divebombers, marching troops, Nazi rallies, street parades, and World War I battles—accelerated and run in reverse. The scene ends only when the documentary footage has been "blasted back" to a still photograph of the toddler Hitler with his mother, his uncanny, piercing dark eyes staring out from the faces of both mother and son, eyes familiar from countless pictures of the psychopathic dictator and mass murderer. Seized with horror, Flor stops shooting, perhaps recognizing the resonance of his own cathartic symbolic violence against the photograph with the literal murder of women and children he has witnessed in a genocidal S.S. raid against a village.

At the same time, in hesitating before this first trace of Hitler's historical existence, Flor marks a limit to his ability to eradicate the facts of history through subjective fantasy and personal acts of will. Hitler has already long been born and grown to adulthood, the Nazis are occupying Flor's country, and it is not through individual revolt against an image that this fact can be revoked but only by realizing this figural revolt through the collective violence of the partisan army. Flor is brought out of his absorption in the fantasy of rolling back history by the call of his comrades who are pulling out and retreating to their camp in the forest. The film ends with the boy's joining them and disappearing into their ranks.

Finally, however, Flor's halt before the document of Hitler as child also marks another limit, self-reflexively related to the filmmaker's own retrospective position in narrating this crucial historical struggle against

fascism, *the* foundational myth of the post-WWII Soviet Union, in a linear, realist narrative. In making Flor regress through the documentary material from the narrated present of occupation, genocide, and partisan resistance to the past of Hitler's infancy, and in allying his hero's subjective consciousness with his own highly artificial intervention into the narrative presentation, reversing its linear flow, Klimov confronts the comprehensibility of history as a causal sequence. In what sense, he asks, could the baby Hitler with his mother in the photograph also be the architect of the bloody attempts to enslave and eradicate the Slavic peoples? It is only the intervening mediation of a vast impersonal structure of history, a complex and contingent web of factors that can bridge this incomprehensible gap. Klimov does not attempt to provide a realist narrative explication of the intermediary links, for he suggests that such an explication is essentially impossible. It is only possible to mark the gap figurally, as a place to return to, to witness for oneself, and to ponder. Klimov's answer is not a causal or a logical one, but rather, in a physiognomic and rhetorical sense, an analogical and *figural* one. It speaks through the eyes, the horrified eyes of Flor in gazing at the fixed stares of baby Adolf and his mother in the old photograph. The figure Klimov offers his viewers is the very organ of witnessing and of repeating that act of witnessing by viewing, retrospectively, the events narratively presented in the film. Come and see, he entitles the film, and this imperative is indeed the figural meaning of the film as a whole.[2]

In this essay, I take this kind of "figural" answer to a problem of historical representation and explanation as characteristic of a body of films that I consider "modernist" both in their aesthetic approach and—in a sense I will soon explain—in their approach to history. In my reading of these films, I follow Hayden White's recent work in which he discusses the notion of a historical figuration "in which and by which reality is at once represented as an object for contemplation and presented as a prize, a *pretium*, an object of desire worthy of the human effort to comprehend and control it."[3] In other words, the figures of history that White is considering and that I believe these films articulate are at once attempts to grasp historical reality and to project that grasp into a time in which the historical fact or event may be recalled and redeemed, the past's power drawn upon in a present moment of resistance or its violence dispelled in a new moment of retrospective revaluation. White suggests that it is particularly modernist texts that embody this figural doubleness to comprehend historically and to transcend projectively, in distinction to nineteenth-century claims for realist narrative and factual historicism. "In modernism," he writes—

literature takes shape as a manner of writing which effectively transcends
the older oppositions between the literal and the figurative dimensions of
language, on the one hand, and between the factual and fictional modes of
discourse on the other. Consequently, modernism is to be seen as setting
aside as well the longstanding distinction between history and fiction, not
in order to collapse one into the other but in order to image a historical
reality purged of the myths of such "grand narratives" as fate, providence,
Geist, progress, the dialectic, and even the myth of final realization of
realism itself. (99-100)

In particular, I will discuss a group of films that explore the reciprocal
relations between the heightened figural imaginations of child protagonists
or narrators and the problems of narratively representing traumatic
historical events such as fascism, political repression, revolution, and war.
I hope to suggest the extent to which child consciousness has been a
crucial means for filmmakers in gaining imaginative purchase on the
"modernist event" of twentieth-century history. At the same time, I want
to argue, this very attempt to depict children's experience of history has
also proven a particularly intense fulcrum of formal innovation in
filmmakers' narrative treatment of historical events, a powerful impetus to
a modernist reimagination of the forms of historical narration and
testimony and the status of historical truth. Finally, I also wish to delineate
the figural patterns into which these filmic representations of children's
experience of history fall, thus constituting an identifiable and consistent
set of narrative types. These narrative types, I suggest, correlate
figuratively to the phenomenological character of children's experience,
especially to their particular mode of embodiment and the crucial role of
mimetic behavior in their processes of interpreting the world and acting in
it.[4]

The Pure Witness

In the opening chapter of *Cinema II: The Time-Image*, Gilles Deleuze
argues that the neo-realist cinema of Roberto Rossellini, Luchino Visconti,
and Vittorio De Sica represented a decisive break with the presuppositions
of classical realism, despite the misleading name.[5] Classical realism, as
Deleuze had discussed it in the first volume of his cinema studies, *The
Movement-Image*, is characterized by the centrality of action in a milieu,
in which the action of characters and the situation that an action produce in
its context are proportionally and organically related. Realism highlights
the efficacious actions of characters as considered responses to the
situations confronting them; in turn, these situations appear as directly

affected by the struggles and efforts of characters. In contrast, Deleuze argues, neo-realism "is a cinema of the seer and no longer one of the agent" (Deleuze, *Cinema 2*, 2).

The neo-realist protagonist is no longer primarily a protagonist of an action that will effect some sort of change in the historical situation, but rather a protagonist of witness—a point of entry into the central imperative of these films to "come and see." The objects, events, and settings take on a heightened sensory intensity—and therefore an intensified affective potential—yet at the cost of immobilizing the character and dispossessing him or her of the capacity to act as an individual in the situation witnessed. "The situation," Deleuze writes—

> is not extended directly into action: it is no longer sensory-motor, as in realism, but primarily optical and of sound, invested by the senses, before action takes shape in it. . . . Everything remains real in this neo-realism. . . but, between the reality of the setting and that of the action, it is no longer a motor extension which is established but rather a dreamlike connection through the intermediary of the liberated sense organs. It is as if the action floats in the situation, rather than bringing it to a conclusion or strengthening it. (Deleuze, *Cinema 2*, 4).

This dispossession of the individual agent's sensory-motor action on the milieu and the compensatory heightening of the subjective element—the imaginative and affective intensities—is crucial not just as a phenomenological characterization of neo-realism. It also suggests that the "realism," the truth- or testimonial-claim, of this mode of cinema must reside in something other than the verisimilar reflection of objective material reality. It introduces a figural or fictional element not necessarily opposed to the truthfulness of the images, but indiscernibly blending subjective and objective components of that truth's advent to the viewer:

> As for the distinction between subjective and object, it also tends to lose its importance, to the extent that the optical situation or visual description replaces the motor action. We run in fact into a principle of indeterminability, of indiscernability: we no longer know what is imaginary or real, physical or mental, in the situation, not because they are confused, but because we do not have to know and there is no longer even a place from which to ask. (Deleuze, *Cinema 2,* 7)

In introducing this mode of indiscernibility, neo-realism thus serves as a point of departure for a much broader range of subjective cinema. In opening up the image to subjective and objective components presented in a single indeterminate complex, neo-realism becomes for Deleuze the

gateway to a number of different innovations in the handling of time in cinema.

Taking up the specific focus of my considerations, the figural role of child protagonists and narrators, it is easy to see how readily child characters fulfill the conditions for the role of "seer" dispossessed of the possibility of action and for the imaginative confusion of objective and subjective aspects of the witnessed scene. In Roberto Rossellini's *Germany Year Zero*, which dramatizes the plight of a young boy in bombed-out Berlin after World War II, for example, the protagonist Edmund is portrayed as being blocked in many practical situations by his physical immaturity and age and at the same time subject to deluded, perverse ideas about the circumstances in which he lives. For example, one of the first scenes of the film is Edmund's being chased away from a worksite—digging graves—because he is underaged. This scene is repeated several times in the film in new variations: when he tricked by an adult buying goods for the black market; when he is taken advantage of by the ex-Nazi, pederastic schoolteacher to peddle Nazi memorabilia to British soldiers; when he is swindled by another young thief whom he has been helping; when he is chased away by older boys from the sexual play they are engaged in. In one of the cruelest scenes, towards the end of the film, he is even rejected by younger, smaller children who are playing with a ball; here his *larger* size is an ironic reversal of his fate through most of the film of having too small a body to assert himself effectively. In each of these instances, we see Edmund pushed to the margins of the world of work and action, even those of the criminal and sexual underworld, because of his not-yet adolescent stature. This physically marked marginality forces him to be the witness of his family's fate at the hands of an unscrupulous landlord and eventually to abandon his older brother and sister and wander through the surreal shell of the destroyed city, with its ruins, its prostitutes, and its construction sites.

The two major exceptions to the film's barring of Edmund from action—Edmund's poisoning of his chronically ill father and his suicidal leap from a building under reconstruction—confirm Deleuze's argument concerning the indiscernibility of subjective and objective elements of the depicted events. The poisoning occurs when Edmund literally applies his schoolteacher's rote Nazi-Darwinian phraseology about the strong surviving and the weak having to die. The horror of Edmund's act of parricide is thus compounded by the viewer's sense that the father was killed by the ghost of ideology past possessing his son. Rossellini, furthermore, allows the actual death to take place off-screen, in the distraction created by a police raid looking for unregistered returned

soldiers.[6] The event's lack of visible presence underscores the implication that this is as much a crime of Edmund's misguided thought as of his violent hand.[7] Similarly in the case of the suicide with which the film ends, the crucial change in Edmund, his recognition of his crime and resolution to kill himself, occurs with very little external registration. After his long nocturnal wandering through the city, he climbs the stairs to a building under reconstruction across the street from where is father's body is being taken away for burial. We see him playing on the construction site, hanging his jacket up on a beam before he slides down, so as not to get it dirty. He looks out over the houses around him and the street, throwing rocks; suddenly, with a look that indiscernibly mixes weariness, impassivity, and recognition, he jumps from the building and falls to his death. There is no outward transition from play to this most serious final act. His jacket still hangs on the beam, unsoiled by either his play or his fatal plunge to the street.

Elem Klimov, in *Come and See*, takes this principle of indiscernability to a more radical extreme than Rossellini's moral complexes of historical damage and spiritual perversion in *Germany Year Zero*. For Klimov, ultimately, wants to depict for his audience the spiritual transformation of the naive boy Flor into an experience-hardened, anti-Nazi partisan and to invite them to participate through film viewing in this inner conversion. As I have already suggested, the crucial force of transformation lies with what Flor witnesses, his "passion," rather than his actions directly.

Two scenes in particular underscore his placement in the role of the pure witness, in both cases because of his immaturity and boyishness. Having left his mother's house to join the partisans, Flor is left behind when they go out on campaign, and his boots are appropriated by a more experienced man whose shoes are worn out. Together with the commandant's young consort Glasha, Flor is temporarily deafened by an artillery bombardment of the woods where the partisans had camped. The scenes that follow take on a lyrical or even hallucinatory quality as they unfold against a subjectively focalized soundtrack of muted and damped sounds. For example, Flor stares in wonder at a German paratrooper dropping "silently" into the trees above him and struggling to free himself from the tangled parachute. The surreal image of the sky filled with slowly drifting parachutes, followed by the strange image of a man suspended in the branches, is set into relief by the eerie soundlessness. Psychologically, the scene effectively renders the stunned wonder of the boy at the spectacle and his momentary oblivion to the danger it implies for him and his people. The next day, having fled deep into the woods, in a scene of childish self-abandonment to gleeful play, Flor and Glasha wash

themselves by shaking down rainwater from the trees. The visual lyricism of the scene—sunlit droplets falling down over the laughing youngsters— is heightened by the non-naturalistic sound, again motivated by the tintinnabulation of Flor's ears following the artillery concussions.

This oddly idyllic set of scenes has its harrowing counterpart later in the film, in the orgy of violence that the captive Flor is forced to witness as the S.S. massacre and burn a village. Having seen women and children brutally killed, Flor himself is randomly spared death by the whim of his captors, who pose for a picture around him with a gun to his head, but shoot off only the camera and not the pistol. After a moment of shocked recognition that he has survived, he loses consciousness and collapses. The entire scene is a fury of sight and sound: the barking of dogs, the laughter and shouts of the S.S. men, the rattle of guns and grenades, the roar of motorcycles and trucks, the smoke and flames of burning buildings, and the bursts and scattered trails of the flamethrowers' gasoline. The camera pulls back to reveal the helpless and traumatized boy in the midst of fire, smoke, and withdrawing columns of Nazi soldiers. Yet in the scene that follows, in which the partisans have captured some of the S.S. officers and their men in an ambush, Flor is able to redeem this passive view of historical events. It is he that is able to bear witness against the Nazi killers, telling that they burned the people of the village alive and leading to their execution by the partisans.

Mimetic Games

The category of the "pure witness" pertains to film narratives centered on characters barred from any effective, proportionate response in action to their situation. Children, because of their limited horizon of experience and the physical limits of their bodies, are easily cast as this type of character. Yet the intensification of sensory experience that compensates for the loss of active agency and the dream-like indiscernability of subjective and objective dimensions of the experience point beyond passive witnessing towards a new domain of agency residing in imaginative processes. These range from the lowest level of play or ritual-like processes through bodily metamorphosis and travel through time. Taking as examples René Clément's *Forbidden Games*, Neil Jordan's *The Butcher Boy*, and Goran Markovic's *Tito and Me*, I will describe the entry point of these imaginative processes by which agency can be recaptured beyond the pure witness state: the detouring of action into mimetic spaces of play, ritual, and theater.

I am suggesting that in the group of films represented by these examples, mimetic behaviors may function in a number of distinct ways to bridge an initial divide between the child as potential agent and the situation in which he or she might act. Such activities may focus the narrative on the *genesis* of a conscious, active subject and reveal the mimetic behavior of this subject-in-formation to carry the figural marks, the stigmata, of the historical situation in which it was enacted. The mimetic activity may be presented as predominately *hermeneutic* in nature, a form of pre-understanding appropriate to an immature view of the world, a fictive or figural grasp of the historical circumstances in the absence of articulate concepts and language to formulate a more adult understanding. Or it may primarily depict a nascent *mode of action* in which the figural dimension—the adoption of roles and the constitution of virtual, theatricalized, imaginatively bracketed spaces of enactment—is inextricable from the action's potential efficacy in the world.

These functions are, of course, not mutually exclusive, since the emergence into conscious and active subjectivity is a dialectical process in which mimetic activity, in its dual dimensions as figural representation and figural enactment, plays a central role. In his book *Role-Playing and Identity*, the phenomenologist Bruce Wilshire, for example, argues that the formation and sustenance of personal identity should be understood as the result of a dynamic and on-going negotiation of mimetic relations with others.[8] Our capacity to project ourselves bodily into the embodied activities, gestures, modes of speech, and forms of life of others keeps us from rigidifying into closed and impoverished monads. Yet we must also develop ways of disengaging from mimetic involvements to avoid "engulfment" and to allow individual thought and decision. Wilshire looks to fictionalized re-presentation and "staged," theatrical redoublings of primary, unreflective mimetic involvements as crucial possibilities for dialectically binding engulfment and disengagement into individualized identities in formation. He writes:

> When we see what the actor does onstage we see that at which the child is aiming, however unwittingly. If another can be enacted by a body—in the other's absence—then that body must realize both that it is a *person*, for it is the other person that it mimetically resembles and all recognize that only persons enact persons; and that it is *a* person because no one need be present to enact the other but he himself the actor! Moreover, he must realize that he is a free person, an agent, for the other is present merely as an enactment; no causal coercion plays from him to the actor. This behavior, then, must tend toward maximalization of individual identity. (Wilshire 200)

Put otherwise, fictional or theatricalized reenactment allows the subject and his/her formation to be affected by the relation to others, but shifts the relation from a directly physical causality—a compulsion to act in such and such a way—to the "figural causation" of potential fulfillment, as defined by Hayden White. As important for Wilshire as the indirect connection that figural causation allows is the partial distance from necessity allowed by the "virtuality" of the figure, the weakening of more direct forms of influence: "It is the force of the fiction that breaks the power of the other without simply losing it" (Wilshire 200).

René Clément's *Forbidden Games*, for example, presents the ritualized play of the two children, the Parisian war orphan Paulette and the farm boy Michel, as a symbolic way of grasping and psychically binding the incomprehensible fact of death in war. At the beginning of the film, as the Parisians flee along the roads from the Nazi invaders, Paulette's parents are shot down and the little dog she has been carrying is killed as well. Another result of the attack on the columns of refugees is that a horse escapes and runs off to the fields; Michel's brother gets kicked by this war horse and after several days of suffering, dies from the blow. Paulette is temporarily adopted by Michel's family, and the bond between the two children grows as they build a pet cemetery, with the first grave devoted to Paulette's dead puppy. The children adorn the graves with crosses, and in one case, with a necklace taken from the nest of an owl living in the rafters of the old mill where they construct their cemetery. Later, as their cemetery becomes increasingly full of dead chicks, kittens, and other animals, and the arrangement becomes more elaborate and ornate, the children become dissatisfied with homemade crosses. Eager to please Paulette, Michel steals crosses from the church and churchyard cemetery to adorn their own childish counterpart of the adult sacred ground. The trouble that results leads to Paulette's being sent to an orphanage and Michel's destruction, rather than return, of the stolen crosses.

Clément's narrative focuses precisely and movingly on the binding force of the symbolic enactment, the children's game, their *play* with death as a source of vitality, joy, and love in the face of inexplicable fate and violence. The gentle irony of the film is that the children's seemingly morbid game represents a living relation between them, their loving cooperation in a kind of shared artwork against death. In turn, the forbidding of the game and the separation of the children is a belated victory for death: figuratively, the death of both children in the undoing of the figure articulated by their rituals and tokens of mourning. Michel's ultimate destruction of the cemetery and his return of the necklace to the owl's nest memorializes his loss, the "death" of Paulette to him, her

passing from his life. Paulette's final scene is even more haunting: about to be taken into an orphanage, she hears the name Michel and runs off looking for him, calling his name. But realizing that it was not *her* Michel that was being addressed, she begins to call in desperation for her mother. Paulette's calling for—and suddenly *recalling*—her mother, after the parenthesis of her time with Michel, dramatizes the unraveling of the symbolic binding of death that the game with the crosses represented to her. At the end of the film a frightened little girl with no one in the world, Paulette has been brought back to the sheer unbound fact of the loss of all those who have mattered to her—her mother, father, and now Michel as well.

Neil Jordan's *The Butcher Boy* (adapted from Patrick McCabe's novel)[9] and Goran Markovic's *Tito and Me* both represent ways in which historical situations shape the formation of personal identities through their precipitation in the imaginative play of children. At the same time, however, they illustrate the deviation and potential freedom from the model that may follow from historical material being transformed through children's mimetic roles, rituals, and enactments. In *The Butcher Boy*, Francie Brady creates a world of play and imagination, at first defensively, to escape from the squalid realities of his life and to hold onto a sense of identity against his drunkard father, his mentally ill mother, and the social institutions of town and reformatory. We see him, for instance, living out various roles borrowed from comic books and television, along with his best friend Joe. Yet even as they remain modulations of this defensive play, Francie's imaginative projections and enactments of roles—the amazing Francie Brady, the Apache, the Fugitive, the Pig, and the Butcher Boy—begin to become shockingly active and effective as instruments of self-assertion and revenge against those he perceives as his enemies. As the film presents it, the erratic violence of his inner life appears to mirror the atmosphere of fear, paranoia, mass media hysteria, and real violence of the Cold War. In the time leading up to Francie's brutal murder of his putative arch-enemy Mrs. Nugent, he sees and hears news reports of the escalating Cuban Missile crisis taking the world to the brink of nuclear destruction. In fantasized scenes, Francie imagines his town destroyed by a nuclear bomb and the residents replaced by ghastly mutants living within the wreckage and rubble. It is instructive to note that this scene echoes— but in a fantastically transfigured way—the wanderings of Rossellini's Edmund among the rubble and the human underworld of post-war Berlin. Yet whereas the hallucinatory qualities of Edmund's night roaming followed from the heightened sensory intensities of the pure witness as he looks out over the objectively shattered landscape of the city, Francie's

destroyed town really *is* a hallucination, mimicking the plots of the science fiction films that Francie loves to watch. Francie's sedative-induced vision gives the viewer figurative access to the inner, subjective mutation caused equally by the death of Francie's father and the traumatic fears of the historical moment.

Markovic's comedy offers a wry historical commentary on how the cult of personality around Tito, with its demand for hyper-identification with the heroic leader, could have given rise to the distinctly unheroic cast of adults that were presiding over the breakup of Tito's Yugoslavia forty years later. The story transpires in 1954, when the lumpish ten-year old protagonist Zoran wins, to everyone's surprise, a writing contest about why he loves Marshall Tito. His poem, full of fervent praise and patriotic spirit, wins Zoran the honor of being included in a hike of young Pioneers around the countryside where the great partisan leader grew up. His teacher is disconcerted that the most desultory and slovenly student has been chosen to represent the school. His anti-communist relatives are concerned about Zoran's zeal for the communist chief, and his parents are worried by the line in his poem that says he loves Tito more than Mom and Dad. Markovic humorously presents Zoran's obsession with his hero. Zoran religiously imitates Tito's gestures from newsreels at the movies, while Tito is a tutelary presence in Zoran's erotic daydreams about the war orphan and schoolgirl Jasna, with whom he is deeply infatuated. On the Pioneer march, however, the communist attempt to create good little Titoists through mimetic identification—revisiting the mythic sites of Tito's childhood—goes awry, mostly because of the failure of the epicurean Zoran to appreciate the ennobling effects of physical discomfort and discipline and his "base" instincts for food, rest, and sleep. Continually in trouble with the ridiculously authoritarian troop leader Comrade Raja, Zoran's passive resistance leads the children to an ultimate revolt and to the troop leader's being taken away by the secret police. The film ends with the children having been invited to Tito's birthday celebration. Zoran, however, slips away when the photo session begins and samples the luscious spread of food set up in one of the adjoining rooms.

The dates of the fiction, as well as that of Markovic's film, are significant to the film's overall historical meaning. Set in the year of Kruschchev's devastating exposure of Stalin's crimes and cult of personality, a crucial turning point in the history of world communism, it depicts Tito's alternative personality cult in full bloom. Ten years old at the moment of the film's events and its interpolated newsreel footage, Zoran had been born with the new Yugoslavian federation that arose out of

the partisan struggle against Nazism and is associatively identified with that new state. He is the human clay, rather soft and lumpy, of the communist and nationalist ideal projected by Titoism. In 1992, the year of the film's release, Zoran would be forty-eight and an adult witnessing the dismantling of Tito's Yugoslavia. Implicitly, then, the film asks the question, who are we, who grew up under the deified Tito and now are to oversee the final dismantling of his creation?

Despite his Tito-mania, however, at heart—and in his roly-poly stomach—little Zoran remains an unheroic proto-bourgeois more interested in food, a bit of comfort, and a happy family than inspiring patriotic rhetoric. Markovic does not simply satirize the communist ideal, however; he shows how the very mechanisms by which communist man was putatively to have been shaped lead to failure. No one could be more obsessively imitative of his exemplary hero Tito than little Zoran. Yet this mimetic identification, which first individuates him and estranges him from his family and schoolboy friends, also provides him with a sufficient sense of personal individuality and freedom to resist Comrade Raja (and by extension, Titoism itself) at a critical point during the disastrous "March around Tito's Homeland." Fallible human material and flawed methods in handling it collaborate to produce the disengaged young consumer who prefers tasty cakes to a photo op with the great man. In presenting Zoran as the ultimate, very un-utopian realization of Yugoslavia's Titoist "new man," Markovic also suggests a kinder, gentler road, alas, not taken, in the breakup of the Federation that would occur shortly after the film's release. Zoran offers an exemplary image of an essentially private, ironic, tolerant, and non-committed bourgeois, incapable of sustaining much nationalistic or ideological fervor for long. Instead, the conflicts he portends, like the constant but inconsequential bickering in his family's overcrowded Belgrade apartment, are not deadly, political, and ethnic ones, but petty domestic quarrels that need not preclude continuing to live together and need not draw blood.

Monsters of Innocence

I have suggested that the child protagonists of the films discussed above come to understand their historical situation and to act within it through the *figural* mediation of mimetic activity. Within this basic framework, there is a wide variety of mimetic modes, ranging from the ritual play of the children in Clément's film to the identificatory role-playing of Zoran in *Tito and Me*. But the extremes of Francie Brady's fanciful self-projection, his hallucination of the nuclear destruction of the

town and its occupation by insect-like mutants, touch on my next category: the imaginative objectification of monsters as figures of the child's understanding of violent or traumatic events. The monster figure, in *The Butcher Boy* as well as in the two examples I will discuss below, is drawn from the iconography of popular culture and transferred onto adult figures in the child's environment. In this way, the monster comes to personify the child's fear, its lack of understanding, its sense of persecution, or even its ambivalent desire for an alliance with a power that exceeds its own weakness.

Victor Erice's *Spirit of the Beehive*, released near the end of Franco's rule in Spain, relates the story of two little girls, Maria and Ana, the daughters of two Republican intellectuals in internal exile in the countryside shortly after the Spanish Civil War. When the two girls see James Whale's *Frankenstein* at the village cinema, the younger sister Ana is deeply troubled by the scene in which the monster first befriends a little girl, then kills her, eventually leading to his own violent death at the hands of the village mob. When Ana asks her sister why the people killed the monster, Maria tells her that it was just a movie and the monster didn't really die. But she goes on to make up stories about the monster to scare Ana. She tells her that the monster is a "spirit" and cannot be seen during the day, but that if you are its friend and call to it, it will come. She further embroiders her tale by showing Ana an abandoned hut with a well that she claims is the spirit's home. Ana begins visiting the hut to see if the monster is there, and one night she sneaks out to look. To her shock, she finds her "monster" laid out in the straw: a hungry, tired, wounded fugitive, a Republican soldier on the run. She brings him food and her father's jacket, which has his pocket watch in it. That night, the police catch up with the soldier, and he is shot. The father is called in to the police, who have found his watch and jacket, and though he is not implicated, this is clearly an uncomfortable and potentially dangerous situation for him as a Republican intellectual hibernating in the countryside. Without saying a word about it, at breakfast the next day he opens the pocketwatch, which has a musical device. Maria, knowing nothing about it, makes no reaction, but Ana is fearful and appalled. She goes to the hut and finds nothing but traces of blood on the straw where the monster lay. Stepping out of the hut, she is confronted by her father, who sternly calls her. She runs away, staying out all night. She finds a mushroom, which her father has earlier told her is deadly, and takes a bite. In a puddle of water, she sees first her own face, then the face of the Frankenstein monster, with the features of her father. She loses consciousness and is found, shocked and exposed, though alive, the following morning. The film ends with Ana's rising from her bed at

night and stepping outside, hearing the sound of a train whistle and calling to her spirit-monster and invisible friend, "I'm Ana, I'm Ana."

At nine or ten years old, Ana has very little experience by which to understand the terrible dislocation that has broken her parents' lives, forced them away from friends and the life of the city, and left them cold and estranged towards one another. Nor can she understand the larger forces at work in the coming and disappearance of her "monster," the fugitive Republican soldier. Nor even can she grasp why her father might be upset with the disappearance of his jacket and its discovery by the police, except that he must in some way be responsible for the vanishing of her ally and spirit-friend. The monster serves as a complex narrative figure—a "spirit"—for a content that cannot be made discursively present in the film. This suppression of statement in favor of figural presentation is at once motivated by the use of a child as the center of the film's narrative consciousness and necessitated by the censorship operating in Fascist Spain at the time of the film's release. But at least three interpretative aspects of the figure can be discerned.

First, the monster figure seems to suggest that Ana has internalized into her personal identity—"I'm Ana," she calls—that which was externally represented by the runaway soldier: the residue of resistance, the traces of the revolutionary spirit for which the Republican army fought. In this sense, like Markovic's Zoran, Erice's Ana becomes a prefiguration of a political subject to be fulfilled in the near future of the present in which the film is being viewed. In other words, Ana, a child in 1940 and the beginning of Franco's reign, would be an adult in 1970 near its end; she points to the possibility of an historical connection of what came before fascism with a life-to-come beyond fascism. Moreover, allegorically, she represents the possibility of reforging the broken link between the educated middle-class intellectuals (such as her father) and the revolutionary masses who were literally the army of the Republic—a bond symbolized in her gift of her father's jacket and watch. Second, echoing the scene from Whale's Frankenstein, she hallucinates the face of the monster in the pool after having confronted the death of the fugitive and attempted suicide by eating the mushroom. The monster functions in this way to figure Ana's confrontation with death and specifically her fear of her own death. The final scene suggests that in overcoming her fear of the monster's power to kill (the little girl's death in the Whale film), she comes to view the monster as a protector and ally. Although in itself this is existentially and psychologically resonant, it also carries over into the level of submerged political allegory. The final scene suggests that Ana may now have the courage, the mastery of her own fear of death, to see

beyond the face of monstrosity imposed by fascism upon its political enemies and to ally herself with them. Finally, the disquieting isolation and longing of Ana at the end of the film may also harbor a utopian content. Her father and mother are shown throughout the film as increasingly resigned, and in fact, they are likely never to be able to enjoy the love and the freedoms they tasted before the Republican defeat. Ana's very discontent, the psychic loneliness into which her experience has cast her, stands as a painful desire for something else, unfulfilled in the present, for which her parents no longer allow themselves to hope.

More recently, Phillip Ridley's film *The Reflecting Skin* offers an American Gothic counterpart to Erice's Frankenstein figure. Ridley's film has at its center the ten-year old Seth Dove and the experience of familial, sexual, and historical violence immediately following World War II. Set on the Western prairies and dominated by a landscape of wide, flat, undulating wheatfields, *The Reflecting Skin* focuses the child's anxieties on a figure combining national foreignness and desirous female sexuality: Dolphin Blue, the English widow who lives near the Doves' home and gas station. Out on the roads running through this rural landscape, a group of leather-jacketed sexual predators are driving around in a shark-finned black Cadillac, and Seth's friends are disappearing and being found dead. Made fearful by Dolphin Blue's hysterical outburst about her dead husband and confirmed in his alarm by a chance resemblance between her and a picture on his father's pulp magazine, Seth comes to believe that Dolphin is a vampire. She, he believes, is the "monster" responsible for the death of his friends.

Two further events enrich the meaning of the vampire figure with political and historical connotations. After the death of one of Seth's friends, the police come to the Dove house to interrogate Seth's father. Suspicion has fallen upon him because of an incident deep in his past in which he was caught in a sexual encounter with a teen boy. The policeman taunts and threatens him, and rather than face the shame of a reopening of his past, Seth's father drenches himself in gasoline and sets himself on fire. The loss of his father and the violence of the police give Seth nowhere to turn, even after he witnesses a friend, later found dead, being pulled into the roving Cadillac. So in his helplessness, Seth disavows his knowledge of the truth and displaces his fears all the more intensely onto the "vampire," Dolphin Blue.

Still more significant than the death of his father, however, is the return of his brother Cameron from the Pacific, where he has been a sailor involved in the tests of the hydrogen bomb. When asked what he did in the "pretty islands," he answers, "Blew 'em up. That's about it." Yet he has

come back discontent with the life to which he has returned and, unknown to him, sick from radiation exposure. The onset of his illness—which leaves him fatigued, thinning, and losing his hair—coincides with his developing love and sexual relationship with Seth's nemesis, Dolphin Blue. In a highly stylized, subjectively focalized scene, Seth witnesses Dolphin and Cameron in a sexual embrace, but interprets it as her biting Cameron and sucking his blood. After this act of "eye-witnessing," Seth will use any means necessary, including the real culprits for the murders that are happening, to destroy the vampire. When he meets Dolphin on the road and sees her accepting a ride from the Cadillac-driving killers, he makes no attempt to warn her and looks on with a sense of victory as the car speeds away. The next day, her body turns up in a ditch. Cameron collapses in an agony of grief, and Seth runs deep into the fields, recognizing what he has done in the final cry of guilt that closes the film.

In *The Spirit of the Beehive*, the Frankenstein figure serves as a figure of relation to the Republican past and to the revolutionary masses that precedes Ana's more active understanding that may come with her adulthood. In contrast, *The Reflecting Skin* uses the imposition of the vampire figure on Dolphin Blue to highlight the tragic effects of misrecognizing and disavowing the real social, political, and historical sources of violence. The child's adoption of the monster figure is initially an innocent, if unfortunate failure of understanding. At this stage, as in *Spirit of the Beehive*, it serves a primarily hermeneutic function, allowing Seth to grasp a perplexing and frightening situation and to focus his actions on the tangible goal of protecting himself from the vampire. If, however, Erice shows Ana passing from this hermeneutic use of the monster to an ethical and (prefiguratively) political alliance with him, Ridley shows Seth failing ethically by self-interestedly holding on to the figure of vampire as explanation long after it has lost any credibility. As events unfold, the vampire figure, as Seth imagines it, becomes an actively maintained self-deception about the murders. The results are tragic—the death of Dolphin Blue and the spiritual destruction of Cameron along with the death of his love and the dissipation of his plans. Yet the film also suggests that Seth, because of his disavowal of the truth and his clinging to his pulp mythology about his foreign neighbor, is morally implicated in the terrible things that happen and must live with the awareness that he was a more-than-passive accomplice in Dolphin Blue's murder.

Embodying Witness

In the previous three sections, I have discussed the figural expression of the child's relation to its historical situation as *external* forms, however much that externality is qualified by subjective tones emanating from the child-witness and agent. In the type of the pure witness, the objective scene is lent a perceptual intensity that reflects the passive, "affected" condition of the immobilized seer, up to a limit of evoking a dream-like indiscernibility between the subjective and objective facets of a unitary perceived event. In the case of mimetic games, the figure takes on externalized form in the embodied activity of playing, making theater, or performing ritual. While the body is necessary and involved in the production of the objective form—the role or performance—it also remains distinct from it, as an actor's body does from the character it supports and signifies. Similarly, although the figure of the monster represents a powerful imaginative and affective investment, it is projected outward onto another body, which may become the guardian or antagonist of the child. In this section, I will explore a self-reflexive turn that renders more problematic the externality of the figure, a new figural type in which the bodily involvement of mimetic games and the monstrous metamorphic powers of the imagination converge on the child's own body. Under the rubric of "embodying witness," I will consider instances of the literal metamorphosis of the child's body itself, its own embodied "figure," in response to a traumatic historical circumstance.[10]

Joseph Losey's first feature film, *The Boy with Green Hair*, provides a transparently allegorical, though by no means simplistic instance of this figural use of the child's body. His framed narrative begins with the protagonist named by the title, Peter, in a police station and notably without any hair at all. After resisting speaking to the policeman, Peter begins to open up to a kindly psychiatrist and tells the story of what happened to his hair and why he ran away from home. Peter's parents, humanitarian workers with children in London during the war, were killed in a bombing, and he was sent from relative to relative to live until finally arriving at the home of the good-hearted "Gramps," a former circus-artist and showman. Everything was going well in Peter's new life until two events struck at the heart of his well-being. Working with his classmates to collect clothes for war orphans, Peter only belatedly discovers that he himself is a war orphan; hoping to allow him to adjust to his new circumstances, Gramps had held off breaking the news to him that his parents were dead. Soon after this insight into his special and stigmatized social identity, the utterly unforeseen happens: Peter wakes up one

morning with a full head of green hair. His new hair causes murmuring, discontent, and eventually fear in the people of the small town, and despite the best efforts of Gramps and the enlightened schoolteacher, a mob-like sentiment grows against Peter. Narrowly fleeing attack, Peter runs away and stumbles upon a place in the woods where he falls asleep and has a dream or vision. The children he has seen on the posters—war orphans from Germany, Yugoslavia, Greece, and elsewhere—speak to him and tell him that his green hair is a good thing and has a meaning. It is a sign to tell people that they must work to stop war and to keep from making more war orphans like himself. Peter returns to the town fired with missionary zeal. But the town is no more assuaged, and after one particularly narrow escape from a gang of boys, he gives in to the pressure to have his hair shaved. Deeply disappointed in himself and in Gramps, who in the end acquiesced in the town's intolerant demand, he runs away and is picked up by the police. The psychiatrist who has been listening rhetorically says that he doesn't believe a word of it, because he thinks Peter doesn't believe it himself; if he did, he wouldn't have given up so easily. Peter agrees to take up the cause again, grow his hair back, and live the role of the sign and messenger for peace. The psychiatrist opens the policeroom door to reveal the town's three enlightened members, the doctor, the schoolteacher, and Gramps, ready to bring Peter home again. The psychiatrist's parting exchange with the doctor underscores the *figural* truth of the story the boy has just told. He says it doesn't matter if Peter had green hair or not; he believes in what Peter was trying to say.

Losey's film is a clearly a parable about racism and nationalism as the fundamental causes of war. Comprehending the pacifist meaning of Peter's embodied difference will require the members of this typical small town to confront their almost instinctual fear of difference, expressed immediately as racist prejudice and more mediately in the kind of nationalism that leads to war.[11] Losey's framing of the story and filtering of it through the child-narrator effectively motivates the simple, parable-like, and often fantastical nature of the story. More sophisticated, however, is his dramatizing of the social and personal struggle around Peter's body as a *sign*, the way in which Peter's difference, his having and being a marked body becomes a site of meaning and of a conflict of interpretation. Peter ultimately claims his body by taking it as a meaningful sign, and this sign in turn allows him consciously to accept and enact what he objectively is (a war orphan). Yet as the framing narrator, he also is able to organize his experience around this embodied sign in the form of a coherent, teleological, autobiographical narrative that only requires the final encouragement of the psychiatrist to bring it to its symbolic

fulfillment in his reconciliation with the enlightened community of elders. Any questions about Peter's factual reliability as a historical narrator ("Do you believe his story?") are secondary to the figural truth of his achievement of individuality and identity through narrative ("I believe in what he was trying to say."). Losey presents Peter ultimate transformation through narrating his story as reabsorbing the bodily figure of change, the green hair, into Peter's less visible but more decisive *consciousness* of having been "the boy with green hair." As character, Peter suffers a dialectical movement from receiving a bodily mark of indeterminate meaning, through a struggle for the meaning of the mark, to the erasure of his difference and alienation from his body under the domination of others; his colorless, bald head at the beginning of the film is the visible sign of his loss of identity. Yet as narrator, he completes the dialectical movement of the film in a final reclaiming of his identity in his reconstitution of the erased sign through language and narrative. The viewer knows in the end that it doesn't really matter if Peter's hair grows back green or even whether it was ever green at all. What matters is the conscious claim he makes on the *meaning* of his green hair as sign, his grasping of his own embodied difference and social individuation not as a deficiency but rather as a potential for positive change.

Völker Schloendorff's adaption of Günther Grass's celebrated novel of Nazi-era Danzig, *The Tin Drum*, offers a more ambiguous figuration of history in the body of its protagonist and diminutive tin drummer, Oskar Mazarath. The story revolves around the parallel between the childhood of Oskar and the rise and eventual fall of Nazism in the Polish-German Danzig area. Allegorically significant is Oskar's deliberate fall down the cellar steps at the age of three and his subsequent failure to grow any larger, despite his increasing psychic and even sexual maturation. Oskar has also been gifted with an extraordinary vocal capacity: his high-pitched scream, usually accompanied by a tattoo on his tin drum, can break the glass of tableware, cabinets, and windows even at a great distance. This imagery of Oskar as the infantile, destructive drum-beater and shouter brings him in contiguity with the figure of Hitler. One scene in particular suggests this juxtaposition. Up in a tower overlooking the city, Oskar drums and screams his glass-breaking cry, shattering windows around him. The scene ends with the voiceover of a Nazi orator addressing a crowd about the Germanness of Danzig and the arrogance of the Poles in trying to take over the city.

Elsewhere, however, the identification of Oskar with the Nazis gets reversed, becoming satiric or pathetic in its connotation rather than allegorically representative. In one scene, for example, Oskar disrupts a

Nazi rally by hiding under the bleachers and drumming off-time from the marching bands at the festivity. He manages to shift the rhythm from a goose-stepping march to a waltz, thus thoroughly destroying the political effect of the mass event. Even more significant is Oskar's wandering through the streets during the events of *Kristallnacht*. Here Oskar's previous glassbreaking appears both magnified to gigantic scale and radically outdone by the racist violence unleashed by the Nazis. Viewed against this organized, collective terror, Oskar's acts of destruction appear not as its allegorical counterpart but as the expressions of a childish and individualistic anarchism, moved by a wholly different spirit than that underlying the Nazi violence. Moreover, Oskar undergoes a decisive inner change on that day with his discovery of the dead body of the Jewish toymaker Sigismund Markus, who had supplied Oskar with his tin drums. Although he does not grow any larger, the death of Markus is symbolically also the end of Oskar's childhood. With this passage out of his arrested childhood, in spirit if not yet in body, Oskar's mirroring of the Nazis in dwarf-like form no longer appears unconscious and allegorically representative, but rather deliberately and strategically adopted on his part. In the ensuing events of the film, Oskar will thus become part of the entertainment troop of the older dwarf Bebra and will tour occupied Europe wearing diminutive uniforms, amusing and parodying the occupying Nazi army.

The ambiguity of Oskar's figure is intentional, bearing a number of different historical and political senses at once. Oskar's deliberate stunting of his growth and refusal to become an adult clearly hints that Nazism may be seen as an expression of Germany's political immaturity, the desire of a people to refuse historical change and to believe in a childish fantasy of omnipotence. As already mentioned, Oskar's shattering voice seems to echo Hitler's oratorical histrionics. Yet as his conversations with the circus dwarf Bebra make clear, Oskar also offers an image of the "little people," the weak, marginal, foreign, or freakish who would suffer the Nazi genocide. And crucially, he also represents little *peoples*, troublesome "small nations," such as the Kashubians and other ethnic groups that fit nowhere neatly into the geopolitical divisions of a nationalized Europe. As Oskar's grandmother remarks near the end of the film, the Kashubians have been kicked around by both the Poles, for whom they were not Polish enough, and by the Germans, for whom they were too Polish. In his mixed heritage—carrying his German father's name but probably the blood paternity of his Polish uncle, the lover of his Kashubian mother—Oskar serves as a warning against taking outward signs (his German name) as a reliable gauge of national and personal identity. In the final scene of the

film, Oskar, who has suffered another fall and has begun to grow again after passing eighteen years in a three-year-old's body, is being loaded aboard a train to Germany, deported from the Russian-occupied territory because he is of "German" paternity. As the train pulls away to take him to a new life in Germany, he calls out the name "Babka"—not the German but the Polish or Kashubian word for "grandmother."[12]

Time Travelers

With my final type, the figural representation of an historical situation through the embodiment and consciousness of child characters reaches a maximum of imaginative latitude. In the films of this type, not only are spatialized relations between the child as perceiving subject and its surroundings rendered fluid, as the child engages in intense acts of witness and mimetic games, personifies affects as monstrous figures, and self-reflexively transforms its own bodily figure according to its subjective response to historical circumstances. But also temporal relations are drawn into the reconfiguration of personal identity, in its various dimensions of embodiment, memory, imagination, and affect. In this last group of films, personal identity and the body are put in play across temporal as well as spatial divides. If we think, for instance, of mimetic activity as implying a virtual play-space in which some of the ontological characteristics of everyday reality are put in suspension, then so too time-traveler narratives play with time and its normally divided compartments of past, present, and future. Time becomes a volumetric "theater" in which virtual roles can be adopted, played out, perhaps also understood and criticized. For just as the fluidizing of identity in mimetic games may leave the actor changed and more aware, so too the time traveler may achieve an insight or gain a power not available to him or her before risking the encounter with the other in time.

The narrative figures that result from such encounters across time are versions of what Deleuze identifies as "time-images" in the second volume of his *Cinema* studies. Unlike classical realist narration, which presents a narrative time indirectly through the variations that emplotment lends to the linear succession of causally linked events, in these films narrative structure derives from the orders of time that are juxtaposed, blended, interlaced, or rendered indiscernible. Similarly, whereas in classic narration, the narrative foundation allows a hierarchical assignment of ontological value to memory (past), action (present), and imagined anticipation (future), in the latter case, the ontological values derive from the relations of time as concretely presented in the time-image. Thus, for

example, in such films, memories, dreams, or imagination may be a means of effective present action, precisely when the body is immobilized or otherwise constrained from its normal active role.[13]

My specific focus on time in this final section only brings to the fore an aspect implicit in all the types I have discussed. Once the basic premise of the pure witness is recognized—that the disengagement or blockage of effective action renders subjective and objective features of a perceptual experience increasingly indiscernible—then this indiscernibility can be seen to unsettle not just the objectivity of space, but also its temporal correlates in objective, linear, homogeneous, irreversible time. In Klimov's *Come and See*, for example, despite the relatively straightforward "realist" narrative succession, there is a strongly accented dissonance between the objective time-span and the character's subjective experience of it. Only a few days pass in the film, yet Flor passes from boyhood to a kind of premature old age in that brief span. This paradoxical structure, of course, is most poignantly registered in the one sequence that dramatically breaks with realist narrative time, the climactic sequence with the shooting of the Hitler picture and the reversed newsreels: Flor's young face, worn, rigid, and etched with shock, grey with frost and grime, is juxtaposed to the motionless face of the infant Hitler in the arms of his mother. Similarly, in the manically subjective narration of Jordan's *The Butcher Boy*, the fusion of past and present, narrator and narrated character, makes it difficult to neatly account for the temporal dimensions of Francie Brady's narrative. Most strikingly, Oskar's bodily figure in *The Tin Drum* appears as a complex temporal image of eighteen years of history and provokes problems of narrative coherence as a result. At the moment of his birth, for example, he is represented as having had the full consciousness of the voiceover narrator of the film. Later, he uncannily spans the range from toddler to adolescent to adult in the same small boy's body. As a result, we see the grotesque image of the puny Oskar engaging in adolescent sexual play with his housekeeper Maria or being seduced by an older woman; and the strangely moving spectacle of his "mature" love affair with Roswitha, with whom he forms a kind of miniature parody of a married couple.

In the time traveler films, however, this interfusing of subjectivity and time structure is made explicit in the premise of a kind of mental communication and traffic across time. In Vincent Ward's *The Navigator: A Medieval Odyssey*, for example, the narrative links the miners of medieval, plague-ridden England with the industrial workers of twentieth-century Wellington, New Zealand, through the visionary time-travel of an epileptic boy in the English village. When the plague threatens to come to their Northumbrian village, the visionary boy and his adult friends set out

to burrow through the center of the earth to the other side, where they believe the city of God must be. They find an unknown shaft and an engine for blasting through and begin a descent. Only later do we discover that the boy has fallen into a trance and continued on in a vision; the film indicates the break with objective, medieval reality to the dreamed modern reality only with the change from the original black-and-white to color. The miners in the boy's vision take copper to the "city of God," modern-day Wellington, New Zealand, and find a foundry that is being shut down because of layoffs. They recognize their fellows in the foundry workers and convince the skeptical modern workers to forge a cross to erect on the cathedral as an offering to God. In the process of setting the cross atop the spire, however, the boy slips and falls, plunging back into his dreaming body in the pit and awakening unharmed. He and his comrades return to the surface to find that the plague has passed over their village. Yet just as in his vision the boy has sacrificed his life to make the tribute to God, so too in real life he will become a sacrifice for his village. He alone will become infected with the plague and die of it, while the village is spared the epidemic.

Ward's film seems primarily concerned with developing a narrative analogy between the destructive and ineluctable spread of the plague and the unconstrained spread of military and media technology. In both cases, these "epidemic" infections are seen to undermine the bonds of community and the values that underlie it. The scene in the foundry, with the workers forging a link of shared feeling across time, suggests a convergence of Christian and working-class values that have been eroded by the forces of post-industrial modernity. It is an image of a good industrialism of the virtuous craft worker, rooted in a deep-seated Anglo-Saxon tradition going back to the Middle Ages. This traditional industrial working-class, soon to disappear altogether, appears as the last bastion of the sort of putatively organic community from which the time travelers have come. Accordingly, three contrasting images of technology suggest the dangerous forces proliferating out of control and threatening to consign the foundry workers to the same oblivion as the latter-day heirs of the medieval British miners. First, one of the time travelers must run terrified through a nightmarish scrapyard in which huge mechanical claws grasp and clutch at the refuse of the industrial process. Second, having commandeered a row boat, the questers are caught in an epic sea battle with a veritable "leviathan," when a nuclear submarine surfaces unexpectedly in the harbor. And finally, the visionary boy is hypnotized by a wall of television sets in a lobby and is "saved" from the evils that appear on the screen (among them, the submarine), when one of his

friends smashes the TVs with an ax. This scene evokes a postmodern information and media society, in which all points of the globe are interlinked both by communicative flows and by the nuclear threat. Making this message still more explicit, Ward incorporates a news commentator talking about the idealistic, but ultimately deluded attempt to make New Zealand a nuclear-free zone. Ward makes this media spectacle one of the obstacles and potential traps for the boy in his quest to raise the cross and save his village; television transmission is, in a sense, the Satanic double of his pious vision. The filmmaker thus implicitly suggests that only a return to traditional values of work, community, and faith can offer any hope of salvation against a postmodern condition undermining tradition with ever-increasing intensity.

Two films by Eastern European filmmakers suggest further alternative possibilities for time-image figures of history in relation to children. Andrei Tarkovsky's *Mirror* presents an intricate, complex, semi-autobiographical narrative figure of fifty years of Soviet history from the early 1930s to the present of the film (early 1970s). Present-tense scenes of an unseen male voiceover with his estranged wife and their son shift unexpectedly and without clear points of orientation back to the 1930s and the war years, with images of the unseen man's mother and of himself as a child. In addition, there are interpolations of additional material, including television and newsreel footage from various periods. Two aspects of the film profoundly undermine the viewer's attempt to establish a temporal and ontological baseline from which the other materials can be considered second-order departures in fantasy or memory. First, similar or clearly related scenes sometimes appear in the mode of straightforward film narration (usually in color), sometimes as narration marked as subjective by a voiceover (for instance, as a memory being recounted), and sometimes in dreams (at certain points simply presented in surreal black-and-white images, at other times recounted by the voiceover). In the end, *all* the narrative material of the film appears to emanate from the unseen speaker of the voiceover, and there is no reason to favor the straight narrative passages over memory or dream on the grounds that it is "more objective." Each of the bits of this mosaic-like narrative seems equidistant from its subjective source. Tarkovsky furthermore undercuts the apparent objectivity of the narrative passages with a peculiar and challenging device: he uses the same actors to play characters in different parts of the voiceover figure's life. The mother in the 1930s and the wife in the 1970s are played by the same actress; similarly, the boy in military training during World War II and the son of that boy, now thirty years older, are played by the same young actor. Tarkovsky heightens the uncanny

resemblance and repetition structuring the relationship between the generations—at least in his voiceover figure's subjective consciousness—by setting in resonance events from the past and in the present. For example, the voiceover figure's mother (during the war) and his wife (in the present) both drop a handbag and sit on the floor picking up the contents; the son (in the 1970s) in helping his mother pick up her things has a sudden feeling of déjà vu, as if he were being haunted by the father's experience thirty years earlier.

If Tarkovsky's narration unfolds a complex image of history out of a highly personal nucleus of time, a pre-differentiated subjective time from which the differences between memory, imagination, dream, and perception flow, András Jeles's film *The Annunciation*, based on Imre Madách's nineteenth-century Hungarian classic *The Tragedy of Man*, presents a visionary panorama of history literally from the Biblical fall of man to the modern age—all played by children between the ages of eight and twelve. It begins with a scene of the temptation of Adam and Eve in the Garden of Eden by Lucifer. Once they have been tempted and expelled from the garden, Adam wants to know if his knowledge has been worth losing paradise, and he asks the impish Lucifer to reveal the future of mankind to him. Lucifer lays him asleep with Eve in a pile of leaves and takes his spirit through a series of dream-visions into history—Ancient Greece, Byzantium, Kepler's Prague, the French Revolution, and nineteenth-century London. In each of the visions, the action is staged by the same cast of children, in a grotesque combination of children's games, theater, and dream. Adam sees in history an uninterrupted spectacle of scapegoating, intolerance, religious and political fanaticism, superstition, mob action, poverty, cruelty, infidelity, and violence.

Like Tarkovsky's *Mirror*, the film shifts time-references while using the same actors and providing a limited amount of exposition of narrative material. We see a set of almost dream-like tableaux of history enacted by this group of child actors, recostumed for each shift in scene. There is even some contamination between historical periods in the visions, as for example when the Greek general from the Athenian scene inexplicably appears in eighteenth-century Paris to announce to Danton "there will be no beheading this time," thus shifting the scene to London. Just prior to this strange transition, Jeles flashes back to an image of Adam and Eve dreaming among the leaves, and the scattered leaves slowly resolve into a scene of bodies and rags in which Danton is crawling. The death of the figure in the dream is thus taken as a kind of ontological limit beyond which the penetration of other realities by the vision or dream cannot pass. Following a still more hallucinatory and temporally confused scene in

London (among other things, Christ is being crucified there), Lucifer finally awakens Adam, having hoped to have plunged his soul into despair, thus to claim it as his own. The film ends with an open question of whether God or Lucifer is the true "angel of history" and what role God plays within or beyond the human history that Adam is about to inaugurate. Hauntingly redoubling the question of who has the last word in history, God speaks to comfort Adam and Eve, admonishing them to "have faith and strive." Concluding the film, Lucifer mimics God's command word-for-word, letting its possible irony ring beyond the film. With an ambiguous smile and with the figure of death standing over Adam and Eve, he repeats, "Have faith and strive."

* * *

These films and the types I identify them as exemplifying invite reflection on four related critical and theoretical issues. First, by setting child characters against intense and difficult historical circumstances, they highlight the peculiar phenomenological capacities and limits of children's abilities to interpret, comprehend, and act in the world. Second, insofar as children exhibit in nascent form the capacities of adult subjects, and insofar as the unprecedented circumstances of twentieth-century history have raised serious issues of the comprehensibility of history by individuals, child characters offer a poignant metaphor for *adult* subjectivity faced with the baffling, inexplicable, and overwhelming contingencies of history. Third, simply because of their incompleteness, their immaturity, and their partial unformedness as social agents and actors, child characters may represent a utopian reserve of openness and hope within an otherwise closed historical horizon of adult experience. And finally, child characters and narrators offer filmmakers (and novelists) key narrative "devices" by which to approach artistically the intractable historical situation. In their acts of witnessing, their mimetic games, their imaginative transformations of themselves and others, and their travel across the divisions of time, they figuratively dramatize the individual's attempt to cope imaginatively and affectively with historical circumstances that often exceed his or her capacities to understand them rationally. Yet they also suggest alternative forms of historical witness, in which factual testimony yields its place of privilege to a wider range of subjectively inflected expressions of historical truth. These narrative figures adumbrate the basic building blocks of a new mode of historical testimony, a "figural realism" better able to represent the problematic nature of twentieth-century European historical experience.

Filmography

Germany Year Zero (Roberto Rossellini, Germany / Italy, 1947-48)
The Boy with Green Hair (Joseph Losey, USA, 1948)
Forbidden Games (René Clément, France, 1952)
The Spirit of the Beehive (Victor Erice, Spain, 1973)
Mirror (Andrei Tarkovsky, USSR, 1975)
The Tin Drum (Völker Schloendorff, Germany / France, 1979)
The Annunciation (András Jeles, Hungary, 1984)
Come and See (Elem Klimov, USSR, 1985)
The Navigator: A Medieval Odyssey (Vincent Ward, Australia and New
 Zealand, 1988)
The Reflecting Skin (Phillip Ridley, UK, 1990)
Tito and Me (Goran Markovic, Yugoslavia, 1992)
The Butcher Boy (Neil Jordan, Ireland, 1997)

Notes

[1] Originally appeared as "The Burning Babe: Children, Film Narrative, and the Figures of Historical Witness," in *Witness and Memory: The Discourse of Trauma,* eds. Ana Douglass and Thomas A. Vogler (New York: Routledge, 2003) 207-233.
[2] Klimov is also making a claim to witness and testimony with respect to the audience of his film. His title refers to the words of the angel who greets Mary and Mary Magdalene at the empty tomb of Christ in *Matthew* 28: 6-7: "He is not here; for he is risen, as he said. Come, see the place where the Lord lay. And go quickly, and tell his disciples that he is risen from the dead." *Come and See* was intended to memorialize the heroic struggle on the 40th anniversary of the Liberation from Nazism; it won Grand Prize at the film festival that was connected with the anniversary. Yet as a statement by Sergei Gerasimov in a roundtable discussion at that event suggests, the problem of bearing witness and keeping alive the historical memory of the period was particularly urgent as it had fallen into increasing oblivion and as a new threat of neo-fascism in Russia began to emerge: "Let's be honest. Even our young people are far from dedicated to the tragic events of the military past. There are even those among them who, not wanting to think about the tragic pages of history, would rather watch films of the most inane kind."— Quoted in Joseph Troncale, "The War and Kozintsev's Films *Hamlet* and *King Lear*," in *The Red Screen: Politics, Society, Art in Soviet Cinema*, ed. Anna Lawton (London: Routledge, 1992) 194.
[3] Hayden White, "Auerbach's Literary History: Figural Causation and Modernist Historicism," in *Figural Realism: Studies in the Mimesis Effect* (Baltimore: Johns Hopkins University Press, 1999) 88.
[4] The films I specifically treat in this article can be found in the filmography following the text. A more extensive list of films pertinent to this topic and helpful

to me in formulating the argument of this essay includes: *Afraid of the Dark, Alice in the Cities, Au Revoir Les Enfants, The Bad Seed, Being Two Isn't Easy, Bicycle Thieves, The Blue Kite, Burnt by the Sun, The Children Are Watching Us, China My Sorrow, Down to the Cellar, Empire of the Sun, Fanny and Alexander, The 400 Blows, Freedom Is Paradise, Freeze-Die-Come to Life, Hate, Hope and Glory, The Innocents, Journey of Hope, Léolo, Lessons at the End of Spring, Lord of the Flies, MacArthur's Children, Ma Vie En Rose, The Member of the Wedding, Pixote, Radio Flyer, Rhapsody in August, The Road to Life, Scarecrow, Shoeshine, The Sixth Sense, Small Change, The Thief, Time Bandits, To Kill a Mockingbird, Vigil, Village of the Damned, Walkabout, When Father Was Away on Business, Where Is the Friend's Home?, Whistle Down the Wind,* and *Zero for Conduct.*

[5] Gilles Deleuze, *Cinema 2: The Time-Image* , trans. Hugh Tomlinson and Robert Galeta (Minneapolis: University of Minnesota Press, 1989) 1-9.

[6] This displacement of attention from the crucial event is typical of what Peter Brunette has nicely termed "dedramatization" in Rossellini.—See Brunette, *Roberto Rossellini* (New York and Oxford: Oxford University Press, 1987) 84.

[7] See Rossellini's discussion of *Germany Year Zero* in "Ten Years of Cinema," originally published in the *Cahiers du cinéma* in 1955: "The Germans were human beings like all the rest. What was it that could have carried them to this disaster? A false philosophy, the essence of Nazism; the abandoning of humility for a cult of heroics; the exaltation of strength over weakness, vaingloriousness over simplicity? That is why I chose to tell the story of a child, an innocent, who through the distortion of a utopian education was brought to the point of committing a crime while believing he was accomplishing something heroic."—Roberto Rossellini, "Ten Years of Cinema," in *My Method: Writings and Interviews*, trans. Annapaola Cancogni, ed. Adriano Aprà (New York: Marsilio Publishers, 1992) 65.

[8] Bruce Wilshire, *Role Playing and Identity: The Limits of Theatre as Metaphor* (Bloomington: Indiana University Press, 1982).

[9] Patrick McCabe, *The Butcher Boy* (New York: Fromm International Publishing, 1992).

[10] In my formulation of this category, I have been influenced by Vivian Sobchack's phenomenological concept of the "marked body" and more generally by her rich discussion of the "lived body," which she develops out of the philosophy of Maurice Merleau-Ponty. My use of the concept of the marked body differs somewhat from her discussion, although in what I believe is a fundamentally complementary way. She raises it primarily in the context of issues of social oppression and the way corporeal features such as sex-specific traits and skin color may be coded in reductive, pejorative ways. In contrast, my emphasis here falls on seeing corporeal signs as a site of hermeneutic conflict, with marked bodies being the basis of interpretative resistance and self-assertive counternarratives as well the material of discriminatory and reductive social codings. See Sobchack, *The Address of the Eye: A Phenomenology of Film Experience* (Princeton: Princeton University Press, 1992) 143-163.

[11] Losey himself, it is worth noting, saw these allegorical senses as distinct, with his screenplay writer's pacifist slant winning out over his own directorial intention to present an anti-racist message: "Well, I quarrel very much with Dore Schary's concept of the basic subject. It was not an anti-war picture as a concept, as a device, it was anti-racist. The best scene in the film for me is the one in which the schoolteacher, after a certain amount of persecution of the boy by the children, asks how many of the children have black hair, how many have blond hair, how many have red hair—two hands—how many have green—one hand. This is the essence of the idea, this is what should have been done primarily, and it wasn't. The important thing to speak about then was peace. It's even more important now—hence, perhaps, the quite unrealistically good reviews in France where it is being seen for the first time."—Joseph Losey, *Losey on Losey*, ed. Tom Milne (Garden City, New York: Doubleday & Company, 1968) 72-73.

[12] As Annette Insdorf points out in *Indelible Shadows: Film and the Holocaust* (New York: Vintage Press, 1983) 168.

[13] Deleuze describes the different sorts of time-image in idiosyncratic terms. The main types include crystals of time, which involve "faceted" conjunctions of actual and virtual elements and an order of "rotation" from facet to facet; "sheets of past," as distinct zones or fields of time between which a narrative may shift; and "peaks of present" contracting temporal relations into singular, atomic events indiscernibly fusing the elements of perception, memory, and anticipation. Although Deleuze's metaphysical categories are fascinating and suggestive in their speculative reach, my use of his notion of time-image is more modestly pragmatic and descriptive, seeking only to reveal certain commonalities between particular instances of modernist film narration.

CHAPTER ELEVEN

"CUT OUT FROM LAST YEAR'S MOULDERING NEWSPAPERS": BRUNO SCHULZ AND THE BROTHERS QUAY ON *THE STREET OF CROCODILES*[1]

I

"And no face is surrealistic in the same degree as the true face of a city."
—Walter Benjamin, "Surrealism"[2]

In 1986, the American-born animators Steven and Timothy Quay adapted the Polish writer Bruno Schulz's short story "Street of Crocodiles," originally published in 1933, into a dialogue-less, animated puppet film. The Quays' film adaptation does not merely translate to another medium an essentially intact narrative structure from Schulz's story. Rather, it subjects the Polish novelist's text to the transformative force of time, working in several ways. The Quays animate Schulz's figures, as if winding up their clockwork springs and setting them in motion; taken out of the virtual realm of words, they come to occupy a definite duration—twenty-one minutes—related to the materiality of the film and the calculated speed of its machinery. Yet the film also detours the text through a semiotic transposition and "projection" (from words to wordless pictures, from space to space): a process one might designate with a term from Marcel Duchamp, "delay." By setting Schulz's prose in literal motion and by highlighting the systems of relays through which the literary text gives rise to a new filmic artwork, the Quays disclose physical and semiotic time as meaningful dimensions of their intertextual artistic efforts. They also, finally, foreground the historical gap between their animated film and Schulz's prose text through the device of a framing narrative. Literally a "framing device": a seedy museum with a proto-cinematic viewing machine called "The Wooden Esophagus" provides the narrative window onto Schulz's story. Cinematic preservation and

physical extirpation of the East European Jewish communities that formed the substance of Schulz's flights of fancy thus appear, in the Quay Brothers' highly affecting film, two facets of the same history that has transpired between Schulz's story and their own work that shares its name and narrative premise.

Between the two works, which inscribe a single fictive and fantastic "street of crocodiles" in the incongruent spaces of text and moving image, there occurs a kind of double projection back and forth that allows the temporal gap that this projection bridges to signify, to "sign" itself in the margins of Schulz's narrative—indeed, to replace the determinate words of the verbal text with vaguer implications of a death, decay, and entropy that must engulf language and erode meanings. The Quay Brothers add their work to Schulz's across the partition of the fifty years of history— including the Nazis' attempted extermination of the European Jews that claimed Schulz himself as one of its victims and the Soviet annexation of the part of Poland in which Schulz was born and died. With it their film constitutes a kind of "bachelor machine" of two partitioned elements, each occupying a different system of perspective and dimensionality. Through the looping delay of the Quays' film, Schulz's "Street of Crocodiles" recurs an indefinite number of times, rehearsing once more that very compulsion to repeat that Schulz's text itself illustrates, and capturing its death drive within its mechanics to transmute it into a lyrical "art of dying."

Noteworthy in both Schulz's and the Quays' instantiation of "Street of Crocodiles" is an image of the city brought emphatically to light. The Quays reread Schulz's provincial dreamworld (based on his home town in southeastern Poland, Drohobycz) through the lens of dadaist and surrealist automatism, through the prism of modernism's fascination with the mechanistic body and the figures of the puppet, the insect, and the automaton. In their translation of Schulz into animated images, they also suggest the reference of these jointed, automatic figures, which populate the works of artists from Francis Picabia and Marcel Duchamp to Max Ernst and Hans Bellmer, to the urban landscape of the twentieth-century metropolis. They reveal both visible, perceptually apprehendable aspects of these relations and the invisible social dimension drawing things, spaces, and bodies together into the vortex of commodity time, subjecting each to a rapid cycle of creation, circulation, destruction, and recreation in a new form.

Through the sightless eyes of their puppet figures, for whose life and perception their camera and editing stand in, the Quays present a subjectively apprehended image of the city as modern ruin. In his study of

surrealist art and literature, *Compulsive Beauty*, Hal Foster has suggested that modernist images of the automaton and the ruin can be understood against the background of capitalist modernization:

> these emblems . . . interested the surrealists because they figured two uncanny changes wrought upon bodies and objects in the high capitalist epoch. On the one hand, the mannequin evokes the remaking of the body (especially the female body) as commodity, just as the automaton, its complement in the surrealist image repertoire, evokes the reconfiguring of the body (especially the male body) as machine. On the other hand, the romantic ruin evokes the displacing of cultural forms by this regime of machine production and commodity consumption—not only archaic feudal forms but also "outmoded" capitalist ones.[3]

These images, which constitute the two basic poles of the Quays' *Street of Crocodiles*, thus both register the forces of capitalist modernity and implicitly, by lingering on those objects and spaces that have been consigned to the scrapheap of history, interrupt them. The Quays conceive of the spaces of outmoded consumables as a labyrinth of delay, akin to the passage from image into language in Duchamp. The outmoded serves them as a language not separate from the commodity, from the circulation of money and goods, but one emerging from their oblique, even perverse way of occupying the commodity *erotically:*

> But if we talk of language, we needn't talk objectively of just English, or Polish, or Portuguese: but rather more so of the language of things. Things of the senses which elude or resist classification, numbering, or cataloguing. A friend of ours once heard the sound of a voice counting out change in Polish and said it sounded like "rustling taffeta." This is a profoundly beautiful footnote to any language, to the innately mysterious texture of that language, and so you approach its hem with more trembling than you dare imagine.[4]

The urban landscape that the Quays depict is charged with a disquieting combination of stillness and agitation, suggesting a restless erotic desire hidden behind the banal inexpressiveness of its walls, windows, and doors. Underscoring the implicit blurring of the boundary between subjective and objective features of this represented space, I will call its basic mode "fetishistic urbanism," which I characterize by three major features. It is, first, ontologically indefinite: the spaces of this puppet-city and the objects inhabiting them confound oppositions of animated and dead, organic and inorganic, active and inert, real and imaginary, genuine and ersatz. Second, it is characterized by a reversibility of properties between the

human body and inanimate objects, with bodies becoming rigid and jointed, while objects take on fleshly, pliable, and pulsate qualities. Finally, it is an essentially entropic mode, dominated by repetition and the dispersal of structured form in a spreading dilapidation and disorder.[5]

This mode of urbanism is not original to the film of the surrealist animator, even though it has found its most faithful historian and archivist there. Rather, it was indigenous to the modern European metropolis itself, resulting from the spatial dynamics of capitalist accumulation, from the movements of value through the built environment that marked the modernization of old European cities such as Paris in the successive implementations of Baron Hausmann's plans. The rapid development of zones of commerce, in which jerrybuilt facades quickly crumbled into strangely juxtaposed mixtures of newness and decrepitude, gave rise to a novel experience of temporal ambiguity embedded in the very spaces of everyday life.[6] The name for this experience was the "outmoded," which writers as varied as André Breton, Louis Aragon, and Walter Benjamin discovered hidden in the built remains of the previous epoch. Benjamin, for example, catalogued spaces and things saturated with this anachronistic temporality of the once-and-no-longer new: "the first iron constructions, the first factory buildings, the earliest photos, the objects that have begun to be extinct, grand pianos, the dresses of five years ago, fashionable restaurants when the vogue has begun to ebb from them."[7] Exemplified by the new-old buildings of aging modern zones of the city, and equally by the commodified objects of dress or domesticity once invested with the gleam of fashionableness, they later, through the mere passage of time, carry the stigma of inauthenticity and destitution. But in their fall from newness, their qualities undergo a change of value.

In turn, the peculiar phenomenology of the outmoded spaces and objects of these zones facilitated their interfacing with perverse forms of erotic desire, fetishistic and masochistic, which displaced the erotic drive from a human object and extended it into the world of inanimate, partial objects. In their freshness and charm, before their decline into the grotesquerie of the out-of-date, such objects and places allowed the fetishism of the commodity to appear anything but perverse; yielding oneself to the "sex appeal of the inorganic," as Benjamin characterized the commodity fetish of the fashionable object, became a public mode of gratification rather than something pursued in the shadows of the back room. In their decline, however, they became the material repositories of a desire fixated in the past, set on disavowing history, recapturing lost time, and preserving it in artificial suspension for periodic recall. Yet this paradoxical impulse, this attempt to arrest the ineluctable movement of the

commodity on its circulatory course from fashionability to outmodedness, never really succeeds in reanimating a lost freshness. Instead, it produces a repetitive life-in-death and death-in-life, an uncanny circling in a narrow ambit among a diminishing selection of treasured things.

The ultimate image one derives from Schulz's and the Quays' works is that of the city as an intransitive and derisive machinery, in which the compulsive repetitions of fetishistic sexuality and the entropic movement of matter are complementary and mutually reinforcing aspects of the dynamics of urban space. Neither suggests anything or either the convulsive beauty that the surrealists thought to discover in such spaces of the outmoded as the Passage de l'Opera in Louis Aragon's *Paysan de Paris* or the flea market in André Breton's *Nadja*, nor the "revolutionary nihilism" Walter Benjamin detected in the surrealists' relation to the impoverished zones of the modern city:

> No one before these visionaries and augurs perceived how destitution—not only social but architectonic, the poverty of interiors, enslaved and enslaving objects—can be suddenly transformed into revolutionary nihilism. . . . They bring the immense forces of "atmosphere" concealed in these things to the point of explosion.[8]

Rather, for Schulz and the Quays, it is as if a mutual regression gripped both the city and its human material. The decay of the urban world sets free the fragmentary objects of the fetishist's desire, while the fetishist's restless wandering from object to object drives forward the corruption, moral and material, of such zones of urban disintegration. Rather than dialectical, tending towards an intensification and reversal of urban decay into revolutionary destruction, the dynamics of fetishistic urbanism are *dissipative*—the entropic spiral progresses from repetition to repetition, gradually spreading from point to point; yet this very expansion of its bounds tends to limit it, slow its spread, and contain its virulence.

II

> "People's weakness delivers their souls to us, makes them needy. That loss of an electron ionizes them and renders them suitable for chemical bonding. Without flaws they would stay locked inside themselves, not needing anything. It takes their vices to give them flavor and attraction."
> —Bruno Schulz to Tadeusz and Zofia Breza, 21 June 1934[9]

Bruno Schulz's "Street of Crocodiles"—actually a single chapter from a book of interlinked stories from Schulz's childhood entitled in the Polish

original *Cinnamon Shops*—explores a modernized section of an old, central European provincial city. Though not identifying it explicitly, Schulz clearly based his fictive city on his hometown of Drohobycz, later incorporated as Drogobych into the Soviet Union (which has, by now, itself been consumed by history). But even before the Nazi invasion and Soviet annexation had done its destructive work, the forces of decay had already taken hold on the childhood city that, as Adam Zagajewski puts it, Schulz imaginatively "transformed into some sort of eastern Baghdad" out of the *Arabian Nights*.[10] Schulz's *Cinnamon Shops* persists as a kind of fantastic ruin, or perhaps, given its author's more lurid imaginings, especially evident in his pen-and-ink drawings, a fetish of a lost object of love. As Zagajewski notes, "In transforming the cramped and dirty Drohobycz—in which probably only the half-wild gardens, orchards, cherry trees, sunflowers, and moldering fences were really beautiful—into an extraordinary, divine place, Schulz could say good-bye to it, he could leave it."[11]

Schulz's Street of Crocodiles is an "industrial and commercial district," a zone of "pseudo-Americanism, grafted on the old, crumbling core of the city."[12] At the same time, however, it is distinctly marked as an area of corruption. For example, it is a place in which the fetishist or masochist might look to find pictures and books to feed his imagination or even find prostitutes willing to service his specialized tastes. Schulz subtly equivocates in his description of the relation of the area to the rest of the city, suggesting its compounding of repulsion and desire, its attraction and the need to disavow the basis of its attraction:

> The old established inhabitants of the city kept away from that area where the scum, the lowest orders had settled—creatures without character, without background, moral dregs, that inferior species of human being which is born in such ephemeral communities. But on days of defeat, in hours of moral weakness, it would happen that one or another of the city dwellers would venture half by chance into that dubious district. The best among them were not entirely free from the temptation of voluntary degradation, of breaking down the barriers of hierarchy, of immersion in that shallow mud of companionship, of easy intimacy, of dirty interminglings.[13]

The Street of Crocodiles represents Schulz's provincial, Central European corollary to Louis Aragon's metropolitan Passage de l'Opera, already fallen from past fashionability into seedy vice, in his surrealist novel *Paysan de Paris*:

The great American passion for city planning, imported into Paris by a prefect of police during the Second Empire and now being applied to the task of redrawing the map of our capital in straight lines, will soon spell the doom of these human aquariums. Although the life that originally quickened them has drained away, they deserve, nevertheless, to be regarded as the secret repositories of several modern myths: it is only today, when the pickaxe menaces them, that they have at last become the true sanctuaries of a cult of the ephemeral, the ghostly landscape of damnable pleasures and professions. Places that were incomprehensible yesterday, and that tomorrow will never know.[14]

Aragon's text in turn inspired Walter Benjamin's extensive study of the historical rise and fall of the arcades as the architectural register of commodity time in the city, the *Passagenwerk*.[15] Schulz's text presents a "dialectical image" (to use Benjamin's term) of the impact of modernization on the small Central European city, offering a set of contradictory predicates for this ambiguous arcade-like zone: new yet rapidly rotting, metropolitanesque yet provincial, fetishistically arousing yet frustrating, bustling yet static.

Significantly, however, Schulz begins his story not with a direct approach to the zone, but rather through the detour of an outmoded domestic object possessed by his father, already revealed in earlier stories to be masochistically and fetishistically inclined and on the brink of psychotic disintegration into a delirium of communication with the material world of dust, insects, and tailor's dummies. The father's object is "an old and beautiful map" kept in the lower drawer of his desk, "a whole folio sheaf of parchment pages which, originally fastened with strips of linen, formed an enormous wall map, a bird's-eye panorama."[16] From the very outset, then, the city is eclipsed by a representation, but in turn a representation whose material support—the parchment and linen strips— threatens to exceed the significance of the lines printed upon it. The Street of Crocodiles, in distinction to other zones richly traced on this map, is marked by a disturbing absence:

On that map, made in the style of baroque panoramas, the area of the Street of Crocodiles shone with the empty whiteness that usually marks polar regions or unexplored countries of which almost nothing is known. The lines of only a few streets were marked in black and their names given in simple, unadorned lettering, different from the noble script of the other captions.[17]

The reassuring perspicacity of the panoramic view is denied this space; the absence of any thickly textured weave of streets and names, the graphic

image of the old European city's historical density, makes this neighborhood gape like an obscene view glimpsed through the otherwise intact fabric of the old city map.

The characteristic quality of this zone is its ambiguity, the same quality Benjamin identified as "dialectical" in his urban dream interpretation.[18] The oneiric ambiguity of the Street of Crocodiles is so strong as to undo the all-too-discrete categories of language in which some description of it might be tendered: "We spoke of the illusory character of that area, but these words have too precise and definite a meaning to describe its half-baked and undecided reality."[19] "Our language," Schulz continues, "has no definitions which would weigh, so to speak, the grade of reality, or define its suppleness. Let us say it bluntly: the misfortune of that area is that nothing ever succeeds there, nothing can ever reach a definite conclusion. Gestures hang in the air, movements are prematurely exhausted and cannot overcome a certain point of inertia."[20]

This inconclusiveness is the general corollary of the story's staging of erotic desire in an extendable series of displacements onto items of print, clothing, footwear, and other objects, which finally return us to the sheer facticity of the commodity, "outmoded" by its passage along the temporal chain of consumer desire and ultimately unsatisfying, leaving the desire that pushed it along progressively more enervated but never fully spent. The exemplary scene in this respect—made a central episode in the Quays' adaptation as well—is the tailor's shop, which remains deeply shrouded in ambiguity as to its true character. In the course of the story, the tailor shop appears, perhaps in reality, perhaps only in the transfiguring light of fantasy, to be a vendor of exotic pornography and a brothel specializing in the perversions. Yet after a narrative digression that explores the erotic scenario, it returns to being, after all, just a tailor's shop and nothing more.

The space of the outmoded is a condensed image of commodity time, in which feverish fantasy and the nausea of the unadorned material are joined in unmediated proximity, through the trick of the collapse of the temporal interval between the fashionable and the no-longer-modish. When, through the passage of time, that vanished interval within the commodity is reconstituted, the result is a kind of Baudelairean spleen:

> Our hopes were a fallacy, the suspicious appearance of the premises and of the staff were a sham, the clothes were real clothes, and the salesman had no ulterior motives. . . . In that city of cheap human material, no instincts can flourish, no dark and unusual passions can be aroused.[21]

III

"I can't stand people laying claim to my time. They make the scrap they touch nauseating to me. I am incapable of sharing time, of feeding on somebody's leftovers."
—Bruno Schulz to Tadeusz Breza, 2 December 1934[22]

In their adaptation of Schulz's complex literary text to a wordless, animated puppet film, the Quay Brothers pick up and intensify his close attention to the material textures and ambiguous qualities of this urban space. Their adaptation appears to draw iconographically not only upon the short story entitled "Street of Crocodiles," but also upon other sources from Schulz's collection *Cinnamon Shops*. For instance, in their central use of animated puppets, automatons, and mannequins, they seem to allude strongly to the three-part story entitled "Tailors' Dummies," which also provides the images of sewing machines picked up in the bobbins and threads that run throughout the film and which offers an important interpretative context for the pervasive presence of incomplete, fragmentary, artificial bodies. In this story, the narrator's mad father delivers a series of disquisitions on the tailor's dummy as a vehicle for philosophizing on the relation between creation, the human form, and the material world. In the second of his discourses, the father suggests that unlike the original Creator, who sought to hide matter under the guise of spirit, human beings must revel in matter's "creaking, its resistance, its clumsiness."[23]

The father would, surely, find his love gratified in the Quays' antique puppets, uncanny machines, and shoddy toys. He might himself be the designer of their mannequins with incomplete bodies, rollers for limbs, and hollow molded heads. Like a bizarrely misplaced Kurt Schwitters declaring the kingdom of Merz in a mid-sized Polish city at the turn of the century, Schulz's father issues a manifesto of the new creation:

We openly admit: we shall not insist either on durability or solidity of workmanship; our creations will be temporary, to serve for a single occasion. If they be human beings, we shall give them, for example, only one profile, one hand, one leg, the one limb needed for their role. It would be pedantic to bother about the other, unnecessary, leg. Their backs can be made of canvas or simply white-washed. . . . The Demiurge was in love with consummate, superb, and complicated materials; we shall give priority to trash. We are simply entranced and enchanted by the cheapness, shabbiness, and inferiority of material.[24]

Another story, "Cockroaches," in which the mad father believes himself to be metamorphosizing into a bug, is alluded to through the furtive, cockroach-like movement of the Quays' adult puppet (to whom they refer in an interview as "The Stalker").

Although the Quays, like Schulz, also incorporate the device of the map to filter the depiction of the Street of Crocodiles through graphic representations and subjective fantasy, they also introduce a novel framing element not in Schulz's text: a black-and-white "prelude" section, entitled "The Wooden Esophagus," set in a run-down museum with a nickelodeon-like optical machine, through which the animated scene is set in motion. This adds one further layer of connotations to the ambiguous corruption of Schulz's "Street of Crocodiles," the "museal" quality that reflects not only Schulz's retrospective look at the city of his childhood, but also the Quay Brothers' perspective on a Central European Jewish milieu largely destroyed by World War II and the Holocaust. Within the narrative frame, this implication of museality is redoubled by a kind of pictorial icon in a panoramic shot of the street. In the upper foreground of the shot, stretched horizontally over the opening of the street on a ledge or in a case, is the skeleton of a crocodile. One is at once entering a kind of gaping mouth and a natural history museum, a curiosity cabinet full of dead fragments of nature. In his essay "Valéry Proust Museum," Theodor Adorno notes the association of "mausoleum" and "museum," arguing that "Museums are like the family sepulchres of works of art."[25] In this light, "the wooden esophagus" appears in a punning relation to a wooden sarcophagus, in which the corpse of the past is being placed in a flesh-eating coffin and digested into images. Schulz's memorial narrative, in the Quay Brothers' hands, thus becomes a self-reflexive commentary on our own museal relation to a history to which we "no longer have a vital relationship" and which only allows itself to be appropriated as a fetishized object, a heap of fragments artificially animated by our disavowal of history, by our desire to get past the dilapidated surfaces of artifacts and documents and to gain access to a throbbing, visceral inner life impervious to time's decay.

The keeper of this dim museum, peering through a device like a peepshow machine or other primitive protocinematic machine, allows a drop of saliva to fall into it, starting its pulleys and bobbins moving. He cuts a thread to which one of the central puppets, representing Schulz's mad father, is tethered, thus allowing him to wander through the Street of Crocodiles. In light of Schulz's text, and also of the Quays' earlier film "Nocturna Artificiala (Those Who Desire without End)" in which this same puppet is seen wandering through an East European city at night, we can interpret this cutting of the thread as the release of the puppet into the

spiral of errant desire, an entry into the fetishistic bachelor machinery of the Street of Crocodiles within which his erotic-entropic quest will be played out. Also, notably, the spaces of the body and visual perspective are mapped onto the city in paradoxical ways. The wooden esophagus through which the museum keeper peers and into which he drops his saliva will open upon the scenography of the Street of Crocodiles, as if it were a dream-like figural translation of a digestion process going on within a slumbering puppet's body. The cutting of the thread might thus alternatively be interpreted as the snapping of the thread of consciousness and the passage of the subject into the rigidified state of sleep and dream. At the same time, however, the Street of Crocodiles is also an objectified space containing the wooden puppet bodies of the father, the child, and the various inhabitants of the Street. Analogously, at several points in the film, the perspective loses its panoramic character and is clearly focalized through the perspective of the father or child. Thus the ambiguities of this space: it both contains and is contained by wooden bodies; it is seen both from outside and from within, panoramically and through focalized views.

The space itself is characterized by what might be described as an entropic animation, a pseudomorphic life-likeness lent to inanimate material by the processes of breakdown and decay. One static image of this non-organic "life" is the dust that has rendered many of the shop windows in the Quays' film nearly opaque and that has gathered in a thick layer on the street.[26] As with Marcel Duchamp's temporal telescoping of movement into a still image by affixing the dust gathered on the surface of the *Large Glass* (Man Ray's famous photograph, *Dust Breeding*, documented Duchamp's glass with months of dust gathered on it), here the dust represents a negative imprint of crumbling facades and the drift of invisible particles in the air, once agitated by the passing of bodies and vehicles and now fallen all but still. While the images of dust are presented fairly unobtrusively in the Quays' film, Schulz's dedication of the father's third discourse on tailor's dummies to the pseudoflora and pseudofauna of dust that sprout in undisturbed rooms and that disintegrate upon their reopening should alert us to its importance in the Quay Brothers' vision of the Street of Crocodile as a sealed chamber of the East European urban past. Schulz recounts the "used-up atmospheres, rich in the specific ingredients of human dreams; rubbish heaps, abounding in the humus of memories, of nostalgia, and of sterile boredom." "On such a soil," he concludes, "this pseudovegetation sprouted abundantly yet ephemerally, brought forth short-lived generations which flourished suddenly and splendidly, only to wilt and perish." [27] In the Quays' film, dust is the index of just such an ephemeral life and rapid perishing in the city space as

a whole, as well as a mark of the distance in time between their authorial present and the semi-fictional moment of Schulz's childhood.

Similarly, in close-up images of rainfall agitating fine grains of sand on the streets of the district, the Quays suggest that the dusty residues of urban life here now persist only in a minimal state of animation, a restless but aimless turbulence of matter at the threshold between motion and inert stillness. Yet at the same time, this minimal life is ambiguous, since it also suggests a pathetic reserve trapped in the very refuse generated by human labor and activity. In his third disquisition on tailors' dummies, following his account of the vegetative life of dust, Schulz's father rises to a mad pitch of mimetic empathy with a matter tortured into form by the work of unknowing men:

> "Who knows," he said, "how many suffering, crippled, fragmentary forms of life there are, such as the artificially created life of chests and tables quickly nailed together, crucified timbers, silent martyrs to cruel human inventiveness. The terrible transplantation of incompatible and hostile races of wood, their merging into one misbegotten personality."
>
> "How much ancient suffering is there in the varnished grain, in the veins and knots of our old familiar wardrobes? Who would recognize in them the old features, smiles, and glances, almost planed and polished out of all recognition?"
>
> My father's face, when he said that, dissolved into a thoughtful net of wrinkles, began to resemble an old plank full of knots and veins, from which all memories had been planed away.[28]

A second set of images of the spurious and uncanny life of the district can be found in the variety of automatons and machines that are the primary occupants of the shops lining the Street of Crocodiles. These include a monkey-doll with a set of cymbals, observed both by the father and son through the toy shop's dusty window and periodically shuddered by a paroxysm of mechanical agitation; the taffy machine in the candy shop window, repetitively jolting to stretch the grey, amorphous gum and snapping back, while a mechanical finger juts up to extract a piece from the extended mass; seen through another window, a hammering craftsman figure made up of mechanical parts, a light bulb for his head and surrounded by other lightbulbs scattered over the floor of the shop; the automaton tailor's assistants; and several other mechanical entities more indefinitely characterized. One should add that the Quays' representation of the city of Bruno Schulz's childhood is evoked by their signature use of antique Central European wooden puppets, which could very well have been seen in a toy store in Poland around the turn of the century. Thus even the central "characters" of the film, the puppet figures of Schulz's

father and the child himself, have an obsolete, artifactual quality. Through these aging children's toys, Schulz's city is self-reflexively evoked as a space of aging, lifeless commodities brought artificially to life by the machinery of cinematic animation (note the implication of "anima," life and soul, in the term).

A third and symbolically rich icon of entropic animation is that of the repeated image of self-unscrewing and self-propelling wood screws. These not only clearly associate the deceptive appearance of life in the Street of Crocodiles with the process of decay and dilapidation undoing the neighborhood, which is almost literally coming apart at the seams; but they also refer back self-reflexively to the process of cinematic animation. The incremental cranking of the animator's camera and the reverse running of the film by which the screws are made to unscrew themselves appear as the correlatives of the agentless undoing of the city's architectonic stability with the passage of time.

The screws, moreover, enter directly into the Quays' psychosexual narrative, both for the father and the child. The child, for example, is seen capturing a screw that is trying to escape by screwing itself, wormlike, into a piece of wood. The boy grabs its head and works it loose, and he is later seen playing with it, making it dance by reflecting light on it with a hand mirror. In case the masturbatory overtones of the image are missed, it is linked associatively to three other erotically charged scenes. First, the father is seen to pick up an errant screw and put it in a box that he is carrying around on his furtive wanderings through the Street of Crocodiles. The Quays allude, perhaps, to a similar container in Luis Buñuel and Salvador Dali's classic surrealist film *Un chien andalou*, in which such a box holds a severed hand. In a second scene in *Street of Crocodiles*, in the tailor shop, this boxed screw is fetishistically replaced by a wooden shoe with a screw inset into it as a spike heel, which is put into the father's box and returned to him by the unctuous tailor assistant automatons. Finally, at the climax of the perverse and pornographic show given the father at the back of the tailor's shop, he is invited to peer into a hidden space, as if upon a particularly obscene spectacle. What is revealed to his glance, however, is the child, seated outside on the ground in the same posture he had been in when playing with the screws. Now, however, instead of his hand mirror casting a reflected light onto a dancing screw, he holds an illuminated light bulb on his lap and caresses it playfully. But soon, the screws in the jackknife-shaped electrical circuit to which the bulb is attached by a thick wire unscrew themselves in the now-familiar manner, extinguishing the light. When the light goes out, the boy covers the darkened bulb with a brown cloth sack.

The tailor shop scene deserves special consideration because of its singular degree of narrative drama, reinforced by the scherzo quality of the music accompanying it up to the more somber ending. The basic narrative of this scene is that the father, wandering about and peering in the shop windows of the district, is drawn into the tailor shop by the blandishment of its tailor and his glowing-eyed, automaton assistants. In a whirl of activity, the tailor and his helpers pull out and measure cloth, remove the wooden head of the father and replace it with a dummy head stuffed with cotton, and begin to refurbish the father's look, not merely by fabricating a new wardrobe for him, but by reconstructing his head and body. At the height of this activity, the tempo suddenly slackens, and the father is allowed to view anatomical drawings; he contemplates suggestively testicle-like pieces of meat with pins jutting out of them and caresses pieces of fur, cloth-covered shapes, and limply hanging, calves-leather gloves. In what appears to be the climax of this obscene spectacle, however, he is led to peer back out into the Street of Crocodiles, where his son is playing peacefully. The scene ends with the tailor's assistants having spent their charge of temporary life, with the camera sweeping past them, as their single arm gyrates erratically, like a burned-out machine.

As I have already suggested, the space of the tailor's shop offers a concentrated image of the contradictory qualities of the Street of Crocodiles as an urban district. In fact, it provides one more instance of the confounding of container-contained, microcosm-macrocosm relations that structure the film as a whole. Its reflective properties, produced through the shop's multiple mirrors and only partially transparent windows, project the inside of the space outside and open the internal vantages of the shop back out into the street. In the somber, long, leftward tracking shot that closes the tailor shop episode, one passes through an extraordinary complex succession of fragmentary spaces in which outside and inside are literally indiscernible. Finally, even the outmost narrative frame—the museum of curiosities of "The Wooden Esophagus"—is redoubled within this scene in the shelf of fetish items, a strange miscellany of outmoded knick-knacks displayed briefly in the frame, as the camera sweeps by.

Attentive viewing of this scene also reveals how closely the Quay Brothers associate the fragmentary organs and tissues of the body, the direct objects of fetishistic desire, with Schulz's original "fetish" of the map. In one shot, the assistants, having removed the father-puppet's wooden head, spread out a piece of liver upon a city map, covering it with the tailor's translucent sizing paper and attaching the blood-dampened paper to the raw flesh with pins. This shot conflates in a single disquieting

image several contradictory meanings: the skin's attachment to the flesh and its painful separation from it; the skin's covering of the flesh and clothing's covering of naked skin; the utilitarian implements of the tailor's work and the extravagant instruments of inflicting masochistic pleasure-pain. In another, rapidly passing image, one sees that the eye of one of the tailor's assistants, gesturing towards a particularly lurid spectacle, appears "bloodshot" with crosshatched lines, as if the viewing of pornography in the Street of Crocodiles had etched its map into the very organ of seeing.

The map in both Schulz's text and the Quays' animated adaptation of it is an *aide-mémoire,* yet it is also strangely mobile in its reference, displaceable from the outer narrative frame into the visceral organs of characters at the deepest heart of its fictional space, the inner sanctum of the tailor's shop. This peculiar de-localization of the map follows from the fact that it corresponds only to a lost territory, memorializing an affectively charged fragment of a Drohobycz that no longer exists. It serves fetishistically to disavow, though not truly dispel, the melancholy knowledge of this district's essential ephemerality, its ultimate vacancy in the historical city's archive of experiences, the disconcertingly rapid slipping into oblivion of a space once so intensely invested with the aura of fantasy and perverse desire. Already by Schulz's time, and certainly for the Quays, the Street of Crocodile designates nothing more than the errant imagination's bringing to temporary, uncanny life a trace of ink on paper—the adult author's memory of his father's map, and derivatively, Schulz's printed text for the Brothers Quay. Obviously, we might say, retracing Schulz's concluding lines, "we were able to afford nothing better than this paper imitation, this montage of illustrations cut out from last year's mouldering newspapers."[29]

Notes

[1] Originally published as "'Cut out from yesterday's mouldering newspapers': Bruno Schulz and the Brothers Quay in the Street of Crocodiles," in *Screening the City,* ed. Mark Shiel and Tony Fitzmaurice (New York and London: Verso Press 2003) 80-99.

[2] Walter Benjamin, "Surrealism, The Last Snapshot of the European Intelligentsia," in *Reflections*, trans. Edmund Jephcott, ed. Peter Demetz (New York: Schocken Books, 1978) 182.

[3] Hal Foster, *Compulsive Beauty* (Cambridge, Massachusetts: The MIT Press, 1993) 125-126.

[4] Timothy and Stephen Quay, quoted from Nick Wadley, "Interview with the Brothers Quay" (March 1995), *Pix* 2 (1997): 136.

[5] Cf. Anthony Vidler, *The Architectural Uncanny: Essays in the Modern Unhomely* (Cambridge, Massachusetts: The MIT Press, 1992).

[6] For theoretical discussion of the spatial aspects of capitalist accumulation, see David Harvey, *The Limits to Capital* (Oxford: Basil Blackwell, 1982) and *The Urbanization of Capital: Studies in the History and Theory of Capitalist Urbanization* (Baltimore: Johns Hopkins University, 1985).

[7] Benjamin, "Surrealism" 181.

[8] Benjamin, "Surrealism" 181-182.

[9] Bruno Schulz, *Letters and Drawings of Bruno Schulz*, trans. Walter Arendt and Victoria Nelson, ed. Jerzy Ficowski (New York: Fromm International, 1988) 54.

[10] Adam Zagajewski, "Preface to the American Edition" of *Letters and Drawings of Bruno Schulz* 15.

[11] Zagajewski 17.

[12] Bruno Schulz, *The Street of Crocodiles*, trans. Celina Wieniewska (New York: Penguin Books, 1963) 100-101.

[13] Schulz, *Street of Crocodiles* 101.

[14] Louis Aragon, *Paris Peasant*, trans. Simon Watson Taylor (London: Picador Books, 1971) 28-29.

[15] Walter Benjamin, *The Arcades Project,* trans. Howard Eiland and Kevin McLaughlin (Cambridge, Massachusetts: Belknap Press, 1999).

[16] Schulz, *Street of Crocodiles* 99.

[17] Schulz, *Street of Crocodiles* 100.

[18] On Benjamin's dream theory, see Chapter 3, "From City-Dreams to the Dreaming Collective: Walter Benjamin's Political Dream Interpretation."

[19] Schulz, *Street of Crocodiles* 108.

[20] Schulz, *Street of Crocodiles* 109.

[21] Schulz, *Street of Crocodiles* 110.

[22] Schulz, *Letters and Drawings* 56.

[23] Schulz, *Street of Crocodiles* 62.

[24] Schulz, *Street of Crocodiles* 61-62.

[25] Theodor W. Adorno, "Valéry Proust Museum," in *Prisms: Essays in Cultural Criticism*, trans. Samuel and Shierry Weber (Cambridge, Massachusetts: The MIT Press, 1967) 175.

[26] I adopt the term "non-organic life" from Gilles Deleuze, who applies it to the cinema of expressionism: "[N]atural substances and artificial creations, candelabras and trees, turbine and sun are no longer any different. A wall which is alive is dreadful; but utensils, furniture, houses and their roofs also lean, crowd around, lie in wait, or pounce. Shadows of houses pursue the man running along the street. In all these cases, it is not the mechanical which is opposed to the organic: it is the vital as potent pre-organic germinality, common to the animate and the inanimate, to a matter which raises itself to the point of life, and to a life which spreads itself through all matter. The animal has lost the organic, as much as matter has gained life."—Gilles Deleuze, *Cinema 1: The Movement-Image*, trans. Hugh Tomlinson and Barbara Habberjam (Minneapolis: University of Minnesota Press, 1986) 51. Cf. Bruno Schulz's description of his book *Cinnamon Shops* in an

essay that accompanied an interview with S.I. Witkiewicz: "*Cinnamon Shops* offers a certain recipe for reality, posits a certain special kind of substance. The substance of that reality exists in a state of constant fermentation, germination, hidden life. It contains no dead, hard, limited objects. Everything diffuses beyond its borders, remains in a given shape only momentarily, leaving this shape behind at the first opportunity. A principle of sorts appears in the habits, the modes of existence of this reality: universal masquerade. Reality takes on certain shapes merely for the sake of appearance, as a joke or form of play. One person is a human, another is a cockroach, but shape does not penetrate essence, is only a role adopted for the moment, an outer skin soon to be shed. A certain extreme monism of the life substance is assumed here, for which specific objects are nothing more than masks."—*Letters and Drawings of Bruno Schulz* 113.

[27] Schulz, *Street of Crocodiles* 67.

[28] Schulz, *Street of Crocodiles* 69.

[29] Schulz, *Street of Crocodiles* 110.

CHAPTER TWELVE

GRAPHIC HISTORIES:
EISENSTEIN'S *QUE VIVA MEXICO!* /
OLSON'S *MAYAN LETTERS*

I

On May 13, 1951, a Sunday, the American poet Charles Olson was getting ready to go to a bullfight in Seybaplaya, Mexico, but took time to write a letter to his friend Robert Creeley. The letter is full of Olson's uncertainties and money woes, aggravations with grant proposals and the bureaucratic fastidiousness of funding institutions. The question looms of how to stay on in Lerma in the Yucatan and continue his somewhat murky research into Mayan archeology, which Olson had undertaken with a mixture of motivations, ranging from sheer disaffection with American life, to a search for fresh intellectual inspiration and a solution of key issues of poetics that occupied his thoughts, to a frankly expressed need to support himself in some way that would not carry him too far from his literary vocation.

Sometime that morning, Olson must have laid his letter to Creeley aside, for after a couple of pages there appears the following addendum:

> *later, same Sunday.* fact is, didn't go to corrida, and for the damndest of reasons, that i didn't want to, was very light-headed, free, sat for an hour looking at words in the dictionary, and mulling over a burst of things which came on the last 24hrs. . . . That is, had put down this sentence: 'It is a most exact thing I have put myself in to here, these glyphs. And they feed me back . . . it is this business of, *exact* (ex., a dictionary, as of, words: words, how exact they—ex., adj. 'dead' has, I discovered today, *19* different uses.[1]

This epiphanic flash before the dictionary, not included in the selection of correspondence that Robert Creeley made for the 1953 publication in Spain of Olson's *Mayan Letters*, strikes me as an exemplary episode. It

marks Olson's real difference from the cult of intense experience of earlier modernist travelers like Ernest Hemingway and D.H. Lawrence, a cult that still held both Creeley and Olson in its spell all too often otherwise. This "business of exact" was the critical distinction, providing Olson with the disenchanting spell to block the magic of the flesh and the malice of the dead, an exactitude buried in words. It was an insight that Olson was not always prepared to trust: the gateway into the place where the dead speak is a page of the dictionary, not the viscera of fiesta crowds and the dark secret blood of a tormented beast. And the specific content that inspired Olson's detour into the historical archive of language appears, in this light, not accidental: he was contemplating, with the aid of his dictionary, the idea that there might be a great number of ways of being "dead," of marking times past, of translating history from an earlier living present to a later one through various sorts of material artifacts, images, and words.

Olson's archivist, George Butterick, remarks on the poet's peculiar dictionary habits in the introduction to the complete correspondence with Creeley in which Olson's Sunday afternoon letter appears. Olson, Butterick observes, brought his Webster's dictionary with him for his six-month residence in Mexico that began in January 1951. The archivist's devoted notes even identify Olson's copy as being of the 5th edition, where at the proper page one can find the definitions referenced in the letter; Butterick cannot resist interpolating a rhetorical question into his report: "would all poets" [have brought their dictionary]?[2] And the answer is obvious to any practical traveler: no, a dictionary makes the baggage unwieldy, especially when like Olson, you add it to the Mayan-Spanish dictionary that you have purchased in Merida, or when you ask your friend Cid Corman to mail you a secondhand copy of Alfred Tozzer's *A Maya Grammar with Bibliography and Appraisement of the Works Noted*, published in the papers of the Peabody Museum of American Archeology and Ethnology at Harvard University in 1921.[3] Poets might be thought to travel light; a pen, a notebook, and a few books are enough for poetic creation to get done. (This may be the materialist definition of lyric poetry.) But some poets, it must be acknowledged, also carry heavy equipment when they work on location.

II

Would any poet bring his Webster's dictionary with him? How about any filmmaker? Precisely one week shy of twenty years earlier than Olson's Sunday letter to Creeley, the great Russian filmmaker Sergei Mikhailovich Eisenstein was on the Hacienda Tetlapayanc, waiting for the

rains to cease so that he might resume shooting the central "Maguey" episode of his film *Que Viva Mexico!* Director and crew were working without salary and without sufficient funding. Problems plagued the shooting: flu, flux, and fever struck the crew at regular intervals; there were continued political wrangles with the Mexican censors and the mailing of film back and forth across the border between the U.S. and Mexico; occasionally the extra-cinematic passions of his non-professional actors broke into the charmed circle of art, like when his female lead ran off to Mexico City with a politician and had to be coaxed back with cash, or when one of the three rebellious campesinos in the hacienda episode shot, in real life, his sister, and was allowed to finish filming only under police guard. And on top of it all, it rained and rained and rained.

On the 20th of May 1931, Eisenstein wrote his producer and sponsor, the internationally-renowned socialist novelist Upton Sinclair, to ask that he send books to help fill the rainy days in which they could not shoot: "The list is included here in. The prices can be I think with the purest conscience laid on our pocket money expenses which we do not touch for weeks and weeks: conditions here are thus that we even can have no opportunity to spend our pocket money!"[4] His wish list included Charles Stockard's book on *The Physical Basis of Personality*; Harry Lanz's book of poetics and metrics, *The Physical Basis of Rime*, published by the Stanford University Press in 1931 and subtitled "On the Aesthetics of Sound"; and a book on American humor. The list also included a biography of the Haitian revolutionary Toussaint—of interest for his never-realized film project *Black Majesty*, which immediately followed the failed Mexico project—and another of Eisenstein's own big boss Joseph Stalin, whose word had sent Eisenstein to the New World and whose word would summon him home again. In an addendum, Eisenstein added a request for an 1892 article by the anthropologist Frank Cushing, "Manual Concepts," which traces the role of the hand in various manifestations of culture from language to writing to ways of conceiving space.[5]

But as he underlines to Sinclair: "The most important in the list is Webster's Dictionary. One volume edition. The one where is described the history and provenance of every word. I need him very much." [6] It was a characteristic need for the intellectually omnivorous Eisenstein. In an essay from November 1932, "In the Interests of Form," Eisenstein admitted:

> I also have a bad habit with dictionaries.
> A kind of ailment. A weakness.

> A preconceived notion that the first salvation of a word or term from
> the confusion that surrounds it is above all a simple dictionary of
> definitions.
> Not so much encyclopedic as etymological.
> It does not always solve the problems but it always leads to profitable
> reflections.[7]

The Webster's Dictionary, it seems, is the one book any modernist traveler
to Mexico should not leave home without.

In 1930, Eisenstein had been in Hollywood, under contract to adapt
Theodore Dreiser's novel *An American Tragedy* for Paramount. He
completed a screenplay version, which was rejected, with hilarious regret,
by David O. Selznick:

> I have just finished reading the Eisenstein adaptation of *The American
> Tragedy*. It was for me a memorable experience, the most moving script I
> have ever read. It was so effective that it was positively torturing. When I
> had finished it, I was so depressed that I wanted to reach for the bourbon
> bottle. As entertainment, I don't think that it has one chance in a hundred.[8]

On the recommendation of his friend Charlie Chaplin, Eisenstein then
approached the Sovietophile author Upton Sinclair for financial backing of
a film about Mexico. He needed, he said, $25,000 and three to four months
to make his film. In fact, Eisenstein and his crew would stay in Mexico
from December 1930 until being forced to return in February 1932,
shooting almost 200,000 feet—40 miles—of film and running up the
budget to nearly four times the projected figure. In the end, the film stock
remained in the U.S., it being by contract the property of Sinclair and his
investors, and a number of films were constructed out of the footage over
the next fifty years, none of them by Eisenstein. These included the
Hollywood productions *Thunder Over Mexico* (1933) and *Death Day*
(1934); Marie Seton's *Time in the Sun* (1939), made from a purchase of
16,000 feet of film; Bell-Howell's documentary series *Mexican Symphony*
(1940), from their purchase of 184,000 feet of film; some ethnographic
films made by the French company Pathé; the four hour "Study Films" put
together in 1957 by Eisenstein's former assistant and Charles Olson's
friend from his Melville studies, Jay Leyda; the version assembled in 1979
by Eisenstein's now-elderly co-director Gregori Alexandrov; and most
recently, Oleg Kovalov's 1998 reconstruction *Mexican Fantasy*.

In a report to the Seventeenth Party Congress, after a token expression
of satisfaction at the direction things had taken for his pedagogical work in
the state film school ("The Party purge has done a great deal to improve
and normalize our work and the Institute is approaching the Party

Congress in fine fettle."[9]), he concluded with a much more heartfelt
venting of his anger and frustration over the fate of *Que Viva Mexico!*:

> In between all these things, I am managing to read the cuttings from
> American and English papers and the letters sent to me in connection with
> the recent premières in America and England of our Mexican film that has
> been ruined and distorted by someone else's editing.
> I rejoice at the praise I have received for those parts through which the
> features of the original conception are perceptible and I gnash my teeth
> with hatred for those film people who, through stupidity and lack of
> culture, have not allowed us to complete our fourteen months of intensive
> work which, by all objective criteria, represents an enormous stage in the
> creative activity of our collective.[10]

Even as late as 1947, fifteen years after the interruption of the filming,
Eisenstein was still lamenting the dispersion and unauthorized reediting of
his stock. As Jay Leyda reports, Eisenstein wrote to Georges Sadoul that
he had not seen *Thunder Over Mexico* and *Time in the Sun* until early in
1947 and found the montage "*plus que navrant*" (more than heart-
breaking).[11] Scattered over the globe, dispersed in the course of a half-
century of sales, recoveries, recyclings, and reconstructions, Eisenstein's
film about how Mexico lives has by now come to resemble the
disseminated meanings of the word "dead" in Olson's Webster's 5th
edition dictionary.

III

Meanwhile, back in Mexico, over a month after his plea for books to
quell the boredom of enforced idleness, Eisenstein still had not received
his dictionary. In another letter to Sinclair of 1 July 1931, pressing Sinclair
for more funds to complete the picture and offering a series of ingenious
and impossible schemes to leverage investment on the basis of the
negatives already shot, Eisenstein appends the following postscript: "Half
the books from you, and half from New York are here. Many thanks. I am
sending for inquiries about the Dictionary."[12] The dictionary arrived at
last, as Eisenstein reported in a letter Sinclair received on the 23rd of July
1931. Yet it seems that Eisenstein, unlike Olson, did not find the key to his
film in browsing through it for an hour: "I finally got the Webster
dictionary and am very thankful to you, although its superficiality
disappointed me very much (in its historical ethymological [sic] part)."[13]
Eisenstein had, perhaps, sought an archeological depth, yet detected a
merely surface reference of one definition to another, without those

ancestral traces of origin derived from rhythmic habits of the voice and hand, residues of earlier forms of life that might be reactivated across great gaps of time. Charles Olson, reflecting on his experiences in Mexico, gave this desire for genealogical connection with the depths a characteristically lapidary formulation in his celebrated programmatic essay "Human Universe": "There is only one thing you can do about kinetic, re-enact it."[14]

What Eisenstein missed in the "historically ethymological part" of his Webster and what Olson discovered in a flash realization about the nineteen uses of "dead" was not, however, first and foremost, something primordial and vital hidden deep in the word (though both artists were regularly led astray by such seductive fantasies of primordialism). Rather what they were looking for was precisely what stared them in the face when they looked up a word in the dictionary: a graphic, spatialized, diagrammatic surface, a representation of history in which time was reinscribed in a horizontal play of difference within and among complex words. This play also traversed differences of representational scale, creating virtual connections between a single object or event and the vast chronicles of national and imperial history—connections that could be realized through conscious artistic construction, through *montage*. Thus, speaking in 1935 of *Que Viva Mexico!* Eisenstein wrote:

> The conception of the film as a whole was meant to represent an even broader generalization.
> It was constructed like a necklace, like the bright, striped colouring of the *serape*, or Mexican cloak, or like a sequence of short novellas. (In the form in which the film is now being screened it represents just one of those novellas, blown up out of all proportion and illegally expanded into a complete film on its own.)
> This chain of novellas was held together by a set of linking ideas— proceeding in a historically based sequence, but not so much by chronological epochs as by geographical zones. For the culture of Mexico of any one epoch from the vertical column of history seems to be like a fan spread across the surface of the land.[15]

History, for Eisenstein, might be thought to constitute a huge frieze of hieroglyphs incised into the geographical surface of a world-historical people's land. In light of his conception of the film's overall construction and its complex relation to Mexican life, however, we can also see the dictionary as a kind of scale model for national history, which the filmmaker conceives as being built up from the events of historical space-time distilled into units of language, sound, grammar, and use.

As Eisenstein points out in his 1929 essay "The Fourth Dimension in Cinema," the single shot possesses a certain analogical relation to language and textuality, but remains closer to hieroglyphic expression rather than alphabetic writing: "The shot never becomes a letter but always remains an ambiguous hieroglyph."[16] The single hieroglyph, however, with its complex of elements, may connect with other glyphs through a reticulated and manifold set of associative principles: semantic, spatial, pictographic, ideographic, phonetic, rhythmic, decorative. The single shot, Eisenstein suggests, "can be read only in context, just like a hieroglyph, acquiring specific *meaning, sense,* and even *pronunciation* (sometimes dramatically opposed to one another) only in *combination with* a separate reading or a small sign or reading indicator placed alongside it."[17] So too, in its way, the dictionary reveals words to be complex, impacted entities, merging grammatical functions, definitions, historical usages, etymologies, sound elements, and orthographies, each of which may be represented in schematic form in the dictionary entry.

In some of his theoretical pronouncements, Charles Olson appears to lean towards a view of glyphic writing as pictographically and gesturally immediate, rather than abstractive, in the manner of alphabetic transcription of speech sounds.[18] Thus, in his celebrated essay "Human Universe," Olson suggests that the Mayan writing system derived from the ancient Mayans' embodied relations to their environment and the cosmos:

> Men were able to stay so interested in the expression and gesture of all creatures, including at least three planets in addition to the human face, eyes and hands, that they invented a system of written record, now called hieroglyphs, which on its very face, is verse, the signs were so clearly and densely chosen that, cut in stone, they retain the power of the objects of which they are the images.[19]

So too this conception seems to lie behind his proposal to Cid Corman to present Hippolito Sanchez's drawings of glyphs in reproduction in *Origin* and in an exhibition in Boston's Museum of Contemporary Art as well. To Creeley, Olson enthuses about the glyphs' pictorial qualities:

> : it cd be a live graphic job, to present these glyphs, without comment, in such a way that their clarities & the width of their comment on human face & gesture, all animal and abstract nature, should sock any reader.[20]

Yet a passage from Olson's 1951 essay "The Gate and the Center," which he was revising in Mexico for publication in Corman's *Origin*, suggests that it was ultimately the dictionary-entry-like, diagrammatic reticulation

of language, and not some sort of archaic imagistic immediacy, that most engaged his interest in non-alphabetic writing:

> Take language . . . : did anyone tell you . . . that all Indo-European language (ours) appears to stem from the very same ground on which the original agglutinative language was invented, Sumeria? and that our language can be seen to hold in itself now as many of those earliest elements as it does Sanskrit roots? that though some peoples stuck to the signs while others took off with the sounds, both the phonetic and ideographic is still present and available for us to use as impetus and explosion in our alphabetic speech?[21]

Olson's attempt to grasp the glyphs as being, at once, sonorous and spatialized, graphically flat and historically volumetric, leads him to one of his most enigmatic attempts to formulate the "principle" behind the glyphs: "*language as, root, graphic:* sound, not as time, but as object in space, as mass, to be pushed around, to be heard as things are eaten, as, in process, of the organism not the 'mind' or 'taste' or 'aesthetics'."[22] The peculiar image Olson offers is that of a writing expanding dynamically, until it passes over into pronounced speech. But as I have already suggested, one model of this "expansion" of the word, this sublimation of writing into voice, is none other than the dictionary, which treats its lexical items like complex folding objects opening out onto history, usage, grammatical inflection, and sound. Arguably, then, the close surface scanning of the dictionary page—and not the fantasy-ridden plumbing for the primordial roots under the dust of history with which it often got confused—is the authentic analogue of Olson's and Eisenstein's shared interest in the so-called "hieroglyphs" (or "ideograms" or "pictograms") of the Chinese, Japanese, and Mayan writing systems.

IV

By all accounts, Eisenstein felt he had made an artistic and personal breakthrough with *Que Viva Mexico!* It is paradoxical, then, to realize this film never reached the phase in which Eisenstein's characteristic innovation, his radical use of montage editing, could come into play. As Eisenstein himself reports:

> When I had finished investigating montage, and foreseeing a unity of laws both in montage and shot, which I examined as stages, I dedicated all my work . . . to the question of the nature of the shot composition: *Que viva Mexico!*—my film about Mexico.

> As if punishing me for virtually leaving montage out of the scheme of
> things, this picture is frequently open to the most diverse of montage
> interpretations by different editors, although it does bear up to audience
> perception, probably simply because it was planned primarily on the basis
> of the shot.[23]

What was it, then, that excited Eisenstein so about the unconsummated
preparation he had done for this film? A viewing of the film re-constructed
in the 1970s by Alexandrov, which of course tells us little or nothing about
how Eisenstein would have edited the film, does nevertheless provide a
clue: the extraordinary graphic—or glyphic—quality of the photography.
If ultimately the failure of *Que Viva Mexico!* brought about a seven-year
hiatus of Eisenstein's filmmaking career (despite his frantic attempts to
restart it in project after project), at the outset it precipitated a return for
Eisenstein to an abandoned medium: drawing, which he had left behind for
nine years: "it was in Mexico that my drawing underwent the process of
internal purification in its striving for a mathematically abstract pure line.
// The effect is particularly striking when this abstract ('intellectualised')
line is used to draw particularly sensual relationships between human
figures, often in especially ingenious and far-fetched situations!"[24] The
style of the filmmaker's drawings, tending toward pictographic
abstraction, deeply permeates the composition of the filmed images as
well. Following the fantasy of the ideogram—expounded most influentially
by Olson's master Ezra Pound's edition of Ernest Fenellosa's *The Chinese
Written Character as a Medium for Poetry* in 1920, when Eisenstein was a
young Proletcult theater set and costume designer—the revolutionary
filmmaker found "photography" to mean "drawing with light" or "writing
with light."[25] A drawing that could be as eloquent and as conceptually
exact as writing.

The moment was ripe for a rebirth of cinematic technique, a
reorganization of film's complex of means that became necessary when
sound, and especially the recorded spoken word, was added to the
filmmaker's tool kit. There was still space for the independent experiment;
the visually static "talkie," the capital-intensive sound-film studio, and the
definitively victorious star system were not yet completely irresistible
outcomes of the shift to sound. In the correspondence surrounding *Que
Viva Mexico!*, F.W. Murnau and Robert Flaherty's highly successful South
Sea fantasy *Tabu*, independently produced and profitably sold to the
studios, was a constant point of reference. Not fully a sound film, Murnau
absorbed the silent film caption into the kinetic act of writing: colonial
officials writing reports, scrolls read by chieftains, love letters written by
native protagonists. (The fact that they write these letters in Western

alphabetic script seems not to have disturbed the filmmakers' prelapsarian image of the young couple torn apart by the weight of primitive law.) Even the ordinarily flat-footed Upton Sinclair rose to poetic heights of ingenuity when it came to addressing the problems of making the written word speak. Perpetually concerned—and not without some reason—about the rising cost and lagging schedule of Eisenstein's Mexican expedition, Sinclair writes the filmmaker on 28 February 1931 to inquire whether he is planning to use a voiceover narration or written titles. He notes that since the film is intended for release internationally, it would be much more expensive to record voiceovers in each of the necessary languages. Nevertheless, the titling associated with silent films appears "out of date" and hence also jeopardizes the film's commercial prospects with the novelty-hungry cinema audience. "It has occurred to me," an inspired Sinclair reports, "that you might find one or more devices from the Mayan legends or present-day Indian customs, which might be used in making the titles. Perhaps you will be using the traditional gods of the Mayans, the feathered serpent."—Sinclair digresses here to offer Eisenstein a copy of D.H. Lawrence's novel *The Plumed Serpent* to inform him about all this. "You might," he then resumes, "show this wind God idol blowing commands or threats and his breath might take the form of Aztec letters and then of the translation." He admits, in conclusion, "This particular suggestion might not be the thing used by you."[26]

The problems of language, image, and sound raised by the glyphic scripts were already implicit at Eisenstein's point of departure. With the release in 1926 of his first cinematic masterpiece—*Battleship Potemkin*—to worldwide acclaim, Eisenstein achieved a peak of success he would never again match in his short and tragic career. In 1927, Alan Crosland and Al Jolson's *The Jazz Singer* brought to the world's attention, in an admittedly primitive form, the new possibilities of recording sound and synchronizing it with the moving image. Almost immediately, the race was on to meet the challenge of the sound film, and the contest not only drew in the big Hollywood studios, hoping to outstrip their competitors in the pursuit of movie profits, but all the major forces in international cinema. In 1928, Eisenstein joined forces with his fellow directors Vsevolod Pudovkin and Gregori Alexandrov, the latter being Eisenstein's co-director of *Que Viva Mexico!,* to release a "Statement on Sound." This early sound manifesto remains important first and foremost as dust on the road not taken: it argues firmly against using sound to make "talking pictures" and for a non-synchronous, "contrapuntal" employment of sound, in which the emphasis should fall on the *discord* of sound with the visual image. The signatories argue that the introduction of sound need not

bound cinema within national markets closed off by language barrier.
"The *contrapuntal method* of structuring a sound film," they argue—

> not only does not weaken *the international nature of cinema* but gives its
> meaning unparalleled strength and cultural heights.
> With this method of construction the sound film will not be imprisoned
> within national markets, as has happened with the theatrical play and will
> happen with the "filmed" play, but will provide an even greater
> opportunity than before of speeding the idea contained in a film throughout
> the whole globe, preserving its world-wide viability.[27]

Eisenstein and his co-signatories also focused specifically on the problem
of the presence of written language in the film, which later occasioned so
much discussion in connection with *Que Viva Mexico!* In the 1928
"Statement on Sound," the filmmakers pronounced in favor of an absolute
replacement of the intertitle with a fully contrapuntal montage of image
and sound fragments: "We must regard as *the first blind alley* the intertitle
and all the vain attempts to integrate it into montage composition as a unit
of montage (fragmentation of an intertitle, magnification or contraction of
the lettering, etc.)."[28] In a conversation on sound conducted about a half-
year later, however, Eisenstein mitigated his position on the intertitle:

> Eisenstein does not think that intertitles in sound cinema should be
> completely replaced by "sound" intertitles. He admits that an intertitle that
> the audience merely reads makes far less impression on them than a
> "talking" title. But, in spite of this, Eisenstein does not admit the
> possibility that "talking titles" might completely replace intertitles in sound
> cinema. He starts from the premises that the intertitle in cinema plays a
> quite independent role, serving as one of the elements of a film and,
> furthermore, as one of its organic elements.[29]

The report continues by quoting Eisenstein directly:

> Everything depends on the goal that the director sets himself in each
> individual instance. I am quite prepared to admit that in a single film part
> of the titles might be written, while others might be conveyed by a sound
> image. It is even possible to have a combination of titles where the written
> text does not correspond with the spoken. (132)

Prior to his mastery of the technical apparatus of sound cinema, then,
Eisenstein had formulated a set of ideas about it that incorporated sound
into cinema's montage-complex of different signifying elements. It is this

speculative theoretical idea that carried Eisenstein forward into his euphoric, and ultimately tragic, encounter with Mexican life.

V

Olson, after floundering a long time with the idea—fed equally by his reading of Ezra Pound and the authoritative but mistaken Harvard University expert in Mayan archeology, Eric Thompson—that the Mayan glyphs were pictographic representations of cosmic myths, had a flash of insight. Olson begins to ponder a basic question: the relation of the glyphs to whatever the Mayans were speaking contemporaneously, that is, their status as instances of *language*. Thus, during his Mexican sojourn, only a few weeks after his arrival, he senses that the contemporary Mayan language and its speech-sounds might be the missing passage into the inner chambers of the codices' meaning. Olson writes to Cid Corman on 9 February 1951:

> But
>
> what is alive, and, is the very most exciting thing of all
> for me, is Mayan, the language! And I have already started
> to learn as much of it as I can: so much more important to
> me than Spanish. In fact, if I were of dreams, instead of
> the usual amount of human stupidity, in five weeks I would
> constitute myself what they call around here a "Mayista". . . .
> For already I smell things in these living Maya which are
> gates to now and then more solid than stones.[30]

He goes on to report that the young anthropologist Robert H. Barlow, who had recently committed suicide, had earlier moved into the fishing village of Telchac and attempted to master the speech. "In other words," Olson concludes, "Barlow was taking the step which the present demands of any worker anywhere: SOUNDS."[31]

This remarkable intuition resurfaces even more strongly several weeks later, in a letter of 28 March 1951 to Robert Creeley. "I was complaining," Olson writes—

> that I have not been able to find, that any of these birds start with the
> simplest of a proposition when they are going on about the question,
> whether the glyphs were a language or not. I was saying, if they agree that
> the chronicles (The Books of Chilam Balam) rest on records previous to
> themselves (as do the codices, definitely), then, why don't they tell us—or
> just ask—what kind of alphabet was it that preceded the Spanish letters in
> which Maya has been written since the Conquest (it is in our alphabet that

the Books of Chilam Balam are written). The question answers itself: it was in hieroglyphics (the codices supplying the answer). So all that's left to answer is, was the invention of a written use contemporary, or later than, the use of same on stone?[32]

Olson is tentative about the exact value of his intuition, but senses that his poet's sensitivity to the question of language has touched on something fundamental:

> Well, said, it doesn't seem to say much. But I smell it as important, tho, just yet, I can't demonstrate (it opens up, the fluency of, the glyphs, for me: which is what I have felt in them since that first day I saw them through Sanchez's drawings. And leads straight on in to the heart of their meaning and design as language, not, as astrological pictographs[.] (62)

Olson concludes that we should "come in fresh" and "see the whole business of glyphs as, 1st, language, and afterwards, uses of same" (62)— in other words, see them first from the point of view of *how* they register and communicate meaning as language, then worry about the religious and mythological content represented by that language.

Armed with this intention, Olson grasps that the glyphs, just like alphabetic writing, must be linked with speech rather than pictures:

> and it is the fact that the glyphs were the alphabet of the books
> that puts the whole thing back to the spoken language. Or so it seems
> to me, this morning.
> and with
> that established, it would seem that the Maya language as we have had
> it since it got the Spanish alphabet should be, by way of its sounds, the
> clue to the meaning of that two-thirds of the glyphs which are still wholly
> unknown[.] (62)

He even goes on to give a diagrammatic depiction of his own method for getting at the field of inquiry that has opened up before him:

<div align="center">

the glyphs
(their design & rhythms, in addition to
what denotation the scholars have found

</div>

the present Maya lang- *uage* (for its sounds & meanings, not its ortho- graphy)	*all surviving tales, re-* *cords, 'poems,' songs etc.* *the 'literature'* (Books of Chilam Balam, plus Co- dices, plus) (63)

Had the poet and amateur "mayista" Olson chosen to follow out this hunch fully, he would likely have been branded a dilettantish crank, and no funding agency would have touched a grant proposal. Instead, for his application for funding to the Viking Fund and Wenner-Gren Foundation to return to Mexico in 1952, he jettisoned his "unscientific" intuitions about glyphs and sounds and returned to a view consonant with the academic hegemony of J. Eric Thompson, that the glyphs were a cosmological repertoire of graphic images. Olson proposed to supplement Thompson's cosmological scholarship on the glyphs with an appreciation of their quality as plastic arts:

> Mayan "writing," just because it is a hieroglyphic system in between the pictographic and the abstract (neither was it any longer merely representational nor had it yet become phonetic) is peculiarly intricated to the plastic arts, is inextricable from the arts of its own recording (sculpture primarily, and brush-painting), in fact, because of the very special use the Maya made of their written stones (the religious purpose their recording of the movements of time and the planets seems to have served), writing, in this very important instance (important not only historically but also dynamically in terms of its use in cultures today), can rightly be comprehended only, in its full purport, as a plastic art.[33]

In short, for his successful grant proposal, Olson has shifted his thinking about the glyphs away from the sonorous radicals of speech, with their intimate ties to everyday life, labor, and the body, towards a more culturally elevated realm of cosmology, ritual, and specialized high art disciplines.

A full year after Olson's return from Mexico, a young Soviet comparative ethnologist, Yuri Valentinovich Knorosov, published an article in the October 1952 issue of *Sovietskaya Etnografiya*, which would take seriously the link of the Mayan glyphs with spoken sounds. A Red Army artillery officer, Knorosov had snatched a one-volume Mayan codex from the burning Berlin Library and carried it back to Moscow; he had never had the opportunity to travel to Mexico for his Mayan research. For years afterwards, Knorosov suffered the contempt of the academic field, led, above all, by that same Eric Thompson whose book, ironically, had led a dissatisfied Olson to his own insightful flash about the glyphs as language first, cosmological discourse derivatively and compositionally. Unfortunately for those who followed Thompson's authoritative lead, Knorosov was ultimately proven dead right.[34] The dictionary, the repository of usage in everyday and literary life rather than the cosmic vision, was after all the royal road into the enigma of the Mayan glyphs.

VI

The Soviet Union had a plethora of new talent and fresh ideas in the cinema, but was poor in technology and the necessary skills to employ it. Eisenstein, as the most famous filmmaker in the world after Charlie Chaplin, was the obvious choice for a visit to the Western European film capitals and then to Hollywood, to master the new sound film technology and put it in the service of the workers' state. According to Alexandrov, this project had the blessing of no less an eminence than Stalin himself, a story made more credible by Stalin's documented meddling in *Que Viva Mexico!,* his pressuring of Upton Sinclair to bring the filming to an end and send the increasingly suspect Eisenstein home.

If Stalinist politics provided the impetus for Eisenstein's travel and made possible, in the end, the Mexico project, it also played a role in the tragic outcome. Again, the question of sound, word, and image was a major stake. Eisenstein's arch-enemy in the film world, Boris Shumyatsky, was appointed in his absence to head the Soviet film industry. Shumyatsky pushed the development of Soviet sound cinema forward, but in a way utterly opposed to the Eisenstein / Pudovkin / Alexandrov manifesto. Socialist film, Shumyatsky thought, needed storytelling with talking heroes, and the possibilities of non-synchronized sound never got developed enough to make it even as far as the dustbin of history. In a letter of 26 July 1933 to the socialist writer Harry Dana, Upton Sinclair reported with self-justifying disingenuousness:

> The Russian Government got their great artist back and avoided having him turn into a White, as Rachmaninov and Chaliapin have done. They owe this solely to our efforts, and we thought they would be ready to do the fair thing about the picture. But Smirnov of Amkino came out here, and I said to him in the midst of a long wrangle: "One thing I want to get clear. Does Moscow want this picture?" The answer was, "Moscow does not want this picture." You beg me in your letter to arrange for a Russian cutting as well as Hollywood cutting. Well, that is exactly what I proposed to Smirnov and his answer was delivered with contempt: "Moscow would scorn to enter into competition with Hollywood."[35]

The collapse of the Mexico film and Eisenstein's return to the dark, dangerous climate of the Soviet Union during the purge years of the 1930s proved devastating to his artistic career. As he lamented in a July 1934 letter to the Argentine writer Victoria Ocampa—who during the months Eisenstein was in Mexico was founding the journal *Sur* in Buenos Aires,

publishing such modernist literary greats as Jorge Luis Borges, Julio Cortazar, Ernesto Sabato, Waldo Frank, and Albert Camus:

> The photography (that is very beautiful) is all that remains—but the whole composition, montage, etc., is completely destroyed by the imbeciles who managed it. . . . I so loved Mexico and it is painful not to be able to express it in this film that's now destroyed. . . . This whole affair so broke my heart that I became disgusted with cinema and have not made another film. Instead I've worked on a big theoretical opus which will be finished in a month.[36]

In fact, Eisenstein would not succeed in releasing another film until 1938, seven years after the failure of *Que Viva Mexico!* After his internationalist expedition to the Americas, his fatal enchantment with Mexico, and his aborted assignment to commemorate the Haitian revolutionary past in *Black Majesty,* his medieval epic film *Alexander Nevsky* returned Eisenstein emphatically to Stalin's "socialism in one country," to a Soviet Union increasingly under Great Russian cultural and historical hegemony . Not just in an extrinsic sense, but in the very idiom of its artistic construction, *Alexander Nevsky* is a film "made in Russia." It would be Eisenstein's first sound film.

Notes

[1] Charles Olson and Robert Creeley, *The Complete Correspondence*, Volume 6, ed. George Butterick (Santa Barbara: Black Sparrow Press, 1985) 45. I have throughout attempted to reproduce Olson's idiosyncratic typewritten punctuation, including its irregularities and errors.

[2] "Editor's Introduction" to Olson and Creeley 9.

[3] Olson to Corman, Letter of 20 February 1951, in Charles Olson and Cid Corman, *Complete Correspondence 1950-1964*, Volume 1, ed. George Evans (Orono, Maine: National Poetry Foundation, 1987) 97.

[4] Sergei Eisenstein and Upton Sinclair, *The Making and Unmaking of* Que Viva Mexico!, eds. Harry M. Geduld and Ronald Gottesman (Bloomington: Indiana University Press, 1970) 77.

[5] Frank Hamilton Cushing, "Manual Concepts: A Study of the Influence of Hand-Usage on Culture-Growth," *American Anthropologist* 5/4 (1892): 289-318.

[6] Eisenstein and Sinclair 77.

[7] Eisenstein, "In the Interests of Form," in *Eisenstein: Writings, 1922-1934*, ed. Richard Taylor (Bloomington, Indiana: Indiana University Press, 1988) 238.

[8] Memo of David Selznick to B.P. Schulberg, 8 October 1930, quoted in Jay Leyda and Zina Voynow, *Eisenstein at Work* (New York: Pantheon Books / The Museum of Modern Art, 1982) 58.

[9] Eisenstein, "For Elevated Ideological Content, for Film Culture!" in *Eisenstein: Writings, 1922-1934* 278.

[10] Eisenstein, "For Elevated Ideological Content, for Film Culture!" 278-279.

[11] Jay Leyda, *Kino: A History of the Russian and Soviet Film* (New York: Collier Books, 1960) 394.

[12] Eisenstein and Sinclair 110.

[13] Eisenstein and Sinclair 113.

[14] Charles Olson, "Human Universe" in *Collected Prose: Charles Olson*, eds. Donald Allen and Benjamin Friedlander (Berkeley and Los Angeles: University of California Press, 1997) 162. Cf. Frank Cushing: "For the hands have alike engendered and attended at the birth of not only all primitive arts, but also many primitive institutions, and it is not too much to say that the arts and institutions of all early ages are therefore memorized by them. In other words, their acts and methods in the production and working out of all these arts and institutions survive as impulses within them, as do obsolete organs in changed animal species; yet more, they survive according to well nigh the same laws of persistent organic inheritance The method of retracing these lost steps in the growth of the arts surviving in the hands of man is comprised in simply turning these back to their formal activities, by reexperiencing through them, in experiment with the materials and conditions they dealt with in prehistoric times; times when they were so united with intellect as to have been fairly a part of it."—Frank Hamilton Cushing, "Manual Concepts" 308-309.

[15] Sergei Eisenstein, "Montage 1937" in *Eisenstein, Volume 2: Towards a Theory of Montage*, eds. Michael Glenny and Richard Taylor (Bloomington, Indiana: Indiana University Press, 1991) 42.

[16] Eisenstein, "The Fourth Dimension in Cinema" in *Eisenstein: Writings, 1922-1934* 182. Eisenstein's concerns with alphabetic letters and hieroglyph reflect an earlier debate among literary intellectuals about the orthographic reform of Russian, beginning in 1904 and settled by the Bolshevik's institution of a new orthographic system upon their accession to power in 1917. Thus, for example, the symbolist poet Vyacheslav Ivanov, in opposition to the elimination of traditional variants, wrote in 1905: "The danger that threatens on this path is graphic amorphousness or formlessness which not only, as a consequence of the weakening of the hieroglyphic element, is aesthetically unpleasant and psychologically unnatural, but also can facilitate general apathy toward language."—Ivanov, quoted in Gerald Janacek, *The Look of Russian Literature: Avant-Garde Visual Experiments, 1900-1930* (Princeton: Princeton University Press, 1984) 14. In many respects, Eisenstein, with his emphasis on cinema as a medium for synthesis of the senses is closer to his symbolist forebears than is generally appreciated.

[17] Eisenstein, "The Fourth Dimension in Cinema" 182.

[18] George Butterick reduces Olson's view of Mayan writing to a single dimension, to a mytho-cosmic pictographic principle: "The glyphs represent an archaic imagism, units of intimate meaning, not simply astronomical configurations or anthropomorphic constructs."—"Editor's Introduction" to Charles Olson and

Robert Creeley, *The Complete Correspondence,* Volume 5, ed. George Butterick (Santa Barbara: Black Sparrow Press, 1983) viii. However, as I am suggesting, Olson offers several different tentative conceptions of Mayan writing, in some cases intuiting the ultimate direction of Mayan scholarship towards a phonetic decoding of the glyphs.

[19] Charles Olson, "Human Universe" 159. See also "Logography," where Olson quotes I.J. Gelb, *A Study of Writing* (1952), which argues that phonetic transcription of sounds occurs in the Mayan glyphs only rarely, almost exclusively in connection with proper names, which are sounded out by a rebus-like process.— "Logography," in *Collected Prose: Charles Olson* 180. Subsequent research revealed a much more extensive process of sound transcription underlying the Mayan writing system.

[20] Olson to Creeley, Letter of 15 March 2008, in *The Complete Correspondence,* Volume 5, 72. Note too that upon his return to Black Mountain College from Mexico, "glyphs" took on another contemporary art resonance for Olson, in the "GLYPH" exhibition organized by Ben Shahn in the summer of 1951. To Wilbur Ferry, Olson wrote: "Ben can tell you what a happy business happened amongst four of us guest faculty this summer—a GLYPH show, initiated by Ben as the consequence of his giving me a drawing as a trade-last for a poem, and now, because of these two acts, [Katherine] Litz the dancer has added a number to her repertory, a GLYPH, with set by Shahn, and my words set to music by [Lou] Harrison."—Quoted in Daniel Belgrad, *The Culture of Spontaneity: Improvisation and the Arts in Postwar America* (Chicago: The University of Chicago Press, 1998) 33.

[21] Charles Olson, "The Gate and the Center," in *Collected Prose: Charles Olson*, eds. Donald Allen and Benjamin Friedlander (Berkeley and Los Angeles: University of California Press, 1997) 169.

[22] Olson to Creeley, Letter of 28 March 1951, in Charles Olson and Robert Creeley, *The Complete Correspondence,* Volume 5, 109.

[23] Draft for 1945 essay "How I Became a Director," in *Eisenstein: Writings, 1934-1947,* ed. Richard Taylor (Bloomington, Indiana: Indiana University Press, 1996) 391-392, n. 26.

[24] Sergei Eisenstein, "How I Learnt to Draw," in Ian Christie and David Elliott, *Eisenstein at Ninety* (Oxford: Museum of Modern Art, 1988) 54.

[25] Eisenstein's most developed discussion of film's relation to Chinese and other "hieroglyphic" [sic] writing systems can be found in his 1929 essay "Beyond the Shot," in *Eisenstein: Writings, 1922-1934,* 138-150.

[26] Upton Sinclair to Sergei Eisenstein, 28 February 1931, in *The Making and Unmaking of* Que Viva Mexico! 56.

[27] Sergei Eisenstein, Vsevolod Pudovkin, and Grigori Alexandrov, "Statement on Sound," in *Eisenstein: Writings, 1922-1934* 114.

[28] "Statement on Sound" 114.

[29] "Conversation with Eisenstein on Sound Cinema" in *Eisenstein: Writings, 1922-1934* 131-132.

[30] Olson to Corman, Letter of 9 February 1951, *The Complete Correspondence*, Volume I 93.

[31] Olson to Corman, Letter of 9 February 1951, *The Complete Correspondence*, Volume I 93-94.

[32] Charles Olson, *Mayan Letters* [1953], ed. Robert Creeley (London: Jonathan Cape, 1968) 60.

[33] Charles Olson, "Project (1951): 'The Art of the Language of Mayan Glyphs," *Alcheringa* 1/5 (1973): 95.

[34] See Michael D. Coe, *Breaking the Maya Code* (London: Thames and Hudson, 1992).

[35] Upton Sinclair to Harry Dana, 26 July 1933, in *The Making and Unmaking of Que Viva Mexico!* 393.

[36] Eisenstein to Ocampo, quoted in Inga Karetnikova, *Mexico according to Eisenstein* (Albuquerque: University of New Mexico Press, 1991) 28.

INDEX